D1479331

The publisher and the University of California Press Foundation gratefully acknowledge the generous support of the Atkinson Family Foundation Imprint in Higher Education.

University Babylon

University Babylon

Film and Race Politics on Campus

Curtis Marez

UNIVERSITY OF CALIFORNIA PRESS

University of California Press, one of the most
distinguished university presses in the United States,
enriches lives around the world by advancing scholarship
in the humanities, social sciences, and natural sciences.
Its activities are supported by the UC Press Foundation
and by philanthropic contributions from individuals and
institutions. For more information, visit www.ucpress.edu.

University of California Press
Oakland, California

Library of Congress Cataloging-in-Publication Data

Names: Marez, Curtis, author.
Title: University Babylon : film and race politics on
 campus / Curtis Marez.
Description: Oakland, California : University of
 California Press, [2020] | Includes bibliographical
 references and index. |
Identifiers: LCCN 2019012205 (print) | LCCN 2019015896
 (ebook) | ISBN 9780520973190 (ebook) |
 ISBN 9780520304574 (cloth : alk. paper) |
 ISBN 9780520304581 (pbk. : alk. paper)
Subjects: LCSH: College life films—United States—
 History and criticism. | Racism in higher education—
 United States. | Racism in motion pictures.
Classification: LCC PN1995.9.C543 (ebook) |
 LCC PN1995.9.C543 M37 2020 (print) |
 DDC 791.43/655—dc23
LC record available at https://lccn.loc.gov/2019012205

Manufactured in the United States of America

28 28 27 26 25 24 23 22 21 20
10 9 8 7 6 5 4 3 2 1

For Beatrice Pita and Rosaura Sánchez

The God of Hollywood wanted white elephants, and white elephants he got, . . . plaster mammoths perched on mega-mushroom pedestals, lording it over the colossal court of Belshazzar, the pasteboard Babylon built beside the dusty tin-lizzie trail called Sunset Boulevard . . . Belshazzar's Feast beneath Egyptian blue skies, spread out under the blazing Southern California morning sun: more than four thousand extras recruited from L.A. paid an unheard-of two dollars a day plus box lunch plus carfare to impersonate Assyrian and Median militiamen, Babylonian dancers, Ethiopians, East Indians, Numidians, eunuchs, ladies-in-waiting to the Princess Beloved, handmaidens of the Babylonian temples, priest of Bel, Nergel, Marduk and Ishtar, slaves, nobles and subjects of Babylon. Griffith's Vision of Babylon! A mare's nest mountain of scaffolding, chariot-race ramparts and sky-high elephants, a make-believe mirage of Mesopotamia dropped down on the sleepy huddle of mission-style bunga-lows amid the orange groves that made up 1915 Hollywood, a portent of things to come. . . . Long after Belshazzar's court had sprouted weeds and its walls had begun to peel and warp in abandoned movie-set disarray; after the Los Angeles Fire Department had condemned it as a fire hazard, still it stood: Griffith's Babylon, something of a reproach and something of a challenge to the burgeoning movie town—something to sur-pass, something to live down.
—Kenneth Anger on D. W. Griffith's *Intolerance,* in
Hollywood Babylon (1965)

'Cause the wicked carried us away in captivity
Required from us a song
How can we sing King Alpha song in a strange land?
—The Melodians, "The Rivers of Babylon" (1970)

Contents

Acknowledgments *ix*

Introduction: University Babylon, the Campus Tour *1*
1. Indigenous Students and Students of Color in Silent Cinema *30*
2. Race and Respectability in the University of California *68*
3. Brown Universities, or the Question of Administration *105*
4. Looking at Student Debt in Films by People of Color *146*
 Afterword: University Babylon Revisited *180*

Notes *185*
Filmography *219*
Bibliography *227*
Index *243*

Acknowledgments

I could not have written this book without the help of many people. My research was supported by several University of California, San Diego, Academic Senate Grants, and thanks goes to Michelle Null for administering them. I also thank librarians and other staff at the Huntington Library, the Margaret Herrick Library of the Academy of Motion Picture Arts and Sciences, and Special Collections at the University of California, Riverside, especially UCR's Cherry Williams, Bergis Jules, and Jessica Geiser. Thanks as well goes to UC Press editor Niels Hooper, editorial assistant Robin Manley, and copyeditor Susan Silver. I'm also indebted to the excellent staff in the UCSD Ethic Studies Department, particularly our former financial analyst, Damarys Santana, and current department manager, Yvette Alvarez Obando.

University Babylon began when I was elected president of the American Studies Association, organized a convention on the topic of debt, and delivered a presidential address focusing on student debt in particular. I'm thankful to program committee member Abigail Boggs, from whom I first learned about critical university studies. I'm also grateful to my ASA program committee cochairs Roderick Ferguson, Lisa Lowe, and Jodi Melamud for reading and commenting on the address. A version of the presidential address was published in *American Quarterly,* and I want to thank the editor, Sara Benet Weiser, and managing editor, Jih-Fei Cheng, as well as respondents Miranda Joseph and Jodi Melamud. That essay would become the kernel of chapter 4 and the initial

impetus for the larger project. I delivered an early version of that chapter at the School of Interdisciplinary Arts and Sciences at the University of Washington, Bothell, where I appreciated thoughtful comments and questions from Dan Berger, Bruce Burgett, and Yolanda Padilla.

I began working on *University Babylon* in earnest in 2014, while teaching a graduate seminar at UCSD titled Ethnic Studies and Critical University Studies, and I want to thank the students for helping me push the project forward, including Crystal Ben, Daniel Gutiérrez, Matsemela Odum, and Vineeta Singh. I am also grateful to the students in my graduate cultural studies class focused on film and TV, including Bayan Abusneineh, Yessica Garcia, Aundrey Jones, Krys Mendez, Omar Padilla, David Sánchez-Aguilera, and Cynthia Vasquez. Thanks goes as well to the undergraduate students in my 2018 ethnic class about recent films by women of color, especially Coryn Hill and Justin Sampson. I also need to thank my graduate teaching assistants in that course, América Martínez and Boke Saisi, for introducing me to *Mosquita y Mari* and *Pariah*.

At the 2015 Unsettling the University: Confronting Capitalism and the Crisis in Higher Education conference at UC Riverside, I gave a talk that became chapter 2, and I am grateful to audience members for their feedback, particularly Jodi Kim and Dylan Rodríguez. A revised version of that talk was subsequently published in *Critical Ethnic Studies Journal*, and I thank editors Junaid Rana and John David Márquez, an anonymous external reviewer, and managing editor Kelly Chung. I also delivered part of chapter 3 at the 2017 State Reason/University Thought conference at UC Irvine, and I'm grateful for discussions there with Williston Chase, Jennifer Doyle, and Rei Terada. I'm further grateful for conversations with Moya Bailey, Aimee Bhang, Ricardo Dominguez, Ayana Jameson, Christopher Newfield, Beatrice Pita, Margaret Rhee, Nacho Sánchez, Rosaura Sánchez, Heather Steffen, Wayne Yang, and Salvador Zaraté.

I want to extend special thanks to folks who read and commented on the entire manuscript, including Roderick Ferguson, Rebecca Schreiber, Shelley Streeby, and Jeffery Williams, as well as the graduate students in the 2018 version of my Ethnic Studies and Critical University Studies seminar, including Sophia Armen, Katherine Garcia, Oscar Gutierrez, Mayra Puente, Brianna Ramírez, and Eduardo Thomas. I'm especially grateful for Oscar Gutierrez's insights into *Higher Learning* and *Mosquita y Mari*.

As always, my best reader is Shelley Streeby. This book required many trips to different archives, and along the way she was my perfect

companion. Riding planes, trains, and automobiles; checking into motels; signing into special collections; stowing stuff in lockers; sitting together at long tables under florescent lights; and staring at boxes and manila folders under cold, climate controlled conditions, she made me happy to be in the archive. What's next, Shelley?

Introduction

University Babylon, the Campus Tour

Somewhere in North America, an ape wearing a red jumpsuit lumbers into view, framed by brutalist buildings against a blue sky. The ape is soon joined by other, similarly outfitted apes, gently swinging their arms from side to side as a police officer leads them down a stairwell and into a concrete quadrangle. Guarded by other club-wielding police officers, a mass of apes in red and green jumpsuits crowd into the courtyard, where more police officers instruct them in menial tasks such as shining shoes, carrying packages, sweeping up trash, and mopping floors (see figures 1–3). The scene is the opening to *Conquest of the Planet of the Apes* (1972), a near-future dystopia set in 1991 about an intelligent ape from the distant future named Cesar (Roddy McDowell), who confronts a police state where apes are imported from Africa and Indonesia, brutally conditioned as workers, and then auctioned as slaves in the quad. The scene's location is between the Social Sciences Tower and Langson Library at the University of California, Irvine (UCI).[1]

The distinctive buildings in the opening of *Conquest* were designed by William L. Pereira, whose firm also drafted the master plan for the university and surrounding city of Irvine. Pereira began his career in the 1930s, helping to design the Century of Progress World's Fair in Chicago before moving to Los Angeles, where he married a film actor and worked in Hollywood as an Oscar-winning art director and producer in the 1940s and as a professor of architecture at the University of Southern California (1949–59) before focusing full time on architecture and

FIGURE 1. An ape lumbers into view. *Conquest of the Planet of the Apes* (1972) was set at the University of California, Irvine.

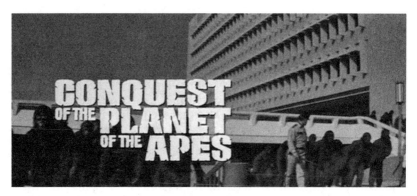

FIGURE 2. Apes are herded into a UC Irvine quad. *Conquest of the Planet of the Apes* (1972).

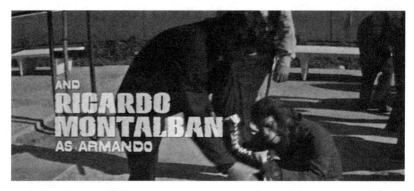

FIGURE 3. Vocational education is taught. *Conquest of the Planet of the Apes* (1972).

community planning until his death in 1985.[2] His most well-known structures include San Francisco's Transamerica Pyramid and the spiderlike Theme Building at the Los Angeles International Airport, but his body of work prominently features a combination of buildings for Southern California media industries (movie theaters and production offices) and college campuses.[3] Pereira's architecture is often described as "optimistic," and in university contexts it materializes the aspirational futures often associated with the Cold War academy. His concrete forms, massive fortresslike facades, square and rectangular boxes, sharp "clean" lines, and repetitive geometric shapes and ornaments suggest the imposition of order on the landscape and a vision of education as the transcendence of material limits. The university building that best exemplifies that vision is the famous Pereira-designed library at the University of California, San Diego. UCSD sits on an elevated tract of land overlooking the Pacific Ocean, and Pereira's library resembles a flying saucer about to launch into the stratosphere, suggesting a "reach for the stars" image of education abstracted from the terrestrial here and now.[4]

By contrast, the makers of *Conquest* chose UC Irvine to represent a fascist state, whose functionaries dress like members of the SS. While commentators have rightly noted that its narrative of enslavement and rebellion was inspired by the Watts uprisings, the collegiate location suggests it can be understood as a film about campus protests as well.[5] Read as a college film, *Conquest* recalls the militarization of campus and the autocratic rule of government officials and university administrators. The film's villain is a law-and-order governor who resembles former California governor and University of California administrator Ronald Reagan (chapter 2). The concrete Irvine courtyard where apes are trained as workers is replicated in the style of the sets the filmmakers built for the subterranean Ape Management Center, where apes are tortured until they learn their tasks. As an interpretation of campus architecture, *Conquest* recalls period and contemporary accounts of university exploitation of faculty, student, and staff labor. It could also be read as a response to forms of vocational education that slot students into menial jobs. Just before it opened, Irvine's first chancellor, Daniel Aldrich, appeared in a short film called *Birth of a Campus* (1965), where he is pictured talking about his ideals for UCI while walking through the unfinished architecture featured in *Conquest,* isolated buildings rising like military garrisons out of an otherwise barren landscape as the wind howls on the soundtrack.[6] *The Birth of a Campus* ends with scenes of students descending the same stairs and entering the same quad represented at the

start of *Conquest*. As if in response, at the conclusion of *Conquest*'s successful rebellion, Cesar declares the "birth of the planet of the apes." The film thus undermines the university's self-promotions by underscoring the potential for violence and domination in its built environment.

A decade after *Conquest*, Hollywood returned to Irvine to make *Poltergeist* (1982). The office of the film's paranormal researcher, Dr. Lesh, is played by UCI's Langson Library, while its suburban housing development, Cuesta Verde, resembles those that surround campus like a company town moat. In *Poltergeist*'s final act, when animate corpses begin to pop out of the rain-soaked earth, it is revealed that an unscrupulous developer has built houses on top of a cemetery. In keeping with the college theme suggested by the setting, the filmmakers acquired real human skeletons from a company that supplied them to universities.[7] The corrupt real estate developer recalls the shady history of the Irvine Company, for which the university and city are named. As detailed in chapter 2, the company played a key role in planning for UCI and its surrounding housing developments, while profiting from speculation in public lands, which were ultimately dispossessed Indigenous lands. *Poltergeist* renders that history ghostly, in Avery Gordon's sense of the term, suggesting that unacknowledged historical violence and displacement continues to haunt the present.[8] This is perhaps why, even though it is explicitly stated in the film that the cemetery is not a Native American burial ground, many viewers and critics misremember the plot of *Poltergeist*, suggesting that universities, like suburban settlements, evoke Indigenous genocide and dispossession.

In what follows I argue that the college-film genre provides a critical lens on the history of universities and their settler-colonial, racial, heteropatriarchal projects. Like Walter Benjamin's materialist history of commodity culture in his "arcades project," I analyze the college film as an archive of the contradictory desires and dreams that universities have anchored.[9] Films make visible the affective and material investments of university administrations in whiteness as it intersects with gender, class, settler colonialism, and sexuality. Such films represent the university's ideological commitments to inequality and exploitation, sometimes with a critical gaze, as in *Conquest* and *Poltergeist*, but more often in a celebratory frame, where hierarchy is reified as common sense or even higher learning. Hollywood films, in other words, often make university inequalities seem not only pleasurable but also natural and true.

University Babylon excavates both cinematic archives that shed critical light on U.S. universities and university archives that illuminate the workings of Hollywood. Combining concepts and methods from critical

university studies, critical ethnic studies, and film studies, I analyze the symbolic and institutional collaborations between Hollywood filmmakers and university administrators over the representation of students and, by extension, of college life and values more broadly. From the silent era to the present, Hollywood-university collaborations have generated influential ideas and practices related to whiteness, racial capitalism, and respectability politics in higher education. Working together, early film and educational institutions produced a powerful ideological formation that linked respectability and academic merit in ways that marginalized Indigenous people and people of color. Hollywood has thus been central to the uneven incorporation and exclusion of different kinds of students, professors, and knowledges by lending glamor and the pleasures of cinematic spectacle to hierarchical academic racial formations.

Conversely, in their collaborations with Hollywood, university administrations have lent their considerable cultural capital to the film industry. Especially at moments of economic disruption, when scandal and public outcry threatened profits, Hollywood studios avidly courted university consultants and sought academic endorsements of the cultural and educational contributions of their films. Indeed, in the twentieth century, universities regularly affiliated with Hollywood by giving honorary degrees to film executives.[10] Film studios have also mined university research about films' impact on different demographics, including people of color, as well as research on race and difference more broadly. Finally, in terms of both content and relations of production, film industries were schooled in racial exclusivity partly by their academic confederates. The term "University Babylon" thus signifies the many material connections and practical partnerships between Hollywood and the academy that combine to form a university-cinema–industrial complex (UCIC). The links between the two institutions, changing over time, are partial and fraught with contradictions. But, as a concept, the UCIC describes a Venn diagram that draws attention to where the film industry and the academy overlap in their pedagogical missions, spotlighting, in particular, their shared promotion of respectability and white nationalism.

With the UCIC as a critical lens, *University Babylon* presents both readings of films about college life and a critical history of institutional relationships. Hollywood has historically drawn writers, actors, and other talent from among the ranks of professors and students, while at the same time striving to legitimate the industry through connections to classrooms, curricula, and film studies programs. University leaders have founded film schools; promoted filmmaking as important to knowledge

production, cultural value, and democratic citizenship; offered their campuses as filming locations; and recruited student and faculty performers to promote and publicize their schools. Finally, in California, film actors and executives have played direct roles in the administration of the University of California as state officials and UC regents. Practically and symbolically entangled with university administrations, Hollywood has often produced a cinema of counterinsurgency, which, like a photo negative, depicts the force of student and faculty protests through their negation.

The rulers of University Babylon do not reign unopposed, however, for dominant academic and film industry collaborations have also inspired resistance. Ideologically, the college film is not a univocally dominant genre but rather a staging ground for competing visions of the university, not only for different audiences but also for Indigenous and minority filmmakers and academics. The conventions of the genre have also been revised so as to disarticulate knowledge and pleasure from inequality and domination. Insurgent filmmakers collaborate with university students and professors to produce cinematic cultures and institutions contra the UCIC. In what follows, then, I also focus on critical minority film and educational formations, on the margins of Hollywood and university administrations, that challenge the respectability politics and white nationalism of the two interrelated institutions while promoting more equitable models of education and cultural value.

University Babylon constructs a taxonomy of different historical representations of college students as filtered through hierarchies of race, class, gender, sexuality, and nation. Such representations constitute powerful images reinforcing a commonsense privileging of white male students. At the other extreme and anchoring intersecting hierarchies of difference, the figure of the Indigenous woman or woman-of-color college student is conspicuous in her absence for most of film history. While there are a few notable exceptions, Indigenous women and women of color have been largely excluded from college movies, serving as abject others to education and helping define dominant visions of academic value by their difference. Hollywood and the academy have promoted forms of respectability and intellectual merit based in hierarchies of race, class, gender, and sexuality that subordinate women of color and Indigenous women in unique ways. At the same time, however, since their exclusion has been constitutive for the UCIC, serving to define, by contrast, white male academia, the relatively rare film representations of Indigenous women and women-of-color college students turn a critical gaze on systems of domination. Chapter by chapter, then, I trace the history of such women students in film as they

flicker into view in the small number of mainstream silent films featuring Indigenous women students and the independent silent Black "uplift" films representing women students and teachers (chapter 1), as well as the marginal history of Chicanx students in college films (chapter 3). But it is especially in recent decades that these students have emerged into critical cinematic relief in works by women-of-color filmmakers, with academic backgrounds, working in the margins of the UCIC (chapter 4).

HISTORICIZING UNIVERSITY BABYLON

A number of scholars have produced important work at the intersection of critical ethnic studies and critical university studies. Jodi Melamed, in her cultural history *Represent and Destroy: Rationalizing Violence in the New Racial Capitalism,* analyzes how universities and other official anti-racisms and models of multiculturalism sustain and extend capitalist investments in racial inequality. In *The Reorder of Things: The University and Its Pedagogies of Minority Difference,* Roderick Ferguson demonstrates how contemporary universities became leading laboratories for the management of difference, containing the radical demands of students and the challenges of the interdisciplines (notably ethnic studies) with forms of symbolic inclusion that reproduce material inequalities. In her study of diversity work in British and Australian higher education, *On Being Included: Racism and Diversity in Institutional Life,* Sara Ahmed argues that critical diversity talk is often contained by administrative discourse, while the formulation of written policy is substituted for action. Meanwhile, in *The Undercommons: Fugitive Planning and Black Study,* Stefano Harney and Fred Moten suggest that universities often aim to police, expel, or effectively deport from campus all forms of what they call "study," a practice of collective thought and social action antagonistic to market logics. Finally, the contributors to the volume *The Imperial University: Academic Repression and Scholarly Dissent,* edited by Piya Chatterjee and Sunaina Maira, reveal contemporary universities as ideological and material agents of imperialism. Chapters focus, for example, on CIA and FBI efforts to recruit Black and Latinx college students; the complicity between neoliberal universities and the prison-industrial complex; administrative clampdowns on campus activism and scholarship critical of Israel; and the policing of research and activism about immigrant rights.[11] All these authors study universities as spaces of containment that suggest comparison with, and are often in fact connected to, other carceral spaces such as reservations, prisons, and detention centers.

Critical ethnic studies and critical university studies research further
focuses on modern universities as influential institutions of what Cedric
Robinson theorized in *Black Marxism: The Making of the Black Radical Tradition* as "racial capitalism." Works by Melamed, Ferguson,
Harney and Moten, and Grace Kyungwon Hong for instance, variously
analyze the role of universities in distributing capital along racial lines.
In his subsequent book, *Forgeries of Memory and Meaning: Blacks and
the Regimes of Race in American Theater and Film before World War
II,* Robinson demonstrates that early U.S. film industries complemented
university-based race science in its derogatory representations of people
of color, thereby rationalizing inequality and labor exploitation.[12]
Extrapolating from Robinson's insights, *University Babylon* contributes to critical university studies and ethnic studies an understanding of
cinema's conflicted historical partnership with the academy. Working
partly in tandem, Hollywood and higher education have historically
helped turn universities into securitized institutions of racial capitalism
that differentially exclude or incorporate different students, thereby
endeavoring to define their social and material value.

Critical ethnic studies research on higher education, as in critical university studies more broadly, focuses on the post–World War II university and, most often, on contemporary college campuses. Commenting
on the relative presentism of critical university studies, Abigail Boggs
and Nick Mitchell argue that it contributes to a "crisis consensus"
about the novelty or newness of a crisis in higher education that risks a
reifying nostalgia for earlier and better universities. While granting the
importance of thinking concretely about the perils of our immediate
contexts, Boggs and Mitchell warn that an exclusive focus on now disarticulates the present from the past and blocks investigation into larger
historical continuities between neoliberal, corporate universities, and
seventeenth-, eighteenth-, and nineteenth-century universities with
origins in settler colonialism and slavery. They invoke Craig Steven
Wilder's *Ebony and Ivy: Race, Slavery, and the Troubled History of
America's Universities,* which begins in the 1600s and extends to the
mid-nineteenth century. Wilder argues that the establishment and
growth of the Ivy League depended on settler colonialism and slavery.
Colonial-era colleges often functioned as armed forts protecting white
settlers, while administrators, teachers, students, and alumni served as
missionaries and soldiers in anti-Indian campaigns. The growth of colleges was made possible by the theft of Indigenous land and investments
in southern and Caribbean plantations. The major donors and trustees

in the early history of U.S. universities were plantation owners, slavers, and merchants who profited from slavery, while the schools themselves were built by Indigenous and African slaves. In fact, many college presidents, faculty and students owned slaves. Finally, early universities helped to produce "knowledge" about white superiority and Black and Indigenous inferiority.[13]

University Babylon extends the story of *Ebony and Ivy* into the twentieth century, where it overlaps with the history of cinema. The first film screened in the White House, *The Birth of a Nation* (1915), boasts a collegiate pedigree. Based on the best-selling novel by Thomas Dixon titled *The Clansman*, when *Birth* was criticized for its racism, the author asked his friend President Woodrow Wilson to screen it at the White House. Its intertitles included several quotations from Wilson's book, *A History of the American People*, which he wrote while a professor at Princeton. The text is steeped in "lost cause" nostalgia, and after screening *Birth* Wilson wielded his academic authority to promote the film, publicly confirming the accuracy of its sympathetic representation of the Ku Klux Klan. Wilson's endorsement not only helped ensure the film's success, according to Robinson, but also promoted a white nationalist consolidation of power over land and labor in the United States and the world.[14]

While this anecdote is often recalled in histories of U.S. film and politics, critics have generally left unexamined the origins of the friendship between the two men. Dixon enrolled in a graduate program in political science at Johns Hopkins in 1884, where he became friends with his classmate Wilson before dropping out to pursue a career in journalism. Years later, "after an exchange of college reminiscences," Dixon asked his college friend to endorse *Birth* by appealing to him "as a former scholar and student of history and sociology." After the White House screening, Wilson recalled that Dixon had been instrumental in the awarding of an honorary degree from Wake Forest. "Apparently," Dixon wrote, "the honor had come to Wilson at a moment in his life when he had been discouraged by the progress of his career and it had a cheering effect on him, as he remembered now: 'I want you to know, Tom, that I am pleased to be able to do this little thing for you . . . because a long time ago you took a day out of your busy life to do something for me.'"[15] This scene of reciprocal collegiality between Dixon and Wilson sharply contrasts with an earlier moment when, as president of Princeton, Wilson effectively barred the son of a prominent local Black minister, William D. Robeson, from enrolling at the university. Taken together these two scenes represent both the UCIC and opposition to it. The first figures the historical

white fraternity between universities and Hollywood, in which film gains the legitimacy of academic knowledge, and academic research acquires the modernity and emotional power of film spectacle. The second scene, however, suggests a critical, resistant trajectory through the history of U.S. universities, a path marked by the double consciousness of students of color, for the esteemed Reverend Robeson was the father of Paul Robeson, and it was Paul's older brother who Wilson reportedly barred from Princeton. Later Paul Robeson became a famous Rutgers University scholar athlete and early film star who was active in antiracist, anticolonial social movements (see chapter 1).

In the twentieth century, institutions of higher education and the film industry collaborated over the production of knowledge about race. Silent cinema took up where late nineteenth-century university researchers left off by representing for mass audiences a new common sense of white superiority. Scientific research was key to the development of motion pictures and their relationship to race, most famously in Eadweard Muybridge's late nineteenth-century contributions to the study of animal and human movement. Muybridge meticulously photographed people and animals in motion and designed a device called a zoopraxiscope, which employed still photos in simulations of movement, research widely regarded as paving the way for film. In 1872 he was commissioned to perform an experiment by Leland Stanford, railroad robber baron, former California governor, and future founder of the university bearing his name. Stanford bred horses at his Palo Alto ranch, on land where the university was ultimately built, and he hired Muybridge to investigate his theory that all four of a horse's hooves left the ground while it galloped. Muybridge was subsequently recruited by University of Pennsylvania provost Dr. William Pepper (an avowed white supremacist) and the painter and faculty member Thomas Eakins to conduct motion studies there, where he joined a prominent group of comparative race anatomists who presumed that Anglo-Saxons were at the top and that Africans and Indians were at the bottom of racial hierarchies.[16] "It was Muybridge, more than any other figure," writes Tom Gunning, "who introduced what Walter Benjamin, decades later, termed 'the optical unconscious,' revealing that much of everyday life takes place beneath the threshold of our conscious awareness," and part of what his experiments made visible was a distinctly racial unconscious.[17]

According to Elspeth Brown, Muybridge's research at Penn was part of a larger network of academic knowledge production that made racial hierarchies visible in three ways. First, he photographed mostly white

men and women against a black background with a white, geometric grid—the conventions for anthropometric photography aimed at measuring raced and gendered differences of size and stature. Second, his motion studies contributed to research into movement and gait as a previously invisible index of racial difference. Finally, many of Muybridge's photographic subjects were white male student athletes, and Brown persuasively argues that he participated in the idealization of Anglo-Saxon physical perfection common in popular representations of college athletes.[18] Muybridge's student athlete subjects were thus perhaps the earliest examples of one of the most popular icons of Hollywood film.

Stanford University has long used its connection to Muybridge to promote itself. In 1929 it staged a "Semi-centennial Celebration in Commemoration of the Motion Picture Research Conducted by Leland Stanford with the Assistance of Eadweard J. Muybridge," which included a delegation from the Academy of Motion Picture Arts and Sciences. As part of the celebration, MGM cofounder Louis B. Mayer gave a lecture titled "The Debt of Motion Pictures to the Early Researcher"; William C. deMille, the president of the academy who helped found the USC film school, gave a talk called "The University and the Future of Motion Pictures"; and, finally, Stanford president Robert B. Swain spoke on "The Relation of the University to Industrial Progress."[19] In 1972, in the wake of national student protests, Stanford celebrated the centennial of Muybridge's Stanford research with a museum exhibition that also commemorated the hundredth birthday of Paramount Pictures' founder Adolph Zukor.[20] Today Muybridge is the first entry on a university web page celebrating Stanford's "pioneers of innovation," including prominent figures in the history of Silicon Valley.[21]

With the emergence of the commercial movie industry, university researchers studied film's social effects at the intersection of race, gender, sexuality, class, and nation. In the early 1920s history and education scholars at Yale researched the possibilities of film for assimilating immigrants and developing democratic citizenship and civic respectability, including race and sex respectability. In collaboration with film personnel from the Hollywood production company Vitagraph, a group of professors endeavored to turn the best-selling Yale book series titled *Chronicles of America* into educational films for primary and secondary students. To produce the film series charting American history from Columbus to Woodrow Wilson, a new company was organized—the Chronicles of America Film Corporation—and while the popularity of the fifteen resulting films was limited, they nonetheless continued to

circulate in schools well into the 1950s. Seemingly echoing *The Birth of a Nation,* the company's final film, *Dixie* (1924), dramatized the Civil War from the perspective of a white woman plantation owner besieged by slaves who threaten to burn down the big house.[22]

Hollywood filmmakers similarly infused college films with racialized ideas about proper and improper comportment. Written and directed by Lois Weber and shot at the Southern Branch of the University of California (the precursor to UCLA), *The Blot* (1921) exemplifies Hollywood respectability politics. As film historian Shelley Stamp reminds us, Weber was one of the silent era's most successful, acclaimed, and powerful film-makers, and she employed film as a medium of social reform.[23] With *The Blot* Weber effectively rallies viewers to the defense of a particular vision of endangered white family values by juxtaposing a "native" white family and their European immigrant neighbors. The narrative is set in a university context, where the admirable, Anglo-Saxon behavior of Professor Griggs and his family is contrasted with the boorish and crass conduct of their immigrant neighbors, the Olsens. Although poor and underappreci-ated, Professor Griggs's family is represented as hard working and noble; by contrast, the teacher's immigrant neighbors are caricatured as mem-bers of a grasping consumer class mired by their modern appetites and oblivious to the virtues of head and heart represented by the Griggs fam-ily. Implicitly framing the immigrant Olsen family as improper or failed whites, *The Blot* idealizes the "native" whiteness represented by Profes-sor Griggs's household. Together Weber and the professors at Yale antici-pated efforts to define the proper relationship between whiteness and social conduct that animated both college films and university research throughout the 1920s and beyond.

In the early twentieth-century film industry, discourse about proper social conduct served to criminalize and police nonnormative gender and sex formations as embodied by Indigenous people and people of color, particularly students. The Motion Picture Production Code, for exam-ple, was effectively a code of conduct for film characters, which, among other stipulations, forbade depictions of race mixing. In the wake of various Hollywood scandals and complaints from religious, civic, and educational organizations about immorality in the movies, film execu-tives formed the Motion Picture Producers and Distributers of America (MPPDA), whose first president, Will Hays, commissioned a 1927 docu-ment titled "Don'ts and Be Carefuls." Written by a committee of film executives including E. H. Allen, head of the Educational Film Corpora-tion of America, which made films for schools, the list promoted tradi-

tional, white family values by prohibiting depictions of "sex perversion" and "miscegenation," defined as "sex relationships between the white and black races." A few years later the list of "Don'ts and Be Carefuls" was elaborated by film executive Irving Thalberg; the Catholic publisher of the *Motion Picture Herald,* Martin Quigley; and the Jesuit academic Father Daniel Lord of Saint Louis University and published in 1930 as the "Motion Picture Production Code . . . to maintain social and community values." Its "general principals" include the injunction that "no picture shall be produced which will lower the moral standards of those who see it. Hence the sympathy of the audience shall never be thrown to the side of crime, wrongdoing, evil or sin." Echoing contemporary eugenics discourse, the code distinguished between "entertainment which tends to improve the race" and "entertainment which tends to harm human beings, or to lower their standards of life and living." In the latter category of films threatening the health of an implicitly white race, the code proscribes representations implying that "low forms of sex relationship are the accepted or common thing" and enjoins filmmakers to uphold "the sanctity of the institution of marriage and the home."[24] In its enumeration of the kinds of film narratives about degraded sex that undermine marriage and threaten the race, the code prohibits all images of miscegenation and not just of Black and white sexual relationships. Indeed, subsequently, the Production Code Administration sought to exclude references to sex between whites and Black, Native American, and Asian characters.

The Production Code was colloquially called the "Hays Code" in recognition of the MPPDA's president and his commitments to Hollywood's racialized respectability politics. Son of a prominent political family in Indiana, Hays projected an idealized model of Hoosier democracy based in Christianity, family, and rural white communities. Before becoming the Production Code czar, he was an important Republican Party operative and, before that, a lawyer with his father's corporate law firm. Hays was a graduate student at Wabash University, where in 1907 he completed a master's thesis titled "On the Negro Question," in which he apparently endorsed the accommodationist respectability politics of Booker T. Washington, who he cites as an inspiration in his autobiography.[25] In the decade prior to becoming MPPDA president, Hays told a reporter that while researching his thesis he "spent some time in the Black Belt making personal investigations." Hays further explained that his graduate research began when he "became interested in a black boy in laboratory at college." Identified only by his first name,

"Frank," according to Hays, lived with him as a servant, "with the exception of two years he spent in penitentiary—he got into a drunken row."[26] While no other information about Frank remains, Hay's paternalist solicitude toward the former prisoner suggests the concerns over Black conduct that animated the Production Code. By contrast, as one of the architects of the code banning films about race mixing, Hays articulated a conservative vision of white family values to idealizations of education and the cultural power of the academy.

Hays wrote in his memoir, "I have often thought of [Hollywood] as a great university" with a similar educational mission. Given film's comparable influence, he argued that the studios should strive to "educate the movie-going public" in the values of family, Christianity, and U.S. nationalism, and he regularly addressed audiences of teachers and professors in pursuit of that mission. In 1922 Hays prompted the formation of a National Education Association committee chaired by University of Chicago psychologist Charles Judd to advise filmmakers on improving picture quality. Similarly, in 1929 he convened a conference of several hundred university presidents on the educational value of Hollywood films. After the conference he organized, with studio support, the Committee on Social Values in Motion Pictures, which supplied film-clip compilations to schools and colleges. By Hay's estimation the program reached millions of students with Hollywood films teaching devotion to family, God, and country. Under his leadership the MPPDA also published study guides to accompany feature films.[27] Since such films centered white characters and settings, their incorporation into classrooms implicitly taught students the virtues of white families, white religion, and white nationalism.

While the 1930 Production Code represented a kind of white nationalist consensus among film executives, religious leaders, and academics, its prescriptions were sometimes ignored by filmmakers. The publication of new university research about film viewing and social conduct, however, ultimately pressured filmmakers to more or less follow the code. Starting in the late 1920s, a conservative foundation called the Payne Fund, an arm of the Motion Picture Research Council, supported twelve studies collectively called *Motion Pictures and Youth*. According to Richard Maltby, the MPRC "was an organization of some social and scientific prestige," with prominent "WASP elites" on its national council. The organization recruited leading scholars in education, psychology, and sociology from Yale, New York University, Ohio State, the University of Iowa, and the University of Chicago, including researchers associated with the Chicago School of Sociology.[28] Out of all the Payne

studies, the most visible and widely discussed was *Movies and Conduct,* based on surveys of white and Black student film audiences by University of Chicago sociologist Herbert Blumer, who would go on to become a prominent academic, teaching at Yale and Berkeley and serving as president of the American Sociological Association. Starting in 1928, he began collecting written responses to questions about movies from his undergraduate students, using course assignments as data for his study. Such accounts were supplemented by similar assignments from students at a second, unnamed university; from women's colleges in Arkansas, New York, North Carolina, and Illinois; and from Chicago-area high schools. Finally, Blumer personally visited University of Chicago fraternities and locker rooms, using his own history as a college football star to gain the trust of his white male informants.[29]

Blumer's *Movies and Conduct* is remarkable for its incorporation of thirty-one written testimonials from Black high school students living adjacent to Chicago's Hyde Park neighborhood and hence in the shadow of the university. Indeed, Blumer did not collect testimonials from any Black college students, only white ones. He was unlikely to encounter Black undergraduates in the sociology classes at his overwhelmingly white university, and so the inclusion of narratives by Black high school students alongside those by white college students both marked segregation in higher education and suggested the dangers of its undoing. Among the moviegoing biographies Blumer chose to excerpt in the study are numerous instances of young Black men expressing their desire for white film stars such as Clara Bow, Greta Garbo, and Pola Negri, and of young Black women articulating their attraction to white matinee idols like romantic lead Rod La Roque. Moreover, a number of Black high school students reported that college films made them want to go to college themselves, suggesting that movies threatened to undermine the kinds of racial segregation represented by the Production Code's miscegenation restriction.

In his analysis of the testimonials, Blumer argued that watching movies, especially "love films," stimulated transgressive sexual impulses in students. Film fantasies are "largely monopolized by the kinds of experiences which are tabooed by the moral standards of community life." Students who watch romantic movies experience "the surging upward of impulse, the relaxing of ordinary inhibitions, [and] the readiness to yield to importunities for love experience." The "emotional possession induced by passionate love pictures represents an attack on the mores of our contemporary life" that "confounded discrimination and dissolved moral

judgement into a maze of ambiguous definitions."[30] In the context of nar-
ratives by Black students articulating desires for white film stars and
white universities, *Movies and Conduct* implies that Black film spectator-
ship threatens the color line. This is further emphasized by Blumer's argu-
ment that the corrosive moral effects of films pose special dangers for
"disorganized city areas"—a partial euphemism for Black Chicago—
where "the school, the home, or the community are most ineffective in
providing adolescents with knowledge adequate for the new world into
which they are entering."[31] The companion volume to *Movies and Con-
duct,* titled *Movies, Delinquency and Crime* and coauthored by Blumer
and his University of Chicago graduate student Philip M. Houser, reaches
similar conclusions about how films encourage the sex and other crimes
of Black reform school inmates and ex-convicts. Blumer's research was
widely disseminated and discussed in a variety of forms, including *McCa-
ll's* magazine and a popular digest of the Payne Fund studies titled *Our
Movie-Made Children,* and his work is partly credited with persuading
filmmakers to more closely abide by the Production Code.[32]

The history of the Production Code coincides with the related history
of film studies at the University of Southern California. The film school
was founded in 1929 by Hollywood icons of whiteness Douglas Fair-
banks and Mary Pickford (chapter 1); *The Birth of a Nation* director
D. W. Griffith; and USC President Rufus B. von KleinSmid, a prominent
eugenicist. Von KleinSmid began his academic career as a psychology
professor at DePauw University while simultaneously serving as the
superintendent and director of research at the Indiana Reformatory in
Jeffersonville. His 1913 lecture titled "Eugenics and the State," which he
delivered before the Cincinnati Academy of Medicine, was in fact printed
by the inmates in the prison's Printing Trade School. Jeffersonville was an
important center of early twentieth-century eugenics research and prac-
tice aimed at combatting racial degeneracy; based on his tenure there as
director of research, von KleinSmid advocated marriage restrictions, seg-
regation, and forced sterilization. His prison research led to an invitation
to address the first National Conference on Race Betterment in 1914. In
1921 von KleinSmid became president of USC, and during the same year
that he helped launch its film school he cofounded the Human Betterment
Foundation, a eugenics organization headquartered in Pasadena.[33]

Also a member of the Human Betterment Foundation, sociologist
Emory S. Bogardus was both a founding film school lecturer and a scholar
of race and film spectatorship at USC. He received his PhD in sociology
from the University of Chicago in 1911, where he studied with Robert

Park. Four years later he established USC's Department of Sociology (which he chaired until 1945), and in 1931 he was elected president of the American Sociological Society (subsequently renamed the American Sociological Association). Today he is best remembered for introducing the still widely used Social Distance Scale for measuring prejudice, but his prior promotion of "Eugenic Sociology" has been largely forgotten.[34] In *The Essentials of Americanization,* Bogardus emphasizes the dangers of miscegenation, writing that "an intermixture of races is taking place illegally. About one-third of the Black race contains white blood. . . . The amalgamation takes place under legally and socially abnormal conditions. As a result there is a vast cauldron of evil, vice, and crime continually boiling." He concludes that "the Negro racially represents a set of lower cultural standards than the Caucasian." While Bogardus criticizes *The Birth of a Nation* as a "gross injustice" that foments white racism, he concludes that its "harrowing illustrations of the actions of individual Negros undoubtedly represent actual happenings" perpetrated by "the meanest elements in the Negro regime during Reconstruction." Like Wilson, then, Bogardus affirms the historical accuracy of the film's racist depiction of Reconstruction, arguing that it was a grave mistake to give free slaves the vote, a decision that supposedly led to anarchy. Similarly, while critical of the conditions faced by Mexican immigrants, he concludes that they represent a "sinister" race problem given their vulnerability to "revolutionary and radical propaganda."[35]

Resonating with the work of Blumer, in *The City Boy and His Problems: A Survey of Boy Life in Los Angeles,* Bogardus applied his eugenic theories to the study of film spectatorship. Young boys, he argued, "are early fed, through the movies, a complete diet of pathological feelings, actions, and thoughts. They see how thefts are committed and love flaunted and think that they can 'get away with without being caught.'" He suggests that movies are especially dangerous for boys of color, whose natural tendencies toward degeneracy are exacerbated by anti–Black, Mexican, and Asian prejudice in schools and employment.[36] As a center of eugenics research in Southern California with connections to related area institutions such as Cal Tech, the Huntington Library and Gardens, and the Citrus Experiment Station at Riverside, Bogardus's employer, USC, has been a key node in the university-cinema–industrial complex. As Alexandra Mina Stern demonstrates in *Eugenics Nation: Faults and Frontiers of Better Breeding in Modern America,* Southern California eugenics research was primarily aimed at containing the threat Mexicans supposedly represented to white racial health. The

myriad practical connections between Hollywood and eugenics research at USC are represented by the vast archive of films representing Mexican men and women as criminals and sexual deviants and the almost complete exclusion of Mexican characters from the college film genre (chapter 1). The ongoing influence of eugenics is further suggested by Renee Tajima-Peña's documentary titled *No Más Bebés* (2015), which is about a USC hospital that forcibly sterilized Chicanas in the 1960s and 1970s, as well as the film *Higher Learning* (1995) by USC alum John Singleton, which features a group of campus Nazis. (chapter 4).[37]

Collaboration between Hollywood and universities in support of racialized respectability politics is a central theme of *University Babylon*, in dialogue with recent work in critical ethnic studies and critical university studies. Christopher Newfield, for example, argues in *Unmaking the Public University* that the privatization of the postwar public university was abetted by culture wars that mobilized racial animus in support of state budget cuts. Ferguson similarly demonstrates that racialized forms of respectability have shaped administrative responses to student demands for racial equality, prompting universities to prioritize symbolic forms of diversity while rejecting as improper student demands for material redistribution and greater access. Meanwhile, in *Campus Sex, Campus Security*, Jennifer Doyle suggests that university administrators have figured campuses as endangered white women in need of protection from people of color.[38] And as Chatterjee and Maira argue, American Association of University Professors norms of conduct for scholars presuppose an implicitly racialized conception of civility that Palestinian professors, notably Steven Salaita, are viewed as violating.[39] *University Babylon* contributes to these discussions with a longer critical history of how Hollywood partly schooled universities in a racialized politics of respectability. From silent college films (chapter 1), to Cold War films (chapter 2), to films about student protests in the 1960s and after (chapters 3 and 4), Hollywood has reproduced racialized forms of respectability that naturalize patriarchal white heterosexuality while vilifying racialized and Indigenous sexualities in ways that dovetail with academic knowledge production about race.

DOUBLE CONSCIOUSNESS, VICARITY, AND THE
CULTURE OF STUDENT MOVEMENTS

"Respectability" is a hinge between Hollywood and the academy, and, as I show in subsequent chapters, universities have borrowed from films to

articulate racialized respectability to ideas about academic value and meritocracy. As a result, academic respectability is also an object of student and faculty critique and protest, partly centered in a cinematic undercommons on the margins of the UCIC. When read against the grain, for instance, the Black student film testimonials collected by Blumer offer critical interpretations of cinematic and educational racism. In 1931 *The Birth of a Nation* was rereleased with new sound effects, and both Blumer's study and a study by his University of Chicago colleagues in psychology Ruth C. Peterson and Louis Leon Thurstone argue that the film encouraged white high school and college students to fear and loath Black people.[40] By contrast, Black high school students used the Blumer study prompt as an occasion to deconstruct *Birth*'s white supremacy. As one anonymous young Black woman wrote,

> It seems to me that every picture picturing a Negro is just to ridicule the race. When a Negro man or woman is featured in a movie they are obliged to speak flat southern words, be superstitious and afraid of ghosts and white men. They have to make themselves as ugly and dark as possible. The bad things are emphasized but the good characteristics left out. This is very unfair to the race. All Negroes are not alike; there are different types as in other races. Why must they be portrayed as ignorant, superstitions animals instead of decent people that are just as capable of doing great things as any other race; all they need is the chance. It is the same with other dark races besides the Negro. They are always the loser, the shrinking coward, and never the victor. It is very unjust of the white race to make every nation appear inferior compared to them.[41]

This young Black woman's argument that films reinforce a color line built on the opposition between Black ignorance and white knowledge speaks directly against ideological constructions, in film and the academy, that supported segregation in higher education. The student extends her analysis to film representations of "other dark races besides the Negro," suggesting that the Indians, Mexicans, and Chinese feared and vilified in the moviegoing testimonials of many other students in the study are similarly positioned as antithetical to the forms of knowledge and intelligence supposedly characteristic of white schools like the University of Chicago.

Similarly, one of Blumer's respondents, a Black male high school senior, wrote that films reinforced forms of anti-Black racism organized around ideas about knowledge and intelligence associated with universities as white institutions: "Sometimes from seeing such pictures as 'The Birth of a Nation' I would not but feel the injustice done the Negro

race by other races. Most of the bad traits of unintelligent Negroes are used in many pictures and a lovable or educated character is rarely pictured. At other times, 'West Point,' a picture of college life and a military training school, stirs within me a desire to go to college or some military or naval school away from home and serve my country as best I can."[42]

The student notes that, in contrast with films like *Birth*, college films make him want to attend university, thereby deconstructing the hierarchical opposition between white knowledge and Black ignorance. Other Black high school students similarly argue that watching college films such as *The Wild Party* (1929), starring Clara Bow as a party girl at a women's university, made them want to go to college. Given that *The Wild Party* represents college as an all-white scene, Black spectators' film-inspired desires imaginatively overturn the racial segregation that has characterized universities, both then and now.

Black student analysis of their own film spectatorship in Blumer's study further presents critical perspectives on the intersection of race and class, as in essays about white-society films that draw into relief the limits of Black material conditions and the unfairness of white-class privilege. Finally, a number of the young Black women authors included in *Movies and Conduct* articulate desires in excess of a white supremacist gaze. Two young women, for example, described their attraction to Mexican actors in great detail. As one fourteen-year-old wrote, "I fell in love with Gilbert Roland. I would imagine I was the leading lady in the picture he played in. I used to sit and day-dream. One day I would marry Gilbert Roland and we would have a lovely time until I went out with, maybe, Ramon Navarro and Gilbert would catch me kissing Ramon." Likewise, commenting on a South Sea romance titled *The Pagan* (1929), a Black high school junior wrote that Ramon Navarro "is so different from the rest of the movie actors. He is so boyish. I imagined I was on the island with him and could almost see myself running hand-in-hand with him along the island, eating coconuts. During the whole picture I sat there as if I was in a dream."[43] By focusing on fantasies of Black and Latino desire, these young women displaced the central role of whiteness in hegemonic representations of love and sex in film and on college campuses.

In *A Third University Is Possible*, la paperson begins an analysis of critical, oppositional elements in the academy by proposing an analogy between film studios and universities:

Each industry requires a willing civil society of moviegoers and university-goers, physical theaters and physical campuses, digital videos and digital learning platforms. Whereas cinema's investments are mostly liquid capital, the university's investments are land and debt. Cinema's horizon of consumption is the total population of visually abled people. Likewise, the university, though historically elitist, has expanded its horizons toward the total debt-enabled population. . . . Pedagogically, cinema and university perform complementary roles in the production of the symbolic order. Cinema is a key industry in the production of "commonsense knowledge," as compared to the university's production of legitimated knowledge.

The appropriation and occupation of Indigenous land is here a defining feature of the university. The Morell Act of 1862 transferred public lands, including thirty thousand acres of recently seized Indigenous lands to Union states, which were encouraged to sell to fund new public universities. The act promoted speculation in Indigenous lands to build universities that would themselves be sited on Indigenous lands. It also tasked land-grant universities with developing agriculture, which they have largely done on behalf of corporate agribusiness interests, thereby further encouraging settler-colonial expansion. And as la paperson insists, academic settler colonialism is not past but an ongoing part of the present, since "stolen land was (and is) the literal capital" used to buy and build so many universities, notably in his account of the UC system.[44] Drawing on film studies distinctions among First Cinema (the commercial industry), Second Cinema (independent or art films that nonetheless remain within a commercial system), and Third Cinema (political films of radical transformation), he describes the First University as the dominant, settler-colonial institution; the Second University as academic liberalism; and, finally, the Third University as "an interdisciplinary, transnational, yet vocational university that equips its students with skills toward the applied practice of decolonization." "Through this analogy of Third Cinema," la paperson concludes, "We can describe the university as an amalgam of first, second, and third world formations."

The comparison between film and educational institutions suggests something more than an analogy, however. Like land grant universities, Hollywood has long appropriated Indigenous lands, starting with the siting of film studios in Southern California; the building of exclusive residential enclaves for the industry's elite; the development of western-style ranches for making film westerns; and the practice of location

shooting, especially in the U.S. West.[45] As similar kinds of settler institutions, Hollywood and the academy are both ideologically and materially intertwined. The comparison of liberal Second Cinema and the liberal Second University, moreover, recalls the historical institutional partnerships between liberal Hollywood and the liberal academy (chapter 3). Finally, we can think of the construct "Third Cinema" and "Third University" not just as an analogy but as a practical and embodied nexus of critical film culture, in but not of the university-cinema–industrial complex. Since the 1970s U.S. universities have housed minority film cultures that challenged hierarchical models of respectability (chapters 3 and 4), and such contexts, I argue, are built on longer histories of critical spectatorship, as in the case of Blumer's Black student informants, as well as early films featuring anticolonial students of color (chapter 1).

Extending la paperson's arguments, then, throughout this book I attempt to make visible the Third University Babylon in the First, or the critical, minority film cultures within the margins of the academy. As central examples, I analyze a group of women-of-color creators, notably Ava DuVernay and Aurora Guerrero, who draw on their college education and Black studies and Chicano studies majors to produce powerful films about working-class women of color in the shadow of both Hollywood and USC.

To appreciate the critical contributions that Indigenous people and people of color have made to both film and higher education, I develop two concepts: multiple consciousness and critical vicarity. The first is indebted to W. E. B. Du Bois's discussion of Black "double consciousness" in *The Souls of Black Folk:*

> The Negro is a sort of seventh son, born with a veil, and gifted with second-sight in this American world—a world which yields him no true self-consciousness, but only lets him see himself through the revelation of the other world. It is a peculiar sensation, this double-consciousness, this sense of always looking at one's self through the eyes of others, of measuring one's soul by the tape of a world that looks on in amused contempt and pity. One ever feels his twoness—an American, a Negro; two souls, two thoughts, two unreconciled strivings; two warring ideals in one dark body, whose dogged strength alone keeps it from being torn asunder.[46]

As Shawn Michelle Smith argues in *Photography on the Color Line: W. E. B. Du Bois, Race, and Visual Culture,* Du Bois understands the color line "*as* a visual culture . . . in which racial identities are inscribed and experienced through the lens of a 'white supremacist gaze.'" To

survive within a Jim Crow visual field, Black subjects are forced to see themselves through the eyes of white others. Du Bois demonstrates that Black subjects are split by experiencing how white others perceive them. Double consciousness thus "enables a powerful social critique . . . that discloses the pathology of white supremacist America." Smith finds Du Bois's metaphor of the veil especially illuminating for thinking about visual culture, comparing the veil to a movie screen where "the collective weight of white misconceptions is fortified and made manifest." If we take the comparison literally, it provides an apt description of the experience of being a Black film spectator under a white gaze. Revising her claims along those lines, we might say that movie screens are one surface where white fantasies of a negative Blackness and of an idealized whiteness are projected and maintained. The white-dominated film screen shrouds "African Americans in invisibility by making misrepresentations overwhelmingly visible," standing in "for the African American subjects it sentences to invisibility." Movie theaters are thus especially important places where African Americans and other people of color are compelled to see themselves "through the eyes of others."[47]

For Black spectators, watching movies under a white gaze is contradictory, marking subordination but also representing a perspective of critical insight that Du Bois calls "second sight." "Second sight constitutes a critical vision," according to Smith, "a sight that enables one to recognize the constructed nature" of screen projections.[48] Likewise, investigating the perspectives of marginalized filmmakers, spectators, and academics provides critical insights into whiteness. An idealized fantasy of white wholeness has been historically maintained by screen projections of white college life that exclude or vilify people of color and Indigenous people. As Michelle Raheja argues in *Reservation Reelism: Redfacing, Visual Sovereignty, and Representations of Native Americans in Film,* historically, films with Indigenous plots, actors, and directors "mirrored the state that Du Bois characterized as 'double-consciousness,'" compelling Native people to see themselves "through the eyes of the dominant culture while also attempting to self-represent in ways that were consistent with Indigenous practices."[49] Raheja argues that Hollywood westerns split Indigenous subjects as they encounter the gap between white representation and Indigenous self-representation. Out of that gap, Raheja suggests, Indigenous filmmakers and audiences generate critical insights into the construction of settler-colonial fantasies.

Drawing on these accounts, in *University Babylon* I use double consciousness to analyze what it means for students and faculty of color to

be "in but not of the academy." Ferguson and Harney and Moten employ the figure of speech "in but not of" to describe contexts where students and faculty work and study in universities while resisting becoming a part of its hegemonic projects. The figure was anticipated by Du Bois, who, writing about his college studies, recalled, "I was at Harvard, but not of it."[50] Commenting on the "in but not of" trope in critical university studies, Abigail Boggs and Nick Mitchell note that it "splits the difference between two ways of understanding one's relationship to the university," and this sense of subjective splitting suggests double consciousness as a model for thinking about critical insights and campus protest.[51]

In *University Babylon* I elaborate theories of double consciousness as *multiple consciousness,* a concept I propose for understanding marginalized modes of spectatorship within visual fields structured by intersecting forms of hierarchy and domination. Moya Bailey's theorization of "misogynoir," or "the unique anti-Black racist misogyny that Black women experience" in visual culture, has sparked my related ideas about multiple consciousness.[52] According to Bailey, misogynoir "describes the co-constitutive, anti-Black, and misogynistic racism directed at Black women, particularly in visual and digital culture" (chapter 4). While insisting on the particularity of misogynoir to queer Black feminist studies of visual culture, by elaborating a theory of "multiple consciousness," I attempt to learn from Bailey how to theorize multiple, intersectional vantage points on the UCIC. As a concept, "multiple consciousness" awaits specification and revision in response to particular intersections of race, class, gender, sex, and national differences. In this way "multiple consciousness" promises to bridge screen theory and intersectional analysis.

I further develop the related concept of vicarity to understand the political implications of empathy and identification across difference. Complementing Saidiya V. Hartman's analysis of vicariousness as a top-down vehicle of racist common sense, *University Babylon* also theorizes vicariousness from below, including modes of critical vicarity.[53] Here I draw on the published writings and archival papers of former farmworker, Chicano movement artist, filmmaker, and University of California administrator Tomás Rivera. Partly through his collaborations with filmmakers and media institutions, Rivera theorized subaltern epistemologies based in the kinds of vicariousness encouraged by watching film and television. For Rivera vicarity is a contradictory dialectic that toggles between appeals to incorporation and the recognition of exclusion and subordination. On one side of the dialectic, Rivera employs "vicariousness" in descriptions of migrant workers' incorporation into

oppressive ideologies and institutions. Vicarious farmworker attachments to film fantasies of heterosexual romance and family, for example, obscure the dangers of low-wage labor under conditions of anti-Mexican racism. On the other side of the dialectic, Rivera suggests that because both education and Hollywood films formally appeal to farmworkers while practically excluding or subordinating them, subaltern experiences with vicarity can generate insights into the construction of social hierarchy and inequality. Recalling Du Bois's study of Black double consciousness as a kind of second sight, Rivera sees how marginal experiences of vicariousness can open up critical perspectives on power in general and the academy in particular (see chapter 3).

Each of the following chapters focus on different yet overlapping moments in the history of the UCIC and its discontents, cutting back and forth between the dominant narrative arc of the partnership between Hollywood and higher learning and the subordinated arc of the myriad collaborations among marginalized filmmakers and academics. The book also splices together different moments in the UCIC's practical and symbolic investments in forms of settler-colonial racial capitalism wed to patriarchal white respectability and academic knowledge. Finally, each chapter foregrounds different scenes of multiple consciousness and critical vicarity staged by filmmakers and academics who are in but not of University Babylon.

Chapter 1, "Indigenous Students and Students of Color in Silent Cinema," argues that silent cinema took up where academic race science left off, legitimating white nationalism by depicting it as the aim and outcome of higher education. Most silent college films celebrate white men and heterosexual romance while subordinating white women and denigrating others as deviant. The few films that depict Indigenous college students or students of color dramatize how they come to learn of their own inferiority as well as the necessity and justice of racial segregation. As the title of a 1917 movie about a South Asian college student at Oxford suggests, the lesson of such films is *Each to His Kind*. While I focus partly on the powerful collaboration between universities and film industries that gave the authority of higher education to heterosexual white nationalisms, I also reconstruct a counterhistory based in the experiences of Indigenous students and students of color. A small number of such students and former students would become early twentieth-century mass media celebrities and producers, including the great Sac and Fox athlete and actor Jim Thorpe (Carlyle); Chickasaw director Edwin Carewe (Universities of Texas and Missouri); Japanese

actor and producer Sessue Hayakawa (University of Chicago); and actor, singer, and activist Paul Robeson (Rutgers). When analyzed from the perspectives of Indigenous students and students of color, silent college films support modes of multiple consciousness critical of early twentieth-century white nationalisms based in a combination of settler colonialism, racial capitalism, global imperialism, and white heteronormativity.

Chapter 2, "Race and Respectability in the University of California," draws on work by June Jordan, Michael Rogin, and Patricia J. Williams to examine the film careers of two actors and California governors as windows into their administration of the University of California. I argue that Ronald Reagan inherited and tried to materially reproduce the white common sense about university students represented in silent films. Reagan was accomplished in the use of racist "code words" and "dog whistles," and he honed those skills in reaction to protests at the University of California. While California governor, he argued that academic freedom must be checked by norms of respectability, and this chapter explores the significance of linking the two. Drawing on Reagan's history as a college athlete, his college film roles, and his numerous college commencement speeches, I conclude that his vision of academic freedom emerged from a matrix of whiteness, settler colonialism, and patriarchy that continues to inform conservative and liberal responses to free-speech struggles on campus.

Reagan's acolyte and successor, Arnold Schwarzenegger, also drew on ideologies of respectability, but whereas Reagan emphasized racial and sexual propriety, the former bodybuilder and action star focused on racialized and gendered idealizations of size and a hardened indifference to the suffering of others. Schwarzenegger rationalized austerity and budget cuts for higher education by appealing to a white, masculinist perspective that rendered workers of color and leftist academics too small and insignificant for inclusion in the University of California. A critical take on Schwarzenegger's film roles as a college professor reveals that, as governor, he became a populist, antilabor administrator who mobilized respect for state power to cut public education and attack university labor studies.

Chapter 3, "Brown Universities, or the Question of Administration," begins with the observation that, as in the silent-film era when Mexican students and professors were unimaginable, Chicanx activism is invisible in college movies. The high point, or nadir, of such films was 1970, which famously saw the release of *Love Story* and numerous other college films.

Together they responded to conflict on campus with liberal narratives of containment and law and order. Since students demanded new kinds of administrators and new models of administration in terms of admissions, curricula, and hiring, films from 1970 often focus on administration. Only one, however, raises the possibility of a brown administrator, a movie titled *RPM* (1970), starring Anthony Quinn as a professor whose appointment as university president is demanded by student protesters. The film asks what if a Latino professor was empowered to translate radical theories into administrative practice? *RPM* thus prompts us to investigate the possibilities and limits of administration as a means of dramatic social change. While today such questions are rarely debated, they were hot topics of discussion among students and professors during the 1960s and 1970s. In those years campus activism encouraged new collaborative projects involving independent filmmakers and academics to use film for education and social transformation. One of the most important and well-known writers associated with the Chicano movement, Tomás Rivera, was central to such projects, and he approached university administration as a means of deconstructing hierarchies of race, class, and respectability. Studying Rivera's career in UC leadership, I reconstruct his compelling rough draft for what la paperson calls a Third University, a blueprint that draws into critical relief the limits of actually existing universities.

In chapter 4, "Looking at Student Debt in Films by People of Color," I argue that the contemporary regime of university debt constitutes a form of racialized and gendered settler-colonial capitalism based on the incorporation of disposable low-wage workers and complicity in the occupation of Indigenous lands. The university domination of land and labor is pursued structurally but also ideologically, in film and other media representing campus life, including *Higher Learning,* John Singleton's meditation on race at his alma mater, USC; and *Dear White People* (2014), Justin Simien's Ivy League satire. The chapter concludes with a study of works by Black, Indigenous, and Chicanx feminist filmmakers including *Middle of Nowhere* (2012) and *13th* (2016), Ava DuVernay's films about the prison-industrial complex, as well *Pariah* (2011), *Mosquita y Mari* (2012), and *Drunktown's Finest* (2014), films by Dee Rees, Aurora Guerrero, and Sydney Freeland, featuring college-bound Black, Latinx, and Indigenous young women.

In the afterword, "University Babylon Revisited," I conclude by speculating about the significance of changes and continuities in the college film genre since the election of Donald Trump and the renewed

FIGURE 4. A medical student named Ruby waits along the prison fence. *Middle of Nowhere* (2012).

FIGURE 5. A college-bound student named Yolanda ("Mosquita") scales a wall. *Mosquita y Mari* (2012).

prominence of white nationalism that his presidency represents. Since 2016, college films have swerved toward horror, mediating contemporary forms of student precarity and connecting them to longer histories of white nationalism in Hollywood and on campus. As a historical study of multiple entanglements connecting film and the academy, *University Babylon* takes a critical look not only at Hollywood's love affair with the university and white higher learning but also the cinematic (and more broadly symbolic or cultural) aspects of university education. For instance, Sara Ahmed's *On Being Included,* a study of university

diversity work, argues that the production and circulation of various documents and white papers affirming diversity serve as magical substitutes for structural transformations. Such documents produce institutional special effects where representations stand in for action, a situation that the university diversity workers surveyed by Ahmed compare to hitting their head against a brick wall, a figure of speech that "gives physical expression to what a number of practitioners describe as 'institutional inertia.'" That image was so important to her informants and to her own analysis that Ahmed includes a large photograph of a brick wall in the book.[54] *University Babylon* argues that the inertia of film and university institutions is partly reproduced by cultural projections, such that walls are also veils and screens. But walls can fall, along with the visions they uphold, and so this book is also about how marginalized students and movie makers have tried to make that happen (see figures 4 and 5).

Universities are brick-and-mortar places, built by the blood, sweat, and tears of staff, students, and faculty, and the university in turn makes the hardware and software of domination, from prisons to the machines of war. The university is also a dream factory, made and remade through fantasies and desires for knowledge, beauty, equality, and justice. Cultural representations like films mediate our material realities, gluing them together but also playing key roles when they come unstuck. This is perhaps easiest to see in the context of student protest movements with their histories of posters, banners, walkouts, memes, and videos, but *Hollywood Babylon* also suggests that administration is a cultural performance. George Lipsitz argues that culture is often a rehearsal for politics, and I would add that political transformation often requires the work of culture to imagine both problems and solutions.[55] If all that is solidly oppressive about the academy can be made to melt into air—if another university really is possible—we will need to love imagining change as much as we love going to the movies.

Indigenous Students and Students of Color in Silent Cinema

Building on Cedric Robinson's analysis of how anti-Black film represen-
tations fortified racial capitalism, in this chapter I argue that the genre
of silent college films succeeded academic race science in legitimating
the racial common sense of white superiority by depicting it as the aim
and proper outcome of higher education.[1] In *White by Law* Ian Haney
López analyzes the so-called prerequisite cases, early twentieth-century
Supreme Court cases that legally defined whiteness based on a combina-
tion of supposedly scientific knowledge and "common sense." When
science failed to affirm prejudice, justices increasingly relied on com-
monsense ideas about racial difference.[2] In what follows I suggest that
films were central sources of such ideas. The majority of silent college
films celebrate white men and heterosexual romance while explicitly or
implicitly denigrating people of color as deviant or "queer" relative to
white norms. The comparatively few films that depict Indigenous col-
lege students or students of color focus on young men and represent
them as inferior to their white classmates, thereby justifying segrega-
tion. Such scenarios fetishize male Indigenous students and students
of color while rendering women invisible. While I've found only two
silent films that include Indigenous women college student characters,
I have not been able to locate any examples featuring Black, Asian, or
Latina women students. (For that we need to turn to films from recent
decades—see chapter 4.) During the early twentieth century, at a time

when only a tiny percentage of the U.S. population attended college, films represented the most important and influential resource for imaging universities as heteronormative, white nationalist, antimiscegenation dream factories.

Concretely exemplifying the university-cinema–industrial complex, many silent films were shot on prestigious college campuses, and university presidents, students, and alumni all appeared in them.[3] *The Courage of the Common Place* (1917) is a striking example of an Ivy League–supported film that resolves conflict between white labor and management under the leadership of a student. Yale undergraduate John McLean is appointed superintendent of the Big Oriel Mine, where he succeeds in gaining the respect of the miners except the foreman, O'Hara, a hotheaded labor agitator. When fire breaks out in the mines, O'Hara panics, endangering the other miners, so John knocks him unconscious and emerges a hero. He returns for Yale's commencement, where he is praised by the president, celebrated by his classmates, and reunited with the girl he loves. The film's conclusion was shot at Yale, with Yale president, railroad director, and labor economist Arthur Twining Hadley playing himself. In other silent-films football extras and even leading men were recruited from the ranks of college all-Americans.[4]

By contrast, in this chapter I also analyze the experiences and perspectives of Indigenous students and students of color, including filmmakers and actors. While Indigenous women, Black women, and other women of color are largely excluded from college films, a few mainstream movies feature Indigenous women students, while independent Black uplift films include women students. When viewed from the perspectives of Indigenous students and students of color, then, silent college films project forms of multiple consciousness that make visible the violence of early twentieth-century racial capitalism. From that vantage point, such movies represent critical reflections on white racism and its imbrication with heterosexual desire. The dominant arc of the college film thus emerges in partial reaction to a history of counterhegemonic interventions by Indigenous people and people of color. Centering Indigenous students and students of color raises epistemological questions about who can be a student and what counts as knowledge. By posing such questions, Native American, Asian, and Black students and filmmakers challenged an emergent, white common sense about higher education as the servant of capitalist nation-building projects based in patriarchal families, settler colonialism, labor exploitation, and global imperialism.[5]

IMAGINING WHITE HETEROSEXUALITY IN COLLEGE

A subject search for the key word "college" from 1898 to 1930 in the American Film Institute's *AFI Catalog of Feature Films* yields 157 titles, the overwhelming majority of which focus on white college students. Silent college films foreground white men, especially athletes, and, secondarily, white women, with character arcs ending in marriage. While the earliest works are documentary "actualities" of college dances and sporting events, the titles of early narrative films suggest the genre's development along heteronormative white lines: *A College Girl's Affair of Honor* (1906) and *College Chums* (1907).[6] Research in queer history locates the construction of homosexuality and the heteronormative in the late nineteenth and early twentieth century, and both university research and cinematic representations of heterosexual romance were pillars of such formations.[7]

As the college film genre develops, the most common stories are set in all-white milieus and focus on a white male college student who wins the game (usually football) and the love of a white girl, while reconciling with white family members (usually a father).[8] Disobedient, dissolute, or otherwise disappointing white sons are redeemed in their father's eyes by success on the college athletic field. In a smaller number of cases white women in college films are reunited with lost white fathers.[9] The narrative momentum of college films is thus toward the reconstitution of white families, headed by white patriarchs and valorized by their associations with higher learning. A number of white college student characters are working-class boys, but others are the children of industrialists or work as mine managers, hence representing the interests of racial capitalism analyzed by Robinson.[10] As imagined by Hollywood, college is a white melting pot that yields cross-class white friendships and marriages while uniting white people from east and west, north and south. Such films resolve differences of class, region, and generation among white men, projecting forms of white kinship across difference and composing visions of white nationalism. In *Rose of the South* (1916), for example, an elderly man returns to his alma mater and tells students the story of two of his classmates, rivals for the same girl who fight on different sides in the Civil War before ultimately reconciling on the battlefield and dying in each other's arms. The dream of going to college further unifies white immigrants and white college boys, as in Frank Capra's *For the Love of Mike* (1927), where three working-class immigrant men (a German, an Irishman, and a Jew) raise an orphaned

white boy and ultimately send him to Yale, where he becomes a star in the varsity crew and wins the love of his hometown sweetheart.[11]

College films further address white gender differences by incorporating white women into respectably subordinate roles relative to white college men. For the most part, white male students are the genre's protagonists and their potential love interests are nonstudents, who can be divided into good working girls (boarding-house proprietors, servers, or shop girls) and bad working girls (vampish cabaret singers or dancers). Whereas the vamp threatens to dominate the boy, the good girl props him up. The hero ends up with the right girl, thereby defining proper white femininity. Excluded from male college settings and thus marginal to their combination of gender and class privilege, white working women are framed as junior partners in love and marriage.[12] In the unusual silent college film with a female student as protagonist, she is matched not with a fellow student but a superior authority figure—a coach, a professor, or an older benefactor.[13] In a variant of that narrative the white college girl can marry a white college boy only after she has been disciplined and reformed out of her bad-girl party ways.[14] A common formulation in period reviews of such films suggest that by winning the game the white boy athlete gets the girl, indicating that women are the stakes in a competition between men.[15] An aspirational character arc, the college boy secures whiteness by winning the deference of a good white girl. One lesson college films teach is that the proper subordination of women to men is a definitive feature of whiteness.

The college athletic field further anchors patriarchal white families in settler colonialism and imperialism. With the closing of the frontier, college football quickly became a highly capitalized, hugely popular spectacle in which fans could take pleasure in struggles over territory, often literally enacted on Indigenous land and in some cases involving Indigenous teams. In the first decades of the twentieth century, college football rivaled Hollywood as a mass entertainment. Thousands of people attended big games, and many more followed them in the press and in newsreels. One of the most famous early twentieth-century college football games took place in 1912, when the army team, including Dwight D. Eisenhower, lost to Jim Thorpe and the Carlisle Indian Industrial School team. (The game was played at West Point, not far from the campus grave of alum George Armstrong Custer.) By contrast, the monotonous repetition of scenarios of white college boy sporting victories suggests a settler-colonial structure of feeling, anxious to reassert and naturalize forms of dominance over people and land that are never

given but must be constantly renewed in the face of new challenges and contradictions. Similarly, building on dime novels such as the Frank Merriwell series, the white college boy is a figure of imperial adventure. Silent films suggest, for example, that white college boys are a bulwark against Latin American revolutions.[16]

Imperial white nationalism based in patriarchal marriage and family is well represented by the careers of "Hollywood's first couple," Douglas Fairbanks and Mary Pickford, who were among the biggest stars of the silent era. Pickford and Fairbanks helped found the Academy of Motion Picture Arts and Sciences in 1929, the same year Fairbanks, along with USC's eugenicist president Rufus von KleinSmid (see the introduction), also helped found the university's film school. Fairbanks was an icon of athletic, U.S. whiteness, whose films and publicity represented him as the winner in physical competitions with Latino, Black, Arab, and Indian men over access to and control over white women.[17] In *Bound in Morocco* (1918), for example, he plays a U.S. American in northern Africa who saves a white woman from being forced into the harem of the cruel Basha El Harib.[18] A year later he starred in *The Knickerbocker Buckaroo* (1919), about a New Yorker who travels to a U.S.-Mexico border town and fights Mexicans who menace the hero's white love interest. As he explained to a reporter while making the film, "I was try-ing to get a fight scene yesterday . . . and I told the bunch of Mexicans to come for all they were worth. There were five of them, but I knew I could take care of myself. Well, one of the bunch was a tough customer, and I really had to beat him before he would quit." Fairbanks condescend-ingly told the same reporter that he liked to spend his spare time on set "playing tricks on the former Mexican generals who were now working for him," as though the film's Mexican extras represented the tribute of Anglo-Saxon Manifest Destiny.[19] He further promoted white privilege in his most famous "brownface" roles as Latino and Arab men in *The Mark of Zorro* (1920) and *The Thief of Baghdad* (1924).

But before graduating to such parts, Fairbanks began his career embodying the athletic college man in silent action comedies. In *The Americano* (1916) he starred as a recent graduate of a mining school who is contacted by his former dean to take a job managing a mine in a fic-tional Latin American country. There the title character uses his athletic abilities to prevent a revolution and save a white U.S. American woman from a general who would force her into marriage. Similarly, in *American Aristocracy* (1916) Fairbanks plays an entomologist who takes a break from his research to foil a plot to smuggle guns to Mexican revolutionar-

ies led by a "mysterious dark-skinned foreigner" masquerading as a porter. Both films foreground the white college man as a counterrevolutionary hero who keeps racialized miners and railroad workers in line. His white collegiate style of heroism is further inflated by contrast with his comic Black sidekicks (played in *The Americano* by a white actor in blackface). The college connection was so important to Fairbank's performance of white imperial masculinity that in numerous interviews he falsely claimed that he had attended both the Colorado School of Mines (recalling his character in *The Americano*) and Harvard.[20]

By contrast, at about the same time that Fairbanks was playing imperial college boys, Mary Pickford was most famous for her roles as white children, notably in *The Poor Little Rich Girl* (1917) and *Rebecca of Sunnybrook Farm* (1917), films she made when she was twenty-five. As Richard Koszarski explains, "audiences insisted on seeing her in this characterization, and as she grew older the women she found herself playing grew younger."[21] While Pickford wielded immense institutional power in Hollywood, demanding and receiving high salaries, film profits, and production credits, and while she is regarded by film historians as the moving force behind the founding of United Artists, the cost was that, to epitomize white U.S. American femininity onscreen, she was infantilized relative to white men.[22] She was so successful at such roles that Pickford was billed as America's sweetheart even though she was a Canadian immigrant. Like Fairbanks, moreover, she also performed her whiteness through brown-, red-, and yellowface roles in *Ramona* (1910), *A Pueblo Legend* (1912), and *Madame Butterfly* (1915).

Pickford did, however, star in one film as a college student: *Daddy-Long-Legs* (1919). In the first third of the film, she plays an orphaned child named Judy Abbot, who is ultimately sent to Princeton by an anonymous benefactor on the condition that they never meet. Judy sees only his tall shadow and so nicknames him "Daddy-Long-Legs." The film presents an all-white world, with the exception of the Black porter who carries Judy's luggage onto the train transporting her to college. At Princeton she is pursued by two suitors: her classmate Jimmie McBride and her roommate's wealthy uncle, Jarvis Pendleton. While she rejects McBride as too young, Judy is drawn to Jarvis, but fearing to reveal her orphanage background, she initially tells him that their age difference is too great. After graduation, however, she discovers that Jarvis is actually "Daddy-Long-Legs." At first repelled, she shouts "you brute," but then Pendleton grabs her by the wrist and pulls her down on to his lap for a forced embrace to which she ultimately yields—and there the film

ends. Throughout, *Daddy-Long-Legs* visually emphasizes gendered hierarchies of white age and size differences, the latter in the form of shot compositions contrasting Pickford's diminutive five-foot-one frame and her older costar's much larger body. The film thus frames college as a site for the eroticization of white nationalist kinship, where white fathers morph into college-girl husbands.[23]

NATIVE AMERICAN COLLEGE FILMS

If it seems as though white characters in silent college films were dedicated to triumphing over Indigenous people and people of color, it is partly because Hollywood brought white actors and filmmakers into direct contact and competition with them. As Michelle Raheja argues, Ho-Chunk silent filmmakers Princess Red Wing (Lillian St. Cyr) and James Young Deer became "one of Hollywood's first 'power couples' alongside their contemporaries, Mary Pickford and Douglas Fairbanks."[24] A graduate of the Carlisle Indian Industrial School, Red Wing starred in a number of important silent films, including Cecil B. DeMille's *Squaw Man* (1914). As such, Red Wing was the rare example of an Indigenous woman college graduate in silent film. Her husband, James Young Deer, was an actor, director, and screenwriter of over a dozen silent westerns. The couple's films inverted conventional white man/Indian woman narratives with miscegenation plots involving Native American men and white women that undermined settler hierarchies of race and gender.[25]

Also a powerful Hollywood player, prolific Chickasaw actor, writer, producer, and director Edwin Carewe (born Jay Fox) worked on more than sixty films between 1913 and 1934. An enrolled member of the Chickasaw Nation (along with his brothers, Finis and Wallace Fox, who were also film and TV writers and directors in the 1920s and after), Carewe studied at the University of Texas and University of Missouri before starting his film career. He famously directed *Ramona* (1928), where the title character is a "half breed" in Spanish California (played by Mexican actor Dolores Del Rio) who elopes with an Indigenous man named Alessandro. They have a daughter (played by Carewe's own daughter, Rita) who dies as the result of an attack by white outlaws, and Alessandro is ultimately murdered by settlers, rendering Ramona a wandering outcast. The film can be viewed as a fairly direct Indigenous representation of historical and ongoing forms of settler-colonial violence, but it is unusual in Carewe's body of work, which includes only a few Native American characters, focusing instead on all-white milieus, even

in frontier settings. But if we think of such films as Indigenous lenses on whiteness, we can appreciate their critical edge. Recalling Michel Foucault's claim in *The History of Sexuality* that the supposedly superior sexuality of the nineteenth-century European bourgeoisie justified its class hierarchies, in settler-colonial Hollywood the imagined superiority of civilized over savage sexuality served to ground racial hierarchies.[26] Examples include the numerous antimiscegenation films analyzed by Robinson and others, with *Birth of a Nation* (1915) and its infamous depiction of a Black rapist standing as the most influential example. In such contexts it is remarkable that between 1913 and 1923 Carewe made thirteen films depicting white-on-white sexual violence and depravity. With ominous titles like *False Evidence* (1919), *The Invisible Fear* (1921), and *Her Mad Bargain* (1921), Carewe's silent American gothics tell lurid tales of white infidelity, rape, child brides, and jealous murderers that deconstruct the myth of white sexual virtue underwriting settler colonialism.[27]

During the silent era, Red Wing, Young Deer, and Carewe were joined in Native American Hollywood by Lakota actor, film adviser, and activist Luther Standing Bear; Yakima actor and film adviser Nipo T. Strongheart; Cheyenne actor Minnie Devereaux (another Carlisle graduate); Penobscot actor Molly Spotted Elk; Apache actor Charles Stevens; and Inupiaq camera worker and actor Ray Mala. As Raheja argues, many Indigenous silent-film actors, as well as protestors and commentators, employed "subtle forms of diplomacy" to "convince directors and production agents to alter aspects of film scripts to conform more closely to early twentieth-century Native American sensibilities." Indigenous actors contradicted assimilationist demands for the disappearance of traditional costumes and practices by answering the call for such representations in film: "For many Native American actors, film thus provided an array of opportunities to protect and utilize Indigenous epistemologies, critique colonization, engage with modernity, and ensure economic survival." In contrast with the relative invisibility of Native peoples in contemporary mainstream media, they were much more prominent in silent films as actors, writers, and critics who, even though they did not dislodge the dominant, largely negative representations, nonetheless brought "Native American experiences to the fore and opened them up for public discussion." In Hollywood Native Americans seized "opportunities for political and social activism and access to a limited range of institutional power."[28]

Overlapping with Hollywood films, the world of college football brought the teams of the Carlisle Indian Industrial School into competition

with the collegiate powerhouses of the early twentieth century. Carlisle was not a college in the white sense but a vocational school, modeled on prisons and the military, and aimed at "assimilating" Indians, which in effect meant accommodating them to postallotment subordination. Among native peoples Carlisle and other boarding schools are remembered as sites of trauma, violence, and forced labor far removed from the idealized image of college as a pastoral enclave devoted to intellectual and physical development. Yet the Carlisle football teams were actively sought out as opponents by Yale, Harvard, Princeton, and other schools eager to demonstrate their athletic superiority in reenactments of nineteenth-century Indian warfare.[29] As early as 1906 the Carlisle team dominated the collegiate game, beating Penn State, Harvard, the University of Minnesota, and the University of Chicago. During their remarkable 1911 season, Carlisle was led by Jim Thorpe, who outperformed the best white college players. In a significant upset he helped beat Georgetown in front of a DC crowd that included government officials and a delegation from the Office of Indian Affairs. The biggest victory of the season, however, was against a top Harvard team coached by the "patrician, snobbish, and belligerent Percy Haughton," who was shocked and dismayed when his boys were beaten by Native American players and had to admit, in his words, that Thorpe was the "theoretical superplayer in flesh and blood." "At a time of minimal national media outlets and a much smaller pool of national celebrities," writes his recent biographer Kate Buford, Thorpe "had become a legend overnight." Buford goes on to note that after the Harvard game Thorpe was described in the press as Frank Merriwell "come to life," suggesting that the Sac and Fox player threatened to supersede the idealized fictional Yale football hero.[30]

Similarly, period media imaginatively pitted Thorpe against white Hollywood's representative of the college athlete ideal, Douglas Fairbanks. An anonymous reviewer for Fairbanks's *Manhattan Madness* (1916), for example, implausibly claimed "that as an all-around athlete Douglas Fairbanks puts Jim Thorpe way back stage."[31] White anxiety over Indian athletic superiority is well represented in a publicity photo of Thorpe's visit to the set of *Robin Hood* (1922). It shows Thorpe, sporting a sharp suit and haircut, standing next to Fairbanks dressed as Robin Hood and wearing a wig of long hair, as the actor demonstrates the use of a prop sword. The caption in part reads, "This is the way they did it in 'them olden days,'" suggesting that Fairbanks is the anachronistic figure from the distant past, while Thorpe looks modern. The actor in fact appears to look nervously over his shoulder, as if he is about to be

FIGURE 6. White icon Douglas Fairbanks looks over his shoulder at Jim Thorpe. The set of *Robin Hood* (1922). Courtesy of the Margaret Herrick Library, Academy of Motion Picture Arts and Sciences.

overtaken by the taller man with the powerful frame (see figure 6). Thorpe's celebrity, and the challenge it posed to white male superiority, inspired a number of silent college films that symbolically contained or wished away his victories over white college athletes with stories about Native American student athletes who are ejected from college and the white modernity it represented. Recalling Thorpe's celebrity also adds an additional layer of meaning to the white college films previously analyzed, which can be read as reactionary "great white hope" narratives about white athletic stars who promise to eclipse Thorpe's brilliance.

In practice, then, college films featuring Native American characters are products of struggle between white and Indigenous artists and performers (including athletic performers). The films are contradictory, registering settler racism and injustice while at the same time lending to settler colonialism and antimiscegenation the cultural value of college as an institution of white modernity. The inevitability (if not always justice) of dispossession and subordination is depicted as what Native American students must learn in school, imaginatively elevating settler-colonial common sense into knowledge. Such films are thus partly aimed at excluding and containing Indigenous power in both education and Hollywood. By contrast, in contexts where Indigenous filmmakers

have greater autonomy and control, silent films made by Young Deer, Carewe, and others articulate college to decolonial imaginaries.

The earliest known film depicting a Carlisle athlete, D. W. Griffith's *The Call of the Wild* (1908) focuses on George Redfeather, a football star who has just graduated with high honors and who returns to a reservation, where an Indian agent, Lieutenant Penrose, hosts a reception in his honor. The reception hall is decorated with "Indian" blankets, but Redfeather enters dressed in formal evening wear and is warmly greeted by the Indian agent, who introduces him to his daughter, Gladys. They talk animatedly before being interrupted as the assembled guests toast the recent graduate. In the next scene Redfeather returns to the agent's home to profess his love for Gladys, who rises indignantly from her chair to denounce him with extended arm and pointed finger, exhorting him to leave. The gesture suggests comparison to the chapter from Franz Fanon's *Black Skin, White Masks* titled "The Fact of Blackness," in which he recounts public encounters where white people verbally point at Black people and say "Look, a Negro," as if to deny them subjectivity by sealing them into a "suffocating reification."[32] In *The Call of the Wild,* the white woman's gesture (repeated by her Indian agent father) pantomimes "Look, an Indian," thereby telegraphing the self-evidence of the sexual color line from within a white settler gaze. Affirming the givenness of white superiority, a reviewer for the *Moving Picture World* wrote of this scene, "You may be sure he is indignantly repulsed by Gladys and ordered from the house for his presumption by her father." Next Redfeather angrily returns to his room and substitutes buckskin and a feather headdress for his Western clothes as he drinks whisky. In the words of *Moving Picture World,* he is "crushed and disappointed, for he realizes the truth: 'Good enough as a hero, but not as a husband.'" That bitter realization casts a retrospective light on the drawing-room setting decorated with Indian artifacts, as if to suggest the white father and daughter desire Indian things but not Indian people, with the blankets as a stand-in for native land divested of its inhabitants. Disillusioned, Redfeather joins a group of other Indigenous men, and together they kidnap Gladys and threaten her with gang rape. Ultimately, however, Gladys persuades Redfeather to free her by appealing to the "All Powerful Master above," leaving Redfeather to wander the forest alone, as if to suggest that education and collegiate football stardom have ruined him for both Indian and white societies. This film and others represent a postallotment response to Native American agency that effectively reasserts segregation and the bar on miscegena-

tion as a way of naturalizing settler occupation of Native American land. Silent films mark the difference between university spaces (many of which are on Indigenous lands) and reservations, where Indian college students return after graduation. Shuttling back and forth between the two settings establishes that Indians have their own (greatly reduced) lands while settlers have "theirs."

The Call of the Wild established a formula repeated in a number of subsequent films in which Indigenous college students learn the lesson of their own abjection. In *The Curse of the Redman* (1911), a Maricopa Apache named Terapai attends an Indian school on scholarship and becomes a gridiron star, but after graduating with honors he returns home, where he is ostracized by his people. As a result, "the call of the wild comes strongly upon him" and he "angrily throws aside the garb of civilization." His "downward career" leads to drinking, until "Terapai becomes a degenerate vagabond" who murders a brutal bartender. An ad for *The Curse of the Redman* boasts of its "realistic film story," thus naturalizing settler common sense.[33] Similarly, based on a play of the same name by William C. deMille (Cecil B. DeMille's brother), *Strongheart* (1914) stars Henry B. Walthall as an Indian football hero at Columbia University who, when he is framed for cheating by his classmates, heroically takes the fall rather than let his white friend get in trouble. He is then expelled and barred by race from marrying his white beloved. (The film was released in a shorter version in 1916 and remade in 1925 as *Braveheart,* which was partly filmed at UC Berkeley.) In the same year as *Strongheart*'s initial release, Native American actor Joe Goodboy stared in *Last of the Line* (1914) as Grey Otter, a Sioux chief who kills his son (Sessue Hayakawa) when the boy returns from college and threatens to sexually assault Native women before drunkenly leading a gang of Mexican bandits in an attempt to rob a U.S. Army paymaster.[34]

Recalling *Strongheart*'s narrative of Indian self-sacrifice but with a *Madame Butterfly* twist, *Maya, Just an Indian* (1913) depicts a Carlisle graduate who falls in love with a white prospector who ultimately abandons her for a white wife. Maya nonetheless gives the prospector her people's gold and voluntarily stands aside in deference to the happy white couple. The unusual silent film depicting an Indigenous woman student, *Maya, Just an Indian* goes to extreme lengths to denigrate the character. Another rare depiction of an Indigenous woman college student, *Betrayed* (1916), features an Indian brother and sister, Heart of Oak and Little Fawn, who leave their western reservation to attend a college in New York. Heart of Oak falls in love with the sister of his

wealthy best friend, Granville Wingham, but she is engaged to another. Meanwhile, Little Fawn falls in love with Wingham. In the synopsis published in *Motion Picture News,* during winter break the Wingham siblings travel to the reservation to inspect a parcel of land they have inherited and

> the young man carries the Indian girl away to a cabin on his estate and there her brother finds them the next morning. He binds the young man, goes and gets his sister, and threatens to treat her in the same manner in which his sister has been treated. Then the Indian girl appears, and in the presence of her brother, the man who has betrayed her, and his sister, she kills herself. Overcome with his sorrow, the Indian abandons his plans for revenge and sends the white people away. These last scenes are taken up in the snow covered woods, most of them are very attractive.[35]

The film was advertised as demonstrating the timeless and inevitable bar on miscegenation under the slogans "A Drama of the Eternal Clash of Human Forces" and "O, East is East and West is West and Never the Twain Shall Meet," the latter a quotation from Rudyard Kipling's "The Ballad of East and West."[36] Ads and promotional pieces in trade publications also noted that it was shot on an Indian reservation in New York and in a "nearby co-educational college."[37] The filmmakers also claimed that "a dozen or more full-blooded Indians were obtained with the sanction of the Federal Government, with the understanding of course that they would be returned to the reservation immediately after the picture had been completed." Hence the production process, like the narrative, supports anti-miscegenation ideologies by reproducing spatial distinctions between white places such as colleges and Indian reservations. Finally, *Betrayed* authenticates settler common sense by boasting of "real" Indians and "real" settings, including a college location, thus lending racial hierarchies the symbolic appeal of knowledge and higher education. The forms of violence, degradation, and death visited on Indian college students are depicted as tragic but inevitable and aesthetically pleasing. The *Moving Picture World,* for example, reports that *Betrayed* presents "one of the prettiest love stories imaginable."[38] Read "with the grain," as it were, such films represent settler racism as entertaining knowledge.

By contrast, when read "against the grain," as Michelle Raheja suggests, such films also critique anti-Indian racism, while the trope of the usually male student caught between two worlds represents forms of double consciousness that would have been familiar to Indigenous audiences and film workers alike. Similarly, from the vantage point of Indigenous multiple consciousness, films like *Maya, Just an Indian* and *Betrayed*

critically spotlight the extreme forms of race and gender subjection demanded of Indian women by a settler-colonial gaze. Silent films with Indian college students are thus contradictory combinations of settler and Indigenous perspectives that emerge partly out of the conditions of production. As expressions of multiple consciousness, silent college films contradict Western literature and films that consign Native Americans and the process of white settlement to the nineteenth-century past, not only by depicting Indigenous people in contemporary university settings but also by dramatizing settler colonialism as an ongoing process central to Western modernity. A good example is *Young Deer's Return* (1910), in which James Young Deer stars as a Carlisle baseball star who falls in love with a white woman despite the racist objections of her father. The father ultimately sees the error of his ways and approves of the relationship, but Young Deer rejects the match and returns to his community to marry a Native American woman. As Philip Deloria argues, one message of the film is that "from a Native perspective, the rhetoric of equality that surrounds education and assimilation looks fraudulent in the face of continued racism."[39] *Young Deer's Return* is thus a rejoinder to more conventional silent college films, suggesting that education reproduces racism rather than transcending it. In contrast with films set in the nineteenth century and focused on images of the vanishing Indian, college films bring Indigenous people into contemporary situations and modern institutions, while at the same time suggesting that contemporary universities reproduce older forms of settler-colonial racism.

ASIAN AND MEXICAN STUDENTS IN SILENT CINEMA

In his memoir, *Zen Showed me the Way to Peace, Happiness and Tranquility,* silent-film star Sessue Hayakawa writes that he migrated from Japan to the United States to attend college, which would make him perhaps the most famous international student in history. According to *Zen,* his father wanted him to become a banker and so around 1911 sent him to study political economy at the University of Chicago. Coached by the legendary Alonso Stagg, Chicago was a football powerhouse, and Hayakawa reportedly made the team and used judo and jujitsu against rushers. "After my first real game, it was noised about the campus that I possessed occult power." During his second season, however, the opposing team complained, and "the use of judo or jujitsu was promptly forbidden." But in the heat of play he would forget and his team was penalized, so he was finally kicked off the team. The

purported end of his college football career suggests a racialized exclusion, as in the silent films where Indian players are kicked off their teams. Indeed, he recalled that his University of Chicago classmates called him "Jap" and "hara-kiri." At the time Hayakawa would have been ineligible for U.S. citizenship, prohibited in many states from owning property, and legally barred from marrying a white woman, which is one context for understanding his claim that at he did not date or have a girlfriend while at university. Writing about his student years, he concludes that "being a stranger was extremely difficult."[40]

While all autobiographies are literary constructions mediated by generic conventions, celebrity memoires, in particular, are often uniquely based in combinations of biographical fact and fantasy. Other than in Zen and records of a University of Chicago correspondence course he took, researchers haven't found any evidence that Hayakawa attended the university and played on its football team, making it seem likely that, like Fairbanks, he largely made up a college-boy biography.[41] Read as a partly fictional story, Zen's focus on higher education and college football partly reflects the fact that such narratives had become a normative biographical trajectory of incorporation into dominant institutions. Hayakawa's strategy of centering college football in the narrative of his own star image suggests the sport's symbolic and material significance to U.S. American power and prestige. In contrast with Fairbanks, however, Hayakawa's college story was fractured and cut short by racism. Even if Zen's depiction of college was fictionalized, Hayakawa nonetheless presents a plausible interpretation of racism in higher education that anticipates the subsequent research of University of Chicago sociologist Herbert Blumer, who, in his survey titled Movies and Conduct, collected evidence of intense anti-Asian racism among undergraduate film audiences.[42]

While it includes moments of critical double consciousness, however, the dominant tenor of Hayakawa's autobiography seems to be disavowal: "To the insults I was handed [at the University of Chicago], I paid little attention. I never disliked their source or got angry; I just smiled and promptly forgot. The insult passed and was gone. Forgetting what is past is high virtue."[43] Similarly, Hayakawa narrates his exclusion from college romance in terms of his own renunciation: "I had not paid much attention to girls while at college. I don't recall that there were any Japanese girls at the university when I was there, and the American girls interested me very little. They were too forward and independent."[44] Hayakawa's patriarchal pretentions also serve to

rationalize the structural racisms subtending white collegiate hetero-sexuality. His Zen-like response to U.S. racial and gender regimes was thus also a kind of studied forgetting, which enabled his incorporation into white-dominated institutions and explicitly racist film narratives, including his several college student roles.

As part of the origin story of his stardom, Hayakawa claimed that he quit college after three years to pursue theater and film work in Los Angeles, but the University of Chicago remained an important part of his star image. Throughout his long career studio biographies, press releases, and other publicity repeatedly promoted the actor's relationship to the university. In 1916, a few years after he reportedly dropped out of Chicago and just before he began playing college student film roles, *Photoplay* magazine published a piece titled "That Splash of Saffron: Sessue Hayakawa, a Cosmopolitan Actor Who, for Reasons of Nativity, Happens to Peer from Our White Screens with Tilted Eyes," which details the actor's university studies. The Hollywood trade publication the *Exhibitors Herald* reported in 1920 that Hayakawa traveled to Chicago, "where he has arranged a conference with several eastern educators in regard to the establishment of motion picture educational courses in universities." A year later he published an essay about Hollywood labor relations titled "Human Motion Pictures" in the *University of Chicago Magazine*. Paramount press releases promoting Hayakawa's first sound film, *Daughter of the Dragon* (1931), in which he "plays the part of an Oxford graduate in England who seeks to solve the mystery of Fu Manchu while working out of Scotland Yard," also recall his college days. The studio claims, for example, that he was "one of the past gridiron heroes at the University of Chicago" and that "the Chicago University athletic association gave a dinner in his honor and he afterwards presented an exhibition in jujitsu and Japanese fencing." Another press release quotes Hayakawa about his football exploits: "I played quarterback . . . and tackled with jujitsu."[45] His college background thus contributed to his broader image as an educated actor. Hayakawa was often photographed, for example, reading in his large home library. The author of one trade journal profile of the actor marvels that he quotes Shakespeare and that "his [English] vocabulary is as complete as a college professor's."[46] At pains to legitimate film as a cultured and learned art form in the face of ongoing scandal and moralizing criticism, both the studios and Hayakawa himself drew cultural capital from higher education.[47]

Although I haven't discovered any silent films featuring Asian women students, Hayakawa starred in five films—three of which he produced

himself—as Asian college students. Such films can be read both with and against the grain as works of Asian double consciousness. In all but one of them, male Asian college students confront racism and the bar on miscegenation when they fall in love with white women. Ironically, at the height of his stardom and power within Hollywood, Hayakawa made college films of Asian student exclusion. In *The City of Dim Faces* (1918), for example, he plays Jang Lung, the college student son of Wing Lung, a Chinese silk merchant in San Francisco, and Elizabeth Mendall, his white U.S. wife. The film is lost, so my interpretation is based on the script and publicity photos. When he is a child, Jang's mother wants to raise him as a Christian American, but his father, who insists he be taught to worship his ancestors, imprisons her in a "fetid" cell fifty feet under Chinatown, and vows that their son "must never know this taint of white blood." Jang grows up ignorant of his white mother and attends an unnamed U.S. university before becoming the representative of his father's silk company in New York, where he falls in love with Marcell Mathews, the daughter of a white U.S. merchant. She accepts his marriage proposal, but then her racist cousin takes her on a tour of the "squalid atmosphere of Chinatown," where she is repelled by the sight of a "dirty Chinaman standing by a "popcorn stove"; shoppers in a fish market; a "Chinaman with a degenerate type of white woman leading a child by the hand"; "a beggar—a terribly depraved creature"; someone "eating chop suey with chop sticks"; and "an old Chinaman smoking a Chinese pipe."

Marcell subsequently breaks her engagement to Jang, exclaiming, "Don't put those yellow hands on me again! I would rather be DEAD!" Dejected, Jang curses white Christians and vows revenge. He responds by drugging his fiancée and imprisoning her in the same underground dungeon where (unbeknownst to Jang) his mother is also held, before selling Marcell to a Chinese merchant who auctions her off to the highest bidder. However, when Jang's "white blood" makes him recoil at the thought of "yellow hands upon lily pale arm," his father's soothsayer reveals the secret of his birth. Jang then confronts his father and rescues his fiancée from her leering Chinese owner but suffers a fatal wound in the process.[48] Before dying he reconciles both with his white mother and arranges for her release and care and with Marcell, whom he confesses that he still loves.

The experience of attending college seemingly precipitates Jang's tragic identity crisis, represented in the film by a clashing set of costume changes. As Wing Lung awaits his son's return from New York, he looks admiringly at a life-size portrait of Hayakawa's character wearing "Chinese

FIGURE 7. Jang Lung (Sessue Hayakawa) returns home from college. *The City of Dim Faces* (1918). Courtesy of the Margaret Herrick Library, Academy of Motion Picture Arts and Sciences.

Imperial robes."[49] He is hence shocked when Jang arrives wearing a sporty morning suit with a top hat and cane and holding a cigar in his kid-gloved hand (see figure 7), followed by a Chinese servant carrying his golf clubs and luggage, also dressed in U.S. American garb. When quizzed about what he has learned, Jang addresses his father in a word salad of collegiate slang about jazz, cocktails, and foxtrots. In horror the Chinese patriarch tells one of his advisers, "It is the accursed white blood! I should have never taken your advice—and sent him to the American schools." But, after Marcell rejects him, Jang throws away the cross she had given him and substitutes a "traditional" Chinese outfit for his modern collegiate costume, signaling that his Chinese blood now holds sway as he sells her into slavery (see figure 8). Here costumes visually represent Chinese sexual perversity relative to white U.S. American norms. When Marcell appears at the Chinese auction, for instance, her Western dress and hairstyle have been replaced with a costume and hair like the "Chinese slave girls" surrounding her, recalling an earlier scene where, after marrying Jang's father, his white mother is forced to adopt a "Chinese

FIGURE 8. Jang Lung (Sessue Hayakawa) trades his collegiate costume for Chinese clothes. *The City of Dim Faces* (1918). Courtesy of the Margaret Herrick Library, Academy of Motion Picture Arts and Sciences.

costume" and hair. When she first appears in her new outfit at the Chinese marriage market, an intertitle likens her to a "cargo of rare silk—waiting to be stamped with the brand— 'Chinese property.'"⁵⁰ The metaphor of the brand recalls racist Western visions of Eastern despots who treat women as property, like livestock, in contrast with supposedly superior forms of white U.S. American marriage and family. The brand also suggests tropes of Asian sexual perversion and, in particular, sadomasochism, as in Hayakawa's most famous roles in DeMille's *The Cheat* (1915), where he plays a brutal Japanese millionaire who loans a white U.S. American woman money in exchange for sex and then brands her on the shoulder when she attempts to renege on their agreement.⁵¹ The product of a perverse intermarriage, Jang's costume change from collegiate to Chinese thus visually condenses the dangers of race mixing.

At the same time, however, scenes in which father and son gaze at Jang's portrait also represent a kind of subjective split or doubling that invites an against-the-grain reading. In the climactic scene where Jang discovers his mixed parentage, he gazes at himself in a mirror. As he later

tells his father, "I have looked upon my face in the mirror—and through my eyes have I beheld the soul of a white man." This disjunction between inside/outside and appearance/reality is suggestive of Asian double consciousness. As in films about Native American college students, *The City of Dim Faces* could be read as critically exposing anti-Chinese racism. Marcell's cousin, Ben Walton, is described as "a westerner to whom a Chinaman is always just a Chinaman," and he is prompted to intervene by disgust at the sight of Jang with his arm around Marcell in a public park—"A white woman and A Chink! . . . I don't know whether to despise—or to pity them." As he takes Marcell on their "scared straight" tour of Chinatown, Walton is twice seen to point off camera, followed by intertitles representing his exclamations, "Chinks!" and "a white woman and a Chink!" thereby recalling my previous Fanonian analysis of a similar scene of finger pointing that serves to fix racial difference in a white gaze.[52] Such visceral, over-the-top expressions of Asian racism by Walton and subsequently Marcell thus also invite a speculative reading from the vantage of Asian film performers and spectators.

The film supports similar interpretations of the traffic in women. Whereas the marriage market is presented as a sensational, distinctly Chinese institution, white marriage and family is also depicted as calculating, instrumentalizing, and market driven. Marcell's father, Brand Mathews, seems to use his daughter as bait in his business transactions. In New York the Mathews take Jang to an "American Café," where they watch scantily clad dancing girls and drink cocktails. When father and daughter visit San Francisco, Brand confides to Marcell, "We must play our cards cleverly with Jang. He can be very useful—now that his father controls silk imports. There are rumors that an American representative is to be chosen—and I *want that position!*"[53] In this scenario the business transaction between men is figured as gambling with Marcell serving as game piece. While the Chinese are vilified for treating her like a commodity and making her interchangeable with silk, Marcell's white father adopts a similar attitude toward his daughter. The white businessman's name—"Brand"—even recalls the "brand" that marks "Chinese property." Read in this way, *The City of Dim Faces* deconstructs the opposition between white sexual superiority and Asian sexual degeneracy. Hayakawa's *The City of Dim Faces,* along with his other college films vilifying the Asian traffic in women, represents the double of similar scenarios in white college comedies, and, depending on perspective, the film alternatively disavows similarities between white and Asian marriage or deconstructs the opposition.[54]

In another college role, Hayakawa stars as a student who foils an Asian rebellion for the benefit of white U.S. Americans. *Li Ting Lang* (1920) features Hayakawa as a Chinese student who once again faces racist romantic rejection but responds by leaving the West, returning to Asia, and putting down a coup threatening his white college sweetheart. The film is presumed lost, but its plot can be reconstructed from the surviving script and period reviews. Li declares his affection for socialite Marion Halstead, who defies the racist protests of her friends and becomes the fiancée of the Chinese immigrant student. Seeing her resulting isolation from white society, Li releases her from her commitment, and through a complicated set of misadventures he returns to China and becomes an important military leader in the midst of a revolution. While honeymooning in China many years later, Marion recognizes Li and attempts to see him at his home, but she's followed by one of his political enemies who tries to murder her and frame Li for the crime. According to the script, "Li defends Marion singlehandedly until a rescue party of his old college chums comes to his aid. After a warm reunion among old friends, Marion departs with her husband, and Li is sadly left alone once again."[55] While the film raises the specter of miscegenation, Li's postgraduation return to China and romantic isolation effectively foreclose it. Looking back on English efforts to produce a Southeast Asian comprador class and anticipating more recent contexts of "brain drain," the college-educated Li Ting Lang employs his intelligence and skill in the service of white U.S. Americans in China.

Finally, Hayakawa's film *The Jaguar's Claws* (1917) is based on a story about a Mexican immigrant who graduates from a Southern California college before returning to Mexico and becoming a bandit. Hayakawa plays the title character, who is introduced in the film's scenario as a threat to U.S. financial interests: "A few years ago, before American business was driven from Mexico, it was constantly at the mercy of bandits, chief among whom was 'El Jaguar,' whose fortified lair was sixty miles south of the border." As his name suggests, the Mexican bandit is represented as animalistic. After he viciously beats one of his men and "plants his spur in the Lieutenant's face," the film cuts to a close-up of "El Jaguar's face, expressing utmost savagery. Just above his shoulder fades in: VISION of a jaguar gnawing a half eaten animal." The villain is also a sexual predator, who kidnaps a Mexican bride from a church and rapes her before handing her over to his gang (see figure 9). As an intertitle explains, "She has now reached the lowest degradation—a plaything for all the men."[56] Complementing the image of a Mexican

FIGURE 9. College graduate and Mexican bandit El Jaguar (Sessue Hayakawa) abducts a bride on her wedding day. *The Jaguar's Claws* (1917). Courtesy of the Margaret Herrick Library, Academy of Motion Picture Arts and Sciences.

rapist, then, is the presumed disposability of Mexican women. El Jaguar subsequently leads his gang as they burn an oil field owned by the Acme Oil Company of California and then drunkenly threatens to rape both the sister and wife of the oil company manager. (With his combination of rape of rapine, the character recalls Hayakawa's previous role in *Last of the Line* as a Native American college graduate in league with Mexican bandits.) Ultimately, however, El Jaguar is stabbed to death by the Mexican woman he raped at the film's start, and the trio of the oil field manager, his wife, and his sister are happily reunited.[57]

As the film's narrative evolved, El Jaguar was transformed from a relatively complex character confronting race, class, and national differences to a more one-dimensional figure of evil. In the original story by William M. McCoy, the character, also called "Melendez," seeks vengeance for the theft of land that had been in his family for generations. He explains to his Anglo-American antagonist that he attended college in Los Angeles, and "when I came back I knew too much for my own good."[58] In the scenario and final script, however, those details are omitted, and El Jaguar is divested of family name and any backstory that might complicate

his absolute otherness. Thus, while *The Jaguar's Claws* incorporates anti-miscegenation themes and alludes to the traffic in women, it does not represent multiple consciousness. The film instead posits a unified Mexican gaze singularly focused on violence against white women and property. In the final script El Jaguar "narrows his eyes" with "the utmost savageness of expression," looks "lustfully," and eyes women both "covetously" and "cruelly." His eyes are filled with "lust" and the "bitter hatred and desire for revenge." El Jaguar even "leers" at the male oil field manager. Unlike the other films discussed in this section, *The Jaguar's Claws* does not include sympathetic scenes of culture clash or experiences with racism because Hayakawa's Mexican character is depicted as pure, undivided evil.

The succession of different textual versions of *The Jaguar's Claws* thus renders ghostly the Mexican college student.[59] In my survey of silent college films, I haven't located any others that represent Mexican students, men or women. Instead, Mexicans are the foils or defining others that white U.S. American college students encounter while traveling in Mexico. In *Frank Merriwell in Arizona, or The Mystery Mine* (1910), for example, the title character, a Yale football hero, saves a white woman from Mexican rapists.[60] *The Grandee's Ring* (1915) is also a revealing example of the white college boy versus Mexican criminal trope in which the "scion of an old Castilian family" saves a white U.S. American woman from Mexican bandits and, as a result, is rewarded by her friend the professor with a spot in the freshman class at Watson College. The Spaniard's battle with the Mexicans demonstrates his fitness for college and the necessity of their exclusion from it. In the rare examples in which Mexican actors play college students, they are depicted as Europeans or white U.S. Americans.[61] Even as villain, the Mexican student remains largely unimaginable in silent cinema, with Mexicans serving as the subaltern outside to the world of white education. As in *The Jaguar's Claws*, the Mexican Revolution's perceived threat to U.S. mining and oil interests no doubt helped make the Mexican college student unthinkable.

THE BLACK RADICAL TRADITION IN COLLEGE FILMS

Silent college films also largely exclude the figure of the Black student, limiting Black characters to positions as housekeepers and porters. Exceptions include racist representations of a new college-educated Black elite, most infamously in *Free and Equal* (1918). It focuses on Judge Lowell, who establishes the Society for the Uplift of the Negro, visits Tuskegee

Institute, and meets a promising young mulatto student named Alexander Marshall. Both men are dedicated to racial equality through intermarriage, and so the judge hires the young college student as his private secretary, while Marshall passes for the son of a wealthy Creole abolitionist to raise money for their organization. Margaret, the judge's daughter, falls in love with Marshall, who is revealed to be a villain who frequents brothels. When his advances repel Margaret, Marshall turns his attention to a housekeeper, whom he attempts to rape before strangling her to death. Margaret witnesses the murder and testifies against Marshall in court, confessing that she had married him. A young mulatto woman, however, also testifies that she is really Marshall's wife, while a Black woman reveals that she is his mother. Disgusted by Marshall's marriage to Margaret, Judge Lowell throws the book about racial equality he had been writing into the fire, and Marshall is led to prison. When screened, the film was introduced by a live prologue in which the actor who played Marshall exhorted Black people to assert their equality to whites, but it ended with an epilogue in which the character concludes that "Booker T. Washington was right in stating that the Negro should stay in his place."[62] Recalling how silent films about Indigenous college students aimed to symbolically contain Indigenous agency and influence in film and related forms of entertainment and celebrity, *Free and Equal* was a reaction to the national prominence of early twentieth-century Black colleges, especially vocational schools such as Hampton and Tuskegee. Robinson categorizes the film as part of the silent genre of "mulatto films" popular after 1914 that vilified the Black middle class as a threat to white authority.[63] Meanwhile, I have not discovered a mainstream silent film featuring a Black woman college student, making that figure another impossible outside to cinematic representations of college life.

Free and Equal was produced in an early twentieth-century context, where Black colleges increasingly mobilized multiple media, including film, to raise funds and promote forms of Black uplift. After his 1895 speech affirming the Atlanta Compromise, in which Black leaders pledged to tolerate segregation, discrimination, and disenfranchisement in exchange for support for vocational education, Booker T. Washington became a national celebrity.[64] In his remarks before a largely white male audience at the Cotton States and International Exposition in Atlanta, Washington articulated his influential vision of uplift through accommodation to racial capitalism, arguing that "the agitation of questions of social equality is the extremist folly" and that Black people must instead begin "at the bottom of life" and discover dignity in manual labor.

Reassuring southern cotton barons and northern philanthropists alike, Washington advised Black people in the South to "cast down your bucket where you are" and seek jobs there rather than migrating north. Finally, Washington suggested that uplift serves patriarchal white nationalism:

> To those of the white race who look to the incoming of those of foreign birth and strange tongue and habits for the prosperity of the South, were I permitted I would repeat what I say to my own race, "Cast down your bucket where you are." . . . Cast down your bucket among these people who have, without strikes and labour wars, tilled your fields, cleared your forests, builded your railroads and cities, and brought forth treasures from the bowels of the earth. . . . As we have proved our loyalty to you in the past, in nursing your children, watching by the sick-bed of your mothers and fathers, and often following them with tear-dimmed eyes to their graves, so in the future, in our humble way, we shall stand by you with a devotion that no foreigner can approach, ready to lay down our lives, if need be, in defense of yours.

Here Washington attempted to claim for Black people a sense of national belonging based on distinguishing between new immigrants and Black workers incorporated as subordinates into U.S. racial capitalism. The most famous alumnus of Hampton, a vocational school enrolling Black and Indigenous students, and the founder of the Tuskegee Institute, Washington created a model of vocational education as a means of Black uplift that was publicized in silent documentaries, produced by both schools, primarily addressed to white donors and secondarily to Black audiences. In movies such as *A Trip to Tuskegee* (1909), *A Day at Tuskegee* (1913), *John Henry at Hampton: A Kind of Student Who Makes Good* (1913), and *Making Negro Lives Count* (1914) the two schools depicted the progress of young Black students from impoverished rural origins to classrooms and workshops, where young men learn carpentry and farming, while young women learn domestic tasks. In historical contexts where other movies denigrated Black people as animals and criminals, uplift films represented an important counter cinema. Moreover, while they were aimed at white philanthropists, they were also screened in theaters, churches, and YMCAs for Black audiences as part of larger programs of "actuality" or documentary films of local Black life.

Also known as "see yourself" films, such documentaries promised local audiences the novelty of seeing themselves represented on the screen. In contexts where mainstream college movies excluded Black people while other films represented them as inhuman, Black audiences may have taken a kind of "reconstructive" pleasure in seeing successful Black students.[65] But such films also presupposed the limits and indeed

blind spots in an uplift lens. According to Allyson Nadia Field in *Uplift Cinema: The Emergence of African American Film and the Possibility of Black Modernity,* educational uplift was about producing "useful citizens" who did not aspire to be the "social equals or political adversaries" of whites, thereby obscuring the brutality of racial inequality. "To trace the visual culture of uplift," according to Field, "is to trace accommodation to racist paternalism as much as resistance to supposed scientifically determined Black inferiority. By working against a certain notion of a racial hierarchy (or the violent enactment of it), the uplift project reinscribed—and reentrenched—racial hierarchies." Quoting Fred Moten, Field argues that the express or implied other of educated, uplifted respectability is the figure of the Black criminal, suggesting that "the assimilationist cultural politics of normative uplift can never be fully separated from the white supremacism it is supposed to combat."[66]

Like the documentaries made by Hampton and Tuskegee, fictional "race melodramas" produced by Black production companies also reveal the contradictions of uplift. An influential example, *The Realization of a Negro's Ambition* (1916), produced by the Lincoln Motion Picture Company, features a Tuskegee-educated engineer who migrates from the South to the oil fields of California, where he is at first denied a job because he is Black but is ultimately hired after he saves the life of the oil baron's daughter. With the support of his new white benefactor, the Tuskegee alum returns to the South, discovers oil, and marries his sweetheart, and the film ends happily. By representing the Black student's return to the South, *The Realization of a Negro's Ambition* dramatized a key uplift theme aimed partly at addressing white fears and interests. At the same time the film is a Black version of white films featuring heroic college men who manage mines and oil fields, thereby enlisting Black audience support for extractive industries dominated by whites. Moreover, the centering of a male Tuskegee graduate recalls what Hazel Carby analyzes as the "gendered framework" of forms of uplift that were unable "to imagine black women as intellectuals and race leaders." In her account such frameworks are preoccupied with the "process of becoming an intellectual" as an "alternative route to manhood" that avoids "gendered and racialized subordination." Within masculinist uplift discourse, gender thus "mediates the relation between race, nation, and a fully participatory citizenship for black people," such that educated, representative "race men" incorporate other Black people into the U.S. nation state.[67] *The Realization of a Negro's Ambition* invokes nationalist narratives in its setting, for, as Jacqueline

Stewart suggests, it was popular among Black audiences "because it featured a new setting for race films—the West"—which resonated with the experience of Black migration west of the Mississippi.[68]

While the film's hero ultimately returns home to the South, *Realization* nonetheless offered Black audiences the vicarious pleasures of participating in Manifest Destiny and settler colonialism. Insofar as film had emerged as a patriotic, nationalist platform, the insertion of heroic Black male characters into narratives of U.S. capitalist and military power linked them to U.S. nationalism and resonated with Washington's xenophobia. Lincoln, for example, followed up *The Realization of a Negro's Ambition* with *The Trooper of Troop K* (1917), staring Noble Johnson, who had previously played a Tuskegee oil engineer. In *The Trooper of Troop K*, Johnson plays a cavalry soldier fighting Mexican military forces during Pershing's pursuit of Pancho Villa, suggesting efforts by Black filmmakers and audiences to prove their patriotism. The cinema of uplift thus also presupposed Black incorporation into U.S. nationalism, as when, according to Stewart, after *The Trooper of Troop K* was screened at the historically Black Whiley University in Marshall, Texas, the school's president wrote to the Lincoln Film Company to praise the film and report that the audience applauded and sang, "My Country 'Tis of Thee," during the final battle between Black and Mexican soldiers.[69]

By spotlighting nationalist heroes of Black male uplift, *The Realization of a Negro's Ambition* and *The Trooper of Troop K* marginalized what Robinson has analyzed as "the Black radical tradition." According to Robinson, "rather than a profound challenge or radical critique of racial capitalism, the most daring of the race film producers seemed to have been contented with displays of bourgeois respectability and modest uplift themes," while actually existing forms of "Black nationalism, Black radicalism, Black resistance, or Black insurgencies . . . were either absent or caricatured." Such movies mostly ignored the Niagara Movement, the NAACP, Black socialism, the Universal Negro Improvement Association, and Black opposition to lynching.[70] The characters missing from so many silent college films, in other words, are radical Black, internationalist college students who challenged nationalist models of male leadership. A critical study of the life and career of Paul Robeson, however, reveals how the actor, singer, intellectual, and antilynching, anticolonial activist made the figure of the radical Black student a global star.

It would be hard to overestimate the significance of Paul Robeson's combined global celebrity and radical politics.[71] As Gerald Horne concludes, "you cannot really appreciate how the Jim Crow system came to

an end without an understanding of the life of Paul Robeson. Robeson pioneered the struggle against Jim Crow throughout the 1930s and 1940s," ultimately helping make possible movements led by Martin Luther King Jr. and Malcolm X.[72] But over the course of his long career, starting in 1925 with Oscar Micheaux's *Body and Soul* (1925), in which he plays a Black inventor who recalls the collegiate heroes of uplift cinema, one of Robeson's most important identities was as a student. He was a voracious reader, whose study of socialism overlapped with his study of world languages. Committed to a socialist view of a common humanity across national differences, Robeson learned how to read, speak, and perform in numerous European, Asian, and African languages. Such scholarly dedication to language acquisition helped extend his global fame and influence, enabling him to address Welsh miners, Spanish antifascist forces, Chinese and Russian workers, South Asian students, and East African dock workers all in their own languages. His language study was of a piece with his political activism of the 1930s and 1940s, which linked the U.S. antilynching movement with global movements for decolonization—notably the movement against South African apartheid—in ways that ultimately brought the full force of Cold War–state repression to bear on him.

Expressions of awe and wonder over Robeson's long hours of study and facility for language learning are staples of the star's media coverage. One reporter marveled at his "extraordinary powers of concentration" as he studied language tapes twelve hours a day. A visitor to his London home around 1935 found it "lined with packed bookshelves," looking "very much like the home of a university professor." In those years Robeson was engaged in a comparative study of African languages and contemplating a PhD in philology.[73] In the immediate aftermath of World War II, he continued to harbor the "secret ambition" to become a "professor of languages" and "join the faculty of a college," even as he organized huge New York rallies against South African apartheid.[74] According to Carby, in photographs Robeson chose to project a studious image, wearing a suit and tie and looking "intellectual, thoughtful, and contemplative."[75] With his public persona as a Black student, Robeson wrested that figure from the white supremacist, nationalist narratives in which it was framed in silent cinema and freed it to perform other kinds of critical work. Reading Robeson as a Black student reveals how his media celebrity and political activism emerged from radical forms of study, antagonistic to the patriarchal white nationalism in silent college films and related representations.

Robeson came from studious kin. His mother, Maria Louisa, was a schoolteacher who died when he was a child. The biggest influence on his life was his father, Rev. William D. Robeson, who was born a slave in North Carolina but escaped in 1860 at the age of fifteen and ultimately worked his way through Lincoln University in Pennsylvania. Founded by Presbyterian missionaries in 1854, Lincoln was the first degree-granting college for Black male students in the United States. Robeson's sister, Marion, became a teacher after attending Scotia Seminary in Concord, North Carolina, a Presbyterian school and the first institution of higher education for Black women established after the Civil War. His brother Ben attended Charlotte, South Carolina's Biddle University, a Black Presbyterian college, and became a minister. Finally, his oldest brother, Bill Robeson, attended his father's alma mater and became a doctor, anticipating Paul's role as a medical student in the film *Jericho* (1937).

Robeson was a child of the interlocking systems of Jim Crow at home and empire abroad. As Horne reminds us, he was born in 1898—hours before the United States declared war on Spain and Cuba—in Princeton, New Jersey, the belly of the Ivy League beast. At the time his father served as the pastor of the Witherspoon Street Presbyterian Church, in a university town that Robeson wrote was "spiritually located in Dixie." Historically, Princeton drew its student body from among white southerners, "and along with these sons of the Bourbons came the most rigid social and economic patterns of White Supremacy. And like the South to which its heart belonged, Princeton's controlling mind was in Wall Street. Bourbon and Banker were one in Princeton, and there the decaying smell of the plantation Big House was blended with the crisper smell of the Countinghouse. The theology was Calvin; the religion—cash."[76] Recalling Robinson's analysis of the collaborations between finance capital and elite universities over anti-Blackness, Robeson here highlights the links between Ivy League whiteness and Wall Street, framing Princeton as a powerful institution of racial capitalism.

Shortly after his birth, Paul's father was pushed out of his church by the white Princeton establishment over the minister's antilynching activism.[77] As a result, William moved to different churches in the area, and the family experienced extreme poverty and racism. Most Black people there worked directly or indirectly for the university, and "Princeton was Jim Crow; the grade school that I attended was segregated and Negros were not permitted in any of the high schools." Black students were also excluded from Princeton University. Hence,

(while) the door of the university president might be open to him, Reverend Robeson could not push open the doors of that school for his son, when Bill was ready for college. The pious president, a fellow Presbyterian, said: No, it is quite impossible. That was Woodrow Wilson—Virginian, graduate of Princeton, professor there for a decade, college president from 1902 to 1910, then Governor of New Jersey, elected President of the United States in 1912, re-elected in 1916 because "he kept us out of the war" into which he led the nation one month after his second inaugural, Nobel Peace Prize winner, apostle of the New Liberalism, advocate of democracy for the world and Jim Crow for America.[78]

In an example of the collegiate old white boy's network implicitly referenced by Robeson, President Wilson endorsed *The Birth of a Nation* as a favor to his former classmate, Thomas Dixon (see the introduction). Effectively barred from Princeton, Robeson didn't imagine Tuskegee as an alternative, since he was drawn to his father's Du Boisian conception of liberal arts education as opposed to the Washingtonian emphasis on manual training.[79] Robeson thus initially aspired to follow in his father's and brother's footsteps and attend Lincoln, but when he won a scholarship competition at Rutgers he enrolled there in 1915, the same year *The Birth of a Nation* was released, as its lone Black student.

At Rutgers Robeson confronted the racism of a white nationalist university. A talented athlete, he tried out for the football team, where he was threatened with lynching by his white teammates. He persevered and made the team, becoming its star player, but Robeson's accomplishments on the field did not shield him from collegiate racism when the team from Washington and Lee University, named for two slaveholders, refused to play against him.[80] According to Martin Duberman, while his "bass-baritone was the chief adornment of the glee club . . . he was not invited to be a 'traveling' member, and at Rutgers sang only with the stipulation that he not attend social functions after performances." He was invited to join the university literary society but could not participate in its initiation ritual, since it took place in a restaurant that would not serve him. Nor could he join in school dances. Even so Robeson excelled in school; he wrote a senior thesis titled "The Fourteenth Amendment, the Sleeping Giant of the American Constitution," which "prefigured the eventual use of that amendment as a civil-rights weapon," and he was selected as valedictorian of his class.[81] In his stirring commencement address he called for racial equality.

After graduating from college in 1919, Robeson embraced the life of the student and cultural worker. He enrolled in Columbia Law School

and moved to Harlem, where the Harlem Renaissance was in full swing, and Robeson was already well known. At Columbia he met Eslanda Cardoza Goode, whom he would ultimately marry. According to her biographer, Barbara Ransby, Goode came from a family of distinguished Black educators, and after winning a highly competitive fellowship she enrolled at the University of Illinois, where she was among a handful of Black students on a campus with a KKK chapter. She had originally planned to study domestic science but found its vocational focus boring, so she instead majored in chemistry. In her senior year she moved to Harlem and transferred to Columbia's Teachers College. After graduating she met Robeson while the two were taking summer-school classes at Columbia in 1920. They were attracted to each other in part because they "were both intellectuals and interested in the world of ideas. She was the scientist and he was the legal scholar. . . . Each one seemed to appreciate the intellectual appetite of the other." When they married in 1921, Eslanda devoted herself to managing Robeson's career before ultimately studying anthropology at the London School of Economics and performing extensive fieldwork in sub-Saharan Africa in the 1930s and 1940s. As Ransby reminds us, Eslanda Robeson was an important author, intellectual, and activist in her own right, serving as a powerful voice for African decolonization and helping "to internationalize Black American politics and identity" through her "travels, writings, migrations, social networks, and political affiliations."[82]

During the decade of the 1920s, the couple built Robeson's successful theatrical career, which included trips to London, where they reconnected with student life and politics. London was home to a significant population of African and South Asian students, who were supported in their education by the British in hopes they would return home as part of a comprador class but who in practice often became involved in anticolonial agitation instead. During a 1930 concert tour through Scotland, the couple met with Nigerian and West Indian students to discuss racism there. In the same years the Robesons embraced African student groups in London. As Ransby writes, in the early 1930s the couple regularly invited African students to their London apartment, including future leaders of Ghana, Kenya, and Nigeria, for discussions of politics and culture. In recognition of their participation in London's African student life in the 1930s, they were made honorary members of the London-based West African Students' Union. "WASU gatherings were the sites of debates, exchanges, and network building that would bear fruit as Pan-

FIGURE 10. Paul and Eslanda Robeson make their way to Cairo to film *Jericho* (1937). Courtesy of the Margaret Herrick Library, Academy of Motion Picture Arts and Sciences.

African initiatives and African independence struggles unfolded," and they included people like George Padmore and C. L. R. James.[83]

It was in this context of anticolonial discourse and organizing that Robeson agreed in 1936 to star in a London production of C. L. R. James's play *Toussaint L'ouverture* about the leader of the Haitian slave rebellion, at a moment when fascist Italy had invaded Ethiopia, instituted Black laws, and spurred protests in the streets of Harlem. Increasingly, Robeson would connect the antilynching movement in the United States to anticolonial movements in the Global South, and those links began to come together for him in London, out of his encounters with African and Asian students. This is also the context informing his most important film role in the neglected anticolonial film *Jericho* (see figure 10).

FIGURE 11. Jericho (Paul Robeson), Gara (Princess Kouka), and their child form a happy ending. *Jericho* (1937).

In *Jericho* Robeson embodies the role of the decolonial, international-ist Black student, playing a medical student and U.S. army corporal named Jericho Jackson, who at the start of the film is unjustly accused of murder. At his military inquest his superior officer, Colonel Mack, serves as a character witness, testifying, in words that could equally apply to Robeson himself, that "in college he had an excellent record as a scholar and athlete." When he is nonetheless convicted of murder, Jackson decries the fact that the military schooled him in violence—asking, "Did I want to learn to kill? No, but they taught me" how to use hands to kill rather than "to heal, to save life, to give life." However, wresting a pistol away from a military police officer, he makes a daring escape, eludes a military dragnet, and sails with a white deserter named Mike Clancy from the south of France to northern Africa. The two trek across the Saharan Desert, shedding their uniforms and adopting Arab costumes along the way before arriving at an oasis, where a tribal goat herder named Gara (played by the Sudanese actor Princess Kouka) feeds them and ultimately welcomes them to visit her village. There Jackson's medi-cal education immediately comes in handy when he sets the broken leg

of Gara's father, the local tribal leader. Jackson ministers to the villagers, a nomadic Berber people, with Gara serving as nurse. When a council of leaders from different tribes selects him to lead the annual salt caravan, he heroically saves it from a bandit attack. Soon, Jackson and Gara wed and give birth to a son. Meanwhile, however, Colonel Mack tracks him down and promises to return him to the United States, where he faces execution, but Jackson remains defiant, declaring, "You were mad to try to take me single-handed. You haven't a chance. You better go back and forget about me." When Mack sees Jackson's wife and son, he relents, but Gara has overheard his initial declaration and mobilizes the rest of the tribe in his defense. Jackson ultimately helps Mack escape but stays himself in northern Africa as the white man flies away. The final shot of the film depicts Jackson and Gara placing their son in a native crib and turning to smile at each other, forming a tableau of the Black internationalist family that stands in opposition to the white miscegenation phobia characteristic of so many Hollywood films (see figure 11).

As the film's happy ending suggests, *Jericho* deconstructs the conventional tropes of silent college films as well as imperialist films more generally. In the first place the film undermines hierarchies of white Western power and knowledge and Black subservience and ignorance. Many imperialist films, according to Ella Shohat and Robert Stam, narrate "penetration into the Third World through the figure of the 'discoverer.'" In such works "the status of hero falls to the voyager (often a scientist) who masters a new land and its treasures, the value of which the 'primitive' residents had been unaware."[84] By contrast, *Jericho* satirizes the scientific discoverer in the figure of an entomologist who travels to Jackson's village to study black beetles. Without a proper name, he is identified in the credits only as the "Explorer." In contrast with the heroic entomologist played by Fairbanks in *American Aristocracy,* the Explorer is a comedic buffoon who speaks a nonsensical jargon that seems to mimic the kind of made up gibberish spoken by natives in so many Hollywood films.

At the same time *Jericho* upends representations of the loyal Black servant. Once again, in contrast with Fairbank's comedic Black sidekicks, in *Jericho* Jackson is the hero and his comedic second banana is a white man played by character actor Wallace Ford. Moreover, Jackson appropriates the image of the simple Black servant to help effect his escape in ways that, double consciousness style, critically foreground the figure as an imperialist construction. When Jackson escapes from prison, he masquerades as a French-speaking Senegalese man to evade capture by military police (see figure 12). With his broad smile, long coat, and fez, Robeson's character

FIGURE 12. Before Fanon: Jericho
(Paul Robeson) evades military police
by performing as a French colonial
advertising icon. *Jericho* (1937).

resembles a French colonial image come to life, recalling ads for the choc-
olate drink "Banania" featuring a similarly dressed and grinning Senega-
lese soldier. In *Black Skin, White Mask,* Fanon analyzes the advertising
icon as a colonialist image of happy Black servants, but in *Jericho* Jackson
uses colonialist stereotypes against the colonizer, passing as a harmless,
Uncle Ben–like character to escape a white military patrol.[85]

Finally, *Jericho* overturns conventional imperialist tropes about Mid-
dle Eastern and African spaces, in particular the desert. Imperialist films,
Shohat and Stam argue, often focus on a "no man's land," where wilder-
ness is represented as "resistant, harsh, and violent, a country of savage
landscapes to be tamed; 'shrew' peoples (Native Americans, Africans,
Arabs) to be domesticated; and desert to be made to bloom." Like other
"wildernesses," the desert is often figured as "uncontrollably wild, hys-
terical and chaotic, requiring the disciplinary tutelage of the law." In a
form of "topographical reductionism," film representations of deserts
imply underdevelopment, which only white westerners can remedy.
Underdevelopment is further linked to ideas about Africa and the East as
outside of modern Western time. The desert, in other words, "forms the
timeless backdrop against which (white Western) history is played out."
Finally, the "barren land and the blazing sands metaphorize the exposed
'hot' uncensored passions of the orient." In numerous Hollywood films,
starting with Rudolph Valentino's *The Sheik,* the desert is rendered as
the perfect setting for white male fantasies of rescuing white women
vulnerable to rape by Arab men, thereby also policing white women.[86]

In Robeson's film, however, the conventional rape-and-rescue narra-
tive is displaced by the happy, Pan-African pairing of Jackson and Gara,
while the desert is invested with anticolonial affect and Black freedom
dreams. Throughout *Jericho* the northern African landscape is lovingly
rendered, but Robeson's achingly beautiful performance of the song

FIGURE 13. Robeson as Jericho sings "Deep Desert," a song of Black diasporic homecoming and postcolonial longing. *Jericho* (1937).

"Deep Desert" stands out as an expression of Black diasporic homecoming and postcolonial longing. Amid the salt caravan, camped at night in the desert and framed by palm fronds, Jackson, in Arab costume, joins other Arab men drinking tea (see figure 13). His performance of the song begins with a close-up of Robeson sifting sand through his hands like an hourglass, and the lyrics, "Sahara / Older than all the ages / Sahara / Wiser than all the sages / Teach me to read your history." In contrast with images of northern Africa as an epistemological desert, Jackson begins by personifying the Sahara as a teacher with vital historical knowledge to impart. Whereas imperial films represent Africa as the "dark continent," such that among other things "dark" signifies the absence of knowledge, here Robeson's character approaches the desert at a site of Black enlightenment. The song concludes with a utopian, postcolonial affirmation that calls into critical relief the limits of Robeson's actually existing world:

> I'm finding a new world
> Far from my native land
> I buried my old world
> In your shifting sands
> Oh, deep desert

Now I know where my place is
Here in your silent spaces
This is my home
Deep desert.

At odds with the patriarchal white supremacy of Hollywood universi-
ties, the desert teaches Jackson how to bury Jim Crow and find a new
postcolonial home.

During the Cold War the "other" stars of early college films became
important figures in period dramas of U.S. nationalism, both cinematic
and political. Starting in the 1930s, Jim Thorpe embarked on a mod-
estly successful film career in Los Angeles, with a brief but memorable
cameo in the Ronald Reagan film *Knute Rockne All American* (1940;
see chapter 2). He was also an agent and activist on behalf of other
Indigenous actors. In 1951 he was hired as a consultant for the film *Jim
Thorpe, All American* (1951), starring Burt Lancaster and filmed at a
Native American university in Oklahoma. A few years later Sessue Hay-
akawa was nominated for an Oscar for his role in *The Bridge on the
River Kwai* (1957) as a World War II Japanese officer in charge of a
concentration camp. In 1956 Robeson testified before the House Un-
American Activities Committee, where he was questioned by committee
chair Representative Francis Walter, whom Robeson referred to as "co-
author of the racist Walter-McCarran Immigration Act."[87]

In 1950 the U.S. State Department denied Eslanda and Paul passports
to prevent them from airing U.S. anti-Blackness abroad, and, in his sub-
sequent testimony before Congress, Robeson defiantly argued that he
was being questioned not because of his communist sympathies but
because he was a critic of U.S. racism and a popular proponent of decolo-
nization. Walter responded by recalling his college days: "Now, what
prejudice are you talking about? You were graduated from Rutgers and
you were graduated from the University of Pennsylvania. I remember
seeing you play football at Lehigh," the senator's alma mater.[88] Robeson
responded, "This is something that I challenge very deeply, and very
sincerely: that the success of a few Negroes, including myself or Jackie
Robinson, can make up . . . for seven hundred dollars a year for thou-
sands of Negro families in the South. My father was a slave, and I have
cousins who are sharecroppers, and I do not see my success in terms of
myself." Elsewhere in his testimony Robeson emphasized a very different
trajectory for the college student of color, invoking radical students from
the Global South who had influenced his anticolonial politics. He was
questioned about a speech in which he reportedly argued that, given U.S.

racism, it made no sense for the fifteen million Black people in the United States to fight in a war against the Soviets.

While in London in 1949, Robeson met with members of the Coordinating Committee of Colonial Peoples and the South African Indian Congress and was persuaded to speak at the World Peace Conference in Paris. In answer to questions from Representative Walter, he described his meetings with thousands of international students in London, representing hundreds of millions opposed to war with the Soviets, including African Americans, and he concluded his testimony by saying, "I thought it was healthy for Americans to consider whether or not Negroes should fight for people who kick them around. What *should* happen, would be that the U.S. Government should go down to Mississippi and protect my people."[89] While we are accustomed to locating the internationalist politicization of college and college students in the student movements of the 1960s, Robeson's testimony makes it clear that battles between racial capitalism and students of color have a much longer history, representing a formative flashpoint and part of the deep historical sedimentation in contemporary struggles over the university.

Indeed, the modes of university-based respectability politics that Thorpe, Hayakawa, and Robeson struggled within and against did not disappear with the end of the silent era but extended deep into subsequent decades. Politicians, film executives, and university administrators inherited early twentieth-century racialized norms of respectability that they reimagined for the Cold War. As we shall see in the next chapter, one of the most influential representatives of the university-cinema–industrial complex, Ronald Reagan, pioneered a form of university administration that was indebted to the historical ideologies I have analyzed in this chapter. Drawing on his own early twentieth-century college experiences, as well as his film roles as students and professors, Reagan invoked racialized respectability to justify limits on academic freedom and a new militarization of campus. The administrative formula of respectability plus militarization was subsequently elaborated, I argue, by Reagan's successor as California governor, Arnold Schwarzenegger, and it continues to define and limit contemporary academic life.

Race and Respectability in the University of California

In an essay titled "Ronald Reagan, the Movie," the late University of California, Berkeley, professor Michael Rogin argued that the forms of political demonology President Reagan directed at leftists, women, unions, and people of color were profoundly informed by his Hollywood career. It was while working in the film industry that the future U.S. president first learned how to objectify himself as a romantic white hero on the screen, removed from the everyday reality of racialized violence and symbolically shielded from the consequences of his flirtation with images of danger and threat. The actor's talent for self-reification came in handy when Reagan became a cowboy president, imaginatively clothing his self-image in the quasi-religious raiment of white nationalism while distancing himself from responsibility for the destructive consequences of his policies.[1] Building on work by Rogin, Patricia J. Williams, and Rogin's Berkeley colleague June Jordan, I turn to Ronald Reagan's college films, arguing that, in their appeals to a form of white nationalism based in settler colonialism, racial capitalism, and heteronormativity, they anticipate articulations of academic freedom mobilized by contemporary neoliberal universities.

This chapter is part of a genealogy of campus militarization in tandem with the neoliberal redefinition of academic freedom as respectability politics. The comparison of militarization and the forms of academic freedom mobilized by contemporary university administrators is revealing since they function in similar ways, combining repression of students

and faculty and the production of market-driven forms of pedagogy and research. Reagan became a key figure in the twin development of campus militarism and neoliberal academic freedom by articulating them to a politics of white respectability that continues to inform contemporary conservative and liberal responses to student protest. Reagan presented limits on academic freedom and respect for police authority as necessary elements of respectability, thereby leveraging white gender and sex norms in support of an emergent neoliberal university. His five college films—three playing a student and two a professor—anticipate in a number of ways his subsequent political demonization of the University of California system. Reagan became California governor partly by vilifying the UCs, especially Berkeley, as places of radical anticapitalist, antiwar, and antiheteronormative politics. As Christopher Newfield has argued, such attacks were part of a larger effort to discredit the ideals of social equality that had, however imperfectly, guided the University of California since its inception.[2]

When Reagan was elected governor, he ended free tuition at state colleges and universities; repeatedly slashed construction budgets for state campuses; and engineered the firing of UC president Clark Kerr and of Angela Davis from UCLA. As governor and subsequently president, Reagan came to and maintained power by fomenting voter resentments against public education; demonizing colleges, professors, and students; and slashing education budgets.[3] At the same time Reagan initiated a new militarization of college campuses, anticipating more recent education-scapes of baton-swinging, pepper-spraying, tank-driving campus cops.

Patricia J. Williams presents a Black feminist perspective on Reagan's embrace of white masculinity. In a collection of autobiographical essays titled *Open House,* Williams contrasts racist representations of Black masculinity with the kind of white masculinity represented by Reagan, Charlton Heston, and Arnold Schwarzenegger. Commenting on the 2012 U.S. presidential election, Williams argues that the contemporary mimicry of Reagan by conservative politicians includes the foreclosure of critical thinking and an antiuniversity, anti-intellectual mindset, or what she calls "our lizard-brain politics."[4]

June Jordan similarly elaborated a Black feminist critique of Reagan. In a number of essays for the *Progressive* that I discuss later, Jordan addresses the era's culture wars on campus, arguing that the Reagan-era promotion of white Western canons and attacks on affirmative action were of a piece with the president's imperial war machine aimed at people of color in the United States and the Global South.

In what follows I reconstruct the early twentieth-century social and cultural formation that produced Reagan and his higher-education policies. First as a college student and subsequently a Hollywood actor, Reagan was a historical heir to a vision of universities as settler-colonial centers of containment articulated to Christianity, white respectability ("good character"), and team-sport spectacles. It was as an actor that Reagan learned how to effectively mediate that vision, becoming one of the university-cinema–industrial complex's most powerful representatives. Reagan casts a long shadow, and his vision of the university continues to inform contemporary institutions of higher learning. A case in point is the political career of fellow actor and Reagan acolyte Arnold Schwarzenegger, who succeeded Reagan as California governor (2003–9). Like his hero, Schwarzenegger attempted to discipline the UC system through fee increases, furloughs, and draconian budget cuts. I conclude by analyzing Schwarzenegger's two film roles as a professor, arguing that they modeled the populist respect for white male power that would guide his administration of the University of California.

REAGAN GOES TO COLLEGE

Reagan's experiences at Eureka College near Normal, Illinois, were formative for his political identity. While governor, looking back on his college years, he concluded "Everything good in my life . . . began at Eureka." Between 1947 and 1980 he served a total of eighteen years on the college's board of trustees. Starting in 1941, Reagan returned to campus eleven times for official events, including, while governor, for the dedication of a new physical-education facility named in his honor. The overlap between college sports and politics is suggested by the fact that he spoke at a Eureka pep rally during his 1980 presidential campaign. Reagan also spoke at commencement three times (1957, 1982, 1992). In his 1982 commencement address now known as "The Eureka Speech," he presented a major foreign-policy statement about the Strategic Arms Reduction Treaty (START) negotiations with the Soviets and returned in 1984 to give another major speech on nuclear arms control, suggesting the extent to which, for Reagan, the idealized image of college life incorporated students into Cold War militarism.

Raised in a relatively poor family, in 1928, around the time when the moralizing, racialized Production Code was being drafted and a year before the founding of the film school at the University of Southern California (USC; see the introduction), Reagan was admitted to Eureka as a

financial aid student. In contrast with a large, public university like Berkeley, Eureka was a small, private, Christian, liberal arts college.[5] The first two decades of the twentieth century witnessed the emergence of large new secular research universities that were self-consciously distinguished from colleges like Reagan's, which were often religiously invested in forming moral subjects. Many of the older colleges responded to the new universities by reasserting their distinctive commitments to a conservative pedagogy, which is not to say that universities were liberating institutions—far from it. But colleges in the 1910s and 1920s were often distinctly reactionary, answering the university and the perceived moral permissiveness of the larger culture by reasserting a mission to maintain the authority of Western canons of knowledge and hand them down to students.[6] Such colleges tended to be paternalistic, devoted to guiding students morally, inculcating discipline, and encouraging submission to authority. In their commitment to a U.S. agrarian ideal, colleges also tended to be located in rural settings to shield students from the dangers of racially diverse cities.[7] Finally, while colleges were sometimes coed, most of their students were male, and the curricular focus on character building aimed to turn bright white boys into respectable white men.

As he explained in his autobiography, *An American Life,* Reagan found his small rural college idyllic:

> There were five Georgian-style brick buildings arranged around a semicircle with windows framed in white. The buildings were covered in ivy and surrounded by acres of rolling green lawn studded with trees still lush with their summer foliage. . . . Eureka was everything I had dreamed it would be and more. In later life, I visited some of the most famous universities in the world. As Governor of California, I presided over a university system regarded as one of the best. But if I had to do it over again, I'd go back to Eureka or another small college like it in a second.[8]

Reagan's preference for a college over a university framed his attacks on the University of California while he was governor. During the 1910s and 1920s, while there was a small but significant increase in coeducational universities and colleges, as well as access for Black students at Black colleges (although many such schools were dramatically underresourced), women were underrepresented and the number of Black college graduates remained tiny. In the first decades of the twentieth century, when at least 5 percent of white people in the United States between the ages of eighteen and twenty-one attended college, the figure for Black people was less than one-third of 1 percent. Many colleges and universities, especially in the South, expressly barred Black students,

while many more did so unofficially. Higher education remained racially segregated, and even schools that admitted Black students consigned them to separate dorms and dining halls.[9] Reagan's ideal campus was hence a largely white and male world.

Segregation was further reproduced in U.S. mass media. "It was standard practice to exclude the Black colleges from the national media, whether major newspapers or other publications about college life" writes historian John R. Thelin. "The anthologies of college songbooks published between 1900 and 1920," he continues, "claimed to be all-inclusive, but the Black colleges were not among the hundreds of institutions from all over the country." Similarly, in 1929, when Reagan was a college sophomore, one of the most popular films was *Horse Feathers,* a Marx Brothers comedy set at a fictional college, where the only Black character is a housekeeper.[10] In these ways the words *university* and *college student* became ideological terms for heteropatriarchal whiteness. The dominant image of the college student in the early twentieth century was a WASP young man who came to partly eclipse the heroic self-made white businessman in period mass media.[11]

Reagan graduated from Eureka in 1932 with a degree in economics and sociology, although fifty years later he confessed to a graduating class at his alma mater that he was a C student who spent more time playing football than studying.[12] In addition to football and drama, Reagan's college life centered on his fraternity, which is to say that as a student he was incorporated into white male institutions of homosocial power and schooled in the often-violent male competition over women and territory. College football, in particular, bolstered Reagan's appeals to voters while he was governor and ultimately president, when he was often photographed throwing a football or wearing a Eureka football jersey, and so it is worth considering sporting spectacles in some detail.[13] As I argued in chapter 1, historically, college football—with its largely all-white, male teams; hierarchical military organization; staged battles over territory; Indian mascots; and often-literal occupation of Indigenous land—has constituted a settler-colonial entertainment spectacle rivaled only by Hollywood westerns.[14] As Frederick Rudolph reminds us, the "rise of college football was contemporaneous with the development of a martial spirit which manifested itself in two forms: in those warlike developments that led to such victories as those of the Standard Oil Company, and in that series of imperial adventure and bellicose adventures that planted the American flag in the Caribbean and the Pacific and paraded the American navy around the world."[15] Just as

white settlers claim Indigenous land as their own and just as white settler colleges often incorporate Indian mascots, the college football player was praised for seemingly incorporating and sublating "Indian savagery." In this context it is striking that the mascot for Reagan's alma mater—the "Red Devil"—is named for an anti-Indigenous slur.

Reagan often remembered college football as an exercise in character building, in which good coaches impart the values of discipline, hard work, sportsmanship, and competition to student athletes. "As a coach," Reagan told graduating students at Notre Dame in 1981, Knute Rockne "did more than teach young men how to play a game. He believed truly that the noblest work of man was building the character of man."[16] Invocations of nobility notwithstanding, by the 1910s and 1920s college football was big business. It was during those years that many universities built massive football coliseums and earned millions of dollars in ticket sales and other revenue.[17] Despite their distinct mission, the colleges that could afford it attempted to emulate universities in terms of football. College and university football games thus became mass spectacles, avidly followed by large newspaper, radio, and film audiences.

Given the relatively small percentage of students who attended college in the United States, football served as the most influential representation of higher education for the vast majority of people and the most important vehicle of university public relations. As a result, many in the early twentieth century began to act "as if *the* purpose of an American college or university were to field a football team."[18] *American College Athletics*, a scathing 1929 report published by the Carnegie Foundation for the Advancement of Teaching, detailed the corrosive effect of football on campus. College football, the report documented, had led to large revenues and inflated salaries for coaches that skewed a school's mission away from education and toward commerce. Football also created an opening for wealthy alumni and other donors to influence and control colleges and universities. The sport became an ideological spectacle that effectively disappeared the violence of capitalist exploitation by celebrating the seeming dissolution of class differences as farmers' sons supposedly played ball with members of the elite and the middle class. Football further promoted the virtues and excitements of free-market competition and an ethics of team loyalty that reconciled an older individualism to a new corporate mentality.[19]

While we are accustomed to thinking about the corporate university as a contemporary phenomenon, I would argue for historicizing it in terms of the patriarchal, settler-colonial racial capitalism represented by

college football. As Thorstein Veblen argued in *The Higher Learning in America* (1918), the prominence of college football was symptomatic of the "corrupting influence of the business ethos."[20] The game generated profits for white institutions and linked capital to whiteness in the figure of successful coaches and players. Football represented a struggle for white power, to preserve white power over capital at the expense of people of color. Collegiate teams were overwhelmingly white. Southern teams were all white, and when they played northern teams, their few Black players were benched. College football powerhouses did play the Carlisle teams but did not themselves include Native American players. Even when allowed to compete, Black athletes experienced racist violence and segregation on campus. As recounted in chapter 1, at Rutgers in 1915, where he was the only Black student, Paul Robeson was beaten and nearly lynched by his white football teammates.[21] Two decades later, despite his phenomenal success on the field, Black track star Jesse Owens was excluded from Ohio State University dorms and forced to live off campus.[22] While a large body of scholarship has focused on racism and college athletics in the South, as these examples suggest, Black athletes in the prewar period also faced racism in the North.[23]

By contrast, in Reagan's reconstruction of his own college history, football symbolically transcends anti-Black racism. In 1986 remarks to students and faculty at Martin Luther King, Jr. Elementary School, for example, he spoke nostalgically about his Black teammate Franklin "Burgie" Burghardt: "He's departed this world now—but he's probably the closest friend I ever had. . . . You see, just one individual with principles like that, like Dr. King and like Franklin Burghardt . . . the world is so different today. And those of us who were a part of that revolution that Martin Luther King performed in, all of us, we are so happy for what has happened and so happy to see all of you here together in this different kind of America."[24] Here King's death is collapsed with Reagan's dead Black classmate to suggest that racism is confined to the past. At the same time he implies that the Reagan revolution was part of a long civil rights movement that originated with college football. In death, then, the two Black men are subsumed by a nationalist ideal represented by Reagan.

REAGAN'S COLLEGE FILMS

Reagan's most famous film role as a college student tells a similar story of white leaders incorporating and transcending racial difference. In *Knute Rockne All American* (1940), a film biography of the Notre

Dame coach, he plays star fullback George Gipp. Reagan brought the idea for the film to Warner Brothers because he desperately wanted the part. It was his favorite role, and he invoked it again and again while president.[25]

In his 1981 Notre Dame commencement speech, Reagan claimed that *Knute Rockne All American* was a quintessential story of U.S. exceptionalism: "Growing up in Illinois, I was influenced by a sports legend so national in scope, it was almost mystical. . . . Knute Rockne as a boy came to America with his parents from Norway. And in the few years it took him to grow up to college age, he became so American that here at Notre Dame, he became an All American in a game that is still, to this day, uniquely American."[26] One of the few Black characters in the film is an unnamed child quarterback (George Billings), against whom a young Rockne plays football. Rockne repeatedly sacks him in the first few minutes of the film, and after that, with the exception of a Black train porter and a cameo by Jim Thorpe, the world of college football in *Knute Rockne All American* is all white (see figures 14 and 15). Reagan's character is introduced to that world as the fulfillment of a white wish. As Rockne muses to his team, "What I would give my right arm for is a halfback who can carry the mail, a fast boy who can run, pass and kick, somebody on the order of Jim Thorpe. That sort of fellow comes along maybe once or twice in a coach's lifetime. But I'm still hoping. And if I ever do find a boy like that . . . " As Rockne trails off and looks dreamily into the distance, the scene dissolves into a new one on the field, where the coach's dream comes true in the form of Reagan as Gipp the football prodigy. In settler-colonial fashion, Reagan's character becomes the great white hope of college football, displacing while symbolically incorporating the Sac and Fox athlete Jim Thorpe, the dominant fullback and star of college football before Gipp. The displacement and subordinate incorporation of indigeneity are further suggested by the film's credits, where Reagan is a star and Thorpe's cameo remains uncredited. The settler-colonial reading of *Knute Rockne All American* is in keeping with Reagan's preference for film westerns.[27]

At the center of *Knute Rockne All American,* after having symbolically displaced and incorporated Blackness and Indigeneity, Reagan as Gipp dies in the flesh but is reborn in spirit. On his deathbed Reagan/Gipp tells Rockne, his coach and father figure, to urge the team to "win just one for the Gipper," a line Reagan the politician would frequently recycle. During his death scene Reagan lies in a hospital bed with his hands arranged across his chest like a corpse in a coffin. Dressed in a

FIGURE 14. Child quarterback
(George Billings) pictured just before
being sacked. *Knute Rockne All
American* (1940).

FIGURE 15. In an uncredited cameo,
Jim Thorpe addresses the Notre Dame
football team. *Knute Rockne All
American* (1940).

white gown and covered by a white blanket decorated with stars, his face is illuminated by the kind of high-key lighting Richard Dyer argues Hollywood has historically used to visually fetishize whiteness.[28] In a subsequent halftime speech, Rockne does indeed tell his team to "win one for the Gipper," but, like his star player, the coach is also marked for death and ultimately dies in a plane crash. The film thus "doubles the theme of regenerative sacrifice by having Rockne catch Gipp's martyrdom." As a celebratory retrospective biography, *Knute Rockne All American* represents the pathos of death and loss but also of spiritual redemption. The death of both college student and teacher are sublated into larger mythical ideals of heteropatriarchy, whiteness, and nation. Later, when President Reagan repeats the words of a dead college student as ventriloquized by a dead college coach—"win one for the Gipper"—he speaks "as if, playing the Gipper, he was witness to his own death and ascension." Through images of "redemptive suffering," Reagan the actor and ultimately politician articulated his image to white victimhood and distanced it from violence and aggression.[29]

In Reagan's two other film roles as a college student, sports are supplemented with military drills. In *Brother Rat* (1938), a romantic com-

edy in which three college roommates at the Virginia Military Institute compete with one another over coeds from a nearby women's college, Reagan plays Dan Crawford, a star on the baseball team (in publicity photos he is pictured in a VMI sweatshirt). Filmed on location at VMI, *Brother Rat* begins with a military review to the sound of the song "VMI Spirit." As the college fight song morphs into "Dixie," the camera focuses on a bronze statue of Confederate general Stonewall Jackson with saber and field glasses, looking at the parade grounds. On the strength of his military successes during the U.S.-Mexico War, Jackson was appointed chair of natural and experimental philosophy at VMI, where he also trained students in the use of artillery. The statue depicts him as he surveyed his army just before the Battle of Chancellorsville, where he was fatally wounded.[30] Near the end of the film, the three college roommates, including Reagan as Crawford, meet at the foot of the statue to plan their futures, where they resolve to "fight" on like Jackson. *Brother Rat* thus implicitly invokes redemptive suffering in nostalgic narratives of a defeated South that will rise again.

Reagan's final role as a college student is also set at a military academy and also includes racialized intimations of tragic military losses redeemed by higher ideals of masculinity, whiteness, and nation. In *Santa Fe Trail* (1940) he plays a young George Custer in his senior year at West Point. During an early dorm scene, a fellow student (Van Heflin) reads aloud a pamphlet by radical abolitionist John Brown, and Reagan as Custer responds by joining his friend, future Confederate general Jeb Stuart (Errol Flynn), in beating their abolitionist classmate, who is then expelled for his subversive views. After a graduation ceremony in which Jefferson Davis delivers the commencement address and Robert E. Lee hands out the diplomas, Stuart and Custer begin competing with each other for the affections of Kit Carson Holliday (Olivia De Havilland). While Stuart ultimately gets the girl and captures the villainous John Brown (Raymond Massey), Reagan as Custer heroically leads the cavalry against the abolitionist in scenes that recall the ride of the Klan in *The Birth of a Nation*. As in *Knute Rockne All American,* Reagan plays the college student as tragic figure since, unlike his character, the audience knows Custer will die at Little Big Horn. Reagan once again assumes the role of college student as militarized agent of settler colonialism and anti-Blackness whose ultimate sacrifice redeems the spirit of white nationalism.

Rogin argues that Reagan's film roles enabled him to become a neoliberal ideologue who cut state spending while ramping up police and

military power. "For Reagan to gain presidential stature, he had to acquire a falsely vulnerable objectified self," reconnecting "through his film roles to the dependence in his personal history in order, finally, to find a substitute for that dependence and play at freedom." As an actor, Reagan played vulnerable characters whose violent sacrifice produced forms of transcendence or "happy endings" based in punishing others. As president, Reagan channeled his film career and embodied "national fears of helplessness and dependence in order to overcome them by punishing the enemies responsible for American weakness."[31] The projection of a falsely vulnerable self as alibi for violence directed at others is an apt description of the psychic mechanisms of white nationalism in recent history. President Reagan's performance of endangered national innocence was manifestly contradicted by a murderous foreign policy in Central America and elsewhere. In her essay for the *Progressive* magazine, titled "Wrong or White" (1990), poet and Berkeley professor of English, women's studies, and African American studies June Jordan argues that white supremacy served to resolve or displace contradictions in the U.S. response to revolutionary movements in socialist Germany, Poland, and Romania in 1989, at the end of Reagan's second term.

> Nobody powerful in the USA, neither the politicians nor their media echo-men, chose to condemn or chide or advise or trivialize or ignore or threaten or misrepresent or patronize any of these anarchic and mysterious, and, yes, ultimate and sometimes deadly confrontations with a demeaning and cruel status quo. No American with national access to network cameras elected to characterize these wild explosions of fury and unrest as "mob hysterias" or "terrorist" or "lawless" or "riotous" or "violent" or "subversive." . . . None of these ordinary heroes would be sneeringly identified as Arabs or Palestinians. They were Poles. Those uproarious hordes overthrowing demands for visas and checkpoint inspections and submission to massive, actual barriers to freedom—they were Germans. The people chanting beneath the palace balconies—they did not speak Spanish, they were not citizens of Nicaragua or El Salvador, or Panama. . . . Consistently from the Oval Office to NBC-TV, these overwhelming facts of European *intifada* came across to us, the regular people of the USA, as unequivocal good news. It was white on white. And, meanwhile, U.S. support of a death-squad government in El Salvador did not abate. U.S. imposition of millions of dollars intended to rig upcoming elections in Nicaragua did not stop. The Administration's and the media's concession to phony questions about the legitimacy of the leadership of the ANC in South Africa and the PLO on the Gaza Strip and the West Bank—these disgusting tactics of racist oppression—they did not wane or disappear. These were matters of wrong and white. . . . Whether it was Washington, D.C., or Jerusalem, or Pretoria, the wisdom and the virtue and the military force to correct and control your misbegotten miserable existence would be and would remain white power.[32]

Jordan describes an ideological moment of both doubling and difference between white and nonwhite political formations, such that white power mirrors its dark others but disavows any doubling with racism. Jordan here deconstructs political demonology in U.S. foreign policy. Political demonology, according to Rogin, is a structure of feeling whereby the imagined transgressions of others (women, unions, nonwhite peoples) serve to authorize supposedly equivalent forms of counterviolence in a kind of fight-fire-with-fire logic. Reagan's projection of a falsely vulnerable objectified self simultaneously motivated forms of political demonology while derealizing state violence and imaginatively insulating him from the consequences of his policies. By foregrounding doubling as a racist contradiction, Jordan further suggests that Reagan-era depictions of danger from the Global South were actually distorted white power self-representations. In her other writing for the *Progressive* in the 1990s, she linked white power in Reagan- and Bush-era foreign policy to related attacks on affirmative action and ethnic and gender studies as dangers to the kind of Western civilizational educational mission Reagan discovered at Eureka and attempted to enforce in the UC system.[33] From the vantage point of Jordan's "Wrong and White," we can appreciate how culture-war accounts of such imagined threats to higher education are demonological self-representations of conservative attacks on higher education.

While the essays by Jordan and Rogin were focused on Reagan's presidency, they also help us understand his tenure as California governor and his promotion of political demonology. In the film *Juke Girl* (1942), for instance, Reagan plays at vulnerability and powerlessness in his role as Steve Talbot, a migrant farmworker who, in the words of *New York Times* critic Bosley Crowther, "starts on a one-man crusade against the local big-shot packer, who is a crook."[34] Set in the tomato fields of Florida but filmed in California's San Joaquin Valley, *Juke Girl* is derivative of *The Grapes of Wrath*, whose Okie farmworkers were themselves based partly on Mexican farmworkers. The film positions Reagan's performance as a kind of symbolic brown face, in which a white man falls to the low level reserved for workers of color.[35] In 1980 a reviewer referenced this trope by writing that Reagan played a "Cesar Chavez type."[36] Ultimately, however, Talbot escapes a lynch mob; finds love with Lola, the titular "juke girl" (who is thereby "saved" from a sordid life of taxi dancing); and receives the gift of a parcel of farm land. Reagan's farmworker vulnerability and degradation pay off with a happy ending, serving as an implicit judgment against farmworkers of color who do not similarly rise.

By comparison, as California governor, Reagan used his office to undermine and attack the United Farm Workers. He actively solicited the support of California agribusiness interests, redbaited the UFW, and famously ate grapes for the cameras to express his opposition to a grape boycott. Having previously played at being a farmworker but then rising above it, Reagan claimed to protect the people of California from the threat represented by actual farmworkers. As governor, Reagan also learned how to scapegoat college students and professors for their supposed dependence on the state. Such a structure of feeling informed his efforts to discipline and punish University of California students with tuition and military violence. Just as Reagan played a college student whose deaths contributed to some greater good, as governor he insisted that students had to pay. From his Black college football teammate, to his farmworker and college student roles, in other words, Reagan practiced top-down forms of vicarity, performing a doubling in difference to authorize aggression and violence against the objects of his vicarious feelings (see the introduction and chapter 3). Having played students, in other words, Reagan could then attack them.

Answering student protests, Reagan wrapped his calls for discipline in the symbols of settler colonialism. Along with a group of conservative politicians, businessmen, and Hollywood stars and executives, Reagan helped build California's modern Republican Party, and settler symbolism was key to his efforts. During the 1964 presidential race, he joined John Wayne and a host of other western stars of film and television to fund-raise and campaign for another politician associated with the West, Arizona's Barry Goldwater. While running for governor in 1966, Reagan mobilized support from stars of western films and TV shows including Dale Evans, Roy Rogers, Randolph Scott, John Ford, Joel McCrea, Walter Brenan, Buddy Ebsen, and John Wayne.[37] Reagan also campaigned from on horseback, riding in a parade while wearing a cowboy hat, bolo tie, boots, and a red, white, and blue western shirt.[38] At his largest campaign event, called the Reagan Roundup and staged at San Francisco's Cow Palace, Reagan's speech attacking bureaucracy, taxes, welfare recipients, and "The Morality Gap at Berkeley" was packaged with a western theme including country-and-western bands, actors dressed as cowboys and Indians, chuckwagons dispensing box lunches, and actor Chuck Connors, star of the TV western *The Rifleman,* serving as master of ceremonies.

In keeping with his self-representation as a settler-colonial icon, Reagan also pioneered militarized reactions to student dissent and struggles

over state-occupied territory.[39] When activists occupied a parcel of university land in Berkeley and named it "People's Park," Governor Reagan called in the National Guard and authorized them to use shotguns to reassert the university's property rights. As a result, one person was killed, one was blinded, and hundreds were injured. He also authorized the aerial teargassing of the entire city of Berkeley. Afterward, Reagan defended the police response by saying, "If it takes a bloodbath, let's get it over with. No more appeasement." When told by a UC Berkeley student reporter that he had blood on his hands, Reagan recalled the U.S. Boraxo Company, sponsor of his western-themed TV show *Death Valley Days* (1964–65), saying, "I'll wash it off with boraxo."[40]

A critical examination of the relationship between the twentieth century's two most famous western icons, Reagan and John Wayne, illuminates the appeal of settler-colonial symbolism in U.S. politics. Like Reagan, Wayne was a fraternity member and college football player, but at USC, where is remembered as the school's most famous student.[41] Wayne attended USC between 1925 and 1927, during the height of eugenics research on campus, before a body-surfing injury ended his football scholarship and he was forced to drop out. In his eulogy for Wayne, Reagan remembered him as "one of the few stars with the courage to expose the determined bid by a band of communists to take control of the film industry."[42] During the 1960s Wayne threw his considerable public and private influence behind a number of conservative political candidates, campaigning and fund-raising for George Murphy, Barry Goldwater, Richard Nixon, and ultimately his good friend Reagan. Wayne tapped his former USC fraternity brothers to pay for the 1964 TV broadcast of Reagan's famous speech supporting Goldwater for president, "A Time to Choose."[43] And, like Reagan, Wayne was particularly incensed by protests on college campuses. When he was heckled by antiwar protestors at a USC fund-raiser in 1966, Wayne proceeded to harangue the students in the audience: "A university should be a quiet place where you go to learn, not to destroy property belonging to someone else. Getting an education is a privilege, not a right. Your professors and administrators should be treated with courtesy and respect. While you're here, you ought to be learning a sense of responsibility. We aren't going to sit by and let you destroy our schools and system." With his assertion that college education should be about learning to respect private property and responsibility, Wayne ventriloquized the early twentieth-century college ideal, and with his insistence on "courtesy and respect" he echoed the fetishization of conduct and respectability in the university-cinema–industrial complex

(see the introduction). Finally, Wayne's outburst was in sync with Reagan, who had been elected governor that fall.

Near the end of Reagan's first term as governor, Wayne gave a vehemently anti- Indigenous, anti-Black interview to *Playboy Magazine* that also made explicit the structure of feeling animating white nationalist attacks on the University of California. Wayne argues that communist professors such as Angela Davis "pervert the natural loyalties and ideals of our kids." In response to the interviewer's claim that Davis has been subject to racial discrimination, Wayne answers,

> I believe in white supremacy until the blacks are educated to a point of responsibility. I don't believe in giving authority and positions of leadership and judgment to irresponsible people. But some blacks have tried to force the issue and enter college when they haven't passed the tests and don't have the requisite background. I think any black who can compete with a white today can get a better break than a white man. I wish they'd tell me where in the world they have it better than right here in America. I've directed two pictures and I gave the blacks their proper position. I had a black slave in *The Alamo*.

A question about race and college access prompts Wayne to invoke slavery, as represented in a film he directed and produced, to suggest his view on the "proper position" of Black faculty and students. While the *Playboy* interviewer doesn't pursue this line of questioning, Wayne's reference to his virulently anti-Mexican film *The Alamo* as relevant to discussions of campus climate suggests an implicitly hostile relationship to Chicanx activism as well. In a related vein, when the interviewer asks Wayne about Native Americans in his films, he responds, "I don't feel we did wrong in taking this great country away from them, if that's what you're asking. Our so-called stealing of this country from them was just a matter of survival. There were great numbers of people who needed new land, and the Indians were selfishly trying to keep it for themselves." Moreover, Wayne rejects Indigenous demands for university access as a form of reparations, arguing, "What happened between their forefathers and our forefathers is so far back—right, wrong or indifferent—that I don't see why we owe them anything. I don't know why the government should give them something that it wouldn't give me."[44] For Wayne, students were like women and children around whom men circle the wagons to protect them from Black, Mexican, and Indigenous people. Like other white nationalists, the greatest icon of western expansion and U.S. militarism viewed universities through the lens of settler colonialism, anti-Blackness, and anti-Mexican racism.

To return to Reagan: his investments in settler colonialism were both symbolic and material. In 1951, while still a Hollywood actor, he bought a 290-acre ranch in Malibu. It had previously belonged to the Chumash people before being appropriated as private property, and when Reagan purchased the land it was surrounded by the Century Ranch, where Fox Studios filmed westerns and other projects. Reagan made his personal fortune when, shortly after being elected governor, he sold the ranch he had purchased for $85,000 to Fox Studios for $1.9 million. Government and journalistic investigators have raised questions about this remarkable windfall, suggesting that it was part of scheme by Fox to secure tax breaks for the film industry or by Reagan's wealthy backers to help pave the way for a future presidential campaign.[45] But while the details of the transaction remain shadowy, one thing is clear—Reagan became a rugged, frontier individual through speculation in Indigenous lands.

Reagan's speculation in Indigenous lands extended to the UC system and his efforts to acquire land for the building of UC Irvine. Reagan's personal lawyer, closest adviser, and UC regents appointee, William French Smith, was also the lawyer for the Irvine Company, which in the mid-1960s owned 130 square miles of ranch land in Orange County. When the company donated 1,000 acres to the state for a university, it secured a substantial tax break that became the seed money for the settlement of the city of Irvine. By 1970 the Irvine Company decided to expand the city but needed approval from the regents to do so. Despite opposition, Reagan and his six appointees pushed the proposal through. Meanwhile, Reagan's State Lands Commission agreed to give 2.5 miles of prime state-owned shoreline to the Irvine Company in exchange for what one state official called "450 acres of useless swampland." The previous administration's Lands Commission, by contrast, had rejected the trade as a misuse of state resources.[46] This history of speculation in stolen land is implicitly referenced in *Poltergeist* (1982), a film made partly at UC Irvine and featuring a housing development on top of a graveyard (see the introduction). As governor, then, Reagan was in the forefront of a particular form of neoliberalism we might call settler-colonial privatization.

In his approach to higher education, Reagan combined symbolic and material attacks, imagining the UC system on the model of a white settler-colonial family and his role as governor as one of paternal protector and disciplinarian. When discussing fee hikes and budget cuts, he compared state spending to a home economy and argued that, like members of a

family on a budget, students and professors would have to do without. He also argued that, like children in the home, students needed to be protected from subversive ideas, sexual deviancy, and immoral and disgusting speech. As Rogin and John L. Shover argue in *Political Change in California: Critical Elections and Social Movements, 1890–1966,* Reagan represented a right-wing Southern California tradition based in ideas about race and white families. That formation injected white family values into the public arena, where they served as models for public institutions, including universities.[47]

Reagan rode a wave of white backlash into office, stoking fear and anger over Black rioters in Watts; the Rumford Fair Housing Act outlawing racial discrimination in housing; and the passage of the 1964 Civil Rights Act.[48] Reagan became governor, as Rogin and Shover argue, by "running on an openly anti-university, anti-obscenity, anti-welfare, and anti–fair housing platform."[49] As a regent of the University of California, Reagan became an expert in the forms of racial coding that Michael Omi and Howard Winant have argued characterized his presidency.[50] When vilifying Berkeley, for example, Reagan often spoke of a dangerous "minority" that took academic freedom too far and disrespected police authority. In a 1967 letter to San Francisco State chancellor Glenn Dumke, Governor Reagan almost makes explicit the racialized scenarios he imaginatively brought to bear on California higher education: "How far do we go in tolerating these people and this trash under the excuse of academic freedom and freedom of expression? . . . We wouldn't let a LeRoi Jones in our living room and we wouldn't tolerate this kind of language in front of our families. Hasn't the time come to take on those neurotics in our faculty group and lay down some rules of conduct for the students comparable to what we'd expect in our own families?"[51] Here, in reference to Jones's appointment as an inaugural Black studies professor at San Francisco State, Reagan imagines kicking such "trash" out of the university—just as he would from his home—to protect white family values. Extrapolating from an imaginary scene where the radical Black poet and teacher is excluded from white homes, Reagan asserts that a racialized model of respectability and proper conduct should also govern university spaces.

According to Rogin and Shover, in the Southern California represented by Reagan, the hallucinatory Black threat to white families was transferred to others as well:

The need to cure or eliminate is extended to cover Communists, the young, drugs, pornography—targets that seem to express relations of sensuality,

rebellion, and acknowledged dependence not permitted in the southern [California] world. Thus the students who want to leave home threaten family unity. . . . The Negro threat to property values, the students' rejection of property, and the Communists' desire to take it away—all metaphorically threaten ownership and control of the self, that is, self-government, self-mastery, and protection against the world of significant objects. . . . The Southwest was always the home of unassimilable minorities—Mexicans, Indians, Orientals—rather than the melting pot immigrants of European stock. Not believing in assimilation, the right-wing [Southern Californian] turns to elimination.

"Elimination" is a primary ideology and practice of settler colonialism, and it is implicit or explicit in Reagan's love of film westerns and the heroic symbols of Indian wars. As a "robot, a sleepwalker, an image on a screen, whose acts are dissociated from his being," Governor Reagan plays the cowboy hero in a "twentieth-century reenactment of the nineteenth-century drama."[52]

Reagan's racialized familial model for the university recalls his most famous role as a college professor. In *Bedtime for Bonzo* (1951) he plays Sheridan College psychology professor Peter Boyd, who is engaged to his dean's daughter. But the dean becomes suspicious when Knucksy Breckenridge, the former prison cellmate of Boyd's late father, a brilliant conman nicknamed "The Professor," pays him a visit. After Knucksy shows him the resemblance between Dr. Boyd's photo on the cover of his book *Slum Crime* and his father's mug shot, the dean presses Boyd to resign and break off the engagement to his daughter. To "prove (as if he were the chimp), that environment can triumph over heredity," Professor Boyd hires a nanny named Jane Linden to pretend to be his wife and help simulate a home for a chimp named Bonzo and teach him right from wrong.[53] To hide his experiments he tells the dean that Bonzo is an exchange student from Africa, and, in the privacy of his home, Boyd and Linden pretend to be Bonzo's "mama" and "papa." The pair ultimately succeeds in teaching Bonzo to respect private property and the police such that the chimp voluntarily returns a diamond necklace he had previously stolen. In the end Boyd and Linden marry, and the dean beams over the new prestige brought to the university by "Operation Bonzo," research that we could understand as a fictionalized rendering of the kinds of university research in conduct and eugenics analyzed in the introduction. As with Reagan's attacks on the UC system, in *Bedtime for Bonzo* norms of respectability associated with white families are folded into respect for property and police power, and, vice versa,

property rights and police authority are presented as components of racialized respectability.

Bedtime for Bonzo's happy ending is secured by the substitution of a good professor for a bad one. Anticipating Governor Reagan's efforts to reform the UC system and discipline wayward scholars, Reagan's character in the film can emerge as its hero only by displacing and transcending his father, the criminal "Professor." As governor, Reagan recalled Professor Boyd, since he seemed to bring to the UC system a vision of teaching and research focused on promoting moral character; respect for private property and the police; and the promotion of private initiative over state welfare provisions. In 1967, just two years after the Moynihan Report pathologized Black families led by women for the expansion of welfare, Governor Reagan called on university researchers at USC to help eliminate dependence on welfare in ways that preview his use of the racially coded term "welfare queen" while president. More broadly, he charged professors with teaching national morality. In his 1967 inaugural address, Governor Reagan asserted, "It does not constitute political interference with intellectual freedom for the taxpaying citizens—who support the college and university systems—to ask that, in addition to teaching, they build character on accepted moral and ethical standards."[54] Shortly after, in a speech installing a new president at Chico State College, Reagan went further, arguing that academic freedom required universities to teach nationalism:

> But I think there is a third element in academic freedom. In addition to the rights of the students to learn, and the teachers to teach, there is the right of society to insist the educational system it supports will further the goals and the aspirations and the moral principles and precepts of that society. There is no question that the publicly-supported colleges and universities contributed to the emerging greatness not only of California but also of our nation, and that is good; but we have a right to ensure that they do not, in some far-out interpretation of "freedom," weaken the social structure essential to the nation's strength and to the perpetuation of these very educational institutions.[55]

In this way Reagan imagined resolving the contradictions of an emergent neoliberalism and its neoconservative variants that combined attacks on state power while promoting military and police violence, since the governor represented universities as the place where students learn submission to the status quo—at the end of a club, if necessary.

At first viewing Reagan's final college film, the musical comedy *She's Working Her Way through College* (1952), seems to negate his others.

Reagan plays drama professor John Palmer at the fictional Midwestern College, where President Copeland favors the football team over the arts. Copeland disrespects Palmer and underfunds the Drama Department, leaving the professor and his wife, Helen, on a tight budget that requires them to take in lodgers. Professor Palmer is further at odds with Shep Slade, a wealthy businessman and influential alum who returns to Midwestern near the start of the film and proceeds to make a play for Helen, his college flame. Palmer mentors a working-class student named Angela Gardner, telling her "college is the inalienable right of every American," and agrees to help her stage a "modern" musical she wrote and in which she will star. When the school paper and ultimately the national press report rumors of Gardner's sexual improprieties, however, President Copeland threatens to expel her and tries to force Palmer to read a speech before the student body canceling the play. Defying the administration, Reagan as Professor Palmer delivers an impassioned speech against discrimination and for the universal right to education. As a result, he becomes a hero among the students, inspires Helen's admiration, and earns the grudging respect of his rival, Slade. Finally, President Copeland promotes Palmer to the rank of full professor, and the play opens as scheduled.

Yet *She's Working Her Way through College* presents an image of higher education that significantly downgrades the stakes of its source, which is focused on a politically volatile question of academic freedom. Reagan's film is loosely based on *The Male Animal* (1942), starring Henry Fonda as Midwestern College English professor Tommy Turner. When an undergraduate student writes an editorial calling the trustees fascists while praising Turner's commitment to free speech and announcing that in his next class the professor would read aloud a letter written by executed anarchist Bartolomeo Vanzetti, a trustee expels the student and warns Professor Turner he will be fired if he exposes students to "un-American" views. Nonetheless, Turner's dean defends him, and the professor gives a stirring public address about the values of free speech before proceeding to read the anarchist's letter.

As *New York Times* reviewer Bosley Crowther wrote, *She's Working Her Way through College* "watered down the plot of the original." Whereas *The Male Animal* is "pointedly concerned with the fate of a college professor on the verge of losing his wife and his job," *She's Working Her Way through College* "has blithely shifted attention to the college career of an ex-burlesque queen."[56] As Professor Palmer in *She's Working Her Way through College,* Reagan defends a student, Angela

Gardner, who has worked as a stripper to pay for college. He ultimately refuses to expel her, decries discrimination against people in "show business," and defends the academic freedom of students to stage an all-white musical review. However, rather than take up the kinds of critical, challenging ideas often conveyed by concepts of academic freedom, the resulting show is a didactic lesson about the gendered virtues of the market. Its central musical number delivers this historical lesson:

> We're doing a show at college,
> To prove you don't need knowledge
> Education is not what it's cracked up to be.
> For instance, take the famous women through the ages,
> They got to where they got by turning heads, not pages.
> The art of cash and carry
> As practiced by DuBarry
> Is a thing every modern girl should really see.

Meanwhile, costumed as the courtesan Madame Du Barry, Gardner performs the song "Love Is Not for Free," while in the finale she and the rest of the white chorus girls wear mortarboards and miniskirts for gowns. *She's Working Her Way through College* thus turns academic freedom into a spectacle celebrating capitalism and the traffic in white women.

While California governor, Reagan helped redefine academic freedom as synonymous with market freedom and its companion, market austerity. This was a dramatic historical shift since, as Christopher Newfield argues, "the hallmark of the postwar university was 'academic freedom' as the fundamental condition of creating and disseminating valid and useful knowledge." That model of academic freedom included, according to Newfield, "the sort of intellectual liberty that challenged the status quo, not just now and then but all the time." Academic freedom also promoted "the cultural capability that enables individuals to see themselves as agents in complicated systems where they must work with (and against) people and groups quite different from them." This postwar model of academic freedom, Newfield contends, affirmed an interpretive understanding of knowledge, "since the truth is not given in advance of systematic encounters with the beliefs of others." That understanding of academic freedom "was so important to the discovery of truth," he concludes, "because it allowed for freedom of interpretation, revision, and reinterpretation."[57] Finally, a model of academic freedom based in encounters with otherness further presupposed the necessity of public education on a mass scale, as represented by the

University of California Master Plan. To be sure, the postwar vision of academic freedom was a real but limited good from which all sorts of marginalized people were practically excluded. But as a set of intellectual, cultural, and social ideals, the academic freedom recovered by Newfield is part of a usable past, potentially open to new articulations by students and faculty of color.

In stark contrast, Reagan would work to foreclose such academic freedoms. Throughout his political career, he argued that public universities threatened academic freedom, which in his view could be sustained only at private schools. Just five years after starring in *She's Working Her Way through College*, for example, Reagan delivered the 1957 commencement address at his alma mater in which he praised Eureka and other private schools as the source of academic freedom:

> Today we enjoy academic freedom in America as it is enjoyed nowhere else in the world. But this pattern was established by the independent secular and church colleges of our land, schools like Eureka. Down through the years these colleges and universities have maintained intellectual freedom because they were beholden to no political group, for when politics control the purse strings, they also control the policy. No one advocates the elimination of our tax-supported universities, but we should never forget that their academic freedom is assured only so long as we have the leavening influence of hundreds of privately endowed colleges and universities throughout the land.[58]

Here Reagan redefines "private" to mean "independent," as in private institutions free from state interference, and with his claim that private schools are unparalleled in their respect for academic freedom, he implicitly celebrates U.S. exceptionalism over and against Soviet state education. Less than a decade later, Governor Reagan would attempt to impose Cold War respectability politics on students and faculty in the UC system, partly by controlling the "purse strings," but also through the use of state police power. So while to the Eureka graduates he denied a desire to eliminate "our tax-supported universities," as governor he sought to dramatically and sometimes violently impose on the University of California a privatizing vision of academic freedom wed to white family values.

Governor Reagan further honed his model of academic freedom in dialectical opposition to faculty and especially student demands for what la paperson calls a Third University (see the introduction). As George Mariscal and Roderick Ferguson have shown, in the late 1960s Chicanx and Black students, including Angela Davis, demanded the establishment of a largely student-controlled college at UCSD, to be

named Lumumba-Zapata College, after the great Congolese and Mexican anticolonial revolutionaries. The proposed curriculum of L-Z College would focus on Black and Chicanx history, histories of Western imperialism and anticolonial struggle, and a problem-solving perspective on science and engineering premised on the rejection of military research. Such demands, according to Ferguson, challenged "(Western) man's self-representation as the universal basis of life, labor, and language. Indeed, the various units of the curriculum point to investigations of how Western man achieved a terrible specificity through the violent suppression of racialized and economically disfranchised communities."[59] The proponents of L-Z College in effect rearticulated the white nationalist college ideal represented by Reagan for radical ends.

Students and faculty saw these and related protest movements on campus as aimed against Reagan's politics of white backlash. Editorials in the student paper, the *Triton Times*, compared him to racist populist George Wallace, while UCSD students attended—no doubt with ironic distance—screenings of his western, *Cattle Queen of Montana* (1954). The *Triton Times* also published remarks by Herbert Marcuse from a campus rally protesting Reagan, in which the Frankfurt School intellectual and UCSD lecturer connected UCSD to the larger world student movement. Similarly, the paper reprinted an editorial from the UC Berkeley student paper that included this assessment: "They are shooting students in Mexico. They are shooting Black people in America. And they are on the verge of shooting students. The Governor seems eager to send the national guard onto the campus." On October 11, 1968, UCSD students invited to campus radical Black sociologist Harry Edwards. Completing his PhD at Cornell, Edwards had recently organized the Olympic Project for Human Rights, which, several days after his UCSD speech, inspired the Black-power fist protest by Black collegiate track medalists Tommie Smith and John Carlos at the 1968 Mexico City Olympics.[60] In his visit to UCSD, then, Edwards represented the antithesis of Reagan's view of college sports.

Students and faculty at UCSD were particularly motivated to protest by Reagan's attacks on academic freedom. Under his leadership the regents revoked credit for an experimental class at UC Berkeley taught by Black Panther Eldridge Cleaver and blocked the renewal of Marcuse's UCSD lectureship. In both cases Reagan and the regents argued that, despite faculty approval of the two instructors, they were unqualified to teach. Reagan also threatened to strip the faculty of final control over the curriculum and appointments, which he claimed should instead

rest with the regents. This proposal was ultimately stopped, however, by faculty and student resistance.

Reagan's market-driven redefinition of academic freedom while California governor not only continued to frame his approach to higher education while president but also paved the way for the broader neoliberal attacks on state funding for education. In 1981, at the start of his first presidential term, Reagan returned to Notre Dame to deliver a commencement address that echoed his earlier Eureka speech:

> You are graduating from a great private, or, if you will, independent university. Not too many years ago, such schools were relatively free from government interference. In recent years, government has spawned regulations covering virtually every facet of our lives. The independent and church-supported colleges and universities have found themselves enmeshed in that network of regulations and the costly blizzard of paperwork that government is demanding. . . . I hope when you leave this campus that you will do so with a feeling of obligation to your alma mater. She will need your help and support in the years to come. Almost every aspect of campus life is now regulated—hiring, firing, promotions, physical plant, construction, record-keeping, fundraising and, to some extent, curriculum and educational programs. . . . If ever the great independent colleges and universities like Notre Dame give way to and are replaced by tax-supported institutions, the struggle to preserve academic freedom will have been lost.[61]

Joining Reagan on the Notre Dame commencement stage was Pat O'Brien, the actor who had played Knute Rockne opposite Reagan as Gipp, and it was in this address that the president referred to the mystical national legend represented by Rockne and Notre Dame football. Given its reputation as the most famous Catholic university in the United States, it is striking that Reagan would champion it as a center of academic freedom, suggesting that his version of freedom presupposes obedience to religious orthodoxies and, conversely, that his free-market rhetoric burns with religious fervor.

Reagan's religion of the market was steeped in racial capitalism, and under his presidency academic freedom dovetailed with the freedom to segregate education. As Patricia Williams reminds us, Reagan attempted to appoint segregationist University of Texas at Austin professor of law Lino Graglia first to the Fifth Circuit Court of Appeals and then as the head of the Justice Department's civil rights division. Graglia, according to Williams, came to Reagan's attention after a three-decade career as a "vocal organizer of resistance to school desegregation," who had urged white parents in Texas to resist school busing. Williams's critical reflections were prompted when in 1997 the former Reagan nominee told

members of an antiaffirmative action organization at UT Austin that Black and Mexican students "are not academically competitive with whites" because they come from a culture that "does seems not to encourage achievement."[62] Meanwhile, Graglia's wife, F. Carolyn Graglia, promoted Republican respectability politics in her book *Domestic Tranquility: A Brief against Feminism*.

Analyzing Reagan's educational politics in light of his early college films thus suggests a different way of thinking about neoliberalism. Reagan has long been considered a central figure in the history of neoliberalism.[63] The cover of David Harvey's book, *A Brief History of Neoliberalism*, for example, includes headshots of Reagan, Deng Xiaoping, Augusto Pinochet, and Margaret Thatcher, forming a sort of "Mount Rushmore" of neoliberal icons. My reference to the famous nationalist monument sculpted on the granite face of a mountain the Lakota referred to as "Six Grandfathers" is meant to recall the matrix of white supremacy, settler colonialism, and heteropatriarchy—in a word, respectability—out of which neoliberalism emerged and where it continues to reside. And, finally, this Mount Rushmore effect suggests that neoliberal forms of academic freedom can be understood as products of that same matrix of domination.

SCHWARZENEGGER'S SCHOOL DAYS

Patricia Williams draws our attention to the phenomena of conservative politicians with histories in Hollywood, suggesting that their appeal depends on a spectacular combination of whiteness and the threat of violence. Following in Reagan's footsteps, as California governor Arnold Schwarzenegger anticipated the rise of Wisconsin's Scott Walker and other Republican governors who have attacked public unions and higher education to the benefit of corporate patrons. As captured by Michael Meranze and Christopher Newfield on their *Remaking the University* blog, in the wake of the subprime mortgage crisis (2007–10) Schwarzenegger protected the interests of the wealthy by refusing to increase taxes but dramatically raising college fees. He also furloughed without pay all state workers, including UC faculty and staff, and he dramatically cut UC budgets.[64] At the same time, in a move more about ideology than budget savings, Schwarzenegger singled out for deep cuts the UCLA Institute for Research on Labor and Employment. After World War II the University of California unevenly incorporated labor studies into the university as part of a contradictory effort to contain

broader, intersecting coalitions among workers, immigrants, women, and people of color. The resulting UC programs focused on corporate unions and an industrial-relations framework that promoted cooperation with management. More recently, however, the UCLA Institute had challenged the postwar model of corporate unions and liberal containment by promoting new models of labor research in collaboration with immigrant organizations, community groups, antiprison activists, and service workers. In this context Schwarzenegger unilaterally slashed funds to the program for multiple years, both before and after the subprime crisis.[65]

Ironically, Schwarzenegger's star image was based partly on playing working-class characters (notably the construction worker Quaid in *Total Recall* but also police officers and a firefighter), and his populist political rhetoric, which is well represented by his commencement speeches to college students, prominently features homilies to discipline and hard work.[66] Much like in Reagan's life, the popularity of Schwarzenegger's biography and films can help us understand the ideological appeal of the combined antilabor populism and neoliberal privatization that guided his administration of higher education as California governor. Schwarzenegger drew on his own education in the gym and in Hollywood to build a political star image as a larger-than-life white man bearing fantasies of settler-colonial power. Perhaps the world's biggest neoliberal star, Schwarzenegger's film and political roles make austerity not only entertaining but even funny, as suggested by the puns and wisecracks that punctuate his acts of both cinematic and political violence. Building on his prior roles as figures of cold white male cruelty, Governor Schwarzenegger emerged as an icon of state budget cuts aimed at public education and multiracial labor movements, as well as a muscular defender of corporate power.

Schwarzenegger was born and raised in a rural, working-class Austrian village, where his grandfathers were factory workers, his mother was a clerk, and his father was a police officer (both a rural police officer and a Nazi military police officer). At fifteen Schwarzenegger entered a vocational school, where the mornings were filled with classes and in the afternoons students worked at different jobs. Perhaps anticipating his seeming disregard for education while governor, he recalled that the work required by vocational school "was lots better than sitting in a classroom all day." His parents "arranged for me to be in a business and commerce program" because he was good at math, and he worked as an apprentice at a small building supply store with four employees. There he did physical labor and took inventory, but "the

most important skill I acquired was selling," a skill he would utilize as both an actor and a politician.⁶⁷ His education also included a mandatory stint in the army when he turned eighteen in 1965. "I liked the regimentation, the firm, rigid structure" because they reminded him of the discipline required to be a bodybuilder.⁶⁸ In the army he went to "tank driving school," and Schwarzenegger would similarly bring his love of discipline to his subsequent college studies.

While Schwarzenegger's early education was shaped by European Cold War educational and military cultures, as the only person in his family to graduate from high school, in the United States he pursued college education in a manner that recalls the experiences of many other working-class immigrants. With a work visa rather than a student visa, he could not enroll in school full-time, and so while working and training he hobbled together classes at Santa Monica Community College, West Los Angeles College, and UCLA, where he took math, history, business, and "English for Foreign Students." Schwarzenegger was photographed posing in a bathing suit by the Santa Monica Community College pool in 1972 for a student newspaper story in which he told the reporter he was "majoring in Business Administration and eventually would like to start his own business."⁶⁹ He also took advantage of UCLA's low fees relative to area private schools like USC to enroll in extension courses on accounting, marketing, economics, and management. As a student, Schwarzenegger drew on his career as an increasingly successful bodybuilder by approaching education as an exercise in self-promotion and moneymaking. Initially, he writes in *Total Recall*, "a degree wasn't my objective; I only needed to study as much as I could in my available time and learn how Americans did business." Like bodybuilding, he explains, "college appealed to my sense of discipline." In a lesson that would serve him well as both a Hollywood star and later governor, at UCLA he learned that "in sales, the larger the salesman, the more he tended to sell. . . . I thought, 'Well, I'm two hundred fifty pounds, so when I go out to sell something, my business ought to be huge.'"⁷⁰

After a decade of course work, Schwarzenegger finally earned a bachelor's degree in international business and international economics in 1981 through a kind of market exchange with the University of Wisconsin, Superior. In need of publicity to attract students, the small college waived out-of-state tuition for the bodybuilder and allowed him to complete course work from Los Angeles. The college also gave him course credit for his "life experience" as a fitness expert. "The career he was aiming for needed some kind of credibility," said Rhea S. Das, a

Wisconsin–Superior psychology professor who recruited Schwarzeneg-ger. "He realized the lack of a degree would be a hole in the fabric."[71] Indeed, his college degree represented an important source of legitimacy and was subsequently referenced in numerous studio biographies and media stories.[72]

In addition to his formal studies, Schwarzenegger is an autodidact who, as he cracked, attended "Schwarzenegger University."[73] Mean-while, his favorite academic author is celebrity free-market economist and University of Chicago professor Milton Friedman. As Schwarzeneg-ger told a reporter for *Cosmopolitan*, his evening activities included watching videotapes of Friedman's popular PBS TV show *Free to Choose*.[74] "I watched every installment, soaking up his ideas like a thirsty sponge. He and his wife, Rose, had written a bestselling book, also called *Free to Choose*, and I'd sent copies to all my friends as a Christmas present." After Friedman retired from the University of Chicago and joined the Hoover Institution at Stanford, the TV producer for *Free to Choose* introduced him to Schwarzenegger. "Getting ready for the evening, I was like a kid going on an exciting field trip. . . . Friedman had become one of my heroes." Friedman repackaged *Free to Choose* in 1990 as a series of videos with new introductions by Reagan, George Schultz, and Schwarzenegger, who introduced an episode called "The Power of the Market." Schwarzenegger's introduction was filmed in his office, and he looks professorial, seated at a desk decorated with a stack of books and several tobacco pipes. Speaking like a religious convert, he looks directly into the camera and says, "I truly believe the series has changed my life and when you have such a powerful experience like that I think you shouldn't keep it to yourself, so I wanted to share it with you." He goes on to tout individual freedom from state interference, noting "for me that meant coming here to America because I came from a socialistic country where the government controls the economy. . . . But me I wanted more; I wanted to be the best. Individualism like that is incompat-ible with socialism."[75] As governor, Schwarzenegger later praised the show in a 2007 resolution making January 29 "Milton Friedman Day."[76]

As the title of his 1977 autobiography, *Arnold: The Education of a Bodybuilder*, suggests, bodybuilding also frames Schwarzenegger's views of education. As a form of *bildung*, or self-making, bodybuilding requires thought, discipline, and hard work. "The built body is an achieved body," writes Richard Dyer, "worked at, planned, suffered for. A massive, sculpted physique requires forethought and long-term organization; regimes of graduated exercise, diet and scheduled rest

need to be worked out and strictly adhered to; in short, building bodies is the most literal triumph of mind over matter, imagination over flesh."[77] Or, as Schwarzenegger writes, his training was guided by "my ideas about positive thinking and the powers of mind over muscles"[78]

One early model of mind over muscles was Mr. Austria Kurt Marnul, whose eyeglasses initially struck young Schwarzenegger as incongruous: "I associated glasses with intellectuals: teachers and priests. . . . How could someone who looked like a professor from the neck up be bench pressing 190 kilos?" This was the question he asked in a high school essay he read out loud in class. Schwarzenegger "came away fascinated that a man could be both smart and powerful," like his glasses-wearing character Professor Alex Hesse in *Junior* (1994) or Professor Victor Fries in *Batman and Robin* (1997). The aim of his life and career would become reconciling the seeming contradiction between brain and brawn by using disciplined thought to produce and control a powerful body, and such intellectual exercises in turn shaped his understanding of political power. Nicknamed the Austrian Oak, in bodybuilding Schwarzenegger competed as a heavyweight and was renowned for his massive frame and powerful poses. Hierarchies of weight and mass are integral to bodybuilding, and he understands relations of power, including in higher education, in similar terms. The goal of education for Schwarzenegger is making it big, where "bigness" connects domineering size to white masculinity, capital accumulation, and settler-colonial nationalism.

In the first place he describes the bodybuilders he admires, as well as the bodybuilder he himself becomes, as "big," "huge," "massive," "giant," and "enormous." Schwarzenegger further transposes the language of physical stature and size to all manner of other contexts. As a young bodybuilder, he looks forward to being "the next big thing" and excelling in "the big-time." He has big goals, including making bodybuilding big and becoming a star. Schwarzenegger admires "big" people who make "big impressions." As a Hollywood star, he applies rhetoric from bodybuilding to his films with their "giant" budgets, "big-league distribution," "huge audiences," and "big pay days."[79] Schwarzenegger further sees his business ventures and the economy in terms of size, where "bigness" and related terms such as "growth" and "expansion" tap into neoliberal market fantasies of capital accumulation and masculine power.[80] As he says in his introduction to Friedman's TV show, in the United States, "I was able to parlay my big muscles into big business and a big movie career."[81] Media profiles of the star similarly emphasize the

connections between bodybuilding and his business acumen as in head-lines like "Behind Schwarzenegger's Brawn, There's Brainpower You Can Bank On," "Turning Iron into Gold," and "Muscular Tycoon."[82]

Through bodybuilding Schwarzenegger learned how to leverage the appeal of his own "bigness" to sell himself to audiences and voters. While taking classes at Santa Monica Community College, he was hired by fitness equipment and supplement maker Joe Weider to promote his products in Asia and Europe. Recalling those trips, Schwarzenegger writes that "selling was one of my favorite things." Dressed in a tank top and surrounded by crowds, "I'd stand in the middle of a shopping mall" with a translator, "hitting poses every so often while I made my pitch." He is exhilarated by the experience of using size to sell products, and, by extension, himself as product: "I'd be selling, selling, selling. 'Vitamin E gives you fantastic extra energy for training hours every day to get a body like mine! And of course I don't want even [sic] talk about the sexual power it gives you." Size sells, as Schwarzenegger learned at UCLA. This early history in the "big" business of selling both products and himself influenced the bodybuilder's subsequent economic ideolo-gies. In *Total Recall* he writes that Friedman's TV show *Free to Choose* "was a big hit," and his ideas "had a big influence on me. . . . His con-cept of the roles of government and markets in human progress was a giant leap beyond the economics I'd studied in school." Schwarzenegger earned a fortune in real estate speculation, where he focuses on "big investments," believing "big risk, big reward."[83]

Schwarzenegger's size fetish extended to his political career, where he worked with and favored large corporations, including "energy giants" and "giant retailers" such as Walmart. He spotlighted big problems and big solutions while governor. When elected, he was eager to take on the "giant challenge" of governing California. During his two terms Schwarzenegger championed big initiatives, including the completion of what he called a "massive" and "monumental" canal that would largely benefit agribusiness interests.[84] Such size-focused political rhetoric ena-bled him to successfully articulate corporate power to populism, linking appeals to big business and "the people." When first considering a run for the governorship, for instance, he resolved "above all, the campaign had to be *big*. I was all about leadership and major projects and reforms that could attract massive public support." In his election campaigns and while campaigning for ballot initiatives, Schwarzenegger claimed to represent and appeal directly to the mass of the people, like Thomas Hobbes's Leviathan on steroids.

Schwarzenegger linked size to extreme forms of U.S. nationalism. In a story in the Hollywood trade press titled "Arnold Schwarzenegger: Chasing the American Dream," the star explains that "I always knew that I would be able to relate to things better here than in Austria, which is a little country . . . because I liked the idea of big things—big cars, big roads, big money. Everything was big here, and people think big rather than worrying about obstacles. I liked that attitude and the way people just went for what they wanted to get rather than thinking of negatives."[85] He loves the United States because it "think[s] big!" and battles communism "big-time."[86] Indeed, both Schwarzenegger and the media narrate his story as a larger-than-life example of U.S. exceptionalism. A 1986 *Daily News* profile, for instance, rehearses the familiar biographical details about an immigrant from a small town who moved to the United States, became a successful bodybuilder, earned a business degree, and then rose to Hollywood stardom under the headline "Schwarzenegger: An American Success Story."[87] A profile in a 1986 issue of the *Hollywood Reporter* was similarly titled "Strong Man Schwarzenegger Realizes His American Dream."[88]

Size further connects Schwarzenegger's nationalism to forms of martial power. Writing about his stint in the military in his 1977 autobiography, he recalls that he "loved driving those big machines [tanks] and feeling the sturdy recoil of the gun when we fired. It appealed to that part of me that has always been moved by any show of strength and force."[89] Schwarzenegger returned to his tanks in his 2012 memoir, concluding, "I love big things." In the 1980s Schwarzenegger drove another kind of large, military-derived vehicle, a brown Cherokee Chief Jeep. "It was massive compared to ordinary cars" and "outfitted with a loudspeaker and siren for showing off or scaring other drivers out of my way." When he first saw a Humvee in the early 1990s, a massive military vehicle that "had played a big role in the Gulf War," Schwarzenegger "fell in love." Ultimately, he successfully lobbied the manufacturer to produce and market a civilian version called a Hummer, and his own purchase of one helped drive a new consumer trend in military-inspired vehicles. And amid the "massive buildup" of Operation Desert Storm, Schwarzenegger "made my own contribution to the military effort" by working with Gen. Colin Powell and Defense Secretary Dick Cheney to airlift bodybuilding equipment to U.S. troops in Iraq.[90]

What are the ideological implications of seeing life, the economy, and state, national, and world politics in terms of bodybuilding bigness? Perspectives based in presumptions of large size take a top-down

view of the world that distances and diminishes contexts defined as small. Robin Wall Kimmerer suggests, for example, that Euro-American perspectives on nature are often biased toward bigness. Kimmerer is the director of the Center for Native Peoples and the Environment at the State University of New York and an enrolled member of the Citizen Potawatomi Nation. In *Gathering Moss: A Natural and Cultural History of Mosses*, she writes that "at the scale of moss, walking through the woods as a six-foot human is a lot like flying over the continent at 32,000 feet. So far above the ground, and on our way to somewhere else, we run the risk of missing an entire realm which lies at our feet. Every day we pass over them without seeing." The simile of the transcontinental flight implicitly represents Manifest Destiny and an expansive, settler-colonial vantage point on the domination of land. This perspectival gigantism leads to dramatic misrecognitions of life at different perceptual scales. While size often connotes success, in a chapter titled "The Advantages of Being Small" Kimmerer reminds us that "being small doesn't mean being unsuccessful. Mosses are successful by any biological measure—they inhabit nearly every ecosystem on earth and number as many as 22,000 species. . . . Mosses can live in a great diversity of small microcommunities where being large would be a disadvantage." Mosses, she concludes, "take possession of spaces from which other plants are excluded by their size. Their ways of being are a celebration of smalless. They succeed by matching the unique properties of their form to the physical laws of interaction between air and earth. In being small, their limitation is their strength."[91]

Despite the differences between the world of moss and the world of political muscle, Kimmerer's perceptual shift in the observation of nature draws into critical relief the limitations of political perspectives built on bigness. A politician invested in big solutions to big problems is likely to overlook everyday life among the "little people" on the ground. In the eyes of a colossus, the problems and powers of groups imagined as small, including university students and state workers, can seem trivial, far away, and hard to see. More precisely, Schwarzenegger's gigantism appealed to particular forms of white, heteronormative masculinity and the pleasures of towering over smaller, racialized, and feminized subordinates. The governor's size and celebrity commanded respect, whereas he diminished his critics in the California State Senate as "girly men" and dismissed as insignificant the demands of unionized nurses.

Schwarzenegger's perspective on the world glorifies not only size but also hardness, as in Klaus Theweilt's *Women, Floods, History* (volume 1

of *Male Fantasies*), where he argues that among the German Freikorp, militarized hard bodies represented symbolic defenses against difference. The fascist soldiers, according to Theweilt, developed an armor of physical and emotional hardness to shield them from women, Jews, communists, and rebellious workers who were all imagined as figures of dissolution and compared to floods and tides threatening to engulf them. While Theweilt focuses on extreme examples, as Barbara Ehrenreich notes, his analysis resonates with more mundane or "normal" misogynist masculinities.[92] Theweilt also suggests that hard bodies imaginatively protect against racial others, as Richard Dyer claims in "The White Man's Muscles." Taking Schwarzenegger as a prime example, Dyer argues that bodybuilding connotes whiteness in multiple ways, including references to Greek and Roman art and an implicitly white California lifestyle "with a characteristic emphasis on ideas of health, energy, and naturalness." "The built body," he writes, "is a wealthy body. It is well fed and enormous amounts of leisure time have been devoted to it." Dyer further argues that the hard body represents the psychic and material borders that have historically defined white masculinity. "A sense of separation and boundedness is important to the white male ego," and so "only a hard, visibly bounded body can resist being submerged into the horror of femininity and non-whiteness." Dyer concludes that "these bodies with their white connotations are on display in colonialist adventure films," including the Schwarzenegger vehicles *Commando* (1985) and *Predator* (1987).[93]

Muscle men in adventure films are often figures of settler-colonial extermination, segregation, and border policing. While his father's Nazi past has attracted media scrutiny, less well known is Schwarzenegger's formative experiences in apartheid South Africa. Schwarzenegger completed his bodybuilding education in South Africa in 1967, living with his hero and mentor, the white British bodybuilder, actor, and South African settler, Reg Park. He trained with Park, who Schwarzenegger claimed was "like a second father to me," and traveled throughout South Africa presenting bodybuilding exhibitions in presumably all-white settings.[94] Schwarzenegger would subsequently return to Pretoria, South Africa, in 1975 for the Mr. Olympia contest featured in the documentary *Pumping Iron* and the high point of his bodybuilding career. As *Rolling Stone* photographer Annie Leibovitz recalled of the contest, "There were separate bathrooms for blacks and whites. It was an uncomfortable situation."[95] As an Austrian immigrant, Schwarzenegger arguably became a white U.S. American by dressing up in settler-

colonial costumes. Like many Europeans he was introduced to U.S. culture through films about cowboys and Indians, and he modeled his sartorial style partly on Hollywood cowboys. As if channeling Reagan, while governor Schwarzenegger regularly wore custom-made cowboy boots from his extensive collection, as well as large western-style belt buckles and hats.

In *Batman and Robin,* Schwarzenegger also recalls Reagan's embrace of settler-colonial symbolism in a narrative where he plays a professor who has become a hard, cutting figure of neoliberal austerity. Schwarzenegger plays Professor Victor Fries of Gotham University, a Nobel Prize–winning molecular biologist. When his wife contracts a rare disease, Professor Fries freezes her but then falls into a vat of "cryo solution" that mutates his body so that to survive he needs extreme cold, supplied by an armorlike "cryo-suit," and thus is born the villain Mr. Freeze. He ultimately joins forces with another professor-turned-supervillain, Dr. Pamela Isley/Poison Ivy, and together they plan to freeze the planet, eliminating all existing life and replacing it with mutant killer plants. The majority and most memorable of Freeze's appearances are scenes of extreme violence in which he towers over cowering victims who are filmed in high-angle shots to emphasize their smaller size relative to the villain. The dramatic differentials in size reinforce Freeze's distance from the destruction he visits. The violence is accompanied by Schwarzenegger's characteristic catchphrases and bad puns ("Let's kick some ice," "Stay cool, Birdboy," etc.). Schwarzenegger's "zingers," according to Sean French, are part of what made him a star:

> As the terminator, Schwarzenegger has that quality that Ronald Reagan had as President of the United States on state occasions, that occasional hint of the twinkle in the eye, the half smile, that showed his own recognition of the improbability of what had happened, and that he was enjoying it and therefore we were free to enjoy it too. . . . Arnold Schwarzenegger makes us feel the enjoyment of watching a film, of guns and explosions and violence, all in the knowledge that he doesn't really mean it and that the lights will come up and we can all go home.[96]

Schwarzenegger's appeal, French suggests, stems in part from the forces of denial that he represents, the denial of all sorts of violence, including, ultimately, the violence of state budget cuts. Freeze is funny, for example, as he disavows empathy. When a security guard begs for his life, Freeze responds, "I'm afraid that my condition has left me cold to your pleas of mercy" before blasting the man with a freeze ray. Subsequently, he freezes Robin, and, when Batman stops his pursuit of the

villain to try and save his partner, Freeze taunts him, saying, "Your emo-
tions make you weak." Ironically, at the same time he was filming *Bat-
man and Robin,* where his character is devoted to his wife, Schwarzeneg-
ger began cheating on his own wife, Maria Shriver, with their housekeeper.
After their divorce Schwarzenegger, now a professor at USC, confessed
to *60 Minutes* reporter Leslie Stahl, "I put everything that's happening
emotionally on deep freeze. So I became an expert in living in denial."[97]
As governor, Schwarzenegger's outsized, hardened denial of empathy
while proposing massive cuts to public education made him the perfect
neoliberal terminator.

Before *Batman and Robin* Schwarzenegger starred in one of two 1993
films about reproductive technology shot at UC Berkeley, which can be
read as both echoes of Reagan's attacks on Berkeley revised for the 1990s
and the contemporary prominence of woman-of-color feminism on the
margins of the academy. The first, *Made in America* (1993), starred
Whoopi Goldberg as Sarah Mathews, the owner of an Afro-centric
bookstore called The African Queen, whose daughter (Nia Long) dis-
covers that her mother was artificially inseminated and that her father is
Hal Jackson (Ted Danson), a white, cowboy-hat–wearing used car
dealer. The opening credits are a kind of time capsule of Berkeley circa
1992. With the iconic Campanile clock tower in the background, the
camera follows Goldberg as she bikes through Sproul Plaza (site of free
speech and other protests), down Telegraph Avenue, up Ashby and past
Espresso Roma before stopping at her College Avenue bookstore (see
figures 16 and 17). The setting combined with the romantic narrative
make it a period culture war film supporting the attacks on public educa-
tion analyzed by Newfield. Goldberg's character is a Hollywood version
of a Berkeley Black feminist who is initially appalled when it seems that
the father of her daughter is a white buffoon, but she ultimately over-
comes her ridged identity politics and learns to love Jackson. The film
effectively uses its setting against a certain vision of Berkeley by sym-
bolically containing Black women associated with the UC system such as
June Jordan and Ruth Wilson Gilmore.[98]

The second film to seemingly satirize UC Berkeley in the 1990s is
Junior, starring Schwarzenegger as a university fertility researcher who
impregnates himself with a purloined egg. Having failed to secure FDA
funding for research to prevent miscarriages, Dr. Larry Arbogast (Danny
DeVito) attempts to persuade his partner, Dr. Alex Hesse (Schwarzeneg-
ger), not to leave his post at the fictional "Leland University." While
implicitly referencing the school founded by Leland Stanford, in an

FIGURE 16. Sarah Mathews (Whoopi Goldberg) rides past UC Berkeley's Sather Gate. *Made in America* (1993).

FIGURE 17. Sarah Mathews (Whoopi Goldberg) passes UC Berkeley's Sproul Hall. *Made in America* (1993).

instance of fictional privatization, UC Berkeley plays the university in *Junior*, recalling the recent history of California state disinvestment in public education. Whereas *Made in America* incorporated and domesticated Black feminism on campus, *Junior* excludes people of color altogether, with the exception of the opening nightmare sequence, in which Dr. Hesse encounters in the library a multicultural classroom of crying babies. As a dream representation of students of color, the scene recalls historical representations of Global South nations as small children and the Unites States as a large white man, such as Uncle Sam. The dream, in other words, dramatizes the racial unconscious of administrative perspectives based in white male bigness, revealing their otherwise occluded dependence on a diminishing view of students of color.

Schwarzenegger became a star as a result of his role in *The Terminator* (1984), where he played a massive cold killing machine, and a decade later in *Junior* he brought that star image to his characterization of a university professor. Even though his research is focused on human reproduction in ways that other characters in the film treat with great reverence and sentiment, Dr. Hesse is initially depicted as driven yet emotionless, without loved ones and disliked by his colleagues. "You've got all the warmth of a wall-eyed pike," explains Arbogast. Over the course of the film this changes, after Arbogast steals a frozen egg from the lab of a colleague, Dr. Diana Reddin (Emma Thompson) and inserts it into Hesse. In the film's complicated narrative, Hesse and Reddin fall in love, fall out of love, and then reconcile after Schwarzenegger's

machinelike professor is softened and humanized by the process of giving birth.

Junior is a fantasy about the patriarchal appropriation of women's (re)productive labor. The egg not only is a part of Dr. Reddin's own fertility study but was also harvested from her body, making for a double theft, both of her work and her vital energy.[99] Like in *Batman and Robin*, where Freeze's humanity depends on his wife's frozen body, in *Junior* cold Professor Hesse becomes a warm human being by incorporating Reddin's frozen egg. The film's premise is an allegory of "accumulation by dispossession" misrecognized as the magic of free-market individualism. Because the university funded Hesse's research, Dean Banes informs him that "you and your baby are university property now," but Hesse responds, "No, my body, my choice." Just as Hesse steals the egg, he appropriates a prochoice slogan to assert his property rights. Historically in the UC system, research was a public good that at least in theory belonged to the people of California, but in the movie version, individual private interests have replaced the public. Governor Schwarzenegger similarly attacked public institutions, from state employee unions to public schools. Rather than raising taxes, the governor cut social services and furloughed university faculty and staff, effectively protecting the assets of the wealthy by dispossessing everyone else. Finally, Schwarzenegger attempted to exclude labor studies, a field devoted to dispelling neoliberal mystifications with research about worker exploitation, from the UC system.

Casting a critical eye on the college films of Reagan and Schwarzenegger enables us to understand part of the long historical development of neoliberalism in higher education. Reagan was rooted in the early twentieth-century parochial college experience, and his films promoted forms of white respectability that subsequently justified batons and budget cuts. With their emphasis on free-market white individualism and settler-colonial symbolism, Schwarzenegger's college films and broader star image make him Reagan's successor. But, while looking to the past, Schwarzenegger also anticipated the future, representing a shift in white respectability politics from racialized norms of sexual propriety to a singular respect for violent white male power. With his reality TV stardom, toxic white masculinity, vicious wisecracks, size-based political rhetoric, and fake private university, Donald Trump is the most recent beneficiary of Schwarzenegger's example.[100]

Brown Universities, or the Question of Administration

Since no one in my family had attended college, when I was a child my mental image of higher education was sketchy, and so movies and television filled in the blanks. As a working-class kid of color watching TV in the 1960s and early 1970s, I learned from shows such as *Gilligan's Island* (1964–67) and *Nanny and the Professor* (1970–71) that professors were white men. Period films taught the same lesson. I remember the precise, upper-class sounding diction of Rex Harrison in *Dr. Dolittle* (1967) and of John Housman as Harvard law professor Charles Kingsfield in *The Paper Chase* (1973); the midwestern drawl of Fred Mac-Murray in *The Absent-Minded Professor* (1961); and the white geek-speak of Jerry Lewis in *The Nutty Professor* (1963). Amid this media surround I recall my soon-to-be-disappointed excitement when I first heard of Brown University, since it must be a place, I thought, for people like me. The title of this chapter, then, suggests a kind of Chicanx multiple consciousness that marks the limitations of dominant representations of college while simultaneously looking beyond them. "Brown Universities" also suggests the chapter's trajectory, starting with Hollywood films about race protests on college campuses in the 1960s, before turning to their dialectical other—dissenting film cultures produced in collaborations between Chicanx artists and academics, the numerous brown professors and students missing from mainstream film and TV.

Like in the silent-film era when Mexican students and professors were almost unimaginable, Chicanx and Latinx activism is invisible in

college movies set in the 1960s. The high point, or nadir, of such films was the year 1970, which saw the release of *Love Story* but also of *Getting Straight* and *The Strawberry Statement*. Together they responded to conflict on campus and, more broadly, a global crisis in racial capitalism, with new narratives of containment and liberal law and order. *Love Story* answered student protests by erasing them, substituting instead a narrative of white heterosexual love, recalling the respectability politics of college films, from the silent period to films of the Cold War. *Getting Straight* and *The Strawberry Statement* dramatize campus protests involving white and Black students but frame them in terms of an emergent liberal and conservative consensus about the need for the police to discipline campus movements viewed not only as irrational but also as unrespectable. Student protestors disrespect authority, these films suggest, and are thus themselves unworthy of respect. All three films reactivate the racialized norms of respectability analyzed in earlier college films but reenvision them for different contexts.

Since students made demands for both new kinds of administrators and new approaches to admissions, curriculum, and hiring, films from 1970 often focus on administration, but only one raises the possibility of a brown administrator, a movie titled *RPM* (1970), in which student protesters demand the appointment as university president of a leftist Puerto Rican professor played by Anthony Quinn. The film is a kind of thought experiment, asking what if a Latino professor was empowered to translate radical theories into administrative practice? And, more broadly, *RPM* prompts us to ask what are the possibilities and limitations of administration as a means of effecting social transformation? What are the conditions of possibility and impossibility for wielding administration in liberating ways? What are the prospects for occupying administrative positions to increase access and redistribute knowledge, capital, and power?

While today such questions are rarely posed, in the 1960s and 1970s they were often asked in the brown academy, or in what Tomás Rivera described as the "academic bent" of the Chicano movement. In the 1960s and 1970s, campus activism produced new collaborations among independent Chicanx filmmakers and academics in projects to use film for education and social transformation, and, while he was a university administrator, Rivera was a key player in such projects. One of the most important and well-known literary writers associated with the movement, Rivera, early in his academic career, pursued degrees and ultimately positions in university administration as a means of dismantling

hierarchies of race, class, and respectability. Rivera also made important contributions to film and media theory, and concepts he developed in relationship to film and TV are useful for understanding his vision of administration as in key ways the inversion of contemporary administrative forms. Ultimately, Rivera's tenure as the chancellor of the University of California, Riverside, represents a path not taken, which helps us map where administration went instead while remembering his plan for a more equitable, postrespectability university.

HOLLYWOOD REACTS TO CAMPUS PROTEST, 1970

Much has been written about U.S. student movements during the late 1960s and early 1970s, so my account is selective, focusing on protests led largely or in part by Puerto Rican and Chicanx students and focused on administrative change. Examples include the open-enrollment movement of Black and Puerto Rican students in New York's City College and CUNY system; the East Los Angeles high school walkouts and related protests over curriculum and enrollments on Southern California college campuses; the San Francisco State University strikes leading to the establishment there of the College of Ethnic Studies; the Lumumba-Zapata movement at UC San Diego discussed in chapter 2; and, finally, protests at UC Riverside in support of Black studies and Chicano studies.

In *The Reorder of Things,* Roderick Ferguson argues that student movements of the period demanded both representational inclusion and material redistribution and that administrations responded by promoting formal inclusion but denying student resource demands. Representational incorporation, in other words, became an administrative tactic for containing demands for material transformation. As a visual shorthand for Ferguson's claim, I think of how my campus, UC San Diego, with its disproportionately small number of Black and Latinx students and overwhelmingly male faculty, includes a large mural featuring Cesar Chavez, next to a college named for Thurgood Marshall. Complementing university walls decorated with murals, the Hollywood movies analyzed here have also worked to contain student demands for redistribution.

Hollywood released several big-budget college films in 1970, with *Love Story* as the most successful. The film presents an almost all-white, protest-free campus setting. Instead of political conflict, love and romance take center stage when its protagonist, wealthy WASP student and Harvard hockey star Oliver Barrett IV (Ryan O'Neal) falls in love with a

Radcliffe student, working-class Italian American Jennifer Cavalieri (Ali MacGraw). While numerous buildings at Harvard are named after Oliver's blue-blood ancestors, Jennifer is represented as an irreverent but appealing ethnic other. Oliver is estranged from his patrician, banker father, and the male generational conflict, combined with his eventual marriage to Jennifer across class and white ethnic lines, restages the politics of difference on period college campuses, preserving their abstract traces in the romantic plot while canceling out the particularities of student demands. The larger conflicts that characterize *Love Story*'s world are reduced to narrowly romantic dynamics.

The character of Jennifer, in particular, combines forms of superficial rebellion that mimic while displacing student protest. In keeping with stereotypes of class and white ethnicity, Cavalieri is assertive (sexually and otherwise) and blunt, derisively calling Barrett a "preppy" but declaring she likes his body. While she wears a cross in honor of her mother, she's an atheist who insists on a civil rather than a church marriage ceremony. Despite the veneer of rebelliousness, Jennifer is slotted into a very conventional and conservative narrative. Upon graduation she readily gives up her plan of studying music in Paris to marry Oliver and become an elementary school teacher to support him in law school before dying young from cancer. *Love Story* in this way rationalizes patriarchal gender roles by representing the young students' marriage as rebellious. Oliver's revolt against his father is also described in politically conservative terms. In the novel Barrett Sr. is a New Deal liberal who worked in the Roosevelt administration before directing the Peace Corp. In his father's words Oliver is "rebelling" by marrying Jennifer, but he is also rebelling against his father's liberalism. Together we can read the characters as figures of reaction against liberalism that dovetailed with the law-and-order responses to campus protest, from California governor Ronald Reagan to President Richard Nixon.[1]

Love Story similarly returns to reactionary representations of the college athlete as romantic protagonist. Oliver is well known as a hockey star, both among admiring young women on campus and wealthy alumni. Both novel and film privilege sports over intellect, Harvard's Dillon Field House over its Widener Library.[2] Although she initially feigns disinterest, Jennifer is attracted to Oliver's athletic fame, and they begin to fall in love as she watches him compete. The allure of the student athlete authorizes expressions of white male violence on the ice, as when Jennifer interrupts his concentration during the game, and Oliver threatens to "total" her just as he plans to "total" the Dartmouth players. In a

subsequent match against Cornell, Oliver fights the French Canadian captain of the opposing team and shouts, "You Montreal faggots," when put in the penalty box. Both matches are filmed in a gritty cinema verité style, with handheld cameras and a dissonant sound design combining crowd noises, referee whistles, and the crunch of physical contact. *Love Story* thus appropriates a cinematic aesthetic associated with liberal and leftist documentary for a reactionary spectacle built around the romance of collegiate sports. The violence of hockey once again sublates (preserves abstractly while canceling out concretely) the violence of war and police crackdowns on student protest.

Unlike previous college film romances that end happily when the student athlete gets the girl and reconciles with his father, however, *Love Story* is tragic: Jennifer dies in Oliver's arms, and he remains estranged from his father. The film's sense of loss diffusely registers the violence and destruction of the Vietnam War era while funneling feelings of mourning into a plot about the death of a beloved white woman and the related demise of patriarchal white universities threatened by student protests. *Love Story* promotes both a subjective regression in the form of a fixation on lost fathers and a historical regression in terms of a nostalgic attachment to an earlier image of college life. According to the author of both novel and screenplay, Ivy League classics professor Erich Segal, "I write for grown-up children, readers who want emotions rather than torrid bed scenes."[3] As much as, if not more than, heterosexual emotions, *Love Story* is based in the intensities of a white boy's abject attachment to his powerful white father and, by extension, to the patriarchal white university tradition he represents.[4]

In a highly successful manifestation of the university-cinema–industrial complex, the filmmakers endeavored to authenticate *Love Story*'s fanciful vision of college as a space for heterosexual white romance and the resolution of class and other differences by shooting scenes on northeastern college campuses, including Harvard, and employing student actors, including Tommy Lee Jones.[5] Just over a year before costarring in *Love Story* as Oliver's boorish roommate, Jones, who was a former student of Segal's and a model for Oliver, had played on Harvard's undefeated 1968 football team. But it was Segal himself who most gave the film academic legitimacy.[6] With a BA, MA, and PhD from Harvard, when he wrote *Love Story* Segal was an assistant professor at Yale who had already published a study of classical comedy called *Roman Laughter* (1968) and who used his first sabbatical to promote his novel and film.[7] Given their combined popularity, he became a celebrity professor, the subject of

profiles in *Esquire, Life, Look,* and *New York Magazine.*[8] Segal was so famous that when he was denied tenure at Yale in 1972 due to his "outside activities," it was covered in the *New York Times.*[9] But his star image as a celebrity professor lent the legitimacy and prestige of the Ivy League to the naturalization of reactionary representations of college that marginalized political movements while privileging white romance and athletic spectacles over education.

Meanwhile, *Love Story* star Ali MacGraw came to represent the quintessential coed in early 1970s film and media. She began her career in the fashion industry, when she won a contest offering college students internships at *Harper's Bazar.* While working for the magazine she was photographed for the cover of *Vogue* and signed by a modeling agency as a "college model." Her first starring film role was in the acclaimed *Goodbye, Columbus* (1969), named for an Ohio State fight song and based on a novel by Philip Roth. Anticipating her role in *Love Story,* in *Goodbye, Columbus* she plays a Radcliffe student, a part for which she was awarded a Golden Globe. While married to Paramount producer Robert Evans, MacGraw read the script by Segal, who she had starred with in a college theatrical performance of *All's Well That Ends Well* when she was a student at Wellesley and he was at Harvard. In magazine covers, films, and the gossip page, MacGraw was styled as the countercultural coed, famous for her jeans, headbands, peasant scarfs, and "ethnic" prints. Her star image rearticulated collegiate rebellion and racial difference as depoliticized signifiers of a consumable counterculture reclaimed for conservative gender norms. Around the time *Love Story* was made, MacGraw was literally between men, her husband, the older, powerful producer Evans, and one of her costars, Steve McQueen, who ultimately become her second husband. At the height of her career McQueen forbade her to work as an actor, which she agreed to for several years. MacGraw's fame, moreover, ensured that the gender hierarchies of her romantic life were widely covered in the press, becoming an integral part of her coed star image.[10]

In dramatic contrast with *Love Story,* the other college films of 1970 prominently feature campus protests. Although set and filmed in California, *The Strawberry Statement,* for instance, was inspired by the 1968 struggle at Columbia University to protest the school's ties to the Defense Department and its plans to displace a nearby African American playground. Meanwhile, both *Getting Straight* and *RPM* were loosely based on the "open enrollment" movement at New York's City College, while *RPM* indirectly references the ethnic studies student movement at San

Francisco State University.[11] Whereas all those student movements were largely successful in securing their demands, the three films conclude on dramatic notes of failure, in which naive and inflexible student protests are reluctantly broken up by university administrators and police in final scenes framed as unfortunate but inevitable. The three films' choreographed clashes between protestors and the police resemble classic movie musical compositions. Such song and dance scenes are often extradiegetic, interrupting the narrative with musical interludes. The three films all use scenes of clashes between protesters and police in similar ways, as if to displace critical narratives of student activists and represent protests as meaninglessness spectacles.

In its fictionalization of Black and Puerto Rican students at New York's City College, *RPM* renders their demands incoherent. The open-enrollment movement at City College started around 1967 and culminated in 1969, when approximately two hundred African American and Puerto Rican students locked the South Campus gates and occupied several buildings. They made five demands: the establishment of a separate school of Black and Puerto Rican studies; distinct orientation programs for incoming Black and Puerto Rican students; student participation in decisions over faculty hiring, promotion, and firing; new admissions policies requiring that the campus reflect Harlem's demographics; and a requirement that all education majors study Black and Puerto Rican history and the Spanish language. Students occupied the campus for two weeks, and, in Ferguson's words, they created a "kind of critical utopia," where Puerto Rican parents brought food and then guarded the gate to block the police, while students led political education classes and organized a free breakfast program and day care for neighborhood children. The movement ultimately forced the board of education to agree to open admissions, guaranteeing that any high school graduate in New York could attend college in the CUNY system. This new policy led to dramatically expanded Black and Latinx enrollments, such that City College was transformed from a largely white institution into a largely Black and Latinx one. In the decades after the open-enrollment movement, CUNY graduated the largest number of Black and Latinx master's students in the state.[12]

As Ferguson argues, the open-admissions movement was a critical answer to ideas about academic excellence that held out the possibility of upward mobility and respectability for the few while effectively excluding the many. Subsequently, June Jordan become a professor of English, women's studies, and African American studies at Berkeley and

a sharp critic of attacks on affirmative action in the UC system in the 1980s and 1990s (see chapter 2). But during the open-enrollment movement, she was a young professor at City College, where her colleagues included a host of important Black feminists, and Ferguson builds on Jordan's critique of the exclusionary effects of "excellence," a quality that critics warned open admissions would imperil. In the 1960s both sociologists and policy makers pathologized Black and Puerto Rican people as nonheteronormative and sexually promiscuous, with too many children and damaged and dysfunctional families. Social scientists, in other words, theorized the "gender and sexual irrationality" of African Americans and Puerto Ricans. Such constructions, according to Ferguson, with their "talk of wild reproduction, sexual degeneracy, and social disorganization—made it next to impossible to imagine Puerto Ricans and African Americans as part of an institution built around rationality, excellence, and standards. The open admissions struggle, like its peer student movements across the country, represented a hegemonic fight over the dominant meanings of minoritized communities and the exclusionary parameters of excellence."[13] Black and Puerto Rican students at City College effectively opposed the discourses of heteronormative romance and respectability that have long served in film and on campus as justifications for white dominance of U.S. universities.

RPM is set in the East, at the fictional "Hudson University," a name alluding to City College, which overlooks the Hudson River. After securing their first demand—the appointment of radical sociology professor F. W. J. "Paco" Perez (Quinn) as university president (see figure 18)—the student protestors occupying the central administration building demand the appointment of a Black trustee, the expansion of Black enrollments, and a say in faculty hiring and the curriculum. This, however, is largely where the similarities between reality and film end. The university trustees in *RPM* refuse to meet the final demand for student control over hiring and the curriculum, and the protestors' rigid unwillingness to compromise, the movie suggests, dooms their movement to failure. Rather than give up their demand for control over the institution, the students dig in and President Perez has no choice but to unleash the police. Instead of representing a successful challenge to racialized discourses of excellence, the student leaders in *RPM* are presented as tyrants who won't listen to reason. Reminiscent of Governor Reagan's attacks on student protestors as sexually perverse and foulmouthed, the students in *RPM* disrespect authority with crude sexual taunts. As in the social science research discussed by Ferguson, the film depicts the

FIGURE 18. University president F. W. J. "Paco" Perez (Anthony Quinn) confronts students occupying the central administration building in *RPM* (1970).

students as irrational and hence hostile to the liberal ideals of reasoned debate and tolerance supposedly represented by higher education.

RPM dramatically rewrites its source material not only by rendering a successful movement a failure but also by imaginatively recentering whiteness on campus. The administration building is occupied by a coalition of white and Black students led by a white agitator named Rossiter (Gary Lockwood) and Black Student Union (BSU) president Steve Dempsey (Paul Winfield, see figure 19). The film foregrounds Rossiter, referred to in the screenplay as the protestor's "obvious leader," while marginalizing Dempsey. Playing the white activist, Lockwood was given more screen time, more prominent placement in credits and advertising, and a significantly higher salary than Winfield.[14] The subordination of Winfield's character relative to Lockwood's is in keeping with both the history Ferguson tells and the actor's biography. Winfield's mother was a labor organizer, and he grew up steeped in materialist race and labor politics. As a young queer Black actor in the 1960s, he was typecast as a student activist in TV shows before his first big break in *RPM*. Winfield studied acting at a number of schools, including

FIGURE 19. Black Student Union president Steve Dempsey (Paul Winfield) looks on as President Perez (Anthony Quinn) reads student demands. *RPM* (1970).

UCLA, and around the time he made *RPM* he was a student at UC Santa Barbara. As if appropriating and transforming the actor's biography for conservative ends, *RPM*'s final screenplay seems to reinforce academic theories about dysfunctional Black families that Ferguson argues were in implicit opposition to the open-enrollment movement at City College and to campus diversity movements more broadly. In *RPM*'s first draft Dempsey's mother bails him out of jail after the protest, but in the final version, however, Perez instead informs the BSU president that his family didn't return phone calls, so the university paid his bail. Here the university takes on the role of uplifting "parent" in the face of a post-Moynihan view of Black family dysfunction.

While subordinating and pathologizing Black activists, *RPM* excludes Latinx activists altogether. *The Strawberry Statement, Getting Straight,* and *RPM* largely erase Latinx professors and students, even though they were shot on the West Coast, where Chicanx student activism was highly visible, especially in Los Angeles, home of the Hollywood film industry. Based on protests on the East Coast, *The Strawberry Statement* was filmed in Stockton, California (home to large numbers of Black, Asian and Latinx people), and in San Francisco's historically Mexican Mission District, but it doesn't include any Chicanx characters. The title seems to allude to the many student statements in support of United Farm Workers (UFW) boycotts, but administrators in the film explain that the phrase is a joke about the frivolous and nonsensical

demands of the students, and the UFW context is elided. *RPM* was also set on the East Coast but shot in Stockton, California, at the University of the Pacific. In contrast to the film, it was actually a group of students from the Black Student Union and MEChA, the Chicanx student organization, that occupied the UOP central administration building in 1968, demanding increased minority enrollments.[15]

RPM does, however, include a rare representation of a Latinx administrator in the figure of Quinn's President Perez, but his character arc reinforces a dismissive attitude toward student movements. At the start of the film, student protestors lynch white male university president Tyler in effigy from the building they occupy, thereby introducing them as intolerant and their opposition to the administration as a kind of racial violence. Tyler's successor, the Puerto Rican professor from Spanish Harlem played by Quinn, bears the traces of the City College protests that inspired the film. However, just as the trustees attempt to incorporate Perez into their plans, the film appropriates Quinn's old Hollywood gravitas and his reputation as a civil rights activist for a conservative campus story. Dismayed when the protestors disrespect his leftist credentials, President Perez convinces an audience made up of the entire student body that a university depends on respect for authority, and so the students should accept the trustee's terms, but the occupiers reject the will of the majority of their classmates, signaling the tyranny of a narrow-minded minority, doggedly unwilling to compromise. Such a situation, the film suggests, requires the unfortunate but necessary reassertion of law and order in defense of the liberal democratic values represented by the university, and Perez decides he has no choice but to deploy riot police. The threats to liberalism represented by college students of color and other protesters in the film justify state violence. The film thus reveals the extent to which liberal views of the university have historically shared right-wing perspectives about the necessity of police power and respect for authority on college campuses.

RPM's rendering of a Latinx professor turns him into a puppet for the perspectives of the white liberals who created the character. It was Segal's follow-up to *Love Story*, written while he was a professor at Yale, and his script reads like Ivy League condescension toward public school protests by students of color. Segal's tendentious fiction was sold as fact, however, and the film was promoted partly on the basis of its "knowledgeable screenplay by Yale professor Erich Segal, who is also the author of the best-selling novel, 'Love Story.'"[16] *RPM* was directed by liberal producer and director Stanley Kramer, famous for race problem films like *Home of the Brave* (1949), *The Defiant Ones* (1958), *Pressure Point* (1962), and

Guess Who's Coming to Dinner (1967). Kramer's films are prominently featured in *The Devil Finds Work,* James Baldwin's 1975 study of whiteness and Blackness in the history of Hollywood film, where he persuasively argues that Kramer's work is based in liberal notions of formal equality aimed at reassuring white people that good and bad people "can be found on both sides of the racial fence" and that Black aspirations don't threaten the status quo.[17] A related claim running throughout Baldwin's book is that Hollywood films appropriate the pathos and injustice of Black experiences for whites, such that white characters pursued by poverty and the police reference while displacing Black abjection. *RPM* and the figure of Professor Perez suggest a similar reading. The film is reassuring to white audiences potentially afraid of race protests by representing student demands as both irrational and readily contained with tear gas and clubs. Such reassurance comes with a brown seal of approval in the form of Perez, who authorizes the police attack. With Perez, Kramer found a mouthpiece for his own white liberal dismay over student-of-color protestors as well as his implicit endorsement of a heavy-handed law-and-order response figured as lamentable but unavoidable.

Anticipating MacGraw's trajectory from college to Hollywood, Kramer began his career when, as a student at New York University, he won an internship for college students at Twentieth Century Fox.[18] His earliest success was producing *High Noon* (1952), a western featuring a sheriff who stands alone against a gang of criminals. *High Noon* was one of Ronald Reagan's favorite films, which the California governor, who had unleashed the National Guard against protestors at Berkeley, greatly admired as a tribute to the values of law and order. But *High Noon* is also Bill Clinton's favorite film, suggesting a bipartisan investment in the heroism of police power in the face of popular protest, or, as Clinton remarked, the film appeals to a politician like himself "who's forced to go against the popular will."[19] Similarly, Kramer positioned himself, and his protagonist Perez, in opposition to the popular will on college campuses. In preparation for *RPM,* the director spent several years visiting more than forty college campuses to talk with students, and, "as a precaution against being out of touch," Kramer hired a "young activist anarchist to act as technical advisor."[20] Despite the particularity and political urgency of student demands at City College and on other campuses, Kramer rendered protestors inarticulate, telling a reporter that the "pathos of these kids and their inability to tell what they want is unfortunate."[21]

In his account of making the film, in a *Variety* article titled "*RPM* Simulated Campus Riot Almost Became the Real Thing, Says Kramer,"

the director represented the UOP student extras as easily "triggered" automatons: "It was as if the [police] uniforms were almost a subliminal catalyst. . . . Even though they knew the whole situation was make-believe, and I had explained the scene to them, when they heard cops being called 'pigs,' for hitting someone over the head with a rubber club, it was enough to set them off."[22] As film critic Charles Champlin noted at the time, *RPM* was "the only one of the recent campus films which sees the crisis from the administration's point of view rather than the protes-tors' point of view," and Kramer is at pains to represent both sides, the protestors and the police, as similarly young, scared, and vulnerable, thereby displacing the sharp structural antagonisms of campus protests with forms of liberal equivalence.[23] This may in part explain why, accord-ing to one reviewer, "Kramer's latest work draws applause from con-servative portions of the audience."[24] The character of Professor Perez functions as a hollowed-out vessel filled with the director's own law-and-order liberalism. Kramer appropriates the figure of the Latinx academic in the service of a liberal critique of student protests in ways that antici-pate more recent culture wars and debates over political correctness.

Critics panned *RPM* but praised Quinn's performance as Perez for transcending the script. Amid stilted dialogue and contrived situations, according to Champlin, Quinn "sustains a low-key naturalness." Another critic wrote that the actor's "beautiful" performance "turns what would surely have been a caricature into an almost believable character."[25] While some reviewers praised Quinn's realism, however, others emphasized the "glamour" he brought to the role of a sunglasses-wearing, motorcycle-driving radical professor. In both cases critics fum-bled for words to describe how Quinn's performance exceeded the film's frame. To prepare for the role, according to a studio press release, the actor "read every book on sociology and college life he could find time for, between conversations with students and faculty members. He sat in on classes and he even lectured, as part of the college's study of 'The Heritage of Man.'" During his lecture Quinn told students that he "first came to Stockton from Mexico when he was a boy with his family of migrant fruit pickers."[26]

In 1970 "farmworker" was a highly charged, political identity, familiar on many college campuses, where the UFW found support and volunteers, and so Quinn's lecture interjected Chicanx activist contexts into the filmmaking process. The actor also introduced into *RPM* a brief scene, at odds with the film's larger disappearance of Latinx stu-dents, where Perez runs into a Chicana student named Estella (Ines

FIGURE 20. Chicana graduate student Estella (Ines Pedroza) and President Perez (Anthony Quinn) have a conversation. *RPM* (1970).

Pedroza) on campus (see figure 20). He calls her by name as she gets into a car, and the two exchange warm pleasantries and sad smiles. Their conversation is in unsubtitled Spanish, and, while seemingly trivial, it feels freighted with silences and the weight of the unspoken. He shakes his head and apologizes for not being in contact, explaining he has been busy, and she says she's been busy too with her studies. He compliments her new short hairstyle. As they part, she asks him to say hello to his family. Segal's script simply notes that the scene is to be played in Spanish but doesn't include any dialogue, suggesting that Pedroza and Quinn supplied it. In a seemingly intimate moment, the two characters speak to each other in a language the filmmakers apparently don't understand. The scene suggests that brown professor and student are secret sharers, who together know more than the film can comprehend. Finally, the figure of Estella is a sort of bronze star, heralding the Chicana college students of future films (see chapter 4).

AND THE UNIVERSITY DID NOT DEVOUR HIM: TOMÁS RIVERA AND CHICANX CINEMA

While Quinn was making *RPM*, Tomás Rivera was completing his semi-autobiographical novel about migrant farmworkers, *Y no se lo tragó la tierra/And the Earth Did Not Devour Him* (1971). He had recently earned a PhD in romance languages from the University of Oklahoma for his 1969 dissertation, "La ideología del hombre en la obra poética de

León Felipe," a study of the leftist Spanish poet exiled in Mexico. His doctorate was the culmination of a long and complicated education. Rivera's farmworker family was often on the move from Texas to the Midwest, following the crops for part of spring, all of summer, and part of the fall. He began his education at the age of five at a private barrio school, Escuelita de Doña Hermina, one of three such schools in Crystal City, the South Texas town where he was born. The instruction was in Spanish, including lessons in reading, writing, and math, and, to accommodate a mobile student body, the school charged a nickel a day on a pay-as-you-go basis.[27] Rivera subsequently attended segregated elementary schools in Texas and integrated elementary schools while working in the Midwest. After he graduated from Crystal City High School in 1954, his father, Florencio, wanted him to become a bookkeeper.[28] Florenio paid $300 in tuition to a small San Antonio business school before a recruiter from Southwest Texas Junior College, Uvalde, explained that his son could receive the same training there for only $25 a semester.[29] Rivera was practiced at catching up, after missing part of the fall and spring in high school, but college proved more challenging, so his first year at STJC was his last as a migrant farmworker. Later he recalled that "I had grown up inventing myself as a scientist," and "from childhood and through high school I saw myself working in a science lab," but he found his junior college science classes boring and uncreative. He liked his literature classes, though, and in 1956 Rivera earned an associate of arts degree in English from STJC and then transferred to Southwest Texas State University, where in 1958 he received a BS in education with a major in English. He had planned on becoming a secondary school English teacher, but after graduation Rivera "had a shocking awakening; I couldn't find a job teaching English because I was Mexican."[30]

He ultimately taught Spanish and English in area middle schools and high schools before returning to Southwest State, where he pursued a M.Ed. in educational administration. Finally, in 1965 Rivera started the PhD program at Oklahoma. Fresh from graduate school he was hired with tenure as an associate professor of Spanish at Sam Houston State University in 1969. Just two years later he accepted a job as a full professor of Spanish and director of the Division of Foreign Languages, Literature and Linguistics at the University of Texas, San Antonio, where in 1976 he was promoted to vice president for administration. In 1978 Rivera was recruited by the University of Texas, El Paso, to serve as its executive vice president and promoted to full professor. One year later he became the chancellor of the University of California,

Riverside—the first person of color to lead a UC campus. Whereas most tenure-track academics in the humanities spend the first decade of their careers pursuing promotion to full professor, Rivera rose to the presidency of a major public university on the same clock.

By all accounts and in keeping with his farmworker past, Chancellor Rivera was *un madrugador* (an early riser), who arrived at his office by six in the morning and often worked long after five in the afternoon. As his colleague Eliud Martinez writes in the guide to the Tomás Rivera Archive at the UCR's Tomás Rivera Library:

> Many persons who wrote letters to Tomás included manuscripts of short stories, novels in progress, poetry collections or anthologies, and scholarly articles and books in various academic disciplines. Requesting that he read, analyze, review, and critique them. And he did. Ponderous in number also, are the requests that he write letters of recommendation for academic positions, merit increases, promotions to full professor, applications to graduate schools. Tomás Rivera responded to these and countless other demands on his time: to serve on various educational and professional committees at national and regional levels, to present papers, to guide people working on dissertations, and to serve as reader and judge on writing competition committees.

Rivera accepted requests to speak at local high schools, military bases, and civic organizations; to write letters for prisoners seeking parole; to judge beauty pageants; and to advise aspiring middle school poets and high school literary critics. He also accepted numerous requests to review and participate in film and television projects. As chancellor, Rivera faced post-Bakke, post-Proposition 13 attacks on affirmative action, funding for public education, and interdisciplinary studies, notably Black and Chicano studies, which is to say Rivera lived through the early 1980s backlash against the student demands fictionalized in Quinn's 1970 film. Rivera's life was cut short, however, when he died of a heart attack after five years as chancellor at the age of forty-eight, the widely cited average life expectancy for farmworkers. The *chisme* in Chicano studies has long been that it was the stress of being the first Chicano in UC administration that helped end his life, and I would add the possibility that he was indirectly killed by Reagan-era attacks on public education. Rivera's early death thus deconstructs conventional idealizations of education as a means of upward mobility and transcendence.

By contrast, in life Rivera was expressly committed to nontranscendence in the form of literary and cinematic reflections on farmworkers' knowledge about their own material conditions. Rivera's great novel *Tierra*, for example, recalls and documents farmworker experiences in

FIGURE 21. Chancellor Tomás Rivera works at his UC Riverside desk, circa 1980. Courtesy of Riverside Libraries, Special Collections and Archives, University of California, Riverside.

the decade ending in 1955, the year before he began junior college. He wrote it while completing his PhD and looking back on the years before he entered higher education. With that act of recollection, Rivera hinged his academic life to migrant farmworker histories. Recollecting farmworker contexts in the academy was a constant feature of his academic career. In Rivera's first speech to the UCR Academic Senate, he introduced himself by recounting his trajectory from farmworker to college administrator.[31] His final CV includes an "Employment Record" in reverse historical order, starting in 1979 with his appointment as UCR chancellor and ending in 1957–58, when Rivera worked as a middle school English teacher in San Antonio. After that his resume includes the category "Prior" and the notation, "Up to the time I started my teaching career, I was part of the migrant labor stream that went from Texas to various parts of the Midwest."[32] In a unique and unprecedented move in the history of academia, Rivera brought to administration a kind of multiple consciousness, viewing higher education *desde abajo* (from below), partly through farmworker eyes (see figure 21).

Rivera's farmworker past also shaped his engagements with film and television in the 1970s and early 1980s. In contexts where Chicanx students and professors were beyond cinematic and other representation, he worked to grow noncommercial, educational media content and institutions. Rivera was especially invested in educational media for

youth of color. In his career as a professor and administrator, he collected catalogs of educational films such as *Henry, Boy of the Barrio* and *Mexican or American* and researched and read extensive bibliographies of scholarship on film and media representations of Mexican Americans.[33] Rivera was also interested in making media. In the same month that he published *Tierra,* with its farmworker child protagonist, he wrote to Michael Eisner, who was then vice president for Daytime Programming at ABC, requesting information about "both animated and live-action productions for children. . . . I have several ideas and scripts which could possibly be implanted into your programming. . . . My main interest is in writing scripts of a human nature interest which pertain to the Mexican-American experience—especially the young."[34]

A year later, in 1972, while he was director of the Division of Foreign Languages, Literature and Linguistics at UT San Antonio, Rivera served as an academic adviser for *Carrascolendas,* a bilingual educational show for children sponsored by the U.S. Department of Education and broadcast nationally on PBS.[35] As executive vice president at UT El Paso, in 1978 Rivera was invited by actor and philanthropist Marlo Thomas to participate in a conference on children's TV. The translation of his literary work into film remained a persistent dream, and in the final years of his life Rivera was in negotiation with independent filmmaker Jay Stephens Rodríguez to turn *Tierra* into a feature film, but the project was never realized.[36] After his death a movie version of the novel was made for PBS's *American Playhouse* in 1995 and directed by Severo Perez, with whom Rivera had previously collaborated on a number of film projects.

While working as a college administrator in Texas, Rivera began participating in Chicanx film networks on the margins of the university-cinema–industrial complex. He regularly attended, for example, a Chicano film festival at Oblate College of the Southwest in San Antonio that was organized partly by Perez and Jesús Treviño. Rivera also served as a juror on the festival's 1976 prize committee and the following year spoke at a symposium there on "the place of film and TV in the Chicano community."[37] He was joined on the panel by a number of filmmakers, including not only Perez and Treviño but also Moctesuma Esparza and Susan Racho, UCLA graduates who had been student leaders of the 1968 Chicano walkouts, student protests against racial inequality in public education.[38] In an effort to draw attention to the impoverished conditions at public schools in East Los Angeles serving predominantly Chicanx populations, more than four thousand students at Garfield, Roosevelt, Lincoln, and Wilson High Schools walked out of classes.

Students at Garfield and Roosevelt were beaten by the police and arrested—scenes broadcast on local TV news. In solidarity around fifteen thousand students citywide also walked out.[39]

The East Los Angeles public school protests focused critical attention on the sorting of students by race and income and the funneling of girls into secretarial work and boys into manual labor rather than college preparation. A year after the walkouts and while students at UCLA, Esparza and Racho helped organize a series of protests and sit-ins that led to the founding of the Ethno-Communications Program dedicated to educating "Third World film students." The young filmmakers thus led a successful version of the kinds of student protests fictionalized as failures in Hollywood films. Esparza and Racho were part of a formative group of Los Angeles–based Chicanx filmmakers in the late 1960s and early 1970s, including Sylvia Morales and José Luis Ruiz, two artists whom Rivera advised on film projects.[40] Finally, Rivera was joined at the Oblate film festival symposium by UC Santa Barbara professor Jesús Chavarria, who had just served as the chair of the historical Task Force on Chicanos at the University of California, which produced a series of recommendations Rivera would later try to implement at Riverside. Rivera's participation in the film festival with activists and academics suggests the overlapping networks of filmmakers and educators that characterized the brown academy, or the Third University Babylon in the First.

Rivera returned to the Chicano Film Festival at Oblate College for the 1978 premier of Treviño's *Raíces de sangre [Roots of Blood]*. Funded by the Mexican state, the film, as the director described it, was "a love story between a Harvard-educated Chicano and a passionate community organizer, set in a Texas border town where Mexican and Chicano workers were organizing an international union." The film is partly a response to *Love Story* that reconnects Harvard to racialized contexts of material inequality obscured in Segal's narrative. Treviño was a particularly important mediator between the worlds of cinema and the brown academy, and a friend and collaborator of Rivera's for much of his career.

The intersection of film and the brown academy helped define the Chicano movement. Elsewhere I have analyzed film and video in UFW campaigns aimed at galvanizing university support in the 1960s and 1970s.[41] While Hollywood made conservative feature films about campus protests, the UFW screened profarmworker documentaries at organizing and fund-raising meetings on college campuses. At the same time, film was an important part of an emergent brown presence in academia. When in

1978 Rivera attended the National Association of Chicana and Chicano Studies Convention in Claremont, California—under the presidency of Professor Margarita Melville—the conference included a day of film screenings "that relate to the Chicano condition."[42] Finally, Rivera helped bring such networks and questions of representation and access into corporate boards and foundations, coconvening a conference on Hispanics in the Media at the Aspen Institute, advising the Corporation for Public Broadcasting, and serving as CEO of the Times Mirror Company, publisher of the *Los Angeles Times*.

Rivera's collaborations with filmmakers and media institutions fed and were fed by his philosophical reflections on knowledge, ethics, and cultural representation. He in effect theorized subaltern epistemologies based in experiences of vicariousness, including film and TV viewing. In her influential study of spectacles of slavery, *Scenes of Subjection*, Saidiya V. Hartman suggests that vicarious relationships to Black suffering have expressed and reproduced white power over Black people.[43] While Rivera is similarly invested in questions of power, he also takes up vicariousness from below. On the one hand, Rivera uses the term to describe how migrant workers are incorporated into ideologies and institutions that contribute to their exploitation. He dramatizes such dynamics in a short story from *Tierra* titled "Los quemaditos"/"The Little Burnt Victims," which begins when a farmworker couple, Don Efraín and Doña Chona, and their three young children, Raulito, Juan, and María, return to the small chicken coop where they live "excited over the movie about boxing they had seen." Most excited of all was Don Efraín, who put boxing gloves on the children and "stripped them down to their shorts and rubbed a bit of alcohol on their little chests, just like they had seen done in the movie." When Doña Chona complains that the chicken coop is too small and that "someone would always end up getting mad and then the wailing would start and last for a long time," her husband persuades her it's okay, saying, "Maybe one of them will turn out good with the glove, and then we'll be set, *Vieja*. Just think how much money champions win. Thousands and thousands."

The next day the parents reluctantly leave their kids at home "because the owner didn't like children in the fields doing mischief and distracting their parents from their work." But by ten that morning the Garcia's shack was "engulfed in flames," and the two youngest children "were charred in the blaze." Mimicking his father, Raulito "made little Juan and María put on the gloves" and rubbed their chests with alcohol "like they had seen done in the movie." When the oldest boy started to fry some

eggs "the kerosene tank on the stove exploded" and "covered them in flames. . . . The only thing that didn't get burnt up was the pair of gloves. They say they found the little girl all burnt up and with the gloves on. . . . You know how those people can make things so good. Not even fire can destroy them." The characters' mimicry of the boxing film, with its idealizations of violent masculine competition and, implicitly, of meritocracy and upward mobility, makes them tragic subjects of vicarity, consumed by more powerful forces of exploitation and disposability. Reenacting the film narrative makes the characters even more vulnerable to their material conditions—chicken coop, cramped space, kerosene stove, rules against children at work, limited or segregated access to public schools. For subaltern spectators under conditions of extreme inequality, the story suggests, vicarious excitement over Hollywood spectacles become self-destructive. With its focus on boxing, the story further suggests a gendered perspective on vicariousness, since it is the father who is most enthusiastic about re-creating the film, and his oldest son who reenacts his father's prior reenactment, with fatal consequences for the youngest boy and girl child made to box.[44]

Rivera further investigates vicarity in the short story "El Pete Fonseca," published in English as "On the Road to Texas: Pete Fonseca." Set in Iowa among farmworkers also living in chicken coops, the story is focalized through the perspective of three children and their encounter with the title character, a "loud mouth" and a "con man" dressed like a *pachuco* and speaking Caló, and his future wife, La Chata, a single mother with two sons. People are suspicious of Pete's intentions, as he brags about women he has pimped, and when he tries to have sex with La Chata in the trailer he shares with several other farmworkers, she refuses and insists on marriage. Pete agrees and enumerates to his friends the benefits of the arrangement. "They could buy a jalopy and then Sundays they could take rides, go to a show, go fishing or to the dump and collect copper wire to sell." But "he doesn't want to go into town to get the papers" because "he's got some sickness in his blood," so in a vernacular marriage, Pete asks the dad of the family to ask La Chata's father, Don Chon, for her hand. After this informal wedding "they were real happy." Together Pete, La Chata, and her two boys "always had work," and they bought a car and went to the movies (*al mono* in *pachuco* slang). Indeed, other farmworkers seemed to view them as if they were in the happy ending of a movie. "They worked together, they helped each other, they took real good care of each other, they even sang together in the fields. We all really liked to see them because sometimes

they'd even kiss in the fields. They'd go up and down the rows holding hands. . . . Here come the young lovers. Saturday they'd go shopping, and go into some little bar and have a couple after buying some groceries. They'd come back to the farm and sometimes even go to a show at night. They really had it good." Here a migrant worker vision of the good life includes going "to a show," and the other farmworkers take vicarious pleasure in the romantic show of Pete and La Chata. But six weeks after they're married, in the final days of the potato harvest, Pete deserts La Chata and the boys, taking the car and all their earnings. After returning to Texas the family hears that Pete had been "cut up in a bar in Minnesota and was going around saying the cops had taken all his money and the car, and that the boss had told the cops after all, and they'd caught him in Albert Lea. Anyhow, no one had given any money to Don Chon or La Chata."[45] With "Pete Fonseca," Rivera dramatizes how vicarious investments in filmic fantasies of heterosexual romance and family obscure the dangers of exploitation and theft.

At the same time as Rivera produced literary accounts of vicariousness as a means of subordination and exploitation, in a series of essays and reflections he also made the case for a kind of critical vicarity. In his essay "Into the Labyrinth: The Chicano in Literature," for example, he argues that literary representation can produce a "vicarious notion of humanity," by which he means an individual's "attempt to search for the other, 'alter ego,' in order to comprehend himself better."[46] In the essay "Remembering, Discovery and Volition in the Literary Imaginative Process," Rivera applies ideas about vicariousness to an understanding of farmworker film viewing. While "many of the workers were illiterate, the narrative system predominated" including the "old traditional stories" of ghosts, the devil, and hidden treasures; tales of the Mexican Revolution; and, finally, film narratives. In the work camps "there were always those who acted out movies, told about different parts of the world and about Aladdin and his magic lamp." Such narrative recollections served as reconstructive exercises in which migrant audiences "escap[ed] to other worlds as well as invent[ed] them. It was natural that a type of narrative would develop in the children and worlds were crystalized because of the tedium of every-day work."[47] Seemingly "escapist" qualities in film and other representations, Rivera suggests, critically foreground the material limits of the world from which farmworkers are trying to escape. Film narratives remain in dialectical tension with "the tedium of every-day work," a tedium whose return in the morning is marked by entertainment in the evening. Like the young protagonist of

Tierra, who discovers in stories of the devil that there is no supernatural world, only this one, migrant re-creations of escapist film narratives paradoxically resist transcendence by commemorating the end of one workday and the beginning of the next.

Rivera further uses vicarity to analyze migrant farmworker confrontations with the movie theaters and schools as related institutions. In one untitled vignette from *Tierra,* a boy learns about racial segregation on the way to a see a movie:

> It was an hour before the afternoon movie started. He needed a haircut, so he went into the barber shop across the street from the theater. At first he didn't quite understand, so he sat down and waited. He thought the barber didn't have time, so he remained seated waiting for the other barber. When he was finished with the client, he got up and walked to the barber's chair. But this barber told him the same thing. That he couldn't cut his hair. Furthermore, he told him that it would be better if he left. He crossed the street and stood here waiting for the theater to open, but then the barber came out and told him to leave. Then it all became clear to him and he went home to get his father.[48]

Here the young protagonist learns about the segregation of social space, from barbershops to movie theaters. Similarly, in "Remembering, Discovery and Volition in the Literary Imaginative Process," Rivera argues that migrant children gain a critical perspective on "American ideology" and their exclusion from its privileges through a dialectical process he likens to the experience of migrant film spectatorship. The child sees "that whole world as a film—real but not real, a vicarious experience." This description of American ideology as "that whole world" recalls what scholars call a film's mise-en-scène, or everything that filmmakers put into a scene to build a compelling imaginary world. But in the original Spanish version of the essay, rather than using *pelicula* (as he does in "The Little Burnt Victims") or even the Caló word *mono* (as in "El Pete Fonseca"), Rivera renders "film" in English—"todo aquel mundo un *film.*" The incorporation of the English word in a Spanish sentence suggests the dialectical tension of critical vicarity that oscillates between appeals to incorporation and the recognition of exclusion and subordination.[49]

The experience of attending white public schools, in Rivera's account, extends and amplifies the dialectic of vicariousness as "the migrant child discovers social strata. He discovers the feeling of not having, of not existing and of not belonging. The educational system is revealed to him as a structure in which he does not belong, in which he cannot exist but in

which he is required to participate." Both Hollywood and schools, Rivera suggests, generate contradictory experiences of vicariousness, since they formally appeal to farmworkers while practically excluding or subordinating them. In both contexts farmworker youth are obliged to participate in systems premised on their absence. However, even though "the child finds himself at the margin of these structures and is forced to participate in them, he does not necessarily go astray but instead looks for and finds refuge in remembering." For Rivera, "remembering" refers to "the method of narrating which the people used" to make popular culture, including the reenactment of film narratives and other stories. Such remembering is one way "the Chicano creates himself and his future." This "invention and futurization" represents a "refuge" in the sense of constructing other worlds of imaginative pleasure that remain rooted in material realities of inequality and exploitation.[50] As refuge, in other words, film narratives about Aladdin's lamp draw into critical relief the conditions that make migrant workers refugees.

Finally, vicarity is the basis for farmworker knowledge production, or what Rivera theorizes as "wisdom"—critical knowledge of the world based on collective experience. In the 1982 essay "Chicano Literature: The Establishment of Community," he refers to the "popular wisdom" of Chicano communities reproduced in creative acts of narrative recollection, or communal "advice and counsel." Like a miner, the writer "extract[s]" wisdom from the community, and literature thus represents the "history of customs," or of customary knowledge.[51] Rivera further argues that film and television provide much of the material for the production of migrant worker wisdom, or what he also calls knowledge from a "proletariat," "third world" perspective. When a friend sent Chancellor Rivera a copy of *Television and Children,* a quarterly journal published by the National Council for Children and Television, he wrote back explaining that what was missing in the issue was a discussion of how

> children as well as teenagers and adults gain quite a bit of wisdom from television (from positive as well as negative reinforcements). For example, it took me a long time, but probably by age 15 I began to recognize stereotypes through structured means in newspapers, books and movies and, as importantly, that I was using those stereotypes in making assessments of people I dealt with. I was shocked when I asked Javier (at age seven) what he thought about so and so in a TV series, and he stated he was okay but that he wasn't real but a "stereotype"—that no one was really like that in real life. He had more wisdom at age seven than I did at fifteen. I dare believe that the many "stories," in cartoons, series, etc., etc., gave him quicker wisdom. . . . Wisdom, not truth, is the essence of education.[52]

Implicitly arguing against a kind of Frankfurt School thesis about the domineering power of the culture industry, Rivera argued for a critical vicarity, where minority subjects respond to dominant representations in deconstructive ways. Such a reading practice, Rivera suggests, presupposes wisdom based in farmworker enlightenment, or the kinds of knowledge about power made possible by positions of extreme marginalization.

Migrant worker wisdom, moreover, is diametrically opposed to the divisions and exclusions characteristic of Anglo-American culture and society. Building on readings of two poems by Rolando Hinajosa featuring women-of-color sex workers, in "Chicano Literature" Rivera argues that wisdom includes "the concept of cohabitation *(vivir y dejar vivir)*. That is, the acceptance in the community of all types of people without singling out a pejorative or positive value as to the role of people in the community. There is the wisdom of acceptability and the wisdom of relationships between men and women, no matter what their position, social class, rank, or endeavor. And more specifically, there is the respect for individual condition and situation."[53] Here Rivera promotes an epistemology of equality in difference at odds with the hierarchies of race, class, gender, and sexuality that govern dominant views of higher education in both Hollywood and on college campuses.

As a young college student, Rivera's historical experience of community wisdom as cohabitation, acceptance of multiplicity and difference, and respect for the particularities of condition and situation prepared him to fall in love with Whitman. In junior college

> we were taught that Walt Whitman was a dirty old worthless poet, so I immediately read him. . . . I came under the spell of Walt Whitman. . . . I read *Leaves of Grass* in the summer of 1956, and it opened up, or perhaps I was ready for it, a new philosophy of worth. *Leaves of Grass* was to be my bible. On the copy that I bought that summer I wrote "Read this book when you feel unworthy." I became an avid Whitman fan. I read all I could get my hand on that pertained to him.[54]

Rivera's affinity for Whitman reads like what in *Epistemology of the Closet* Eve Kosofsky Sedgwick calls "camp recognition," a form of vicariousness that asks, *"what if:* What if the right audience for this were exactly *me?* What if, for instance, the resistant, oblique, tangential investments of attention and attraction that I am able to bring to this spectacle are actually uncannily responsive to the resistant, oblique, tangential investments of the person, or of some of the people, who created it? And what if, furthermore, others whom I don't know or recognize

can see it from the same 'perverse' angle?"[55] Here Sedgwick describes a projective queer fantasy of community that recalls Rivera's theorization of vicariousness as farmworker world making.

Rivera's vicarious relationship to Whitman also resonates with Nadia Ellis's study of C. L. R. James and his vicarious relationship to Bette Davis, in her book, *Territories of the Soul: Queered Belonging in the Black Diaspora*. Ellis argues that forms of vicarity (or what she analyzes as "prosthetics" and "surrogacy") were central to James's diasporic sense of place and belonging. His excessive, affect-laden identification with Davis puts him at odds with the nationalist and masculinist reassessments of his work after he died, and it implicitly feminizes and queers his oeuvre.[56] Similarly, Rivera's affinity for Whitman is in keeping with his renderings of the beauty and wisdom of vernacular speech as well as his affectionate, nonjudgmental representations of all kinds of marginal or "unrespectable" qualities that, in hindsight, exceed the limits of the Chicano nationalist frames that have sometimes been applied to his life and work.

Rivera's ideas about both community and knowledge were thus based in forms of popular wisdom opposed to a politics of respectability, including in higher education. This well describes, for example, his earliest educational experiences, starting with the world of letters he discovered as a scavenger: "My dad knew I liked to read, so he would go knocking on doors, asking if they had any old magazines. . . . We also used to go to the dump to collect reading materials. I found encyclopedias and different types of books. At home I still have my dump collection gathered from the dumps in northern towns. People threw away a lot of books."[57] Rivera's research trips *al dompe* are memorialized not only in *Tierra* but also in "Pete Fonseca," where the dump competes with the movies as farmworker entertainment.

Rivera was introduced to formal education at the age of five, in a barrio school in Crystal City, where he reenacted community wisdom about work and class as part of local pageants. As Rivera recalled, his first teacher, Doña Hermina, had been a "professor in Mexico" and was the "first influence upon myself as a writer." As in the labor-camp practice of recreating film narratives,

> she made us read stories aloud and to dramatize them. It was an interesting experience, she made us tell of our experiences as migrant workers, we were 100% migrant workers, and she had a great capacity for love. Also, of course, each year she had a "function" at a local Chicano [movie] theater, either El Nacional or El Ideal, where all her 30 or so students performed. We

performed skits, read poetry, sang, etc., to a full house of parents, relatives and the several *sociedades culturales, mutualistas,* and *circulos auxiliaries* that existed then. My first performance was reading poetry supposedly written by a proletariat coal miner. My mother made me a miner's suit, with a cap and a light attached to it. I also had a lamp and a little pick axe, and a pail full of coal. So *declame.* The poem spoke of the virtues of labor, of the laborer, his importance, his responsibilities.[58]

For working-class Mexicans in 1940, in racist South Texas, where the legal and extralegal lynching of Mexicans was a living memory, the movie theater declamations of community children were life-sustaining performances. This is part of what Rivera must have had in mind when he wrote in *Tierra* about the spoken word as "the seed of love in the darkness" (see figure 22). In another account of the event Rivera notes that it was "interesting for the parents to have their kids up on stage reciting," and it "gave a sense of pride in your child," but he emphasizes that the pageant was attended by a larger brown public, including the organizations referenced earlier but also, more broadly, *"todos los barrios"* in Crystal City, suggesting the importance of performance and film in the reproduction of community wisdom. Doña Hermina taught her students "the idea of community, that all these people are important in our lives. That's why everyone portrayed a job." In contrast with Hollywood films glorifying white, college-boy mining engineers and often vilifying miners (see chapter 1), Rivera recalls the worthiness of racialized workers in one of the dirtiest, most dangerous jobs in the world. Rivera's beloved grandfather, in fact, had been a miner and union organizer in the mines of northern Coahuila, Mexico.[59]

Rivera's recollections of his early performance in a Chicanx movie theater provide a glimpse of his pedagogical theories and their resistance to bourgeois models of education based in hierarchies of respectability. The wisdom of cohabitation, acceptance of difference, and respect for particularities of condition and situation suggested to Rivera the worthiness of representing nonnormative characters and situations for young readers. While he was an associate dean at UT San Antonio, for example, Scholastic Books asked Rivera to submit a story for publication in a literary anthology, and he offered them "El Pete Fonseca" as appropriate for readers eight to twelve. The press, however, rejected the story as "too sexually graphic for our prospective audience."[60] "El Pete Fonseca" was ultimately published in *Aztlán: An Anthology of Mexican American Literature,* edited by Luis Valdez and Stan Steiner in 1972, and subsequently republished in a number of anthologies; it has also

FIGURE 22. Tomás Rivera, circa 1938,
holds a piece of fruit he will soon learn
to pick. Courtesy of Riverside Libraries,
Special Collections and Archives,
University of California, Riverside.

often been taught in college classes. As Rivera notes, the primary audi-
ence for his literary writing was always college undergraduates, suggest-
ing that his model of college education incorporated wisdom critical of
respectability.

Historically, a small group of respectable, middle-class Mexican
Americans have chased upward mobility and the forms of privilege gen-
erally limited to white people. The influential U.S. civil rights organiza-
tion the League of United Latin American Citizens (LULAC), for
instance, promoted a model of Mexican American worthiness based in
U.S. patriotism, commitment to capitalism, and English-language profi-
ciency. Founded in 1929 and influential for decades to come, LULAC's
legal teams, according to David G. Gutiérrez, chipped away at segrega-
tion in Texas schools, helping prepare the ground for *Brown v. Board of
Education*.[61] At the same time, however, Neil Foley argues that "LULAC

members constructed new identities as Latin Americans in order to arrogate to themselves the privileges of whiteness routinely denied to immigrant Mexicans, blacks, Chinese and Indians."[62] LULAC limited its membership to U.S. citizens, while its leaders identified as white and in opposition to Black people. LULAC's claims to white respectability thus specifically entailed opposition to Mexican and Black intermarriage. Although the UFW made common cause with the Black Panthers and did not subscribe to LULAC's anti-Blackness, the union was ultimately undermined by conflicts over patriarchal, heteronormative respectability politics.[63] In these ways both LULAC and the UFW anticipate what Grace Hong has analyzed as neoliberal ideologies and practices of disposability based in judgments of worth. Neoliberalism, in Hong's account, affirms "certain modes of racialized, gendered, and sexualized life, particularly through invitation into reproductive respectability" to deny ongoing forms of race and gender violence and exclusion. Neoliberalism is partly an epistemological structure that claims to protect and promote the life of some segments of minority communities while obscuring the vulnerability to premature death that characterizes the lives of others who are variously vilified with terms such as "prostitute," "drug dealer," "homeless," "welfare cheat," or "illegal immigrant."[64] Rivera's critical and creative projects represent a prescient critique of the murderous neoliberal logics of worth and worthlessness, respectability and disposability, analyzed by Hong.

Rivera's fiction renders the critique of neoliberal respectability as brown noir. In his study of literary and film noir in *City of Quartz: Excavating the Future in Los Angeles,* Mike Davis argues that the genre deconstructs idealized representations of Southern California with depictions of greed, violence, political corruption, labor exploitation, and racism. Novels and films such as *Double Indemnity* (1944) and *Mildred Pierce* (1941), for example, displace idealizations of the heteronormative middle-class family with images of "poisoned bungalows whose white-walled, red-tiled normality . . . barely hid the murderous marriages within." Meanwhile, Chester Himes novels about segregated low-wage labor present a "brilliant and disturbing analysis of racism in the land of sunshine." Finally, Davis discusses the noir revival of the 1960s and 1970s, notably the film *Chinatown* (1974), focused on water, real estate, and the monstrous greed and incestuous desires of the rich in Mexican and Asian Los Angeles.[65] Rivera's literary works anticipate Davis's study of noir as a vehicle of social critique aimed at respectability politics. Instead of poisoned bungalows, murderous marriages, and

the perversions of the wealthy, in "El Pete Fonseca" Rivera represents fetid chicken coops and nonnormative sexual relationships. The family in "The Little Burnt Victims" also lives in a chicken coop, and the story's tragic conclusion is figured as a consequence of racialized labor exploitation, structural inequality, and Hollywood ideology. But it was ultimately his story in *Tierra* titled "La mano en la bolsa"/"Hand in His Pocket" that Rivera chose to turn into a brown *film* noir.[66]

By linking education and disposability, Rivera's plans for a film version of "La mano en la bolsa" recall the theme of nontranscendence with which I began this discussion of his academic career. While an administrator at UT San Antonio, Rivera was approached by actor Peter Gonzales about making a movie.[67] The proposed film version of "La mano en la bolsa" was never produced, but Rivera wrote a treatment for it that, while rudimentary, is still quite accomplished, the work of a brilliant autodidact. The story is a disturbing coming-of-age tale focused on a young farmworker protagonist. Rivera's treatment begins as the parents of the unnamed boy return after leaving him in the care of Don Laíto and Doña Bone to finish the school year. The parents notice that their son looks pale but reason it must be because of his studying. "Ready to start working and stop worrying about school?" his father asks. The parents thank the couple, and the couple praise the boy's good behavior. When Don Laíto says they gave him a ring as a present, the camera cuts to a close-up of the ring as the boy nervously moves it up and down his finger. Rivera's script next signals a temporal shift with a sound cue—the loud, "wild" sounds of Don Laíto and Doña Bone in their kitchen—and the film flashes back to the boy's time with his guardians. The couple makes a living by selling cheap commodities to migrant workers, and the boy quickly discovers that the pair is shadier than people know. Don Laíto adds spit and armpit sweat to the sweet bread he sells, while Doña Bone feeds the boy rancid meat to save money. The boy also learns that Doña Bone has sex for money with an old man referred to as the "wetback." Alone in his junk-filled bedroom one night, the boy overhears the couple plotting the wetback's murder:

> This man has money. He doesn't have any relatives, no relatives. . . . It would be very simple, *viejo,* no one to look out for him. . . . You think so? . . . He could care less. . . . He's a wetback, no one knows him here, if anything happened to him, do you think anybody would care? . . . You're crazy. . . . No one knows he comes here (both laugh). . . . Leave it to me. Don't worry, just leave it to me. . . . Yea, that would be easy, that would be easy enough.

FIGURE 23. A farmworker boy digs the wetback's grave. *And the Earth Did Not Swallow Him* (1995).

In the morning Don Laíto stakes a small plot in the yard and tells the boy to dig a cellar for Doña Bone's canned fruit. By late afternoon the boy is "waist deep" in the earth and looks up to see the wetback walk past him to the steps of the house (see figure 23, the scene as represented in the 1995 film made after Rivera's death). As the man knocks on the door, the film cuts to a close-up of his hand and ring. At dusk Doña Bone calls the boy inside for dinner, but he says he's too tired to eat and retreats to his bedroom. Seeking refuge in sleep, he sits on his bed, but as the boy leans back he feels a body (in the story Rivera writes that he "touched what felt like a snake but what was in reality the wetback's arm"), followed by "quick cuts" of a hand, face, and blood on the boy's hand. In terror he runs out of his bedroom and into the waiting couple, whose "shadows loom over him as he looks up." Doña Bone tells him, "Don't worry. Nobody knows. Nobody knows him. Here, this is for you," as she gives him the dead man's ring. "*Mi viejo* has his wrist watch. It's ok. Nobody knows. *Nobody knows* [underlined in the original]. Just you. You dug his grave. You knew. You saw him walk by the grave. You knew." The flashback concluded, the film returns to where it began—the scene of parents retrieving their son at the end of the school year. As they part, the couple tells the boy, "Just don't tell the police and don't lose the ring." Don Laíto then adds, "It's good luck. Took it off a dead man," and everyone laughs (see figure 24, the scene as depicted in the 1995 film). The camera freezes on the boy's face, and the film fades to black.

The film's flashback narrative structure describes a circle, like its central prop: the wetback's ring. Both the ring and the narrative structure represent historical memory, or what Rivera called "recollection." Together the two closed circles suggest the inescapable persistence of

FIGURE 24. Sam Vlahos and Lupe Ontiveros are brown noir
villains. *And the Earth Did Not Swallow Him* (1995).

memory, in this case the boy's recollection of the wetback's murder.
Moreover, Rivera's "La mano en la bolsa" script suggests that memory
is the basis of knowledge, its condition of possibility. The boy's stay
with Don Laíto and Doña Bone is supposed to be an academic refuge
from migrant labor, but the film instead circles back to disposability and
death. In contrast to depictions of education as linear progress and
upward mobility, the film shows that, for the boy, knowledge can never
transcend memories of violence and loss. After he digs the grave, Doña
Bone says to him, "rest your mind," but he learns rest is impossible with
the wetback's body in his bed.

Anonymous, with no one to mourn him, the wetback's murder raises
life and death questions of epistemology. When Doña Bone gives him the
ring, for example, she speaks of the known and the unknown—"Nobody
knows. *Nobody knows.* Just you. You dug his grave. You knew. You saw
him walk by the grave. You knew." In this sense the wetback is subal-
tern, unknowable and abject within dominant epistemologies. He also
represents migrant aspects of life excluded from "respectable" circles,
including in education. The wetback produces a kind of panic when the
boy finds his body in bed and feels his snakelike arm, while the ring and
the grave allude to the nonnormative.[68] In short, the wetback condenses
multiple forms of unworthiness. Rivera suggests in this way that educa-
tion often depends on burying the subaltern and the queer—but the boy
can never forget what he knows. The film thus dramatizes wisdom as
nontranscendence. Education, here represented by the boy's entry into
largely white public schools, is forever linked to the wetback and depend-
ent on unacknowledged processes of exclusion and abjection. To revise
Walter Benjamin's famous aphorism from "Theses on the Philosophy of

History," Rivera's film treatment suggests that there is no institution of education that is not at the same time an institution of barbarism.[69]

At UC Riverside Rivera applied the theory of critical vicarity he developed in his film and literary projects to the work of administration. Like W. E. B. Du Bois's memory of his time at Harvard, Chancellor Rivera was at but not of the university. As he noted in a speech to UCR faculty, "After my first meeting with the Academic Senate, it was reported to me that as two professors were leaving the hall, one said to the other . . . Well what do you think? . . . The other answered 'I can understand why the governor would appoint a Chicano as Chancellor for political reasons, but did he have to look so much like a Chicano?'"[70] This conviction that Rivera was out of place and would never "arrive" in the University of California was revived several years later when he was denied entry to a UC regents meeting at UCLA.[71] In a 1984 letter to Rivera, a UCLA patrol officer apologized "for any embarrassment I may have caused you" by blocking his entrance to the meeting. "I was advised to keep the public out of the area reserved for the University's top officials," and the officer thought Rivera "had been in the visitor's section." When Rivera identified himself as the Riverside chancellor the officer said he didn't recognize him and so made Rivera wait while he consulted an official UC photo of the chancellor to verify his identity.[72] In her UCR oral history, Rivera's wife, Concha Rivera, recalls feeling that in the "conservative town" of Riverside, he received intense scrutiny. Many people on campus were unsupportive and unwilling to follow his leadership, wondering "can Hispanics do this kind of job?"[73] Concha Rivera's memories suggest that, because he was Mexican, Rivera was "presumed incompetent" by some faculty on campus.[74] This is borne out by faculty responses to drafts of his strategic plan that are condescending, disrespectful, and steeped in prejudice.

Rivera entered the UC system in the wake of the *University of California v. Bakke* Supreme Court decision (1978), which chilled affirmative action efforts in the UC system, as well as California Proposition 13 (1978), which reduced property taxes and threatened state support for public education. In the wake of new budget austerity, in 1982 UC president David S. Saxon pressed Riverside to cut departments and programs judged unworthy. In addition to decreasing the allocation of faculty positions, Riverside was asked to review and terminate graduate programs with a high application-to-acceptance ratio and to disestablish small undergraduate programs such as Black studies and Chicano studies with lower-than-demanded enrollments. This was a major

moment in the history of public university privatization, when the UC Office of the President (UCOP) effectively opposed movements for open enrollment and related democratizing impulses by reasserting models of academic value based in scarcity and exclusiveness.

As Rivera worked with his cabinet and consulted with faculty to formulate an answer to UCOP, his critics on campus argued that UCR should respond to budget cuts by becoming even more focused on agricultural research. The chair of the Academic Senate and professor of earth sciences, Michael O. Woodburne, wrote Rivera to point out a number of perceived errors and oversights in the draft strategic plan, even complaining that it was poorly written. Woodburne was especially upset that the chancellor hadn't given enough attention to UCR's Agricultural Experiment Station, writing in all caps, "IT IS MISLEADING AND UNREALISTIC TO MAINTAIN THAT UCR NOW IS, EVER WAS, OR EVER SHALL BE, A GENERAL CAMPUS. THE AES ALWAYS WILL BE A MAJOR FACTOR OF IMAGE ON THIS CAMPUS. UCR WILL NEVER BE LARGE ENOUGH TO RELEGATE THE AES TO THE SIGNIFICANCE OF A PARAGRAPH." In the same letter Woodburne criticized as unnecessary the chancellor's affirmative action policies.[75]

Rivera faced another powerful critic in Donald T. Sawyer, a founding member of the Chemistry Department, who wrote the chancellor to express his "disappointment and discouragement" over the draft. Sawyer insisted that "the only viable goal for the UCR campus is to achieve scholarly excellence in a selected group of academic programs" such as the "Agriculture of Plant Crops" and related fields in the natural sciences. He concluded that "to advocate the continued development of marginal programs (those without a distinguished faculty that is engaged in research and graduate education) in the interest of increased enrollments is akin to the inclusion of a diseased prostitute on an Olympic team in the interests of fund raising."[76] Since the handful of departments under review for possible disestablishment prominently included Black studies and Chicano studies, Sawyer's simile is a valuable reminder of how raced and gendered respectability politics govern university administration. UCOP's stipulations regarding applicant-to-acceptance ratio could be read in a similar way, suggesting a model of academic value based in exclusivity and implying that graduate programs that accept large numbers of their applicants are too common or "loose" to be excellent. Rivera's experience in the UC system makes visible the ways academic excellence overlaps with and draws on idealizations of white, heteronormative respectability elaborated by both Hollywood films and university administrations.

Rivera's views on community wisdom put him at odds with a hierarchical administrative culture based in exclusive models of excellence. In his university oral history, Sawyer fondly recalls the "gentleman's club" of five white male faculty members in the sciences who effectively ran the university in the 1950s, "close personal friends" who "entertained their families on a social basis."[77] That gentleman's club ethos continued while Rivera was chancellor, as suggested by a letter sent to him by professor of biology Eric T. Pengelley. In his absence while on sabbatical in Europe, Pengelley advised the newly appointed Rivera to "seek and heed the advice" of three male faculty, including Sawyer, "*above all others* [emphasis in the original]." They know how the University of California works, what ails Riverside, and what to do about it. You are taking over a sick campus, which is greatly to your credit, but you will need the best advice you can get."[78] In contrast with Rivera's farmworker origins, Pengelley's UCR obituary notes that he grew up "on a colonial plantation in Jamaica, where his father was the engineer, and from which he was sent annually on the 'banana boats' to boarding school in England."[79]

Historically, UC Riverside has served as one of the research wings of California's plantation-like agribusiness industries. Hostile responses from science faculty to Rivera's strategic plan reflect UCR's historical basis in agricultural research. In 1982 the university celebrated the seventy-fifth anniversary of the founding of the Citrus Experiment Station (CES) with a series of events, many of which were presided over by Rivera. UCR began when, in the words of seventy-fifth-anniversary promotional material, "citrus growers, the kingpins of the rural economy of Southern California in the 1900s," successfully lobbied the California legislature for the CES. The experiment station was funded by the state legislature and founded by the UC regents in 1907. In a feat that was remembered during the anniversary celebrations as one of the CES's most significant accomplishments, researchers "established the largest collection of citrus tree varieties in the world—a veritable museum of living genetic material" with two specimens of more than a thousand different types of citrus trees.[80] CES research has been of direct interest to agribusiness because it is devoted to improving product quality, increasing yields, and protecting trees and fruit from pests, diseases, and decay. In 1982 UC Riverside estimated that CES research "saves citrus growers $25 million a year—a figure that is probably too low."[81]

Citrus is a major industry in California, and growers have thus exercised direct influence over research in the UC system. In an interview for the seventy-fifth-anniversary program, Alfred Boyce, the CES director

from 1952 to 1968, described a postwar boom in agricultural research. "The state legislature gave us lots of money. . . . Everyone was hot on postwar planting. We got just about everything we asked for. We had money for positions that we couldn't even fill. Bob Sproul, president of the University system, and his administration had Sacramento in their laps." Boyce claimed that as CES director, "You've got to have the confidence of people who make decisions and have money" and that he "gained the confidence of growers." According to the interviewer, Boyce "recalled a time when powerful figures in the University of California, the California State Legislature and the agricultural industry reached informal agreements in unofficial surroundings," including "the annual Robert Gordon Sproul Weekend, held on the several-thousand acre spread of the Andreas Canyon Club, an organization of leading growers" that seems in keeping with the historical gentlemen's club ethos at UC Riverside. In such settings, according to Boyce, "growers set priorities for what they thought should be done" at the university.[82]

By contrast, in the 1970s and 1980s, the UFW criticized the UC system for subsidizing agribusiness and the exploitation of farmworkers. In 1978 the UFW unsuccessfully demanded that the UC regents devote a percentage of resources earmarked for research into the automation of agriculture to instead fund research to aid the farmworkers who would be displaced, drawing critical attention to the public university's private subsidies.[83] As Cesar Chavez explained in a speech at Pacific Lutheran University in support of a grape boycott, historically the University of California was the enemy of the farmworker movement: "America's colleges and universities are the best research facilities in the world. But farm workers are of the wrong color; they don't speak the right language; and they're poor. The University of California and other land grant colleges spend millions of dollars developing agricultural mechanization and farm chemicals. Although we're all affected in the end, researchers won't deal with the inherent toxicity or chronic effects of their creations. Protecting farm workers and consumers is not their concern."[84]

Given UC Riverside's dependence on agribusiness patronage, on the one hand, and the farmworker movement's challenges to agribusiness and its public university research agendas on the other, it is not surprising that Rivera would face opposition on campus. His plans for UCR—including the expansion of affirmative action, support for Black studies and Chicano studies, and service to surrounding communities of largely poor people of color—clashed with agribusiness-centered views of research excellence. Given their demands for low-wage labor, it is unlikely

FIGURE 25. Chancellor Tomás Rivera plants an Oroblanco tree in commemoration of the seventy-fifth anniversary of the founding of the Citrus Experiment Station at UC Riverside (1982). Courtesy of Riverside Libraries, Special Collections and Archives, University of California, Riverside.

that agribusiness interests within and outside the university would be compelled by Rivera's vision of a Chicano studies curriculum (which would focus partly on labor exploitation and the farmworker movement) or, for that matter, his vision of UC Riverside as an engine of development and upward mobility for Black and Chicanx people in the region. In this context Rivera the former farmworker was in effect being pressed by powerful white male scientists to be more deferential to agribusiness. As part of the seventy-fifth anniversary of the founding of the Citrus Experiment Station in 1982, the chancellor joined faculty members in planting an Oroblanco, or "White Gold," tree on campus (see figure 25). Oroblanco is the name given to a variety of white-fleshed grapefruit bred at UC Riverside to remove the fruit's bitterness. What did Rivera think as he shoveled dirt into the hole in the earth? Did he recall harvesting onions, potatoes, and beets? Did he remember the wetback's grave?

In a direct affront to the chancellor and the constituencies he represented, soon after the CES anniversary, in the fall of 1982, members of the UC Riverside Academic Senate voted to disestablish the Black Studies Department and Chicano Studies Program. The two academic units

originated in response to students demands, as represented in a UCR promotional documentary made that year, titled *Occupation: Student* (1969) and narrated by Raymond Burr. In the film members of the BSU Board and administration leaders are featured discussing Black studies.[85] Riverside established the Black Studies Department and the Mexican-American Interdisciplinary Studies Program (later renamed the Chicano Studies Program), chaired by Dr. Maurice Jackson (sociology) and Dr. Eugene Cota-Robles (microbiology), respectively, in 1969. An assistant professor, Jackson was the only full-time faculty member in the department, with the rest working as temporary lecturers. Jackson ultimately resigned from the position, arguing that the administration had dramatically underresourced the department and, as if anticipating Rivera's fate, claiming that the resulting pressure was harming his health.[86]

Meanwhile, the BSU demanded more resources for the department and, like the protestors in *RPM*, student control over admissions and hiring. In *Occupation: Student*, Rivera's predecessor, Chancellor Ivan Hinderaker, can be heard saying that while there are "sound ways" to "develop ethnic studies," there are also "some very unsound ways," and the chancellor ultimately made it clear he found student demands unsound. In 1970 he called an emergency faculty meeting to announce the department's disestablishment and its downgrading to the status of program, arguing that conceding to BSU demands would "set a precedent for acts that could only result in the erosion and eventual destruction of quality education on this campus."[87] Hinderaker's announcement was rewarded with a standing ovation from the overwhelmingly white male faculty members present.[88] According to the *Highlander*, the UCR student newspaper, political science professor David McLellan, a self-proclaimed "elitist" and former CIA agent, led the ovation. Subsequently, the BSU offices were destroyed by arson, and the underfunded Black Studies and Chicano Studies Programs continued to scrape by until 1982, when UCR officials argued that they, too, should be disestablished.[89]

As part of the strategic-planning process and in the context of budget cuts, the dean of humanities and social sciences in Rivera's administration, David Warren, recommended that the programs be shuttered, arguing that enrollments were too low, faculties were too small and difficult to retain, and the departments' missions were not academically "legitimate." Warren was particularly critical of the Chicano Studies Program, claiming that it contributed to the "dilution of concentrated strength" in the division and that its stated aims "range well beyond those that I would define as *proper* for an academic unit [emphasis added]."[90]

Subsequently, the UCR Committee on Educational Policy concluded, "Chicano Studies does not represent an academic discipline," while "the academic quality of the [Black studies] program is questionable." Like Dean Warren, the committee used highly charged language in its criticisms of the two programs, arguing that they suffered from "excessive introspection" and an "inadequate disciplinary base," leading many on campus to consider them "academically inferior."[91] Official rhetoric painting the programs as improper, illegitimate, and undisciplined recalls the raced and gendered discourse of academic respectability more crudely represented by references to diseased prostitutes.

For over two years the Black Studies Department and Chicano Studies Program were extensively reviewed, not only by distinguished external review committees but also by numerous UCR official bodies, including the Executive Committee, the Graduate Council, the Academic Senate Committee on Affirmative Action, the Student Committee on Budget and Academic Planning, and the Academic Affairs Committee. All those bodies recommended against disestablishing the programs. Finally, both Executive Vice-Chancellor Carlton Bovell and Chancellor Rivera opposed disestablishment. To avoid the appearance of biasing the process, Rivera remained silent during the review period while ignorant and hostile faculty debated the merits of a field he had helped found. Given histories in which white male academics have valorized their own broad disinterestedness in opposition to the seemingly narrow, "introspective" self-interest of people of color, Rivera tried to stay out of the fight, anticipating, however, that the question of disestablishment was ultimately his decision. In recent history at UCR, disestablishment had indeed been the chancellor's prerogative, but as the review process came to a close, Academic Senate chair Woodburne successfully petitioned UCOP to rule that the senate was solely responsible for disestablishing programs. After stripping Rivera of the chancellor's customary authority, the Academic Senate voted to dismantle the Black and Chicano Studies Programs. At about the same time, the senate also voted to establish a new Classical Studies Program.[92] Although austerity was the initial impetus for the reviews, in the end it was widely agreed that savings from shuttering the programs were negligible, suggesting that the real dividends were ideological.[93]

Blocked from supporting Black and Chicano studies, Rivera focused on formulating a strategic plan based on wisdom about cohabitation, acceptance of multiplicity and difference, and respect for the particularities of condition and situation.[94] His views on wisdom as cohabitation

informed his vision of an inclusive university, free from judgments of "excellence" wed to histories of respectability. His strategic-planning document argued against UCOP's "appalling" method of gauging graduate program worthiness in terms of ratios of applications to acceptance, rightly arguing that "program quality is a composite of many elements." Here and elsewhere we can also detect Rivera's ideas about wisdom as acceptance of multiplicity and difference, thinking that also governed his plans to make UCR a "general university" that includes multiple disciplines and interdisciplinary departments rather than a specialized agribusiness academy. Wisdom about cohabitation and the acceptance of multiplicity and difference animated his plans for the expansion of affirmative action. As the Academic Senate debated the fate of Black and Chicano studies, and the chancellor continued to defend them, Rivera insisted it was his responsibility to faculty to "become pro-active" about affirmative action for Black, Chicano and women faculty and students.[95]

Moreover, in response to budgetary pressures, Rivera also promoted current and future efforts to increase undergraduate and graduate school enrollments and retention rates, focusing on Black and Chicano students. The chancellor detailed a series of efforts UCR would undertake to "increase Black and Chicano enrollment by at least 2.0% of the total enrollment over the next two years" and to increase Native American enrollment by 3 percent. While these goals may seem modest, such an increase in such a brief period is in fact quite significant in the life of a UC campus, particularly in a post-Bakke context of heightened scrutiny from both the Department of Justice and California voters, and when so many other administrators were running scared from support for affirmative action. Rivera affirmed the importance of affirmative action for the administration, which was overwhelmingly white and male; for the faculty, especially in the sciences; and for the nonacademic staff. Related to his affirmative action plans, Rivera's theory of wisdom as respect for the particularities of condition and situation shaped his argument that UCR's mission was to support the material development of the surrounding urban region and in support of the people of color there. As Rivera put it, "Close to 80% of our undergraduate students come from a 30 mile radius," so UCR's mission is to serve local communities.[96]

The afterlife of Rivera's tenure as chancellor is complex. His vision of the university as a place of multiplicity and an engine of regional development was undermined by budget cuts. He was caught between a privatizing UCOP and a recalcitrant "gentleman's club" at UCR, and he was unable to prevent the disestablishment of the Black Studies

Department and the Chicano Studies Program. Historically, protests by students of color raised the possibility of administration as a means of social transformation. Rivera entered administration with such ideals but found that neoliberal austerity and exclusionary ideologies of excellence reinforced each other, and together they foreclosed administration as a site for producing wisdom. True to some of his aims, UC Riverside is now a Hispanic-Serving Institution, but struggles over what Rivera would call wisdom remain at UCR in ways that are partly continuous with the past I have reconstructed here. Finally, Rivera's theories help us understand some of the terms of contemporary struggles over the university as antagonisms between wisdom and its inverse, administration.

Looking at Student Debt in Films by People of Color

Student debt cut me to the quick a few years ago while I was teaching an undergraduate class on Chicanx film and media in the Ethnic Studies Department at the University of California, San Diego. We screened *Salt of the Earth* (1954), a movie made by a New Mexican mining community and a racially integrated crew of blacklisted Hollywood filmmakers, about a recent strike, initiated by a group of mostly Mexican male miners, which was ultimately taken over by Mexican women in the community when a court injunction prevented the men from striking. *Salt* is often admired for its attempt to represent intersections of class, race, and gender, and a scene of the police interrupting a worker party to repossess a radio purchased on credit especially grabbed the attention of my students. The Quintero family lives in cheap company housing without plumbing or appliances, and the radio is their most significant piece of household property. The music it broadcasts is particularly important to Esperanza Quintero, who listens as she works around the house. For many Mexicans on both sides of the border, radios have supported transnational connections while representing symbolic states of what Deborah R. Vargas has theorized as "transport," or musical experiences that enable listeners to imaginatively fly beyond social realities and their normative, heteropatriarchal sex and gender constructions.[1] *Salt* suggests that the radio's repossession is particularly poignant because it reasserts those very limits.

When I explained that, in southwestern company towns, management used debt to control workers, one student raised her hand and

said, "That sounds like college." As other students nodded in agree-
ment, we decided to try and list points of comparison between company
towns and college campuses. Management in company towns tied
workers to the company and limited their alternatives by selling them
consumer goods such as cars, washing machines, and radios on credit;
students are tied to the university, and their options are limited by
crushing levels of debt, not only for tuition but also for books, equip-
ment, and computers, all sold by the campus bookstore. In *Salt* the
miners are dependent for food on credit from a company store, but
credit is cut off when the strike begins; at contemporary colleges and
universities students often depend on expensive dorm meal plans, not to
mention the fast-food franchises in the student union. While miners
were often paid in scrip that was redeemable only in company stores,
today's students use their university-issued IDs like debit cards to pay
for goods and services on campus. The workers in *Salt* rent company-
owned shacks and are threatened with eviction if they organize; college
students rent campus housing and often live in fear of not being able to
pay their bills and reenroll. The mining community was dependent on
the company for medical care when they were injured at work; contem-
porary students, who now tend to work long and dangerous hours and
are therefore vulnerable to injury and illness, often depend on the uni-
versity for health care. In the film the violence of debt is racialized and
gendered, such that Mexican men are more vulnerable than their Anglo
coworkers, and Mexican women are the most vulnerable of all, given
their unpaid domestic labor in substandard company housing. Most of
the students in my class were women of color, and they testified to how
debt made their lives as students precarious.

In the party scene from *Salt,* we hear in the background dance music
from the radio, as Ramón tells Esperanza of his hopes for the strike;
then we hear the voice of the police, and the music stops when they
repossess the radio (see figure 26). The radio as debt machine is internal
to the film's diegesis, the source of music the characters all hear and
dance to until the police pull the plug. In the contemporary college
scene, the machinery of debt is the student's constant surround, an
ambient feature of a world where hope is interrupted by the police,
who, in the last instance, enforce debt.

At $1.3 trillion in 2017, federal student debt in the United States has
surpassed credit card debt, emerging as a brutal force of domination in
contemporary universities and beyond.[2] As Jeffrey J. Williams argues,
student debt "is not just a mode of finance but a mode of pedagogy." It

FIGURE 26. A police officer *(left)* enters a miner's home to repossess a radio. *Salt of the Earth* (1954).

teaches that "higher education is a consumer service"; that career choices should be tailored to servicing debt; that the rule of the capitalist market is "natural, inevitable, and implacable"; "that democracy is a market" that obligates citizens to capital; and, finally, that inequality is not a collective but an individual problem.[3]

While president of the American Studies Association in 2013, I helped to organize its annual conference on the theme, "Beyond the Logic of Debt: Toward an Ethics of Collective Dissent." The theme and call for papers were collectively written by myself and the program committee cochairs Roderick Ferguson, Lisa Lowe, and Jodi Melamed. To paraphrase from the call for papers, the contemporary university of debt creates a hierarchy of value in which nonnormative immigrant, unpropertied, undocumented, Indigenous, marginalized, or queer others are cast as in debt or as "failed" subjects. For these and other reasons, the critique of student debt involves, in the suggestive phrase contributed by Lisa Lowe, "a critique of fidelity to the normative."[4] This is because student debt has become a primary means of enforcing norms of respectability that help reproduce intersecting hierarchies of difference. From such a vantage point, respectable people are free from debt or at least pay their debts, whereas to be in debt is to risk being labeled irresponsible and immoral. Because of such stigma, people in debt often internalize guilt and avoid telling others about their secret shame, such that debt dovetails with neoliberalism's reduction of structural inequalities to individual choices. Contemporary representations of student debt draw on and succeed earlier moments analyzed in *University Babylon,* particularly during Ronald Reagan's administration of the University of California and his use of fee increases to contain student dissent and make it more difficult for low-income students of color to enroll (chapter 2). Combined with his claims that white patriarchal norms of

respectability trumped academic freedom, Reagan's fee increases helped set the stage for contemporary systems of debt.

Student debt complements, in other words, university practices based on the occupation of Indigenous lands and the exploitation of disposable low-wage labor. The university domination of land and labor is pursued structurally but also ideologically, through film and other media representing campus life. But in this chapter, after providing a critical overview of student debt as a form of power, I turn to an analysis of independent films by people of color and Indigenous writers and directors that center debt and student dissent: John Singleton's *Higher Learning* (1995), Justin Simien's *Dear White People* (2014), Alex Rivera's *Sleep Dealer* (2008), Ava DuVernay's *Middle of Nowhere* (2012) and *13th* (2016), Dee Rees's *Pariah* (2011), Sydney Freeland's *Drunktown's Finest* (2014), and Aurora Guerrero's *Mosquita y Mari* (2012). Together these filmmakers represent a cohort of Indigenous and people-of-color college graduates—and in some cases with graduate film degrees—who all, to varying degrees, were inspired by their college experiences and, in several instances, by their encounters with ethnic studies readings and concepts. In other chapters I have analyzed histories of resistance to the university-cinema–industrial complex from its margins by focusing on critical forms of multiple consciousness and vicarity, as well as on the minority film cultures that infiltrated universities in the 1970s and 1980s. Here, I turn to more recent cinematic formations, which I argue represent opposition within the belly of the beast, or what we might call, following la paperson's analysis in *A Third University Is Possible*, the Third Hollywood Babylon in the First.

The final four filmmakers—Ava DuVernay, Dee Rees, Sydney Freeland, and Aurora Guerrero—represent, in particular, the emergence into cinematic visibility of women of color and Indigenous college women. A number of them were directly shaped by readings in women-of-color feminism in and around the university, and their films can be understood as cinematic mediations of such ideas. By imaging women of color and Indigenous women in college, these filmmakers dramatically break with the history of their invisibility in Hollywood films but also with the historical respectability politics that have marginalized them.

STUDENT DEBT AS DOMINATION

Student debt teaches lessons in value and difference by reproducing and rearticulating hierarchies and exclusions. According to a 2013 study by

Brandon A. Jackson and John R. Reynolds, "over 70% of Black students who borrow do not receive a college degree. Given that borrowers who do not complete their degree are more likely to be unemployed and default on their loans in comparison with borrowers who complete their degree, these Black students face long-term economic disadvantages."[5] This is particularly the case at for-profit schools, where students of color are overrepresented.[6] The numbers are similar in the case of Latinx students, and while it is difficult to find data about Indigenous students, they likely face similar burdens, as suggested by the out-of-court settlement for *Rodríguez and Gregoire v. Sallie Mae*, a 2007 class-action lawsuit alleging racial discrimination at Sallie Mae in which the loan provider agreed to include Native American students in the settlement class and to advertise the settlement in the *Native American Times*.

Rodríguez and Gregoire v. Sallie Mae was filed on behalf of a Latinx student named Sasha Rodríguez and a Black student named Cathelyn Gregoire. It alleged that the company had, in a version of student-loan redlining, calculated fees and interest rates on the basis of the racial composition of the schools attended by applicants, such that students of color attending colleges with relatively higher numbers of minority students received worse loan packages than white students attending less diverse schools. Without admitting wrongdoing, Sallie Mae settled out of court, and while the focus was on racial discrimination, it also helps us think about student debt at the intersection of race, gender, and other axes of difference.[7] Both Rodríguez and Gregoire went into debt to attend for-profit schools owned by the Career Education Corporation (CEC), which is infamous for putting profits above graduation and placement rates and whose student body is made up largely of women and people of color who are offered training in health care, restaurant and hospitality services, and fashion design and merchandising.[8]

As the example of the Career Education Corporation suggests, debt effectively tracks women of color into the service sector where, if they do get jobs, their debts tend to keep them there. Not only do women take out student loans in greater numbers than men, but, as Amanda Armstrong-Price argues, women take out larger loans than men, "anticipating that they'll need to be better credentialed to compete for the same jobs," and, because of the continuing gendered wage gap, it takes women longer to pay off their student debt. "When combined with cuts in state spending for child care, public housing, and welfare, debt-financed higher education" intensifies "the burden of unwaged domestic labor . . . that still falls unevenly on women, and particularly on women of color.

Student debt captures time that could otherwise be used for care work, among other activities, and captures income that could otherwise go to purchase increasingly privatized goods, such as childcare or housing."[9] Armstrong-Price's claims were confirmed in a subsequent study by the American Association of University Women, titled *Deeper in Debt: Women and Student Loans* (2018), which found that women hold two-thirds of all student debt in the United States, while Black women graduates held the most debt—at $30,400—compared to $22,000 for white women and $19,500 for white men. The study concluded that such disparities were compounded by family care costs and the race and gender pay gap, since "compared to white men with bachelor's degrees, Black and Hispanic women with bachelor's degrees make 37 percent and 34 percent less (respectively) and struggle to repay their loans as a result."[10] The unequal distribution of student debt along intersecting race and gender lines, in other words, compounds and extends such inequalities in the workforce.

In *How the University Works,* Marc Bousquet argues that, while administrators are mesmerized by the vision of an online university without workers, their dreams obscure higher education's ongoing dependence on the labor of part-time faculty, graduate students, and undergraduates. The last three decades have witnessed a dramatic expansion in the university's exploitation of women workers, who are overrepresented among the ranks of part-time instructors, as well as in the exploitation of undergraduate and graduate student workers, particularly young women and people of color. In such contexts the category of "student" refers to "someone who can be put to work but does not enjoy the rights of labor."[11]

The university works by reproducing hierarchies of value, forms of raced and gendered settler-colonial capitalism specific to universities as occupiers of land and employers of labor. "The typical faculty member has become a female nontenurable, part-timer earning a few thousand dollars a year without health benefits. The typical administrator is male, enjoys tenure, a six-figure income, little or no teaching, generous vacations, and great health care." "Nontenurable faculty" and nonteaching staff are more likely to be women and people of color than the tenure-track faculty, while administrators are more likely to be white the higher they are in university hierarchies. The ranks of casual, flexible workers in the university are made up of graduate students and former graduate students, often working at poverty wages to service their student loan debts. University regimes of debt devalue student labor to better exploit

it by constituting graduate student work as simultaneously racialized and gendered forms of service. The case of undergraduate workers compels a similar conclusion. About one-third of college students work thirty-five hours a week or more, but often without the kinds of benefits traditionally linked to full-time employment.[12] A large number work directly for the schools they attend, while, in many other instances, universities partner with private employers to provide them cheap student labor. Finally, while access and degree rates remain relatively low, when students of color *are* included in the university, it is often as unpaid diversity workers, not only simply by virtue of their presence on campus and in university promotional materials as representations of institutional diversity but also in terms of the formal and informal labor of recruiting and retaining other students of color—work universities often outsource to students.

The story of two undergraduate roommates, Paige Laurie and Elena Martinez, suggests how universities of debt reproduce students as raced and gendered workers. Laurie is the heir not only to the Walmart fortune but also to the system of managing a flexible workforce that Walmart pioneered and that contemporary universities emulate. Her parents are also corporate university partners, having given a $25 million naming-rights gift to the University of Missouri to build a basketball stadium named for their daughter. The purchase of naming rights by wealthy patrons has a long history, linking universities to white supremacy and empire. As Gauri Viswanathan wrote about the naming of Yale after an East India Company merchant, the practice of naming institutions after individuals "gestures toward the survival of the institution beyond the limited lifespan of the individual" by metaphorically translating "biological reproduction into institutional growth." In this regard "the power of naming" represents a "form of appropriation and possession paralleling—indeed, even perpetuating—acts of territorial acquisition."[13] Given that many land-grant campuses such as the University of Missouri sit on Native land, we can read the claiming of naming rights as a settler-colonial gesture consistent with Walmart's broader exploitation of Indigenous workers, lands, and resources.[14]

In 2001 Laurie the Walmart heir enrolled at the University of Southern California, where she met Elena Martinez. From the working-class desert community of Banning, California, Martinez joined the Army Reserves and took out student loans to pay tuition. After Laurie graduated with a degree in communication, Martinez, who remained degreeless, appeared on the news show 20/20 and revealed that for three and a

half years Laurie had employed her to write all her course papers and emails to professors. Martinez was ultimately forced to drop out and reenroll in a community college when she could not afford USC's tuition, but she continued to write Laurie's papers for pay.[15] In her interviews with the press, Martinez makes visible the material and ideological pressures that discipline raced and gendered student labor. Like many students, she was forced to service debt by working in undesirable and precarious jobs, including not only her work for Laurie but also for the Army Reserves, which she joined at a particularly dangerous time in the aftermath of 9/11. Martinez's roommate treated her like a domestic servant: "She's always had everything done for her. . . . When she first came I taught her how to do her laundry. I did some of it for her sometimes," Martinez told 20/20.[16] The fact that Laurie required her not only to write course papers but to email professors further suggests the relationship between a manager or administrator and a secretary, a job that, like that of a housekeeper, is also often a raced and gendered position, including in many universities. And the Walmart heir was a stern supervisor, sweating her employee to produce the most for the least by yelling at Martinez for small errors in punctuation or a less than perfect grade.[17]

In a related way, universities and corporations increasingly mobilize ideas about diversity as a way to control workers. A good example is the UPS "earn and learn" program, in which the company partners with universities to supply undergraduate workers for packing facilities euphemistically referred to as "colleges." In Jodi Melamed's account, the UPS slogan, "What can brown do for you?," exemplifies "neoliberal multiculturalism." As she writes, "Brown emerges as an antiracist coalition-building term among people of color, a shorthand for racial pride and solidarity that short-circuited restrictive black-or-white notions of race relations." The UPS appropriation of "brown," however, "kept the color but blotted out the people and the movements." UPS in effect sublated "brown," canceling out its antiracist history while preserving its positive associations with "pride, warmth, solidarity, and functioning community networks." "More insidiously," Melamed concludes that the slogan, "What can brown do for you?" plays on "racist associations of people of color with service."[18] Melamed's analysis helps us understand UPS's exploitation of student workers in the guise of multicultural education and diversity. Historically, UPS has recruited college students to work the worst and most dangerous shifts loading packages. The company presents the fiction that students are working toward a degree, but the reality is that taking a job at UPS dramatically reduces a

student's chances of graduating. Meanwhile, UPS continues to target women and, ironically, given the history of its slogan, Latinx students for low-wage service work.[19]

In *The Reorder of Things: The University and Its Pedagogies of Minority Difference*, Ferguson presents a compelling framework for understanding the university's mobilization of intersecting differences of race, gender, class, sexuality, ability, and nation in the production of surplus values. Whereas student movements in the 1960s and 1970s insisted both on more equitable forms of racial representation *and* on material redistribution, universities responded by focusing on representation as a way to contain demands for redistribution. Universities became laboratories experimenting with new techniques for managing differences by absorbing them. According to Ferguson, "the academy and things academic" became "conduits for conveying unprecedented forms of political economy to state and capital, forms that would be based on an abstract—rather than a redistributive—valorization of minority difference and culture."[20] Instead of imagining contemporary universities as reflections or extensions of forms of neoliberalism produced elsewhere, as is sometimes suggested by terms like the "corporate university," Ferguson concludes that in recent history it has in fact been the university that "socializes state and capital into emergent articulations of difference."[21] Student debt, in particular, educates the world around it in the inevitability and indeed justice of raced and gendered capitalism and the exploitation of low-wage minority workers, both inside and outside the academy.

The analytic of student debt further opens possibilities for comparative, transnational, and global critical thinking and action such as those explored by Edufactory, "a transnational collective engaged with the transformations of the global university and conflicts in knowledge production." Its website collected and connected "theoretical investigations and reports from university struggles," and the network "organized meetings all around the world, paying particular attention to the intertwining of student and faculty struggles." Edufactory also produced a web-based journal of the same name, and in its first issue (January 2010), the editors outlined "the double crisis" produced by contemporary regimes of debt: the crisis of the university and "the crisis of post-fordist conditions of labor and value, many of which are circuited through the university."[22] This double crisis, they stress, is global, and the inaugural issue includes essays about the United States, Africa, Europe, and South America.

The contribution to the issue by George Caffentzis about African universities provides a particularly important point of comparison for American studies scholars. He argues that World Bank demands for cuts in African state spending on higher education during the 1980s reproduced neocolonial labor relations. Spending cuts effectively downgraded universities, reproducing Africa's historically subordinate position in the global economy as a source of resources and cheap labor by further marginalizing Africa in the world patent system and by increasingly training students for manual labor. While the African situation is dramatically different from the North American, the history recounted by Caffentzis roughly coincides with the history of cuts in public funding for U.S. higher education in the 1980s and 1990s and the increasingly extensive reproduction of students as flexible workers.[23]

In a related way, we can understand regimes of student debt as a defining feature of what Sunaina Maira and Piya Chatterjee call the "imperial university." Their edited volume of the same name analyzes the imperial dimensions of contemporary struggles over privatizing universities.[24] Rather than disinterested bystanders or even byproducts of imperialism, they suggest, contemporary U.S. universities are imperial institutions with multiple direct and indirect connections to militarized state power. In the first place universities silence dissent from post-9/11 U.S. imperialism, and the volume includes contributions from scholars who have been at the center of conflicts over academic freedom. Several chapters foreground the limits and contradictions of the forms of academic freedom that have been used to sanction student and faculty critics of the U.S. war on terror and of Israel's occupation of Gaza and the West Bank. *The Imperial University* persuasively demonstrates that far from being exceptional or marginal, such repression is a normalized and constitutive component of U.S. imperialism. Contemporary universities also produce military weapons and strategies, as well as cultural knowledge about race, nation, and religion, which often supports U.S. militarism.

Maira and Chatterjee argue that universities are complicit in the history and present reality of U.S. settler colonialism, including post-9/11 knowledge production but also efforts to limit dissent from the U.S. war on terror and from U.S. support for the Israeli occupation of Palestinian territories in the face of faculty and student calls for boycott, divestment, and sanction. Indeed, as I suggest throughout this book, the history and present context of U.S. universities overlaps with the history and present context of U.S. settler colonialism in multiple ways. In *Ebony and Ivy: Race, Slavery, and the Troubled History of America's*

Universities, Craig Steven Wilder argues that settler colonialism and slavery were materially and ideologically intertwined with the founding and consolidation of powerful northeastern universities such as Harvard, Yale, Princeton, Dartmouth, and the University of Pennsylvania, from the colonial period to the mid-nineteenth century. *Ebony and Ivy* demonstrates that colonial universities often served as garrisons helping fortify settlements, while administrators, faculty, and graduates participated in missionary efforts and anti-Indian warfare.

Colleges grew by appropriating Indigenous land and investing in southern and Caribbean plantations. Planters, slavers, and the merchants who profited from slavery served as trustees and were the most important donors in the early history of universities. Northern campuses catered to the white male planter and merchant class for donations and enrollments. The colleges, moreover, were built by Native American and African slave labor. Owning Indigenous and African slaves was the norm for the majority of college presidents and for many faculty and students, such that college campuses were often sites of white supremacist violence where slaves were imprisoned, whipped, raped, and tortured. At the same time universities were invested in the production of racist knowledge purporting to demonstrate white superiority and Black and Indigenous inferiority.[25]

From the colonial era to the mid-nineteenth century, higher education was built on a foundation of settler colonialism and slavery that continues to serve as part of the sedimented conditions of possibility for contemporary universities. A longer genealogy of U.S. universities and settler colonialism includes the appropriation of Indigenous land to build colleges, the establishment of Native American boarding schools; the history of racist team mascots and of Indigenous protests against them; university resistance to demands for the repatriation of Indigenous remains; the struggles of Indigenous students, intellectuals, and activists over existing universities and efforts to produce alternative educational institutions; and, finally, of course, the marginalization and indebtedness of contemporary Indigenous college students.

To return to *The Imperial University,* Maira and Chatterjee begin the introduction by describing—the first from the perspective of her university office in the United States and the second from Ramallah, Palestine—the heavy-handed police responses to student protests over a 31 percent fee increase at the University of California, including the widely disseminated images of a UC Davis campus police officer pepper spraying peaceful protestors, which raises the question: what is the relationship

between the disciplining of campus dissent by settler-colonial militarism, on the one hand, and the disciplinary force of student debt, on the other?

In distinct yet not unrelated ways, both student debt and the occupation of Palestinian territories cut to the heart of articulations of a right to education, or, more broadly, what Stefano Harney and Fred Moten call "study," a practice of collective thought and social activity antagonistic to market logics. This point is suggested by a contribution to *American Quarterly* by Rana Sharif titled "The Right to Education: La Frontera to Gaza." Sharif's essay was part of a forum based on a teach-in at USC organized by Laura Pulido and David Lloyd to consider "the connections and differences between the struggles of the Chicana/o and Palestinian peoples."[26] Sharif notes that the "cartography" of the Israeli occupation, with its "fragmentation of land due to borders, checkpoints, barricades, and the apartheid wall," limits Palestinian students' access to education. The wall, for example, blocks the path of 36 percent of students at Al-Quds University and prevents about 15,740 students from reaching their schools, while over 90 percent of An-Najah University students report missing classes because of checkpoint delays. Palestinian students are also often harassed and detained for their campus organizing efforts. Finally, Sharif argues that the educational system in the occupied territories often elides knowledge about Palestinian history and culture: "The systematic denial by Israel of the histories of the expulsion of Palestinians from their homes, the fate of the refugees, and the destruction of Palestinian villages amounts to an attempt at eradicating any cohesive Palestinian identity."[27] The material obliteration of Palestine is thus complemented by its ideological erasure in education.

Sharif draws on the work of Birzeit University's "Right to Education Campaign," and story titles circulated on their website provide a concise taxonomy of how the occupation blocks Palestinian education: "Students in Detention"; "Closure of Educational Institutions"; "The Wall's Impact on Education"; and "Incursions and Attacks" on Palestinian schools and universities. Their website also reported on how the Israeli blockade of Gaza has financially devastated both universities and students, who have increasingly gone into debt. Finally, Birzeit's website has featured notices of boycott, divestment, and sanctions endorsements from non-Palestinian student groups focused on the abolition of student debt.[28] The student-led BDS movement on college campuses could thus also be described as part of a broader effort to take some control over the student debt financing of settler-colonial violence.

THE CINEMA OF STUDENT DEBT

A comparative, global lens for understanding the political significance of student debt is suggested by John Singleton's *Higher Learning*, set at the fictional "Columbus College" and based on his years as a screenwriting student at USC.[29] Revising the tradition of college sports as white supremacist spectacles, *Higher Learning* begins with a fascist football rally. Immediately after the opening credits, the film jump cuts to an image of the U.S. flag that completely fills the screen, as a marching band plays on the soundtrack. In a long crane shot, the camera pans down from the flag to focus on the students beneath it, raising their right arms and extending two fingers in the USC victory salute while shouting "fight, fight, fight." The camera travels over a marching band, color guard, and a crowd of mostly white students making the salute before zooming in to follow one of the film's protagonists, a Black student named Malik Williams (Omar Epps) as he navigates a white sea (see figure 27). The scene ends with a deep-focus crane shot depicting the rally in the background and, in the foreground, the face of Columbus on the school's statue of the explorer.

As Singleton describes it, "This rally is a kind of Fox parody of USC, you know, my days at USC, they did this and I always thought it was fascist, you know like really Leni Riefenstahlish. . . . It's a matter of school pride but these kids are all closet fascists. At least that's how I felt as a Black student like this kid right here."[30] Singleton grew up in South-Central Los Angeles, near USC, and the director's recollections of feeling that he was walking among white supremacists on campus reminds us not only of the history of eugenics research at USC (see the introduction) but also of the university's domineering relationship with the Black and Latinx neighborhoods surrounding it, including the heavy-handed use of campus police power. Singleton's view would perhaps have been reinforced by former president Ronald Reagan's visit to USC in 1989, while Singleton was a student. An icon and agent of white nationalism on college campuses (chapter 2), Reagan had long been materially supported by members of USC's administration.[31] The Trojan marching band fictionalized in *Higher Learning* has repeatedly saluted him, performing a rousing musical send-off when he left Southern California for Washington in 1980, playing at his second inauguration in 1984, and performing "Hail to the Chief" upon his return to California in 1989, when he was made an honorary Trojan. In his final speech on campus,

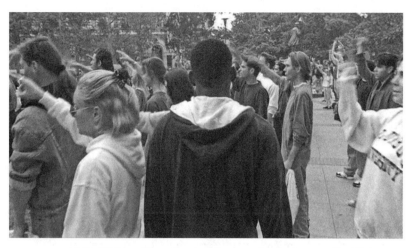

FIGURE 27. Malik Williams (Omar Epps) walks through a fascist pep rally. *Higher Learning* (1995).

Reagan was serenaded by the marching band as he performed the USC victory salute satirized by Singleton.[32]

Made in the wake of celebrations for the Columbus Quincentenary, *Higher Learning*'s statue of Columbus references the complicity of universities in conquest. A double for USC's famous statue of Tommy Trojan, the Columbus statue also memorializes the historical partnership between Hollywood and the academy. USC installed its statue of the sword-wielding Trojan warrior in honor of Warner Brothers Studio head Jack L. Warner, who was made an honorary alumnus and presented with a desk-sized replica of the statue as part of the school's fiftieth-anniversary celebration.[33] Tommy Trojan marked the institutional alliance between the studio system and the university, and so Singleton's substitution of the Columbus statue is doubly significant, speaking to conquest and domination in both academic and cinematic institutions. *Higher Learning*'s statue represents the explorer with a sword and a rolled-up document resembling a club. (Life recently imitated art when the USC film school installed a statue in its Spanish-style courtyard of white nationalist icon Douglas Fairbanks, similarly holding a sword and a rolled-up script.)[34] The plaque on the Columbus statue includes a Latin inscription, reading, "Columbus University, because of the gold that they have taken and because of the blood that has flowed." Echoing *Brother Rat* (1938), where Ronald Reagan's character rallied with

his white Virginia Military Institute classmates at a statue of Confederate general Stonewall Jackson, in *Higher Learning* Nazi skinheads meet at the university's Columbus statue. Signifiers of conquest extend to the school's logo, the letters "CU" in gold and topped with the image of one of Columbus's ships; its pennant, emblazoned with the word "CONQUERORS"; and its lecture halls, decorated with paintings of Columbus landing in the Americas.

Higher Learning's setting is thus steeped in histories of conquest that remain living forces shaping the film's narrative about contemporary college students. During a party scene at the start of the school year, the radical Black college student nicknamed Fudge (Ice Cube, who, like Singleton, also grew up in the shadow of USC) enlightens his peers on how the world is dominated by debt: "Man, governments ain't running things no more. Financial institutions, they controlling the whole scene. You ever hear of the World Bank or the IMF. Nah, huh, y'all probably don't even have checking accounts. But y'all got them credit cards, huh. Buy stuff out your means and wonder why you're still a slave." Fudge's global perspective on debt is localized in a subsequent scene where, in a large lecture hall decorated with a painting of Columbus, political science professor Maurice Phipps (Lawrence Fishburne) asks for a volunteer to read names from a list and then tells those students to stand as he announces that "your financial bill has of yet not been paid. You may leave and settle your debts; however, you may not return to this course until you have done so. There are no handouts in the free world, and, appropriately, none in my course." The scene effectively dramatizes the politics of respectability and shame articulated to student debt and framed as part of a global history of conquest.

In the 2013 American Studies Association call for papers, we raised questions about how debt shapes relationships between the Global South and North and to what extent strategies first deployed in the South have subsequently been extrapolated among the poor in the North. Such a periodization is supported by the history of Chile, where the neoliberal experiment in higher education began with the installation of army officers as administrators, anticipating the recent renewed militarization of U.S. campuses and the appointment of former military leaders to positions as university teachers and administrators.[35] But *Higher Learning* also suggests an expanded historical frame for understanding austerity measures in the North and South not as successive but as overlapping and, in many ways, convergent projects. (Five years after the release of *Higher Learning*, Elena Martinez would arrive at USC.)

In keeping with an overlapping and convergent North-South genealogy, I first began thinking about student debt in the wake of the mass student protests against budget cuts and increased tuition starting in the fall of 2010 in Puerto Rico, Europe, and the United States. Such protests at the University of California, San Diego (UCSD), were followed in February by protests in response to a blackface fraternity party called the "Compton Cookout" and the larger pattern of structural racism on campus that made it possible. The invitation for the event, billed as a commemoration of Black History Month, provided detailed suggestions for parodying Black people, especially Black women:

> For guys: I expect all males to be rockin Jersey's, stuntin' up in ya White T (XXXL smallest size acceptable), anything FUBU, Ecko, Rockawear, High/low top Jordans or Dunks, Chains, Jorts, stunner shades, 59 50 hats, Tats, etc. For girls: For those of you who are unfamiliar with ghetto chicks—Ghetto chicks usually have gold teeth, start fights and drama, and wear cheap clothes—they consider Baby Phat to be high class and expensive couture. They also have short, nappy hair, and usually wear cheap weave, usually in bad colors, such as purple or bright red. They look and act similar to Shenaynay, and speak very loudly, while rolling their neck, and waving their finger in your face. Ghetto chicks have a very limited vocabulary, and attempt to make up for it, by forming new words, such as "constipulated," or simply cursing persistently, or using other types of vulgarities, and making noises, such as "hmmg!," or smacking their lips, and making other angry noises, grunts, and faces. The objective is for all you lovely ladies to look, act, and essentially take on these "respectable" qualities throughout the day.

Given the hypervisibility of representations of young Black men from Compton in popular culture, notably in works by Singleton and Ice Cube, it is striking that the Compton Cookout invitation disproportionately focuses on Black women. In this way the invitation exemplifies what Moya Bailey has theorized as "misogynoir," or "the unique anti-Black racist misogyny that Black women experience."[36]
As Baily and her coauthor, Whitney Peoples, elaborates,

> *Misogynoir* describes the co-constitutive, anti-Black, and misogynistic racism directed at Black women, particularly in visual and digital culture. The term is a combination of *misogyny*, "the hatred of women," and *noir*, which means "black" but also carries film and media connotations. It is the particular amalgamation of anti-Black racism and misogyny in popular media and culture that targets Black trans and cis women. Representational images contribute to negative societal perceptions about Black women, which can precipitate racist gendered violence that harms health and can even result in death.[37]

The Compton Cookout invitation similarly constructs an anti-Black, misogynist, and classist image of Black women based in popular visual culture. Its reference to Compton, for example, evokes Singleton's *Boyz n the Hood* (1991), a film that Michelle Wallace argues "demonizes black female sexuality."[38] By suggesting "Shenaynay" as a model for non-Black women partygoers, the invitation also refers to the character of Sheneneh Jenkins from the TV sitcom *Martin* (1992–97). Played in drag by Black comedian Martin Lawrence, Sheneneh manages Sheneneh's Sho' Nuff Hair Salon. As described on Wikipedia, "she is an exaggerated parody of a stereotypical 'ghetto girl' from Detroit." Wikipedia further describes the character as grotesque relative to white norms of gender and sexuality: "nature has endowed her with a disproportionately over-sized ghetto booty. . . . Full of quirks, Sheneneh is tall and thick in build and often describes herself as a *'la-a-a-dy.'*"[39] More recently, Lawrence's character was reappropriated in the form of "Shanaynay," a popular "ghetto girl" character performed by white YouTube star Shane Dawson in a series of videos made between 2008 and 2010. As Shanaynay, Dawson makes racist anti-Mexican and anti-Asian cracks and jokes about Rianna's beating by Chris Brown.[40] The Compton Cookout organizers thus drew on misogynoir film and media to denigrate people who are dramatically underrepresented at UCSD while demeaning their Black women classmates.

A student-generated anticipation of renewed culture wars on campus, the Compton Cookout attacked Black access to the university, a point forcefully made by student activists at UCSD. Understanding the Compton Cookout as an expression of the longer history of structural racism, sexism, and classism at UCSD, students and faculty spotlighted the school's "yield" problem, meaning its inability to enroll even the relatively small number of Black students admitted. As the university's own 2007 *Yield Report* indicated and as students and faculty reminded the administration during protests and negotiations, only around 13 percent of Black students admitted decided to come to UCSD, versus UCLA's 44 percent yield rate. UCSD ethnic studies and critical gender studies professor Sara Clarke Kaplan put it best when she said on local public radio, "It's not that students—that there aren't tons of very qualified if not over qualified young African-American students who are being accepted to UCSD about at the same rates as at Berkeley or UCLA, it's that we actually can't seem to get them to come" because of "a longstanding campus climate . . . of hostility and alienation toward African American students and other students of color."[41]

In response, the BSU demanded the necessary redistribution of resources to transform that climate, including material support for the recruitment and retention labor that students of color have historically performed for free: "In regard to access to higher education for underrepresented students we demand permanent funding for student-initiated access programs. As a public institution, UCSD has a responsibility to the historically underrepresented communities that it should serve on top of the fact that it has a Student-Promoted Access Center for Education and Service doing more than enough work in the field of access. SPACES is a student-run, student-initiated center, meaning that the STUDENTS are doing the work that the university should do."[42] Their demands were made in a context of state disinvestment in public education, higher fees, and hence expanded student debt—some of the conditions for Black exclusion and the reproduction of anti-Black racism. A month after the party, as part of protests against state funding cuts for higher education, students at UCSD in effect framed the Compton Cookout as part of a raced and gendered budget crisis.[43]

Just as the Compton Cookout drew on film and media, writer and director Justin Simien referenced the event in his film *Dear White People,* a college race satire that culminates with a "ghetto" blackface party. The movie's party invitation quotes directly from the Compton Cookout invitation, and the final credits include screen grabs of online news stories about anti-Black and anti-Mexican parties at Dartmouth, the University of Florida, the University of Southern Mississippi, Penn State, and, finally, UCSD. The queer Black director grew up in Houston, and, echoing Singleton's time at USC, Simien drew on his experiences as one of the few Black students at the largely white, private Chapman University in Orange County. But he was also inspired by UCSD: "There was a blackface party in [an earlier version of] the movie, and I took it out. I just thought, I'm pushing this thing way too far. And then it made national news: UC San Diego had the Compton Cookout incident. And that began my whole rabbit hole research experience where I realized how prevalent the blackface parties were. It was just kind of interesting that, in the Facebook age, they're bubbling up to the mass culture."[44] The director here suggests that satire was outstripped by social reality, thus belying narratives of postracial "progress." The initial surprise that blackface has become newly popular in the era of social media gives way to the recognition that it never really went away. If blackface and other forms of racism keep "bubbling up" on college campuses, it is partly because they have been built on a foundation of white supremacy newly reinforced by regimes of debt.

FIGURE 28. Film student Samantha "Sam" White (Tessa Thompson) points her camera at the viewer. *Dear White People* (2014).

Responding to the Compton Cookout and material questions of access and student debt, Simien remixes the history of the college film genre analyzed in previous chapters. Set at the fictional Ivy League school Winchester University, *Dear White People* focuses on four Black students: Sam (Tessa Thompson), a biracial Black feminist activist, filmmaker, and host of the titular campus radio show (see figure 28); her ex-boyfriend, Troy (Brandon P. Bell), the son of Winchester's dean of students and a "talented-tenth" aspirant; Coco (Teyonah Parris), a working-class woman from the South Side of Chicago who disidentifies with her origins; and, finally, Lionel (Tyler James Williams), a queer nerd and school newspaper reporter who is marginal to both white and Black settings.

I began this book by analyzing the college friendship between Thomas Dixon and Woodrow Wilson that helped make *The Birth of a Nation* a box office success, and in *Dear White People* we come full circle with the silent-film parody of *Birth* that Sam makes for her film class, depicting white actors in whiteface pantomiming racist hatred for Barack Obama. As in previous college films, *Dear White People* presents Winchester as a setting for engaging heterosexual romance, family, and racialized and gendered ideas about knowledge and respectability. For much of the film Troy, the son of Winchester's Dean Fairbanks, negotiates a homosocial triangle with Sofia, the white daughter of his father's boss and rival, President Fletcher, and her brother, Kurt, who first proposes the Compton Cookout-like party. Doubling Troy's love affair, Sam is secretly involved

with a white graduate student, her film studies teaching assistant Gordon. When asked "why there are so many parents and adults in *Dear White People* even though it's ostensibly about college kids," Simien answers that the college administrators in the film figure the "weight of racial identity" in which previous generations' view of "what a Black man should look like and do in the world" represents a genealogical "pressure on me that, frankly, I had to overcome to become the person I am."[45]

That answer suggests a broader historical reading in which the college film genre's race, gender, and sex history weighs on *Dear White People* as that which is to be overcome. Troy splits with Sofia and hooks up with Coco, over the objections of his father, the dean. Sam's relationship with her teaching assistant is unresolved and made more complicated by a relationship with fellow Black activist Reggie. Finally, the film critically foregrounds the homosocial desire implicit in blackface. When Lionel busts up the blackface party, he is tackled by an enraged Kurt, who straddles him and threatens to rain down blows, as a crowd cheers him on. But Lionel responds by saying, "Looks like you've got me right where you want me" before pulling him down for a kiss. Whereas college films have often focused on the reconciliation of white fathers and sons and the resolution of class and other conflicts in heterosexual white marriage (chapters 1 and 2), the erotic relationships in *Dear White People* lead to conflict and unresolved questions. Like many of the works discussed in earlier chapters, Simien's film presents race, gender, and sex relationships on campus as problems that drive the narrative. But whereas other films resolve such problems with endings that celebrate white marriage and family and the exclusion of people of color, *Dear White People* preserves the problems but edits out the college genre's third-act marriages and father-son reconciliations.

Dear White People's depiction of Mexicans follows a similar logic of debt to, but transcendence of, college film conventions. As preceding chapters indicate, from the silent era to the present, the figure of the Mexican college student is largely excluded from the genre. While *Dear White People* doesn't include any Mexican or Latinx characters, in a significant break with generic conventions, it critically foregrounds Mexican exclusion. As if recalling blackface, the character of Lionel wears a "Mexico" T-shirt depicting a sombrero-wearing frog mariachi band. Further, when responding to the critique of white racism in Sam's radio show, President Fletcher articulates a postracial perspective that affirms a Mexican exception, telling Dean Fairbanks that "racism is over in America. The only people thinking about it are, I don't know,

Mexicans." In all these ways the film signals its debts to the college film genre but cancels them, as it were, by deconstructing its norms.

Finally, *Dear White People* revises conventions by spotlighting debt. College films are often premised on the budgetary challenges faced by universities, which are usually dramatized in terms of heterosexual white families. College movies are peopled with donors, presidents, deans, professors, coaches, and students who are also fathers, brothers, sisters, and lovers. The films of Ronald Reagan are exemplary in this regard since, in both *Bedtime for Bonzo* (1951) and *She's Working Her Way through College* (1952), material support for the university depends on normative resolutions of white differences in family reconciliation and marriage. In *Dear White People* the university's financial problems are also entangled with family melodrama. Angered by Sam's radio criticisms of white privilege at Winchester, President Fletcher exclaims, "Free speech, my ass!" and cancels her show, fearing it will turn off donors and make it impossible to clear the university's debts. But what does it mean to imagine an Ivy League school in debt?

An Ivy League school with a deficit makes sense only as a MacGuffin. Introduced into film studies by Alfred Hitchcock in a lecture for a Columbia University film class, a MacGuffin is a person, thing, or even an abstract goal or aim that motivates characters and drives the forward movement of a film's plot, even though the MacGuffin itself remains unnarrated, an object tasked simply with supporting the larger story. A famous example occurs in Hitchcock's *North by Northwest* (1959), where characters pursue a pre-Columbian statuette. As Juan Bruce-Novoa writes in his essay "When West Was North: Spirits of Frontier Experience, or Can the MacGuffin Speak?," the statuette "supposedly contains invaluable microfilm, although in MacGuffin fashion the audience is never shown the content or told what information it carries. . . . And it functions perfectly in the film, serving its purpose then receding to the fringes of memory from where it provokes no question about the plot or its meaning that might undermine the rhythm of the denouement or the audience's pleasure in a well-rounded plot."[46] Bought at auction by the film's villain, the pre-Columbian artifact, identified in the screenplay as a statue of a "Tarascan Warrior from the state of Kolemia [*sic*] in Mexico," reminds us of the historical traffic in Indigenous art. The statuette is thus a metonym for conquest, and hence this Mexican MacGuffin is an apt symbol for *Dear White People,* where Winchester University's deficit alludes to the longer history of the Ivy League's dependence on the expropriation of Indigenous lands and the exploitation of Black labor. Indeed, in *Dear White People*

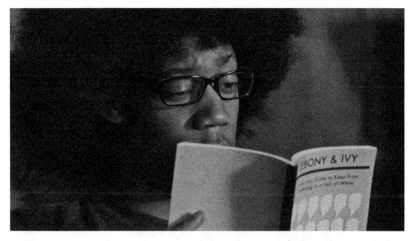

FIGURE 29. Journalism student Lionel Higgins (Tyler James Williams) reads *Ebony and Ivy. Dear White People* (2014).

the title of Sam's self-published book, *Ebony and Ivy: A Survival Guide to Keep from Drowning in a Sea of White*, seems to cite Wilder's work (see figure 29). Whereas student-debt discourse reproduces forms of shame and respectability that have historically excluded or subordinated students of color, with its representation of university debt as MacGuffin, *Dear White People* turns the tables, calling attention instead to the university's indebtedness to histories of theft and inequality.

The colonial past weighs on the present and future in college films. Debt confines students to the status quo by colonizing the future, tying present activities to plans for servicing its imperatives and limiting time for reflection, experimentation, protest, or any other unprofitable endeavors. As Armstrong-Price writes, "Debt carries a gravitational force, which draws students on into futures subordinated to its imperatives . . . giving them less time for organizing strikes, and other uneconomic activities." "Universities initiate students," they continue, "into years of future indebtedness, thus closing them off from the temporal substance of their present and future lives."[47] Debt has increasingly come to shape and limit how we imagine the future.

This is the case, for example, with Alex Rivera's *Sleep Dealer,* a speculative film in which student debt defines a dystopian future. Rivera recounts starting to make movies when he was a political science and media studies undergraduate at Hampshire College: "I became a filmmaker, in some ways, to avoid writing papers. While I was studying political science, I was searching for a way to make dynamic and

FIGURE 30. Luz Martinez (Leonor Varela) receives a threatening video message about her student debt. *Sleep Dealer* (2008).

accessible arguments about what I saw happening in the world. I found video and film, and convinced my professors at Hampshire to let me make videos instead of writing final papers."[48] Informed by his college readings in political theory and his proimmigrant activism, *Sleep Dealer* represents a world where the U.S.-Mexico border has been closed, and, instead of physically migrating to the United States, "workers go to cities in Mexico and work in giant factories or sweatshops where they connect their bodies to high-speed, network-controlled robots that do their labor. So their pure labor crosses the border, but their bodies stay in Mexico."[49]

Sleep Dealer focuses on Memo Cruz (Luis Fernando Peña), a migrant to Tijuana from Oaxaca, who has installed electrical nodes all over his body so that he can operate a construction robot in the United States. While most commentary has focused on the high-tech maquiladora where Memo works, the film includes two other characters who also perform long-distance virtual labor: a Chicanx drone pilot, Rudy Ramirez (Jacob Vargas), and a recent Mexican college graduate, Luz Martinez (Leonor Varela), who sells the stories of other working people on the internet to repay her student loan debt. One evening, when she returns to her apartment, Luz plays a video message from a university administrator declaring that her student loan is in default and, if she does not pay it immediately, armed agents will break into her apartment and confiscate all her things (see figure 30). Rivera has said of this scene that he was attracted to the interface between the contemporary moment of student debt and the speculative future in which dreams and memories are

for sale, but I would suggest that such an interface characterizes the present, where student hopes for the future are already exploited for profit. In *Sleep Dealer* the university as debt collector suffocates student aspirations, while the school's name, the Institute for Bio-Media, is suggestive of the kinds of biopower that debt reproduces in the form of disciplined low-wage workers.

The final group of writer-directors I analyze in this survey of the recent cinema of debt are woman-of-color feminists who draw on their own college experiences and academic orientations in the form and content of their work. The most well known is Ava DuVernay, cowriter and director of *Selma* (2014) and *A Wrinkle in Time* (2018) and director and writer of two films about the prison-industrial complex, *Middle of Nowhere* and *13th*. Like other filmmakers in this chapter, DuVernay, having grown up in Compton, is connected to South-Central Los Angeles. Her mother was from Compton and her father was from Montgomery, Alabama, areas she describes as "hotbeds of black consciousness."[50] Her early films were aimed at contradicting widespread representations of Compton as a space of Black criminality. In DuVernay's documentary *This Is the Life* (2008), for example, she counters the hyperfetishization of gangsta rap images associated with the area by instead focusing on South Central's "Good Life" hip-hop movement. Her documentary *Compton in C Minor* (2009) similarly undermines dominant representations with scenes of Black survival and joy in the city where she grew up. In her life and career, DuVernay sharply represents the structural inequalities and forms of segregation she encountered growing up as a Black girl next to USC. As if reflecting on a world characterized by raced and gendered regimes of debt, when *13th* was released she told a reporter, "I grew up in Compton, and there were two really silly things I'd say when I was a little girl driving around with my mom. The first one was: 'If I'm ever homeless, that's a good place to sleep overnight.' I would do that all the time, just look for a little nook, say under the freeway sign. I guess it just came from seeing people homeless. And I would also always say, 'If I'm ever in prison, I'll miss this.'"[51]

From an early age, then, DuVernay was in effect scouting Compton locations while looking out the car window, and such a frame or protoscreen, I would argue, shaped her filmmaking gaze. One striking index of inequality in South Central is the fact that, while it is adjacent to USC and its acclaimed film school, there are no movie theaters in Compton. As DuVernay remarks, "The films I might have been interested in as a young person didn't play near me, because there's no movie theater in Compton. You can't see *Straight Outta Compton* [F. Gary Gray's 2015

FIGURE 31. Ruby (Emayatzy Corinealdi) and Brian (David Oyelowo) watch *Ali: Fear Eats the Soul. Middle of Nowhere* (2012).

film about Compton rappers NWA] in Compton. . . . Even if I was interested in independent films at that time, I would've had to get on a bus to take me across town. Which is not possible. I'm not getting from Lynwood to Westwood. It only happened when I went to UCLA. And how many of us went to UCLA?"[52] DuVernay dramatized this situation in the Compton-set film *Middle of Nowhere,* when her protagonist, Ruby (Emayatzy Corinealdi), explains to a romantic interest, Brian (David Oyelowo), that she likes primarily independent and foreign films, the kinds of movies that "play on the Westside, mostly; they don't even show them over here." The couple ultimately travel west to see Rainer Werner Fassbinder's *Ali: Fear Eats the Soul* (1973; see figure 31).

Given Compton's status as a film-theater desert, attending UCLA proved crucial to DuVernay's cinematic education. After graduating from high school in 1990, she became an African American studies and English double major at UCLA, where she was "very active in black student life" and "black student politics," working, for example, as a writer for the Black student newspaper *NOMMO.*[53] As she told a reporter, "My first consciousness came in college, when I went to UCLA. . . . It sharpened my view of what I experienced growing up, and added a political context to it. You start reading great thinkers. You're reading Frantz Fanon for the first time. You're going through your red, black, and green phase."[54] She thus sees herself in the tradition of the "L.A. Rebellion" directors Charles Burnett, Julie Dash, and Haile Gerima, who could get access to cameras and thirty-five millimeter film stock only because they were students at UCLA.[55] That college history has continued to influence her work, notably her interest in examining the prison-industrial complex.

DuVernay's first film on that topic, *Middle of Nowhere* (2012), is a narrative work about Ruby, a young Black woman in Compton who drops out of medical school so she can regularly visit her husband, Derek (Omari Hardwick), when he is incarcerated at the high desert city of Victorville, a more than six-hour round-trip bus ride. "As I started to really examine what life is like in Compton where I grew up and really think about the texture of the lives of women who live there, incarceration kept coming up," she said, and so the director interviewed numerous women whose partners were imprisoned.[56] As DuVernay told *UCLA Magazine,* the film is about Ruby's

> interior life and how she very intimately works through the challenge, struggle and chaos of a relationship that's defined by separation while struggling with her own identity. The film was based on my interest in exploring complex characterizations of black women, which I feel is lacking in cinema. It also shares my interest in shedding light on women from all walks of life who are in waiting due to the incarceration of a loved one. . . . The film [presents] a black woman in a part of town we don't often see. That juxtaposition of a woman with a lot of dignity and character unfortunately is really rare when that woman happens to live in Compton or South Central.[57]

DuVernay's focus on women from different "walks of life" is well represented in the film's settings, which shuttle back and forth between Compton, where Ruby lives and works, and Victorville. Reflecting its working-class Black feminist mise-en-scène, much of *Middle of Nowhere* takes place on the bus—the public bus she rides to work and where she meets Brian the bus driver and the Greyhound bus that takes her to visit Derek. Moreover, with its renderings of complex Black women characters, *Middle of Nowhere* employs a lens on the prison-industrial complex that resonates with UCLA law professor Kimberlé Crenshaw's theorization of intersectionality.[58] Finally, released two years after the infamous UCSD fraternity party, *Middle of Nowhere* counters misogynoir representations of Black women like in the Compton Cookout.

DuVernay's second film about the prison-industrial complex, the Netflix documentary *13th,* combines visually striking infographics, archival film footage, and interviews with politicians, activists, and especially academics, including Michelle Alexander, Jelani Cobb, Angela Davis, Henry Louis Gates, and Khalil Gibran Muhammad. When asked by a *Los Angeles Times* reporter about the use of talking heads in the film, DuVernay responded, "It's like a classroom of very, very wise people around the subject just looking straight in your face and telling you what they know."[59] Indeed, the film recalls a university lecture as it

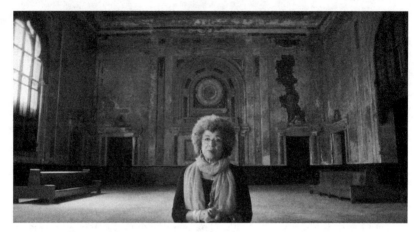

FIGURE 32. In an old Oakland train station, Angela Davis talks about the prison-industrial complex. *13th* (2016).

builds a historical argument, starting with the Thirteenth Amendment to the Constitution referenced in the title. As its press kit claims, "In the loophole of the 13th Amendment, slavery and involuntary servitude is outlawed except as a punishment for crime. Thus a 'prison boom' immediately began [at the end of the Civil War] with the mass arrests of African-Americans for relatively minor crimes. These charges were used against former slaves to force them to build infrastructure and restart the nation's economy."[60] The film charts the history of substitute mechanisms for slavery, including systems of sharecropping debt. Formally, *13th* references racial capitalism with settings that evoke work. As DuVernay told an interviewer, "The idea was that all of the backdrops [to the talking-head interviews] would denote industrial labor, like brick and steel and glass and rock. For Angela Davis, we basically broke into this old abandoned train station in Oakland" (see figure 32).[61]

The film *13th* comes to similar conclusions as Cedric Robinson in his book *Forgeries of Memory and Meaning,* where he argues that anti-Black representations in the early twentieth century, notably the criminalization of Back people in *The Birth of a Nation,* provided the ideological justification for regimes of racial capitalism based in the exploitation of Black workers in timber, mining, and railroad industries. According to its press kit, "*13th* shows that in the second decade of the 20th century, the new medium of motion pictures set a template for American racism when D. W. Griffith's Civil War drama 'The Birth of a Nation,' adapted from the book 'The Clansman,' became a cultural event." The press kit then

quotes Khalil Gibran Muhammad, director of the Schomburg Center for Research in Black Culture, on *Birth*'s immense popularity; a 1915 *New York Times* review praising scenes of the Klan; and Wilson's phrase that *Birth* was "like writing history in lightening," concluding that Griffith's work helped lead to the Klan's early twentieth-century resurgence.[62]

Given not only its historical significance but also its centrality to film history and hence university curricula, DuVernay felt it was important to begin with *The Birth of a Nation*. "I wanted to look at it because it is the foundation of the very medium that I work in." *Birth*, she continues, inspires technical wonder: "I look at some of those shots and I think, "Where was the camera; was it on a cart?" DuVernay has studied the film carefully, "really deconstructing the close-up, editorial innovations, innovations with the camera," but such studies have a cost. "In order to look at it, I have to look at racism on my screen, and that affects me. I have to look at a characterization of myself that is a complete fabrication and a myth that affected my people. To me that mirrors the story where we talk about media images and how much we over-index images of black criminality."[63] In her divided view of *Birth*, DuVernay recalls critical approaches to the film by the Black students in the University of Chicago study analyzed in the introduction, as well as the satiric take on it in *Dear White People*. Viewed together, then, *Middle of Nowhere* and *13th* posit a Black, feminist, working-class gaze, or what I've previously described as intersectional multiple consciousness.

I conclude this chapter with a collection of narrative films about young, college-bound Indigenous women and women of color that represent contradictory responses to regimes of student debt. They all upend the college film genre's focus on white respectability with narratives of queer and trans Indigenous students and students of color. The first is *Pariah*, written and directed by queer Black filmmaker Dee Rees. Raised in Nashville, Rees graduated with an MBA from Florida A&M University, Tallahassee, and her first jobs were in marketing for Procter and Gamble and Dr. Scholl's.[64] While on the set of a TV commercial for shoe insoles, she decided she liked filmmaking, and so Rees enrolled in New York University's Tisch School, where she took classes with Spike Lee. She later interned for his film about Hurricane Katrina, *When the Levee Broke*. Rees has directed *Mudbound* (a family melodrama about white and Black famers in the postwar Mississippi Delta, 2017), *Bessie* (a TV biography of queer blues singer Bessie Smith, played by Queen Latifaha, 2015), and episodes of *Empire* and *Philip K. Dick's Electric Dreams*. Her first feature film, *Pariah,* was based on her graduate thesis film of the same name. In

the film's press kit, Rees cites Alice Walker and Audre Lorde's *Zami* as inspirations, noting that she gave Lorde's book to her lead actor as research for the role.[65] *Pariah* focuses on Alike (Adepero Oduye), a queer Black teen from Brooklyn. A smart student and an accomplished poet, Alike struggles with her identity in butch/femme contexts and with a homophobic Christian mother, Audrey (Kim Wayans). Like *Middle of Nowhere*, with its rendering of different, complex Black women characters, *Pariah* presupposes a kind of multiple consciousness.

The second coming-of-age film is *Drunktown's Finest*, written and directed by trans Diné filmmaker Sydney Freeland. The writer-director earned a BFA in computer animation from Arizona State and an MFA in film and television from the San Francisco Academy of Art University and held a Fulbright Scholarship for fieldwork among Indigenous people in Ecuador. Evoking desires for "transport" beyond the limits of a heteropatriarchal, settler-colonial world, in Freeland's short film titled *Hoverboard* (2012), a young Diné girl named Max (Magdalena Begay) watches *Back to the Future II* and then builds her own hover board. Most recently, Freeland has turned to TV, directing episodes of *Grey's Anatomy*, *Heathers*, and the horror miniseries *Chambers*. *Drunktown's Finest* is set in Gallup, New Mexico, near the reservation where the director grew up, and its title references an infamous *60 Minutes* report about Gallup titled *Drunk Town USA*. Freeland describes the film as a "coming of age story of three Native Americans growing up on a reservation": Luther Sickboy (Jerimiah Bitsui), "a rebellious father-to-be"; Felixia (Carmen Moore), "a promiscuous transsexual"; and Nizhoni (MorningStar Angeline), "an adopted Christian girl" on her way to college. With its complex stranding of characters arcs, *Drunktown's Finest* represents a multiple consciousness rejoinder to anti-Indigenous representations.

The third film is *Mosquita y Mari*, written and directed by queer Chicanx activist and filmmaker Aurora Guerrero. Born in San Francisco's Mission District, Guerrero grew up on the border of Richmond and El Cerrito while working alongside her Mexican immigrant parents at their Berkeley restaurant. She subsequently enrolled at UC Berkeley, where she majored in psychology and Chicano studies and read women-of-color feminists, including Audre Lorde, Cherríe Moraga, Gloria Anzaldúa, Chrystos, June Jordan, and Angela Davis.[66] Like Rees and Freeland, Guerrero has also worked in television, directing episodes of *Fly* (about an Atlanta-based flight crew of Black women) and Ava DuVernay's *Queen Sugar*. Set in the Huntington Park neighborhood of South Los Angeles, *Mosquita y Mari* tells the story of the friendship and queer romance

FIGURE 33 (left). Alike (Adepero Oduye) rides the bus to UC Berkeley. *Pariah* (2011).

FIGURE 34 (right). Film ending fades to white. *Pariah* (2011).

between an undocumented immigrant named Mari (Venecia Troncoso) and her college-bound neighbor, Yolanda (Fenessa Pineda), who she nicknames "Mosquita." Once again reminiscent of multiple consciousness, Guerrero's movie explores intersecting differences of gender, sexuality, and citizenship in a working-class Mexican immigrant community.

All three films end in similarly indeterminate ways. At the conclusion of *Pariah*, the protagonist, Alike, boards a bus from Brooklyn to Berkeley, where she will take summer-school classes before enrolling, and the final shots are of her looking out the window at the passing traffic with a faint smile on her face, as the screen slowly fades to white before cutting to the credits (see figures 33 and 34). In *Drunktown's Finest* Nizhoni, after finding out that her white Christian adoptive parents prevented her from seeing her Indigenous family as she grew up, leaves their home for Calvin College in Michigan. In the film's final act, Nizhoni follows the signs to Highway 40 East and toward college when a police roadblock sends her on a detour into the Navajo reservation and toward her Diné grandparents, in time for her to join a cousin's *kinaaldá,* a ceremony marking the transition to adulthood and involving extended family in a run toward the sunrise, as the screen fades to black (see figures 35–37).[67] In *Mosquita y Mari* Yolanda hopes to go to college and encourages Mari to try and do the same, but when Mari has sex with a young man to support her mother and sister, the friendship is broken. The final shots of the film, however, depict the two looking at each other from across a neighborhood street in a shot-reverse-shot sequence that ends in a close-up of Yolanda with of look of resolution and resolve on her face, before the film fades to white (see figures 38 and 39) and then cuts to a previous scene, where Mari writes their initials in the dust of a car windshield, before finally fading to black.

FIGURE 35. Nizhoni (MorningStar Angeline) takes a detour on the way to college. *Drunktown's Finest* (2014).

FIGURE 36 (left). *Drunktown's Finest* (2014) ends with a coming-of-age ceremony.

FIGURE 37 (right). *Drunktown's Finest* (2014) fades to black.

One inspiring template for the three films is *Real Women Have Curves* (2002), directed by film-production professor Patricia Cardoso and written by Josefina López. It centers on a young East Los Angeles garment worker named Ana García (America Ferrera, who enrolled at USC the following year), who is bound for Columbia University.[68] The film ends with scenes of her grandfather and father saying good-bye at the airport, then cutting to an exuberant Ana emerging from the subway into a busy Times Square before fading to black. All these films remain open-ended, concluding with liminal moments that fade to white or black, suggestive of indeterminate college futures.

These films close with images that draw critical attention to student debt. On the one hand, the endings are in keeping with the long history of college movies in which Black, Indigenous, and Chicanx women students are unrepresentable. The films' foregrounding of college-bound Indigenous women and women of color is groundbreaking, but their inability or unwillingness to imagine the college experience itself is symptomatic not only of the historical absence of cinematic conventions for representing marginalized students but also of contexts of debt that have made it even harder for such students to contemplate college. Instead, the fade to black or white represents a kind of empty placeholder, marking how debt threatens to disappear college futures.

On the other hand, the open-ended film conclusions also suggest a utopian rupture with the limits of a debt dominated here and now and the

FIGURE 38 (left). Yolanda (Fenessa Pineda) looks at Mari and into an uncertain future. *Mosquita y Mari* (2012).

FIGURE 39 (right). *Mosquita y Mari* (2012) begins fading to white.

anticipation of different futures. Breaking with the longer history *University Babylon* reconstructs, in each case we can glimpse the possibility of women-of-color college students as they flicker into view. Elsewhere I have theorized this as futurity, or the expectation of the future as possibility, not guaranteed but also not foreclosed. Such desires for something beyond the here and now constitute a collective historical materialist critique of the present and its limits. Futurity performs the givenness of future existence, a utopian prospect in contexts where access to a future is unequally distributed. Filmmakers, activists, and creators of all kinds perform the imaginative work of presupposing a future as such. The filmmakers' ability to project futures beyond contemporary cages raises questions about how material conditions would have to be transformed to support widespread expectations of the future. Implicit in the debt-shaped film endings, then, are questions about who can expect a future, who can't, and why.[69]

In its mode of production, *Mosquita y Mari* practically exemplifies futurity. A former UC Berkeley Chicano studies major and student of Cherríe Moraga, Guerrero reproduced reciprocal pedagogical relationships on location, once again in the shadow of USC. Working with Communities for a Better Environment, a local environmental justice organization in the Huntington Park neighborhood, where the film was shot, she established internships for local youth as assistant directors and in cinematography, the art department, and properties.[70] The film also employed local youth as extras and as the characters Vero and Vicky, played by Huntington Park sisters Marisela and Melissa Uscanga. As Guerrero told an interviewer,

> There were heads of departments and each had to mentor young interns on this film. Three years before, I had reached out to a nonprofit that had done a lot of work in the neighborhood and was well known. They helped to keep

me grounded in the community and to make sure the film was truthful in its depiction of the community. I also wanted to open the doors to the process of making a film, because I didn't have that and it's very rare to have access to that kind of thing. I told all the heads of the departments that if they wanted to be a part of the film, they would have to mentor.

The director attempts to provide access to the kinds of filmmaking knowledge denied her. I hear in this emphasis on access to knowledge an echo of DuVernay's question, "How many of us went to UCLA?" The *Mosquita y Mari* internships compensate for and hence mark the deprivations of decreased state support for public education, increased tuitions, and expanding student debt, while responding to longer histories of educational segregation and representational exclusion. At the same time the internships "open the doors" onto future possibilities beyond a logic of debt. As Guerrero recalls, "There were young people in every department and their energy is very present in the movie. They were very invested and offered input and weren't just workers learning from us. We were learning from them, every step of the way. Some of those young people are going onto film school or going on to become actors."[71]

Guerrero imagines film production along the lines of community-based research. As she wrote in her director's statement for the film's press kit, "During the development of *Mosquita y Mari* I sought out a community partner to help me bridge the film with the community of H.P. I didn't want to come into H.P. without making this film accessible to the community in some way. I felt that I owed it to H.P. It would become my muse for years so I felt I had to offer something of value in turn. I didn't want to take from this community like a Ph.D. student coming in, conducting research, then leaving to become an expert on that community without making the process collaborative."[72] Like the director's community-based filmmaking, scholars engaged in community-based research emphasize collaboration and framing research questions in terms of community perspectives and needs.[73] Guerrero's collaborative production process thus resonates with interdisciplinary research methods generated in ethnic studies and women's studies.

Like my experience discussing *Salt of the Earth* in the classroom, the preceding study of filmmakers on the margins of the academy suggests that university spaces simultaneously reproduce regimes of student debt and sustain critical thought and action against them. For the foreseeable future, universities continue to ground conflict and contestation over debt and the violence it finances, as well as critical projections of

different and better worlds beyond debt. This is because, at one and the same time, the university has been a key institution of racialized and gendered settler-colonial capitalism *and* a site of transformative thinking and practice, as represented by films that project different kinds of students and, in particular, critical perspectives on intersections of race, gender, sexuality, and class in higher education and beyond.

Afterword

University Babylon Revisited

While, historically, college films have skewed toward romantic comedy, in recent years the genre has turned to horror. Since the 2016 U.S. presidential election, a new wave of college horror films have been produced, including *Parched* (2017), where road-tripping students find an abandoned house and drink infected water that turns them into homicidal maniacs; *Prank Week* (2017), about a frat-house serial killer; *Haunting on Fraternity Row* (2018), which depicts an evil entity's attack on a fraternity house's "Winter Luau" party; and *Clickbait* (2019), about a young woman student obsessed with internet fame who is kidnapped by a fan. A number of similar films are currently in production, including *Dark Thirst*, featuring a freshman in an Ivy League fraternity who confronts a series of supernatural disappearances; *Dead Reckoning*, in which backpacking students are stalked by a group of fundamentalist religious extremists; *Evil's Toy*, about a young college woman who unleashes a demon on social media; *Fear Follows*, a tale of college friends trapped in a haunted house; *Guys at Parties Like It*, in which a date-raping fraternity pledge is violently punished; *Just Killing*, where students inadvertently hire a serial-killer clown for a friend's birthday party; *Kill Me Too*, the story of a college woman brutalized by classmates who seeks revenge at a college reunion; *Nesting Dolls*, a psychological thriller focused on murderous sorority sisters; and *Something in the Shadows*, where college students attempt to earn scholarships by spending the weekend in a house haunted by the ghost of an enraged father from the 1850s.

Two college horror films stand out in light of the broader history recounted in *University Babylon*. Both are popular films aimed at a youth market and produced by Blumhouse Productions, the company responsible for *Get Out* (2017) and *The Purge* (2013) and its sequels. The first, *Happy Death Day* (2017), was filmed at Loyola University in New Orleans. A cross between *Groundhog Day* (1993) and *Scream* (1996), it features a blond sorority girl named Tree stuck in a temporal loop, forced to relive the same day over and over—the same walk from a hook-up's dorm room, across the campus quad to her sorority, and finally to her surprise birthday party—ending with her murder at the hands of someone dressed as the school's mascot, an adult-sized white male infant named the Bayside Baby. The second film, *Truth or Dare* (2018), is set at an unnamed college but was filmed at the University of Southern California. It focuses on a student named Olivia, who reluctantly postpones plans to build low-income housing with Habitat for Humanity so she can instead join friends on spring break. On the last night of their vacation, however, a stranger lures the friends into a game of truth or dare, in which players are possessed by a demon that compels them to tell shattering truths and perform murderous dares.

Scholarship on contemporary horror films read them as symptomatic responses to precarity, and the turn to horror in films about college students should surely be understood as mediating state disinvestment in education and the expansion of student debt.[1] But while both *Happy Death Day* and *Truth or Dare* speak to present precarities, they also remain tethered to the deeper history of the university-cinema–industrial complex (UCIC). As if embodying Jennifer Doyle's claim that administrations figure universities as young white women in need of protection, over the course of *Happy Death Day*, Tree's redemption builds on longer histories of racial capitalism on campus.[2] After being murdered over and over, she learns to be a better person, reconciling with her dad, breaking off a relationship with a married professor, treating her boyfriend with new love and respect, and being nicer to her roommate. To escape her endless temporal loop, however, Tree must locate her killer. After several suspects are proven innocent, she discovers that the university hospital is holding an infamous serial killer, but he turns out to be a red herring. Ultimately, the killer wearing the Bayside Baby mask is revealed as her Black nursing student roommate, Lori (played by Puerto Rican actor Ruby Modine), who Tree kills at the end of the film. *Happy Death Day* dispenses with any backstory or explanation for Lori's murderous rage, rendering the character a kind of MacGuffin (see

chapter 4) that reifies women of color as the evil others of higher educa-
tion and the scapegoat for the danger faced by the white woman college
student.

The resolution of *Truth or Dare* also incorporates a racist scapegoat
for the precarity of a white woman protagonist. Olivia and her class-
mates are possessed by the evil game while on spring break at Rosarito
Beach, Mexico, where they pass through a hole in a chain-link fence
into an old Mexican mission. Along the way Olivia stumbles across a
shrine, knocking over what looks like a small Olmec head and an Indig-
enous pot, surrounded by flies and a horrible smell. After the friends
play truth or dare in the mission, they return to Southern California,
where they are beset by a host of frightening tragedies. As Olivia
remarks, "Something's really been weird since Mexico. . . . It's the
game—it's followed us home." She learns that the game can be stopped
only if she returns to Mexico and reseals the Indigenous pot, thereby
containing the evil south of the border. While spring break misadven-
tures are a staple of college films, *Truth or Dare* recycles such scenarios
in support of contemporary forms of anti-Mexican white nationalism.
Which is also to suggest that, while students and professors must neces-
sarily keep their eyes on the here and now, another world will be pos-
sible only when we come to terms with the conflicted past from which
films like *Truth or Dare* have come.

Throughout this book I have used the phrase "University Babylon" to
name the complex of material, institutional, and symbolic partnerships
between Hollywood and the academy. It has enabled me to pose com-
parisons and juxtapositions across time, from the early twentieth cen-
tury to the present, which illuminate historical transformations and con-
tinuities, particularly in terms of white nationalism and respectability
politics in film and on campus. As part of my analysis of University
Babylon, I have also theorized the university-cinema–industrial complex.
The term's debt to precursor cognates such as "military-industrial com-
plex" and "prison-industrial complex" suggests that the history of the
UCIC is a story partly about the hegemonic power of such Hollywood-
university partnerships over access to higher education. Starting around
1915, when *The Birth of a Nation* was released, the UCIC helped repro-
duce settler-colonial racial capitalism both materially and ideologically.
Historically, both universities and film studios have been largely white
worlds, settled on Indigenous land and exploiting racialized low-wage
labor. The two partners are joined in a symbiotic embrace: Hollywood's
college films and the academy's research about movies have often

combined to legitimate racial capitalism. The UCIC has helped reproduce intersecting hierarchies of race, class, gender, and sex by marrying the values of higher learning to models of respectability. UCIC respectability politics are durable, though they change over time, and are entangled in different ways with white nationalism in both universities and Hollywood. Culture wars over the university from the 1980s to the present thus presuppose longer histories, in which racialized respectability limited dominant definitions of intellectual value and academic freedom. At the same time the defense of respectability has justified the militarization of college campuses in both film and the world. In all these ways, University Babylon names the ensemble of historically changing but persistent white nationalisms produced in tandem by Hollywood and higher education.

The concept of the UCIC has also enabled me to analyze opposition to it from within. In both Hollywood and academia, Indigenous people and people of color have engaged forms of multiple consciousness and critical vicarity to deconstruct respectability. Building on earlier moments of multiple consciousness in film production and spectatorship since the 1970s, minority film formations have struggled for footing and vantage points within University Babylon, constituting a critical Third Cinema/Third University assemblage. Historically, Indigenous women and women of color have been largely invisible as students and hence rendered other to higher education by their absence. In recent years women of color and Indigenous women filmmakers on the margins of the UCIC have turned intersectional lenses on students like themselves. Given that the absence of Indigenous, Black, Chicanx, and other women of color is constitutive for the UCIC and its hierarchies of respectability, making such students present in film is profoundly radical in the etymological sense of revealing the roots of institutions such as universities and film studios.

I have also attempted to analyze the long reach of the past in present configurations of power and knowledge. In the introduction I drew on Abigail Boggs and Nick Mitchell's claim that a critical focus on the crisis in the contemporary "corporate" or "neoliberal" university threatens to obscure the longer and larger historical narratives in which higher education remains embedded.[3] Too many recent discussions of academic freedom, student protest, and white nationalism on campus focus on the present as a rupture with the past or at least overlook their relationships to the longer histories recounted here. During the early decades of the twentieth century, for instance, Hollywood and the academy

jointly constructed raced and gendered models of respectability that continue to haunt the more recent past and present. As I argue in chapter 2, Ronald Reagan's model of academic freedom was implicitly delimited by white family values, and today most spectacular conflicts over campus free speech focus on white nationalist speakers. Each chapter has analyzed respectability as a weapon mobilized against student dissent, which resonates with contemporary polemics about Antifa and other protestors on campus who supposedly disrespect property rights. Finally, when combined with a resurgence in racist film and TV representations of Mexican drug cartels, reports by the Southern Poverty Law Center and other organizations about new forms of white nationalism on campus are especially alarming, given the extensive history of white nationalism in the UCIC.[4] While the presidency of Donald Trump has elicited dismayed commentary about the unprecedented threat to democracy posed by the former reality TV star and head of the fake Trump University, the recent turn to horror in college films remind us of the longer genealogy of white nationalism and opposition to it that *University Babylon* reconstructs.

Notes

INTRODUCTION

1. See Curtis Marez, "Public Universities Make Dreams of the Future Concrete: *Conquest of the Planet of the Apes,*" *Critical Commons for Fair and Critical Participation in Media Culture,* accessed May 1, 2019, www.criticalcommons .org/Members/cmarez/clips/uci_planet_of_the_apes.mov/view.

2. Michael Seiler, "Pereira, Architect Whose Works Typify L.A., Dies," *Los Angeles Times,* November 14, 1985, http://articles.latimes.com/1985–11–14 /news/mn-2250_1_master-plan.

3. Pereira's firm designed the Pan Pacific Theater, CBS Television City, Hollywood Motion Picture and Television Museum (unbuilt), Vogue Theater, Cathay Circle Theater, ABC Paramount Theater headquarters, Hollywood Communications Center, Santa Ana Cinema, and a Warner Brothers office building. In addition to UC Irvine, he also designed buildings for UC Santa Barbara, UC San Diego, UC Riverside, and UCLA, as well as for Occidental College, Southern California School of Theology, Otis College of Art and Design, University of Southern California, Pepperdine, Los Angeles City College, Stanford, Golden West College, Brigham Young University, University of Vermont, and Hawaii Loa College. For a complete list of his firm's projects, see Wikipedia, s.v. "List of William Pereira Buildings," last modified October 23, 2018, 20:37, https://en.wikipedia.org/wiki/List_of_William_Pereira_buildings.

4. Like the UC Irvine campus, UC San Diego's Geisel Library has been incorporated into dystopian entertainments including an episode of the TV series *Mission Impossible,* where the library plays the part of the headquarters for a multinational corporation that profits by promoting war. See Lewis Allen, dir., *Mission Impossible,* episode, "The Pendulum," CBS, Dailymotion Video, February 23, 1973, www.dailymotion.com/video/x6gz95e. More recently, Geisel Library inspired the Snow Fortress in the film *Inception* (2010). See Sarah

Pfledderer, "Inside the Icon: Geisel Library," *San Diego Magazine*, October 13, 2017, www.sandiegomagazine.com/San-Diego-Magazine/October-2017/Inside-the-Icon-Geisel-Library/.

5. Eric Green, *Planet of the Apes as American Myth: Race and Politics in the Films and Television Series* (Middletown, CT: Wesleyan University Press, 1998), 78–113.

6. "Moving Image: Birth of a Campus, NBC-TV," was part of an episode of a show titled *Survey '65*. It can be viewed on the University of California's digital archive *Calisphere*, 1965, May 24, 2019, https://calisphere.org/item/2f830917–1ada-45a2-a5b7–198a5d6e85f8/.

7. The origin of the skeletons was revealed in a 1985 lawsuit deposition with *Poltergeist*'s (1982) special effects artist, Craig Reardon, which can read at "Craig Reardon on the Film's Makeups," *Poltergeist: The Fan Cite*, May 1, 2019, www.poltergeist.poltergeistiii.com/reardon.html.

8. Avery Gordon, *Ghostly Matters: Haunting and the Sociological Imagination* (Minneapolis: University of Minnesota Press, 2008).

9. Walter Benjamin, *The Arcades Project*, trans. Kevin McLaughlin (Cambridge: Harvard University Press, 2002).

10. Cecil B. DeMille, the director of the influential anti-Indian, antimiscegenation film titled *Squaw Man*, was awarded honorary degrees from Baylor, Pennsylvania Military Academy, Brigham Young, and Temple. "Honorary Degrees," Cecil B. DeMille Foundation, May 1, 2019, www.cecilbdemille.com/awards/honorary-degrees/. Meanwhile, Walt Disney, creator of a cartoon mouse derived from blackface minstrelsy, received honorary degrees from the University of Southern California, Yale, and Harvard. "Walt's Honorary Degrees," *Walt Disney Family Museum*, June 27, 2014, www.wdfmuseum.org/blog/walts-honorary-degrees. See also chapter 4, where I discuss the honorary degree that USC conferred on Warner Brothers Studio head Jack L. Warner.

11. Jodi Melamed, *Represent and Destroy: Rationalizing Violence in the New Racial Capitalism* (Minneapolis: University of Minnesota Press, 2011); Roderick Ferguson, *The Reorder of Things: The University and Its Pedagogies of Minority Difference* (Minneapolis: University of Minnesota Press, 2012); Sara Ahmed, *On Being Included: Racism and Diversity in Institutional Life* (Durham: Duke University Press, 2012); Stefano Harney and Fred Moten, *The Undercommons: Fugitive Planning and Black Study* (New York: Minor Compositions, 2013); Grace Kyungwon Hong, *Death Beyond Disavowal: The Impossible Politics of Difference* (Minneapolis: University of Minnesota Press, 2015); Piya Chatterjee and Sunaina Maira, eds., *The Imperial University: Academic Repression and Scholarly Dissent* (Minneapolis: University of Minnesota Press, 2014).

12. Cedric J. Robinson, *Black Marxism: The Making of the Black Radical Tradition* (Chapel Hill: University of North Carolina Press, 1983); Robinson, *Forgeries of Memory and Meaning: Blacks and the Regimes of Race in American Theater and Film before World War II* (Chapel Hill: University of North Carolina Press, 2007), 62–81.

13. Abigail Boggs and Nick Mitchell, "Critical University Studies and the Crisis Consensus," *Feminist Studies* 44, no. 2 (2018): 432–63; Craig Steven

Wilder, *Ebony and Ivy: Race, Slavery, and the Troubled History of America's Universities* (New York: Bloomsbury, 2013).

14. Robinson, *Forgeries of Memory and Meaning*, 82–126.

15. Richard Schickel, *D. W. Griffith: An American Life* (New York: Simon and Schuster, 1984), 17, 32, 269.

16. Elspeth H. Brown, "Racialising the Viral Body: Eadweard Muybridge's Locomotion Studies, 1883–1887," *Gender and History* 17, no. 3 (2005): 627–28, 639–42.

17. Tom Gunning, "Never Seen This Picture Before: Muybridge in Multiplicity," *Time Stands Still: Muybridge and the Instantaneous Photography Movement*, ed. Phillip Prodger (London: Oxford University Press, 2003), 224.

18. Brown, "Racialising the Viral Body," 631–38, 642–48.

19. *Semi-centennial Celebration in Commemoration of the Motion Picture Research Conducted by Leland Stanford with the Assistance of Eadweard J. Muybridge*, program, Stanford University, May 8, 1929, Stanford subject file, Margaret Herrick Library, Academy of Motion Picture Arts and Sciences (hereafter cited as AMPAS), Beverly Hills.

20. Arthur Knight, ed., *Eadweard Muybridge: The Stanford Years, 1872–1982* (Palo Alto: Stanford University Museum of Art, 1972).

21. "Stanford Innovators: Eadweard Muybridge, 1830–1904," *Stanford Stories from the Archive*, May 1, 2019, https://exhibits.stanford.edu/stanford-stories/feature/stanford-innovators.

22. For period accounts of the project, see Hawthorn Daniel, "American History in Moving Pictures," *World's Work: A History of Our Time* 44 (May 1922): 538–47; Daniel, "Yale's Movie Version of American History," *Literary Digest*, March 4, 1922, 41–43; and Clayton Hamilton, "American History on Screen," *World's Work: A History of Our Time* 48 (August 1924): 525–32. For a more recent account, see Donald J. Mattheisen, "Filming U.S. History during the 1920s: The Chronicles of America Photoplays," *Historian* 54, no. 4 (1992): 627–40.

23. Shelley Stamp, *Lois Weber in Early Hollywood* (Berkeley: University of California Press, 2015).

24. Motion Picture Producers and Distributors of America, "Don'ts and Be Carefuls," *MPPDA Digital Archive*, May 24, 1927, https://mppda.flinders.edu.au/records/341; Motion Picture Producers and Distributors of America, "The Motion Picture Production Code," March 31, 1930, repr. in *Hollywood Cinema*, ed. Richard Maltby (London: Blackwell, 2003), 594–95.

25. Will H. Hays, *The Memoirs of Will H. Hays* (New York: Doubleday, 1955), 146–47.

26. Hays, quoted in Edward F. O'Day, "Town Talk: Varied Types," *San Francisco Daily Times* 32, no. 1339 (1918): 5.

27. Hays, *Memoirs of Will H. Hays*, 341, 428, 327, 351, 354, 480, 487.

28. Richard Maltby, "The Production Code and the Hays Office," in *Grand Design: Hollywood as a Modern Business Enterprise, 1930–1939*, ed. Tino Balio (Berkeley: University of California Press, 2007), 56.

29. Garth S. Jowett, Ian C. Jarvie, and Kathryn H. Fuller, *Children and the Movies: Media Influence and the Payne Fund Controversy* (Cambridge: Cambridge University Press, 1996).

30. Herbert Blumer, *Movies and Conduct* (New York: Macmillan, 1933), 90, 103, 116, 199–200. The study was one in a series of twelve on the "influence of motion pictures upon children and youth" sponsored by the Payne Foundation at the request of the Motion Picture Research Council (iv).

31. Blumer, 197.

32. Herbert Blumer and Philip M. Houser, *Movies, Delinquency and Crime* (New York: Macmillan, 1933); Henry J. Forman, *Our Movie-Made Children* (New York: Macmillan, 1934); Maltby, "Production Code," in Balio, *Grand Design*, 57.

33. Rufus B. von KleinSmid, *Eugenics and the State* (Jeffersonville: Indiana Reformatory Printing Trade School, 1913); von KleinSmid, "Some Efficient Causes of Crime," in *Proceedings of the First National Conference on Race Betterment* (Battle Creek, MI: Gage, 1914), 532–42. For the history of eugenics research at Jeffersonville, see Alexandra Mina Stern, "'We Cannot Make a Silk Purse Out of a Sow's Ear': Eugenics in the Hoosier Heartland," *Indiana Magazine of History* 103, no. 1 (2007): 3–38; and Perry R. Clark, "Barred Progress: Indiana Prison Reform, 1880–1920," master's thesis, University of Indiana, 2008. For the USC context, see Terry Nguyen, "Untold History: How Rufus von KleinSmid Supported the Eugenics Movement at USC," *Daily Trojan*, August 23, 2017, https://dailytrojan.com/2017/08/23/untold-history-rufus-von-kleinsmid-supported-eugenics-movement-usc/. For the broader historical context of eugenics in Southern California, see Stern, *Eugenics Nation: Faults and Frontiers of Better Breeding in Modern America* (Berkeley: University of California Press, 2016). Today at USC its eugenicist former president is memorialized by the iconic building called the Von KleinSmid Tower and Center.

34. See Emory Bogardus, "Eugenic Sociology," in *A History of Social Thought* (Los Angeles: University of Southern California Press, 1922), 325–37; and Bogardus, "Hygienic and Eugenic Factors in Social Progress," in *An Introduction to Social Sciences: A Textbook Outline* (Los Angeles: Ralston, 1913), 41–59. See also Colin Wark, "Emory Bogardus and the Origins of the Social Distance Scale," *American Sociologist,* December 4, 2007, 383–95.

35. Emory Bogardus, *Essentials of Americanization* (Los Angeles: University of Southern California Press, 1920), 124–25, 129, 125, 22, 221.

36. Bogardus, *The City Boy and His Problems: A Survey of Boy Life in Los Angeles* (Los Angeles: Ralston, 1926), 78, 38, 107–8.

37. See Jessica Wolf, "UCLA Professor's Film Documents Forced Sterilization of Mexican Women in the Late '60s and '70s," *UCLA Newsroom,* October 23, 2017, http://newsroom.ucla.edu/stories/ucla-professor-s-film-documents-forced-sterilization-of-mexican-women-in-late-60s-l-a.

38. Christopher Newfield, *Unmaking the Public University: The Forty-Year Assault on the Middle Class* (Cambridge: Harvard University Press, 2008); Ferguson, *Reorder of Things;* Jennifer Doyle, *Campus Sex, Campus Security* (South Pasadena: Semiotext[e], 2015).

39. Chatterjee and Maira, *Imperial University,* 23.

40. In *Movies and Conduct* Blumer notes that "to many, perhaps to most" students in the study, *The Birth of a Nation* "awakened some feelings of antipathy or hostility towards Negroes." See also Ruth C. Peterson and Louis Leon

Thurstone, *Motion Pictures and the Social Attitudes of Children* (New York: Macmillan, 1933). Peterson and Thurstone's study, which was part of the same Payne Foundation series as Blumer's book, concluded that among their different film case studies, white high school student viewers in rural Illinois were dramatically influenced by *Birth*, as registered in before and after surveys of attitudes toward Black people. The pair concluded that the student's increased post-*Birth* antipathy to Black people was the most significant and durable of the film-inspired attitudes studied, notably outpacing student reactions, for example, to negative representations of Germans (33–38, 60–61, 64–65).

41. Quoted in Blumer, *Movies and Conduct*, 146.

42. Blumer, 257.

43. Blumer, 67, 68.

44. la paperson, *A Third University Is Possible* (Minneapolis: University of Minnesota, 2017), 36, 25. For the larger discussion of the Morell Act, see pages 26–28.

45. For a discussion of the history of Hollywood land practices, see Curtis Marez, *Drug Wars: The Political Economy of Narcotics* (Minneapolis: University of Minnesota Press, 2004), 105–45; and Marez, "Pancho Villa Meets Sun Yat-sen," *American Literary History* 17, no. 3 (2005): 495–96. For a discussion of Ronald Reagan as a mediator between Hollywood and university speculation in Indigenous land, see chapter 2 of this volume.

46. W.E.B. Du Bois, *The Souls of Black Folk*, in *W.E.B. DuBois: The Writings*, ed. Nathan Huggins (New York: Library of America, 1987), 364–65.

47. Shawn Michelle Smith, *Photography on the Color Line: W.E.B. Du Bois, Race, and Visual Culture* (Durham: Duke University Press, 2004), 25, 40.

48. Smith, 42.

49. Michelle Raheja, *Reservation Reelism: Redfacing, Visual Sovereignty, and Representations of Native Americans in Film* (Lincoln: University of Nebraska Press, 2013), 65.

50. Ferguson, *Reorder of Things*; Harney and Moten, *Undercommons*; Du Bois, quoted in Cynthia Silva, Lisa Hinds, and Roberta Young, "Minority and Third World Students," *How Harvard Rules: Reason in the Service of Empire*, ed. John Trumpbour (Boston: South End, 1989), 304.

51. Boggs and Mitchell, "Critical University Studies," 459.

52. Bailey, quoted in "Bio," on Moya Bailey's personal website, May 1, 2019, www.moyabailey.com.

53. Saidiya V. Hartman, *Scenes of Subjection: Terror, Slavery, and Self-Making in Nineteenth-Century America* (New York: Oxford University Press, 1997), 18–22.

54. Ahmed, *On Being Included*, 26–27.

55. George Lipsitz, *Time Passages: Collective Memory and American Popular Culture* (Minneapolis: University of Minnesota Press, 1990), 16.

CHAPTER I

1. In *Forgeries of Memory*, Robinson extends his analysis of racial capitalism to Hollywood, arguing that, starting in the late nineteenth century,

industrialists (of railroads, mining, lumber), finance capitalists, government officials, and academic experts produced a new public culture supporting imperialism and racialized labor exploitation. While it drew on older imagery, this racist public culture was new in the sense that its focus and forms mediated particular historical contexts from roughly the 1880s to World War I, when the global racial order was in flux, including the end of Reconstruction, the institutionalization of Jim Crow, and the exploitation of Black convict labor in the railroad and extractive industries such as coal mining, timber, and turpentine; the expansion of railroads and mining in the West and the increasing exploitation of Mexican workers; U.S.-based finance capital's global search for cheap labor; labor organizing and strikes among white workers and workers of color; and the Mexican Revolution's socialist and anarchist challenges to U.S. capitalism in general and to U.S. investments in Mexico in particular. In Robinson's account powerful people responded to this tangle of forces by waging a "culture war" aimed at differentiating and disciplining workers. During the early twentieth century, finance capitalists with direct stakes in the exploitation of racialized labor were the central players in the filmmaking industry, which helps explain the number of silent films spotlighting white male industrialists. Anti-Black films added new symbolic dividends to the "wages of whiteness" while also promoting racisms directed at Native American, Asian, and Mexican peoples. Racist film representations simultaneously propped up forms of exploitation in the United States and imperial expansion abroad (180–98; for a discussion of academic race science as a precursor to film, see 75–78).

2. Ian Haney López, *White by Law: The Legal Construction of Race* (New York: New York University Press, 2006), 3–11.

3. Except where otherwise indicated, plot summaries and film details are based on entries in the American Film Institute's *AFI Catalog of Feature Films*, May 1, 2019, https://catalog.afi.com/Catalog/Showcase. *The Winning Stroke* (1919) tells the story of a Yale crew star, Paul Browning, who falls in love with the dean's daughter, Aida Courtlandt, but when rival fraternity members lure him to a roadhouse, the coach suspends him. Aida convinces the dean to intervene, and Paul is reinstated just in time to lead Yale to victory over Harvard and become engaged to Aida. *The Winning Stroke* was filmed partly at Yale, including scenes of the annual Yale-Harvard varsity race. In *One Minute to Play* (1926), the role of college football player Red Wade was played by University of Illinois gridiron star Harold "Red" Grange. In *Varsity* (1928) Pop Conlan, the "dean of janitors," arranges for an orphan, Jimmy Duffy, to enroll at Princeton. When the boy is led astray into drinking and gambling by a showgirl named Faye, Pop rescues him from ruin. Jimmy graduates and ultimately marries a reformed Faye. The film was shot on location at Princeton.

4. *The Drop Kick* (1927) features football star Jock Hamill, who faces a series of misadventures involving embezzlement, a vamping coach's wife, and accusations of murder, before he makes the winning kick, his innocence is revealed by his mother, and he is reunited with his true love. The cast included ten college players from USC, Stanford, and other schools, and its climactic football game was shot on USC's home field, the Los Angeles Coliseum. In *Maybe It's Love* (1930) the spoiled son of a wealthy father, Tommy Nelson, is

redeemed by his winning football play for Upton College, reconciling him with his father and winning him the love of his girlfriend. Members of the 1928 and 1928 all-American teams appeared as extras in the film.

5. The films analyzed here pose related epistemological challenges in terms of research methods. As Allyson Nadia Field reminds us, over 80 percent of films made in the silent era are considered lost. See *Uplift Cinema: The Emergence of African American Film and the Possibility of Black Modernity* (Durham: Duke University Press, 2015), 23. Only a handful of the films discussed in this chapter survive, and as a result I have based my readings on a wide range of fragmentary sources, including reviews and articles in film industry publications, advertisements, publicity photos, scrapbooks, screenplays, memoirs, and related biographical materials.

6. Also see American Film Institute, *Catalog of Feature Films,* entries for *Minuet and Dance—College Women's Club* (1904); *Basket Ball, Missouri Valley College* (1904); *Fencing Class, Missouri Valley College* (1904); and *College Life at Amherst* (1906).

7. Michel Foucault, *The History of Sexuality,* vol. 1, *An Introduction* (New York: Vintage Books, 1990); Eve Kosofsky Sedgwick, *The Epistemology of the Closet* (Berkeley: University of California Press, 2008); Siobhan B. Somerville, *Queering the Color Line: Race and the Invention of Homosexuality in American Culture* (Durham: Duke University Press, 2000), 39–76.

8. Examples of such narratives include the following films. *The College Orphan* (1915): A wealthy father sends his wild son, Jack, to college, where he becomes a football hero and falls for Daisy, his boarding housekeeper. When he is unjustly suspended, his father disinherits him, but after Jack makes a smart business deal for the family business, he is reconciled with his father and becomes engaged to Daisy. *The Pinch Hitter* (1917): With his father's refrain that he will never amount to anything in mind, Joel enters college, falls in love with the counter girl at a local candy store, and joins the baseball team. During a big game attended by his father, Joel makes the winning play, wins the girl, and gains his father's respect. *One Touch of Nature* (1917): Yale student and baseball star William "Bill" Vandervoort Cosgrove is disowned by his wealthy, pork-packing father when he marries a plumber's daughter and vaudeville actor. But during the big game Bill hits the winning home run, and his father forgives him and blesses his cross-class marriage. *The Silent Witness* (1917): Janet loves a college student named Richard, seemingly loses him in a fire, and then gives birth to his illegitimate child, Bud. When Bud himself goes to college and classmates ridicule his poverty and illegitimacy, a fight ensues, and Bud is wrongly accused of killing another boy. In court it is revealed that the district attorney is Richard, who survived the fire and now helps prove his son's innocence. Finally free, Bud reunites with his mother and rediscovered father. *Ashamed of Parents* (1921): A poor shoemaker, Silas Wadsworth, scrimps and saves to send his son, Arthur, to college, where he falls in love with a heir, Marian Hancock, and becomes a football star. When the couple gets engaged, Arthur tells his father not to come to the reception, but Marian intervenes and, ultimately, father and son are reconciled. *Live Wires* (1921): On the eve of a big college football game, Bob Harding learns that his father has died without providing for his education.

He fends off some thieves who try to force him to throw the game and is reunited with his college sweetheart, Rena, whose father pays Bob's tuition. Bob boards a train, and from on top of it an airplane lifts him up and transports him to the football field in time for him to win the game. *Two Minutes to Go* (1921): After his father suffers a business loss, Baker University football star Chester Burnett is forced to work delivering milk, which he keeps a secret from his girlfriend, Ruth. He begins the big game playing poorly, but when he receives a telegram about his father's financial recovery and a love note from Ruth, his spirits revive and he leads the team to victory. *The Quarterback* (1926): The star of the Colton College team is unjustly disqualified from playing and jilted by his girlfriend, but he is ultimately reinstated by the dean and leads his squad to victory as his girlfriend cheers him on; *The College Boob* (1926): A Baldwin College football star saves his team from defeat, reconciles with his estranged aunt and uncle, and secures the love of his sweetheart. *The Kick-Off* (1926): A small-town football hero transfers to Farnsworth University, overcomes the dirty tricks of his upper-class rival, wins the big game, and is reunited with his girlfriend and mother. *Readin' Ritin' Rithmetic* (1926): A college professor objects to his daughter's relationship with a college athlete, but after many complications the athlete wins the professor's respect and the hand of his daughter. *One Minute to Play:* Star college football player Red Wade is estranged from his wealthy father, but the two are reconciled when Wade Sr. witnesses his son's amazing performance on the football field and vows to give the school a large endowment. *Brown of Harvard* (1926): A popular athlete performs heroically in a football game against Yale, winning the love of a professor's daughter. *College Love* (1929): After a series of misadventures involving a roadhouse, Caldwell College football star "Flash" Thomas wins the game and the girl. *Win That Girl* (1928): As part of a football rivalry extending over three generations of college men, Johnny Norton overcomes his initial poor play to lead his team to victory and win the love of his sweetheart. *Good News* (1930): Tait College football star Tom Marlow wins the game and the love of a girl named Connie.

9. In *Sweet Lavender* (1920), for example, the niece of a boardinghouse proprietor in a small college town falls in love with one of her aunt's boarders, a wealthy college student named Clem Hale. Clem's guardian, Horace Weatherburn, objects to a match with a "commoner" but relents when he witnesses Lavender's devotion to his ward. Ultimately, it is revealed that Weatherburn is Lavender's long-lost father; reunited with his daughter, he gives his blessing to the couple.

10. A number of films feature white male college students who manage mining companies, railroads, land speculations, and so on, including *The Americano, The Courage of the Common Place,* and *Langdon's Legacy* (1916), about Jack Langdon, a college man sent by a San Francisco corporation to manage its mine in Peru.

11. While white college boys are often reconciled with their biological fathers, in a number of cases they are orphans raised by multiple adopted fathers, as in *For the Love of Mike* (1927) and *When We Were Twenty-One* (1915), which focuses on Richard, an orphan raised by three male guardians. Richard grows into a handsome college football hero who falls for a gold-digging dancer named

"The Firefly," but he is finally saved from the disastrous engagement by his trio of guardians and ultimately finds true love. Such scenarios suggest an investment in forging white kinships above and beyond biological families.

12. In *The Rejuvenation of Aunt Mary* (1914), a college freshmen who is disinherited by his wealthy aunt when he becomes engaged to cabaret singer is redeemed when he falls for good girl Betty, his classmate's sister. The title of *The College Widow* (1915) refers to Jane Witherspoon, the daughter of a college president who says good-bye to another fiancé each graduation day. The football coach persuades her to entice Billy, a star halfback and son of a millionaire, to play for her father's team. Ultimately, the coach and the football team "form a flying wedge" to break into a burning building and save the couple. The film was remade in 1927 and in 1930, as a film titled *Maybe It's Love* (1930). *The Thousand Dollar Husband* (1916) features Olga, a housekeeper at a college boarding house, who falls in love with a wealthy boarder, Tom Gordon, who, however, is forced to quit school when his father loses his fortune. When she inherits a fortune from an uncle, Olga marries Tom to get him out of debt. The title character of *Plain Jane* (1916) works in a boarding house, where she falls in love with John Adams, a college student too busy with his studies to notice. But that changes when her picture is taken by a famous photographer, and a newspaper names her the prettiest woman in town. John takes notice and they begin a romance at film's end. The previously described films, *The College Orphan* and *Sweet Lavender*, also feature white working women who marry white college students.

13. *In Mizzoura* (1914) depicts a western sheriff who reaches an agreement with the local blacksmith to pay for his daughter Kate's college education. When the coed becomes infatuated with a train robber, the sheriff saves her from ruin, and Kate falls in love with her benefactor. *The Girl Who Couldn't Grow Up* (1917) features Peggy, the daughter of an oil magnate who goes to college and, after a series of misadventures, meets and marries one of her classmates, a European noble. In *Up in Mary's Attic* (1920), a college girl must keep her marriage to a coach a secret from her guardian, Professor Pennanink. After a series of comic misunderstandings, she publicly avers her marriage and is reconciled with Pennanink. Marion, the heroine of *The Fair Co-Ed* (1927), joins the girls' basketball team to get close to its coach, Bob, a fellow student working his way through college. While the two initially come into conflict, when Marion scores the winning points in the final moments of an important game, she also wins his love. In *The Wild Party* (1929) a student at Winston College for Women falls in love with her anthropology professor. The title character of *The College Coquette* (1929) falls in love with a college coach and becomes engaged to him by film's end. See also the upcoming discussion of Mary Pickford's *Daddy-Long-Legs* (1919).

14. In *The Plastic Age* (1925), champion athlete Hugh Carver battles rival Carl Peters (played by Mexican actor Gilbert Roland) for the affection of party girl Cynthia Day (Clara Bow). Late nights at roadhouses cause Carver to falter on the track, so Cynthia decides she is a bad influence and refuses to see him again. His athletic powers restored, Carver wins the big football game, and upon graduation he reunites with a reformed Cynthia.

15. The role of women as stakes in athletic competitions between men is concisely suggested by the title of a 1928 college football film, *Win That Girl*.

16. On dime novels of imperial adventure and the character of Frank Mer-
riwell, see Shelley Streeby, *Radical Sensations: World Movements, Violence,
and Visual Culture Class* (Durham: Duke University Press, 2013), 160–67.
Films featuring college boy anti-insurgents include the previously noted *Lang-
don's Legacy*, which is about a college boy sent by a San Francisco corporation
to manage its mine in Peru, where he stops a revolution; and *The Kid Is Clever*
(1917), which focuses on a recently graduated college student, Kirk White, who
boards a ship to South America to claim an inheritance, but on the way he and
his sweetheart, Violet Ray, are menaced by a band of revolutionaries. The cou-
ple is imprisoned, but White ultimately manages to send a telegram to the U.S.
Marines, who rescues them. See also the discussion of *The Americano.*

17. Lary May argues that Fairbank's film roles often depicted him excelling at
boxing, wrestling, and all manner of physical conflict, "threatening activities"
often "personified by non-whites." According to May, Fairbanks spoke of his
fears of Asian and Black men, "whom he constantly wanted to dominate." See
*Screening Out the Past: The Birth of Mass Culture and the Motion Picture
Industry* (Chicago: University of Chicago Press, 1983), 112, 280n29. Fairbanks
told one interviewer, for instance, that physical feats depicted in his film origi-
nated with his youthful conflicts with a Chinese laundry worker. The actor
describes his "deep and abiding fear of Chinamen," which he confronted as a
boy by throwing a rock through the window of a Chinese laundry. Running
from the owner and eluding capture represented an early "thrill" for Fairbanks,
which enabled him to master his terror. As a result, he returned again and again
to throw rocks at the Chinese laundry, and later, in his films, he would reproduce
versions of this primal scene of white supremacy (Charles K. Taylor, "The Most
Popular Man in the World," *Outlook*, December 24, 1924, 683–85). Fairbanks
told another reporter the "most trying moment of my life" was when he was an
undergraduate at Harvard and joined a group of his male classmates on a trip to
Paris. "We had great sport with the Frenchmen and the Martinique negroes
(pronounced niggers)" by calling them names in English that they could not
understand. But one day he tries it on a "six foot two shade" who understood
the insult and answered it with his fists. Fairbank's classmate returned the blows,
and "the coon went down. . . . Blood was running from his eyes and he was in
bad shape. . . . We don't know to this day if we killed that fellow or not." Carl
W. Seitz, "Douglas E. (Electricity) Fairbanks," *Motion Picture Magazine*, Decem-
ber 1916, 66.

18. Fairbank's public persona as a domineering white man is well represented
in a magazine article about the filming of *Bound in Morocco*, which is illustrated
with a photo of two Black men in "African" costumes on all fours, one on top
of the other, with Fairbanks (dressed all in white) standing on the back of the
second man to reach a second-floor window, where the blond woman author of
the story looks out. See Emma-Lindsay Squier, "Extra!," *Picture-Play* 9, no. 4
(1918): 177–83. Fairbanks cut the picture out and glued it into his personal
scrapbook. Scrapbook 4, Douglas Fairbanks Papers, Herrick Library, AMPAS.

19. Karl K. Kitchen, "A Day with the Playboy of the Movie World," *Phila-
delphia Record Motion Picture Magazine*, Scrapbook 3, Fairbanks Papers, Her-
rick Library, AMPAS.

20. Jeffery Vance, *Douglas Fairbanks,* with Tony Maietta (Berkeley: University of California Press, 2008), 16.

21. Richard Koszarski, *An Evening's Entertainment: The Age of the Silent Feature Picture, 1915–1928* (Berkeley: University of California Press, 1990), 268.

22. When analyzing Hollywood whiteness, Richard Dyer focuses in particular on the image of Pickford. See *White: Essays on Race and Culture* (New York: Routledge, 1997), 129.

23. *Daddy-Long-Legs* was remade twice, starring Janet Gaynor and Warner Baxter (1931) and Leslie Caron and Fred Astaire (1955).

24. Raheja, *Reservation Reelism,* 25. Red Wing was an enrolled member of the Ho-Chunk Nation and Young Deer was of Ho-Chunk descent, but it is unclear if he was enrolled (248–49).

25. Philip J. Deloria, *Indians in Unexpected Places* (Lawrence: University of Kansas Press, 2004), 96–97.

26. Foucault, *History of Sexuality,* 1:147–50.

27. Carewe made only two films with Native American characters, *Ramona* (1910) and *The Bad Man* (1923), which includes a minor character called "Indian Cook." His first film credit was for *The Inside of the White Slave Traffic* (1913), where he played the role of a white "procurer," and many of the films he subsequently directed similarly focus on violence and sexual depravity among whites. *The Cowboy and the Lady* (1915), for example, is a lurid western gothic involving sexual and other conflicts among white people. Carewe's film *Destiny, or The Soul of a Woman* (1915) tells the story of a ruined woman who runs a brothel, where she ultimately encounters her son. *The Upstart* (1916) is a romantic comedy about white infidelity and divorce. A melodrama set in the woods along the U.S.-Canadian border, *The Snowbird* (1916) depicts a deadly romantic triangle among two white men and a white woman. A cross-dressing subplot in which the female protagonist passes for a man and lives with her future lover, initially a "woman hater," explicitly thematizes white misogyny. *The Dawn of Love* (1916) dramatizes a violent white love triangle against the backdrop of illegal smuggling, while *The Trail of the Shadow* (1917) depicts another violent white love triangle involving murder and threatened rape. A number of Carewe's films employ western settings, where one might expect to find characters of color, but instead the director continued to focus on white depravity, as in *Their Compact* (1917), which features white infidelity and attempted murder in a mining town; *The Trail to Yesterday* (1918), which represents forced marriage and murder for hire among whites; and *False Evidence* (1919), which depicts the violence and intrigue that arises from the traditional practice in a western town of betrothing infant white girls to wealthy white men. Carewe continued to develop such plots in the 1920s, with *The Invisible Fear* (1921), a melodrama centered on a white man who attempts to rape the white fiancée of a rival; *Her Mad Bargain* (1921), which focuses on a poor young white woman forced to seek employment as an artists' model and who must fend off advances from several white male artists; and *I Am the Law* (1921), which highlights white infidelity, murder, and suicide. Carewe also directed films featuring Mexican characters, but they drastically depart from conventional narratives, where Mexican men represent sexual threats to white

women. *The Girl of the Golden West* (1923), for example, features a white sheriff who saves a Mexican man from a lynch mob and enables him to happily marry a white woman, while in *The Bad Man* (1923) a Mexican bandit enables a white couple to marry.

28. Raheja, *Reservation Reelism*, 11, 13.

29. Kate Buford, *Native American Son: The Life and Sporting Legend of Jim Thorpe* (New York: Knopf, 2010), 34. As Buford notes, "By 1917, historian Frederic L. Paxon, a disciple of Turner's, would affirm that sport had become the 'new safety valve' replacing the frontier" (45).

30. Buford, 101, 103.

31. Quoted in Tracey Goessel, *First King of Hollywood: The Life of Douglas Fairbanks* (Chicago: Chicago Review Press, 2016), 120.

32. Frantz Fanon, *Black Skin, White Masks,* trans. Richard Philcox (New York: Grove, 2008), 89.

33. *The Curse of the Redman* ad, *Motion Picture World*, William N. Selig Collection, Herrick Library, AMPAS. See also Deloria, *Indians in Unexpected Places*, 90. As reported in *Moving Picture World*, a delegation of more than thirty Aishinabe (Ojibway) men from Minnesota traveled in 1911 to Washington, DC, for an "'uprising' against the motions pictures," protesting their "grossly libelous" depiction of Indians. "The Indians are contemplating a call at the White House tomorrow to lay the case before President Taft and may ask for congressional action looking to the regulation of moving pictures in which Indians are shown." One of the protestors seemingly singled out *The Curse of the Redman* for special condemnation, telling reporters that "he had gone into one of the motion picture theaters here, where a picture was shown in which a young Indian graduate of one of the non-reservation schools was the chief figure. He was shunned by the members of his tribe upon his return to them, took to drink, killed a man and fled, but was killed after a long chase. This was denounced as an untrue portrayal of the Indian." *Moving Picture World*, March 18, 1911, 581, cited by Raheja, *Reservation Reelism*, 46.

34. Deloria, *Indians in Unexpected Places*, references the film but incorrectly states that it stars Lakota actor William Eagleshirt (90). See also Daisuke Miyao, *Sessue Hayakawa: Silent Cinema and Transnational Stardom* (Durham: University of North Carolina Press, 2007), 81–84.

35. Harvey F. Thew, "Betrayed," *Motion Picture News* 13, no. 4 (1916): 554.

36. Ad for *Betrayed, Motion Picture News* 13, no. 4 (1916): 466.

37. *Betrayed* entry, in American Film Institute, *Catalog of Feature Films*.

38. "Mutual Masterpictures," *Moving Picture World* 27, no. 4 (1916): 584.

39. Deloria, *Indians in Unexpected Places*, 99.

40. Sessue Hayakawa, *Zen Showed Me the Way to Peace, Happiness and Tranquility* (New York: Bobbs-Merrill, 1960), 97, 98, 96.

41. Amy Monagan, "Art and Artifice," *University of Chicago Magazine* 111, no. 1 (2018): 36–37.

42. Blumer, *Movies and Conduct*, 81, 115, 144–46.

43. Hayakawa, *Zen Showed Me*, 96.

44. Hayakawa, 121.

45. Grace Kingsley, "That Splash of Saffron: Sessue Hayakawa, a Cosmopolitan Actor Who, for Reasons of Nativity, Happens to Peer from Our White Screens with Tilted Eyes," *Photoplay*, March 1916, 139–41; "Sessue Hayakawa to Visit Universities," *Exhibitors Herald*, November 27, 1920, Hayakawa Biography file, Herrick Library, AMPAS; Sessue Hayakawa, "Human Motion Pictures," *University of Chicago Magazine* 13, no. 7 (1921): 250–51; Paramount press release, n.d., Hayakawa Biography file, Herrick Library, AMPAS.

46. Emma-Lindsay Squier, "Was Kipling Right When He Said 'Oh East Is East and West Is West and Never the Twain Shall Meet?,'" *Picture Play* 10, no. 1 (1919): 84.

47. The promotional connections between Hayakawa and the university continued until late in his career. For example, studio press packages for *The Bridge on the River Kwai* (1957) and for *The Swiss Family Robinson* (1960) include biographies of Hayakawa featuring his years at the University of Chicago. Hayakawa Biography file, Herrick Library, AMPAS.

48. *The City of Dim Faces*, intertitle script, Paramount Pictures scripts, Herrick Library, AMPAS, 1, 4, 7.

49. *The City of Dim Faces*, shooting script, Paramount Pictures scripts, Herrick Library, AMPAS, scene 45.

50. *City of Dim Faces*, intertitle script, AMPAS, 3, 6.

51. See Sumiko Higashi, "Ethnicity, Class, and Gender in Film: DeMille's *The Cheat*," in *Unspeakable Images: Ethnicity in the American Cinema*, ed. Lester D. Friedman (Champaign: University of Illinois Press, 1991), 112–39; and Gina Marchetti, *Romance and the "Yellow Peril": Race, Sex, and Discursive Strategies in Hollywood Fiction* (Berkeley: University of California Press, 1993), 10–45.

52. *City of Dim Faces*, intertitle script, AMPAS, 7, 4.

53. *City of Dim Faces*, intertitle script, 4.

54. In another lost film that Hayakawa both wrote and produced, *A Heart in Pawn* (1919), he plays a Japanese college student named Toyama, whose education is funded by his wife's prostitution. Also made by one of Hayakawa's production companies, *Where Lights Are Low* (1921) features the actor as a Chinese prince who immigrates to the United States for college and there discovers the woman he loves is for sale in a San Francisco Chinatown slave auction.

55. *Li Ting Lang*, synopsis, in American Film Institute, *Catalog of Feature Films*.

56. *The Jaguar's Claws*, scenario, Paramount Pictures scripts, Herrick Library, AMPAS, 1, 2, 29.

57. In addition to the film's scenario, the foregoing synopsis is based on the final shooting script for *The Jaguar's Claws*, Paramount Pictures scripts, Herrick Library, AMPAS.

58. William M. McCoy, "The Jaguar's Claws," Paramount Pictures scripts, Herrick Library, AMPAS, 12.

59. The scenario for *The Jaguar's Claws* was written by Beatrice C. deMille (Cecil B. DeMille's mother) and Leighton Osmun, who also wrote the scenario for another Hayakawa film titled *Forbidden Paths* (1917). In the later work the actor stars as Sato, a Japanese man in love with a white woman who is in love

with a white man who is married to a Mexican woman. In the end Sato kills the Mexican woman and himself so that the white couple can be happy. For an extended analysis of the film see Miyao, *Sessue Hayakawa*, 106–16.

60. *Frank Merriwell in Arizona, or The Mystery Mine* (1910), YouTube video, 26:43, posted by Eye, November 17, 2014, www.youtube.com /watch?v=wGO_2pZKTNM.

61. Mexican actor Gilbert Roland, for example, plays an Anglo-American student in *The Plastic Age,* while Mexican actor Ramon Navarro plays a Spanish law student in *In Gay Madrid* (1930).

62. *Free and Equal* and *Betrayed* entries, in American Film Institute, *Catalog of Feature Films.*

63. Robinson, *Forgeries of Memory*, 215.

64. Booker T. Washington, "Atlanta Compromise Speech," 1995, *History Matters*, May 16, 2019, http://historymatters.gmu.edu/d/39/.

65. Jacqueline Stewart analyzes early Black film audiences and what she calls "reconstructive spectatorship," a term that "seeks to account for the range of ways in which Black viewers attempted to reconstitute and assert themselves in relation to the cinema's racist social and textual operations." See *Migrating to the Movies: Cinema and Black Urban Modernity* (Berkeley: University of California Press, 2005), 94.

66. Field, *Uplift Cinema*, 5, 81.

67. Hazel V. Carby, *Race Men* (Cambridge: Harvard University Press, 2000), 34, 31.

68. Stewart, *Migrating to the Movies*, 205.

69. Stewart, 207. Even though uplift films were accommodationist, mimicking aspects of the white college film and reinforcing patriarchal nationalism and imperialism, they were still viewed as threatening to a white monopoly on power and knowledge and hence inspired vicious, racist responses of the sort analyzed by Robinson, to delegitimize a Black middle class. We could thus read *The Birth of a Nation* and other racist silent films as reactionary responses to the challenges uplift posed for white supremacy.

70. Robinson, *Forgeries of Memory*, 231, 271. The exception to these criticisms, Robinson argues, is the work of Oscar Micheaux.

71. Carby, *Race Men*, 3; Gerald Horne, *Paul Robeson: The Artist as Revolutionary* (London: Pluto, 2016), 1–3.

72. Horne, *Paul Robeson*, 1–2.

73. Horne, 53–56, 63. See also 93–94.

74. Horne, 102–3.

75. Carby, *Race Men*, 64.

76. Horne, *Paul Robeson*, 10; Paul Robeson, *Here I Stand*, with Lloyd L. Brown (1958; repr., Boston: Beacon, 1988), 10.

77. Kathryn Watterson, *I Hear My People Singing: African American Voices at Princeton* (Princeton: Princeton University Press, 2017), 257–60.

78. Horne, *Paul Robeson*, 30.

79. Robeson, *Here I Stand*, 18.

80. Horne, *Paul Robeson*, 15. In his junior and senior years Robeson was named an all-American and after graduation he paid for law school partly by

playing football professionally for the Milwaukee Badgers, where he squared off against a pro team led by Jim Thorpe.

81. Martin Duberman, *Paul Robeson: A Biography* (New York: New Press, 1989), 24, 25.

82. Barbara Ransby, *Eslanda: The Large and Unconventional Life of Mrs. Paul Robeson* (New Haven: Yale University Press, 2014), 30, 7.

83. Ransby, 64, 87.

84. Ella Shohat and Robert Stam, *Unthinking Eurocentrism: Multiculturalism and the Media* (New York: Routledge, 2008), 145.

85. Fanon uses the product's advertising slogan, "Y a bon Banania," to typify anti-Black imagery. See *Black Skin, White Masks*, 17, 35, 92, 163. In other translations "Y a bon Banania" is rendered in stereotypical African American dialect as "sho' good eatin.'"

86. Shohat and Stam, *Unthinking Eurocentrism*, 143, 148, 169.

87. Robeson, *Here I Stand*, 42.

88. As Robeson pointedly reminded Walter, "We beat Lehigh." The entire testimony can be read on the *History Matters* web site: "You Are the Un-Americans, and You Ought to Be Ashamed of Yourselves': Paul Robeson Appears before HUAC," June 12, 1956, http://historymatters.gmu.edu/d/6440/.

89. Robeson, *Here I Stand*, 41–42.

CHAPTER 2

1. Rogin's claims were influential well beyond academia, generating a number of high-profile media events. When he delivered an early version of what would become the title essay in his book *Ronald Reagan, the Movie and Other Episodes in Political Demonology* (Berkeley: University of California Press, 1988) at the American Political Studies Association in 1985, it was reported on in the *New York Times*, with photos of Reagan playing Notre Dame football star George Gipp, as well as pictures of Sylvester Stallone as Rambo and Clint Eastwood as Dirty Harry, actors whose film lines Reagan had famously borrowed. Martin Tolchin, "How Reagan Always Gets the Best Lines," *New York Times*, September 9, 1985, B8. When Rogin published *Ronald Reagan*, the *Times* gave it a detailed, positive review. Andrew Hacker, "He Found It at the Movies: 'Ronald Reagan,' the Movie," *New York Times*, April 19, 1987, BR6. Rogin's research even inspired a segment on *60 Minutes*, also called "Ronald Reagan, the Movie," in which he was interviewed by reporter Morley Shafer. "60 Minutes {Ronald Reagan: The Movie; Jimmy Evans; Dead or Alive} (TV)," Paley Center for Media, December 15, 1985, www.paleycenter.org/collection/item/?q=ronald+reagan&p=3&item=T86:1625.

2. Newfield, *Public University*, 51–54.

3. Gary K. Clabaugh, "The Educational Legacy of Ronald Reagan," *Educational Horizons* 82, no. 4 (2004): 256, 259.

4. Patricia J. Williams, *Open House: Of Family, Friends, Food, Piano Lessons, and the Search for a Room of My Own* (New York: Picador, 2004); P. Williams, "Our Lizard-Brain Politics," *Nation*, October 11, 2012, www.thenation.com/article/our-lizard-brain-politics/.

5. Unlike the Ivy League schools analyzed by Wilder in *Ebony and Ivy,* Eureka was founded by Christian abolitionists, but, as we shall see, that did not prevent it from being a conservative institution.

6. According to historian Frederick Rudolph, "by the 1920s, the temper of American higher education was really counterrevolutionary as far as the university movement was concerned" and bent on a "return to aristocratic ideals." *The American College and University: A History* (1962; repr., New York: Knopf, 1990), 449, 453.

7. Rudolph, 87–88, 95–96.

8. Ronald Reagan, *An American Life* (New York: Simon and Schuster, 1990), 45–46.

9. Christopher J. Lucas, *American Higher Education: A History* (New York: St. Martin's Press, 1994), 207, 209.

10. John R. Thelin, *A History of American Higher Education* (Baltimore: Johns Hopkins University Press, 2004), 186, 215–16.

11. Daniel A. Clark, *Creating the College Man: American Mass Magazines and Middle-Class Manhood, 1890–1915* (Madison: University of Wisconsin Press, 2010).

12. Ronald Reagan, "Address at Commencement Exercises at Eureka College," Ronald Reagan Presidential Library and Museum, May 9, 1982, www.reaganlibrary.gov/research/speeches/50982a.

13. See the following photos from Getty Images. Publicity still of Reagan throwing football: "Statuesque Ron," 1939, www.gettyimages.com/detail/news-photo/american-leading-man-and-future-us-president-ronald-reagan-news-photo/3205546; Reagan catching a football, gubernatorial campaign: "Ronald Reagan," 1966, May 24, 2019, www.gettyimages.com/detail/news-photo/1911politiker-usaspielt-mit-einem-kind-football-news-photo/541018555; and Reagan in Eureka jersey, presidential campaign: "Presidential Campaign of Ronald Reagan in Illinois, United States on October 18, 1980," 1980, www.gettyimages.com/detail/news-photo/presidential-campaign-of-ronald-reagan-in-illinois-united-news-photo/124131580, July 16, 2015.

14. Middle-class magazines directed at white audiences celebrated college football as part of the "muscular Christianity" and social Darwinist reform movements to renew the vitality of white masculinities. With the so-called closing of the frontier, athletic contexts emerged as substitute means of forging "martial virtues as well as Christian character through competition and physical exertion," which partly explains why imperialists like Teddy Roosevelt were also football fans. D. Clark, *Creating the College Man,* 85.

15. Rudolph, *American College,* 379–80.

16. Ronald Reagan, "Address at Commencement Exercises at the University of Notre Dame," Ronald Reagan Presidential Library and Museum, May 17, 1981, www.reaganlibrary.gov/research/speeches/51781a.

17. On the building of campus coliseums, as well as the magnitude of the college football audience and the revenues generated, see Rudolph, *American College,* 388–89; and Thelin, *American Higher Education,* 202–8.

18. Rudolph, *American College,* 384, 387.

19. Howard J. Savage et al., *American College Athletics* (New York: Carnegie Foundation for the Advancement of Teaching, 1929); D. Clark, *Creating the College Man*, 88, 90; Rudolph, *American College*, 374–93. See also Thelin, *American Higher Education*, 177–80.

20. Veblen, quoted in Lucas, *American Higher Education*, 192.

21. Robeson, *Here I Stand*, xii.

22. Thelin, *American Higher Education*, 253.

23. Tyran Kai Steward, "At the University but Not of the University: The Benching of Willis Ward and the Rise of Northern Racial Liberalism," *American Studies* 55, no. 3 (2016): 35–70.

24. Ronald Reagan, "Remarks to the Students and Faculty at Martin Luther King, Jr. Elementary School," Ronald Reagan Presidential Library and Museum, January 15, 1986, www.reaganlibrary.gov/research/speeches/11586b. Despite the claim that Burghardt was his best friend, Reagan reportedly confused him with George Wilson, a Black teammate from Reagan's high school team. "William Burghardt, 69, Reagan's College Crony, Dies in Maryland Hospital," *Jet*, September 3, 1981, 7.

25. Rogin, *Ronald Reagan, the Movie*, 15.

26. Reagan, "University of Notre Dame."

27. As Rogin explains, "While fighting communists off screen, he fought Indians in front of the camera." *Ronald Reagan, the Movie*, 38.

28. Dyer, *White*.

29. Rogin, *Ronald Reagan, the Movie*, 15, 39.

30. "Stonewall Jackson and VMI," Virginia Military Institute, May 11, 2019, www.vmi.edu/media/content-assets/documents/communications-and-marketing/media-relations/VMI_SWJackson_Fact_Sheet_2019.pdf.

31. Rogin, *Ronald Reagan the Movie*, 35.

32. June Jordan, "Wrong or White," reprinted in *Life as Activism: June Jordan's Writings from the Progressive*, ed. Stacy Russo (Sacramento: Litwin Books, 2014), 27–28. See also Jordan, "Nicaragua: Why I Had to Go There," *Some of U s Did Not Die: New and Selected Essays* (New York: Basic Books, 2002), 199–210.

33. Jordan, "Toward a Manifest New Destiny," "In the Land of White Supremacy," and "Justice at Risk," in Russo, *Life as Activism*, 72–84, 156–58, 173–77.

34. Bosley Crowther, "'Juke Girl,' a Tumbled Melodrama about Florida Vegetable Growers, Opens at the Strand," *New York Times*, June 20, 1942, www.nytimes.com/movie/review?res=9405E7DE173EE13BBC4851DFB0668389659EDE.

35. This fall is a common trope in U.S. films and literature about farmworkers. See Curtis Marez, *Farm Worker Futurism: Speculative Technologies of Resistance* (Minneapolis: University of Minnesota Press, 2016).

36. David Sterritt, "Juke Girl," Turner Classic Movies, 1980, May 24, 2019, www.tcm.com/this-month/article/221743%7C0/Juke-Girl.html.

37. Donald T. Critchlow, *When Hollywood Was Right: How Movie Stars, Studio Moguls, and Big Business Remade American Politics* (London: Cambridge University Press, 2013), 191–92.

38. "CA Republican Gubernatorial Candidate," Getty Images, 1966, May 24, 2019, www.gettyimages.com/detail/news-photo/republican-gubernatorial-candidate-ronald-reagan-clad-in-news-photo/53379300.

39. Seth Rosenfield, *Subversives: The FBI's War on Student Radicals and Regan's Rise to Power* (New York: Picador, 2013), 321–22.

40. Reagan, quoted in Michael Rogin and John L. Shover, *Political Change in California: Critical Elections and Social Movements, 1890–1966* (Westport, CT: Greenwood, 1970), 212n111.

41. Rick Jewell "John Wayne, an American Icon," *USC News*, August 1, 2008, https://news.usc.edu/15621/john-wayne-an-american-icon/.

42. Ronald Reagan, "The Unforgettable John Wayne," *Reader's Digest*, October 1979, reprinted in *Duke, We're Glad We Knew You: John Wayne's Friends and Colleagues Remember his Remarkable Life*, ed. Herb Fagen (New York: Citadel, 1979), xxiii.

43. Donald T. Critchlow and Emilie Raymond, *Hollywood and Politics: A Sourcebook* (London: Routledge, 2009), 9.

44. All quotations from Wayne in this paragraph are from a May 1971 *Playboy* interview, reprinted in John Wayne, *Fifty Years of Playboy Interviews: John Wayne*, Kindle ed. (Chicago: Playboy, 2012).

45. Howard Kohn and Lowell Bergman, "Ronald Reagan's Millions," *Rolling Stone*, August 26, 1976, www.rollingstone.com/politics/news/reagans-millions-19760826.

46. Kohn and Bergman.

47. Rogin and Shover, *Political Change in California*, 198.

48. Rosenfield, *Subversives*, 359.

49. Rogin and Shover, *Political Change in California*, 177.

50. Michael Omi and Howard Winant, *Racial Formations in the United States*, 3rd ed. (New York: Routledge, 2014), 221–22.

51. "Ronald Reagan on the Unrest on College Campuses, 1967," *History Now*, Gilder Lehrman Institute of American History, August 15, 1967, www.gilderlehrman.org/history-by-era/sixties/resources/ronald-reagan-unrest-college-campuses-1967.

52. Rogin and Shover, *Political Change in California*, 200, 201.

53. Michael Rogin, *Ronald Reagan, the Movie*, 25.

54. Ronald Reagan, "Inaugural Address, Ronald Reagan, 33rd Governor of California," Ronald Reagan Presidential Library and Museum, January 2, 1967, www.reaganlibrary.gov/research/speeches/01021967a.

55. Ronald Reagan, "Address by Governor Ronald Reagan: Installation of President Robert Hill, Chico State College," Ronald Reagan Presidential Library and Museum, May 20, 1967, www.reaganlibrary.gov/research/speeches/05201967a.

56. Bosley Crowther, "The Screen in Review: 'She's Working Her Way through College,' with Virginia Mayo, New Bill at Paramount," *New York Times*, July 10, 1952, 27.

57. Newfield, *Public University*, 257, 258.

58. Ronald Reagan, "Your America to Be Free," Commencement Address at Eureka College, June 7, 1957, in *Ronald Reagan: The Great Communicator*, ed. David Henry and Kurt Ritter, (Westport, CT: Greenwood, 1992), 133.

59. George Mariscal, *Brown-Eyed Children of the Sun: Lessons from the Chicano Movement, 1965–1975* (Albuquerque: University of New Mexico Press, 2005), 210–46; Ferguson, *Reorder of Things,* 41–75, 53.

60. "Ronnie and Co. Do It Again," *Triton Times,* October 4, 1968, 2–3; "Cattle Queen of Montana," film screening advertisement, December 6, 1968, 8; "Marcuse Speaks," November 26, 1969, 2; "Let Us Sing Again," October 11, 1968, 2, 1.

61. Reagan, "University of Notre Dame."

62. Patricia J. Williams, "Cluelessness and Culture," *Nation,* October 20, 1997, 9.

63. David Harvey, *A Brief History of Neoliberalism* (New York: Oxford University Press, 2007).

64. See Michael Meranze and Christopher Newfield, *Remaking the University* (blog), May 22, 2019, http://utotherescue.blogspot.com/search?q = Schwarzenegger.

65. Evan Halper, "Labor Studies Alone under Gov.'s Budget Ax," *Los Angeles Times,* April 8, 2005, http://articles.latimes.com/2004/apr/08/local/me-labor8; Peter Drier, "Labor Pains at UCLA, " *Huffington Post,* August 17, 2009, www.huffingtonpost.com/peter-dreier/labor-pains-at-ucla_b_238723.html.

66. Arnold Schwarzenegger, "Be Hungry to Make your Mark," Commencement Address, Emory University, *Emory Report,* May 17, 2010, 2; Mark Cooper, "Stumbling Schwarzenegger," *Nation,* June 15, 2005, www.thenation.com/article/stumbling-schwarzenegger/; Arnold Schwarzenegger, "2009 Commencement Address," *About USC,* University of Southern California, May 15, 2009, https://about.usc.edu/history/commencement/2009-address/.

67. Arnold Schwarzenegger, *Total Recall: My Unbelievably True Life Story,* with Peter Petre, (New York: Simon and Schuster, 2012), 4, 29, 33.

68. Arnold Schwarzenegger, *Arnold: The Education of a Bodybuilder,* with Douglas Kent Hall (New York: Simon and Shuster, 1977), 35; Schwarzenegger, *Total Recall,* 38.

69. Valerie Hirschl, *Santa Monica College,* clipping, 1972, Schwarzenegger Biography file, Herrick Library, AMPAS.

70. Schwarzenegger, *Total Recall,* 138, 139.

71. Jeff Leeds and James Bates, "A Degree of Fame for Each: Schwarzenegger Got a Small Campus Pumped Up in 1979, Leaving in '80 with a Diploma," *Los Angeles Times,* August 22, 2003, http://articles.latimes.com/2003/aug/22/entertainment/et-bates22.

72. In a 1987 profile, for example, film critic Roger Ebert noted that Schwarzenegger had earned a business degree and remembered that the first time they met Schwarzenegger "was carrying a textbook under his arm. Something about accounting." Roger Ebert, "Muscular Tycoon," *Movieline,* July 10, 1987, 27.

73. Schwarzenegger, *Total Recall,* 502–3, 515.

74. Wayne Warga, "Arnold Schwarzenegger: Big, Beautiful, Biceptual," *Cosmopolitan,* August 1992, 74.

75. Arnold Schwarzenegger, introd. to "The Power of the Market," *Free to Choose,* 1990, March 24, 2019, www.freetochoosenetwork.org/programs/free_to_choose/index_90.php?id=the_power_of_the_market.

76. Naomi Klein, *The Shock Doctrine: The Rise of Disaster Capitalism* (New York: Picador, 2007).

77. Dyer, *White*, 153.

78. Schwarzenegger, *Arnold*, 44.

79. Schwarzenegger, *Total Recall*, 50, 123, 233, 286.

80. For the history of the use of ideas about physical stature to understand economic growth and expansion, see Michael Tavel Clarke, *These Days of Large Things: The Culture of Size in America, 1865–1930* (Ann Arbor: University of Michigan Press, 2007), 101–77.

81. Schwarzenegger, introd. to "Power of the Market."

82. "Behind Schwarzenegger's Brawn, There's Brainpower You Can Bank On," *Rolling Stone*, January 17, 1985, 12; "Turning Iron into Gold," *Hollywood Reporter*, November 23, 1987, 85; Roger Ebert, "Muscular Tycoon," 27.

83. Schwarzenegger, *Total Recall*, 141, 285, 432.

84. Schwarzenegger, 549, 567, 514, 557.

85. Alan Karp, "Arnold Schwarzenegger: Chasing the American Dream," *Boxoffice*, November 1985, 11. Compare this passage from his 2012 autobiography: "America meant one thing: size. Huge skyscrapers, huge bridges, huge neon signs, huge highways, huge cars" (Schwarzenegger, *Total Recall*, 81).

86. Schwarzenegger, *Total Recall*, 121, 90.

87. Frank Swertlow, "Schwarzenegger: An American Success Story," *Daily News* clipping, February 17, 1986, Herrick Library, AMPAS.

88. Leonora Langley, "Strong Man Schwarzenegger Realizes His American Dream," *Hollywood Reporter* clipping, November 24, 1986, Herrick Library, AMPAS.

89. Schwarzenegger, *Arnold*, 38.

90. Schwarzenegger, *Total Recall*, 38, 239, 397.

91. Robin Wall Kimmerer, *Gathering Moss: A Natural and Cultural History of Mosses* (Corvallis: Oregon State University Press, 2003), 10, 15, 20.

92. Klaus Theweilt, *Male Fantasies*, vol. 1, *Women, Floods, History* (Minneapolis: University of Minnesota Press, 1987). For Ehrenreich's remarks, see her preface, xv.

93. Dyer, *White*, 148, 152–55.

94. Schwarzenegger, *Total Recall*, 66; "Reg Park, 79; Won Mr. Universe 3 Times," *Los Angeles Times*, November 24, 2007, http://articles.latimes.com/2007/nov/24/local/me-park24.

95. Annie Leibovitz, "Annie Gets Her Shot," *Vanity Fair*, September 6, 2018, www.vanityfair.com/news/2008/10/annie_excerpt200810.

96. Sean French, *The Terminator* (1996; repr., London: British Film Institute, 2004), 46.

97. "Arnold Schwarzenegger: Success and Secrets," transcript, *60 Minutes*, September 30, 2012, www.cbsnews.com/news/arnold-schwarzenegger-success-and-secrets/4/, 4.

98. While Goldberg was preparing for the role, one of her representatives contacted UCLA about the possibility of the star visiting to observe Gilmore teaching. At the time Gilmore was teaching in the Ralph J. Bunche Center for African American Studies at UCLA, but it does not appear as though

Goldberg or the representative actually visited one of her classes (Gilmore, email to the author, February 3, 2019). Shortly after *Made in America* was released, Danson donned blackface for a Friar's Club roast of Goldberg. See Lena Williams, "After the Roast, Fire and Smoke," *New York Times*, October 14, 1993, C1.

99. For a theorization of "vital energy" in the production of value, see Kalindi Vora, *Life Support: Biocapital and the New History of Outsourced Labor* (Minneapolis: University of Minnesota Press, 2015).

100. When Trump quit the show to focus on his 2016 presidential campaign, Schwarzenegger replaced him on the reality game show *The Celebrity Apprentice*.

CHAPTER 3

1. On Reagan, see the previous chapter; on Nixon, see Roderick Ferguson, *We Demand: The University and Student Protest* (Berkeley: University of California Press, 2017), 18–20.

2. In the novel version of *Love Story*, Oliver confesses he gained more on the athletic field than the library.

3. "Authorized," *US Magazine*, August 19, 1980, Erich Segal subject file, Paramount Studio Biography, Herrick Library, AMPAS.

4. Also released in 1970, *Getting Straight* makes explicit the reactionary terms of Hollywood's response to campus protest. Elliot Gould plays an English graduate student sleeping with an undergraduate (Candice Bergan), who does his laundry and grading. Studiously avoiding student protests for a Black studies program, Gould's character physically attacks a professor who suggests that his beloved F. Scott Fitzgerald was gay. The film also traffics in anti-Blackness, referring to minor Black characters as "spades" and welfare cheats, while its only Latinx character is a student named Garcia (Gregory Sierra) who reads comic books and speaks broken English. As such, Garcia is one of the rare examples of a Latinx college students in Hollywood cinema.

5. *Love Story* was the most widely consumed representation of college life in the 1970s. One in five U.S. readers read the novel, which topped best-seller lists for months. Its first New American Library paperback run of 4,325,000 copies was at the time "the largest single printing in the history of moveable type." "Erich Segal," in *Current Biography Yearbook, 1971*, ed. Charles Moritz (New York: Wilson, 1971), 387–89. *Love Story* was translated into thirty-three languages ("Best-Selling Author Erich Segal Tells How He Came to Write 'Love Story' and 'Oliver's Story' Books,'" 1978, Segal subject file, Paramount Studio Biography, Herrick Library, AMPAS). The film version was equally popular. Grossing almost $200 million, it saved Paramount from bankruptcy. Margalit Fox, "Erich Segal, Classicist Who Wrote Populist Blockbuster 'Love Story,' Dies at 72," *New York Times*, January 10, 2010, A15. It was nominated for seven Golden Globe Awards and won five, including best screenplay; it was also nominated for seven Academy Awards and won for best original score.

6. Segal subsequently revealed that Jones was the primary model for the character of Oliver, with Al Gore serving as the inspiration for Oliver's strained relationship with his family. Fox, "Erich Segal."

7. "Erich Segal," in *Current Biography Yearbook*, 387, 389; and Paul Goldberger, "Erich Segal's Identity Crisis," *New York Times Magazine*, June 13, 1971, 16–17, 34–37, 45.

8. Nora Ephron, "Mush," *Esquire*, June 1971, 89–93, 152–57; "Classics Scholar on a Fast Track," *Life*, April 20, 1970, 13; Paul Wilkes, "Yale Is No 1. with the Promoter and the Idol," *Look*, April 6, 1971, 60–62; Catherine Breslin, "Not Just Another Interview with Erich Segal," *New York Magazine*, May 31, 1971, 39–42.

9. Martin Arnold, "Erich Segal Denied Tenure as Yale Professor," *New York Times*, April 12, 1972, 47.

10. For the details of MacGraw's life in this paragraph, see her autobiography, *Moving Pictures: An Autobiography* (New York: Bantam Books, 1992).

11. *RPM* includes a satiric representation of S. I. Hayakawa, the San Francisco State University president who first opposed but finally relented to student demands for ethnic studies, in the figure of a Japanese linguistics professor (Bob Okazaki) who responds to a student protest with nonsensical jargon about semantics. I'm indebted to a reader on the University of California Press board for suggesting this connection.

12. Ferguson, *Reorder of Things*, 76–77.

13. Ferguson, 96.

14. Casting records for the film indicate that Lockwood was given costar billing, paid $65,000 for twelve weeks of work, and afforded first-class location expenses and transportation. By contrast, Winfield's name wasn't listed on posters for the film, he was paid only $1,150 for thirteen weeks of work (one week longer than Lockwood), and he was apparently required to pay his own expenses. See "R.P.M.—Casting," William "Billy" Gordon Papers, Herrick Library, AMPAS.

15. This history is according to Victor F. Ornelas, UOP class of 1971, who was a MEChA spokesperson during the occupation and an extra in *RPM*. See "Letters," *Pacific Review*, University of the Pacific, Winter 2009, www.pacific.edu/about-pacific/administrationoffices/office-of-marketing-and-communications/publications/pacific-review-/pacific-review-archives/review-letters.html.

16. "R.P.M.* *Revolutions per Minute: Promotion, 1969–1970," Jack Atlas Papers, Herrick Library, AMPAS.

17. James Baldwin, *The Devil Finds Work* (New York: Vintage, 2011), 75.

18. Stanley Kramer, interview, Southern Methodist University Collection of Ronald L. Davis Oral Histories on the Performing Arts, Herrick Library, AMPAS, 1.

19. J. Hoberman, "It's Always High Noon at the White House," *New York Times*, April 25, 2004, AR 11.

20. "*RPM* Simulated Campus Riot Almost Became the Real Thing, Says Kramer," *Variety*, December 8, 1970, 3; Vernon Scott, "Long-Time Rebel Films Story of Campus Revolt," *Los Angeles Herald-Examiner*, February 25, 1970, B-6.

21. "*RPM* Simulated Campus Riot," 3. Similarly, a reviewer for *Newsweek*, Alex Keneas, concluded that with their "clichéd characterization and dialogue" the students seem like "simple-minded adolescents, utterly incapable of serving

either as custodians of our conscience or sentinels of crisis." "Flunking Out," *Newsweek*, September 28, 1970, *RPM* Production file, Herrick Library, AMPAS.

22. "RPM Simulated Campus Riot," 3.

23. Charles Champlin, "Rejection of the Liberal in Kramer Film," *RPM* Production file, Herrick Library, AMPAS.

24. Bridget Byrne, "Kramer's 'RPM' Stars Quinn, Ann-Margaret," *Los Angeles Herald Examiner,* October 7, 1970, *RPM* Production file, Herrick Library, AMPAS.

25. Champlin, "Rejection of the Liberal"; *Westways,* October 1970, *RPM* Production file, Herrick Library, AMPAS, 62.

26. Columbia Pictures press release, *RPM* press book, Herrick Library, AMPAS.

27. Tomás Rivera, "Academic Development, Career Goals and Objectives," S1.B1.F.4, Tomás Rivera Archive, UA 253, Tomás Rivera Library, Special Collections and Archives (hereafter cited as SCA), University of California, Riverside, 1; Rivera, interview with Juan D. Bruce-Novoa, in Bruce-Novoa, *Chicano Authors: Inquiry by Interview* (Austin: University of Texas Press, 1980), 137–62.

28. Florencio Rivera's hope that his son could use education to become a bookkeeper is particularly poignant, given historical contexts in which growers often cheated farmworkers by controlling accounting.

29. Tomás Rivera, "Chancellor Designate Address to the UC Riverside Academic Senate," April 23, 1979, S3.B24.F1, Rivera Archive, SCA.

30. Rivera recalls, "When I graduated with a degree in English, and I couldn't get a job because I was a Mexican, they said, 'why don't you teach Spanish, there's a lot of jobs open in Spanish.' There were a lot of openings in English *también, nomás* (also, but) they wouldn't hire me. The placement office would not even give me the chance to apply and get rejected; they were very protective, *más bien* (more like) patronizing." Quoted in Bruce-Novoa, *Chicano Authors.*

31. Rivera, "Chancellor Designate Address," SCA.

32. Tomás Rivera, "Employment Record," CV, August 27, 1984, S1.B2.F8, Rivera Archive, SCA.

33. Rivera saved, for example, a catalog from a documentary and educational film company. See Atlantis Productions, *Films on Mexican-Americans,* February 15, 1971, S4.B61.F1, Rivera Archive, SCA.

34. Tomás Rivera to Michael D. Eisner, September 1, 1971, S1.B7.F44, Rivera Archive, SCA.

35. For documents from 1972 about *Carrascolendas* and Rivera's participation in the program, see S3.B1.F13, Rivera Archive, SCA.

36. Marlo Thomas to Tomás Rivera, telegram, February 21, 1978, S1.B15.F9, Rivera Archive, SCA. For Rivera's 1984 correspondence with Rodríguez about a film version of *Tierra,* see S2.B15.F8 in the Rivera Archive, SCA.

37. Tomás Rivera to Adán Medrano, Director, Centro Video, Oblate College of the Southwest, March 8, 1977, S1.B11.F36, Rivera Archive, SCA.

38. "Second Annual Chicano Film Festival Schedule," August 25, 1977, Oblate College, S1.B11.F36, Rivera Archive, SCA.

39. Jesús Treviño, *Eyewitness: A Filmmaker's Memoir of the Chicano Movement* (Houston: Arte Público, 2001), 2.

40. Marez, *Farm Worker Futurism*, 79–118.

41. National Association of Chicana and Chicano Studies Convention newsletter, February 1, 1978, S1.B11.F38, Rivera Archive, SCA, 2.

42. Hartman, *Scenes of Subjection*, 19, 22.

43. Tomás Rivera, *Y no se lo tragó la tierra/And the Earth Did Not Devour Him* (hereafter referred to as *Tierra*), in *Tomás Rivera: The Complete Works*, ed. Julián Oliveras (Houston: Arte Público, 1992), 34/95.

44. Tomás Rivera, "El Pete Fonseca"/"On the Road to Texas: Pete Fonseca," in Oliveras, *Tomás Rivera*, 167–68/135–36.

45. Tomás Rivera, "Into the Labyrinth: The Chicano in Literature," in Oliveras, *Tomás Rivera*, 261.

46. Tomás Rivera, "Remembering, Discovery and Volition in the Literary Imaginative Process, in Oliveras, *Tomás Rivera*, 302–3.

47. Rivera, *Tierra*, in Oliveras, *Tomás Rivera*, 80.

48. Similarly, in his notes for a lecture on migrant workers that followed a screening of the film *Bitter Harvest* (1981), a film about toxic chemicals in agriculture, Rivera distinguishes between migrants traveling on the highway and in worlds of TV and Hollywood that exist "outside the car." S1.B6.F52, Rivera Archive, SCA.

49. Rivera, "Remembering," in Oliveras, *Tomás Rivera*, 304; Tomás Rivera, "Chicano Literature: The Establishment of Community," in Oliveras, *Tomás Rivera*, 304.

50. Rivera, "Chicano Literature," in Oliveras, *Tomás Rivera*, 333, 336, 340.

51. Tomás Rivera to Roberto (no last name recorded), February 14, 1983, S5.B4.F9, Rivera Archive, SCA.

52. Tomás Rivera, "Critical Approaches to Chicano Literature and Its Dynamic Intimacy," in Oliveras, *Tomás Rivera*, 307–8; Rivera, "Chicano Literature," in Oliveras, *Tomás Rivera*, 340.

53. Tomás Rivera, "Philosophical Ideas," ca. 1970–78, S1.B1.F.12, Rivera Archive, SCA, 3.

54. Sedgwick, *Epistemology of the Closet*, 156.

55. Nadia Ellis concludes her study of James by underlining the limits of his particular version of Black diasporic vicarity, noting that he overidentified with white women stars to the relative exclusion of Black women in part because "he did not cultivate a robust political imaginary for black women" and instead acceded "to the racist, sexist logic by which black women's bodies could not count for affirmative national imaginaries." See Nadia Ellis,*Territories of the Soul: Queered Belonging in the Black Diaspora* (Durham: Duke University Press, 2015), 60.

56. Rivera, interview, in Bruce-Novoa, *Chicano Authors*, 143.

57. Rivera, "Philosophical Ideas," 1, SCA, 1.

58. Rivera, interview, in Bruce-Novoa, *Chicano Authors*, 191.

59. Rivera, *Tierra*, in Oliveras, *Tomás Rivera*, 119; Scholastic Books to Tomás Rivera, August 22, 1973, S2.B4.F7, Rivera Archive, SCA. Previously, "El Pete Fonseca" had been excluded from *Tierra* by Herminio Ríos and

Octavio Romano, the Berkeley professors and editors of the Chicano press Quinto Sol, because it presented a "negative" view of the pachuco, a figure who was often idealized in male-centered forms of Chicano cultural nationalism. For the respectability politics of Quinto Sol, see Yolanda Padilla, "Felix beyond the Closet: Sexuality, Masculinity, and Relations of Power in Arturo Islas' *The Rain God*," *Aztlan* 4, no. 2 (2009): 11–34. While he ultimately agreed to cut the story, Rivera later wrote that its characters, as well as the grifters and sex workers in *Tierra* (Don Laíto and Doña Bone), "are my favorite character-types which I have developed. I made and make no pretense at moral judgment and simply wanted to present them as amoral types." Rivera, "Critical Approaches," in Oliveras, *Tomás Rivera*, 309.

60. David Gutiérrez, *Walls and Mirrors: Mexican Americans, Mexican Immigrants, and the Politics of Ethnicity* (Berkeley: University of California Press, 1995).

61. Neil Foley, *The White Scourge: Mexicans, Blacks, and Poor Whites in Texas Cotton Culture* (Berkeley: University of California Press, 1999), 209–10.

62. Ana Raquel Minian, "'Indiscriminate and Shameless Sex': The Strategic Use of Sexuality by the United Farm Workers," *American Quarterly* 65, no. 1 (2013): 63–90; Marez, *Farm Worker Futurism*, 105–7.

63. Hong, *Death beyond Disavowal*.

64. Mike Davis, *City of Quartz: Excavating the Future in Los Angeles* (New York: Verso, 2006), 38, 43, 44.

65. Originally from South Texas, Gonzales had appeared in Federico Fellini's *Roma* (1972), and in his letter agreeing to work with him Rivera congratulated the actor on his recent role in Burt Reynolds's black comedy about death titled *The End* (1978). Tomás Rivera to Peter Gonzales, August 24, 1977, S2.B4.F7, Rivera Archive, SCA.

66. Tomás Rivera, "La mano en la bolsa"/"Hand in His Pocket," in Oliveras, *Tomás Rivera*.

67. On rings, see Eve Kosofsky Sedgwick, *Between Men: English Literature and Male Homosocial Desire* (New York: Columbia University Press, 1985), 161–79. On graves, see Leo Bersani, *Is the Rectum a Grave? And Other Essays* (Chicago: University of Chicago Press, 2010).

68. Tomás Rivera, Academic Senate address, n.d., S3.B20.F12, Rivera Archive, SCA.

69. Walter Benjamin, "Theses on the Philosophy of History," in *Illuminations: Essays and Reflections*, ed. Hannah Arendt, trans. Harry Zohn (New York: Schocken Books, 1969), 248.

70. In a justly famous chapter from *Tierra* called "Cuando llegemos"/"When We Arrive," Rivera represented a diverse group of farmworkers reflecting on what they will do when they arrive at their destination, only to die when the truck they are being transported in is struck by a drunk driver. See Rivera, *Tierra*, in Oliveras, *Tomás Rivera*, 52–55/115–18.

71. Alan F. Charles to Tomás Rivera, 1984, S1.1.B6.F30, Rivera Archive, SCA.

72. "Transcription of Oral History Interview with Concepcion G. Rivera," August 13, 1998, University of California, Riverside, www.ucrhistory.ucr.edu /pdf/rivera.pdf, 24, 26.

73. The phrase "presumed incompetent" alludes to Gabriella Gutiérrez y Muhs et al., eds., *Presumed Incompetent: The Intersections of Race and Class for Women in Academia* (Logan: Utah State University Press, 2012).

74. Michael Woodburne to Tomás Rivera, November 2, 1982, S3.B20.F13, Rivera Archive, SCA, 2.

75. Donald T. Sawyer to Tomás Rivera, November 1, 1982, S3.B20.F13, Rivera Archive, SCA.

76. Donald T. Sawyer, interview with Jody Swartzbaum, "Sawyer Interview," Chemistry Department, UC Riverside, March 2, 2001, http://chem.ucr.edu/documents/history/interview_sawyer2001.pdf, 8.

77. Eric T. Pengelley to Tomás Rivera, July 1, 1979, S3.B24.F12, Rivera Archive, SCA.

78. "In Memoriam: Eric T. Pengelley," UC Riverside Academic Senate, 2003, May 24, 2019, http://senate.universityofcalifornia.edu/_files/inmemoriam/html/erictpengelley.html.

79. "At 75, It's Orange-Plus," *At UCR*, February–March, 1982, O42.B2.F7, Citrus Experiment Station Collection, Special Collections (hereafter cited as SC), University of California, Riverside, 11.

80. Janet White, "From the Roots of Citrus, an Agricultural Savior Grew," *Citrus Experiment Station, Riverside, 1907–1982: Special Program*, April 16, 1982, O42.B2.F7, SC, 3.

81. "Alfred Boyce," *Citrus Experiment Station, Riverside, 1907–1982: Special Program*, April 16, 1982, O42.B2.F7, SC, 13–14.

82. United Farm Workers, "UFW Chronology," May 9, 2019, https://ufw.org/research/history/ufw-chronology.

83. Cesar Chavez, "At Pacific Lutheran University," *An Organizer's Tale: Speeches*, ed. Ilan Stavans (New York: Penguin Books, 2008).

84. *Occupation: Student*, 1969, YouTube video, 27:06, posted by University of California, Riverside, October 25, 2013, www.youtube.com/watch?v=uvtYx1FiOJs.

85. Rich Zigler, "Chairman of Black Studies Tells Why He Resigned," *Press-Enterprise*, February 7, 1970, B-5; see also Maurice Jackson's resignation letter, "Text of Hinderacker Speech before Emergency Faculty Meeting," *Highlander*, February 6, 1970, 6.

86. Hinderaker, quoted in *Highlander*, February 6, 1970, 10.

87. An image of the ovation is included in the 1970 UCR yearbook. See "All Fall Down: The Crisis in Black Studies," in *Tartan*, ed. Bill Elledege, 82–89. Riverside: Associated Students, University of California, Riverside.

88. Bob Craven, "Arson-Set Explosion, Fire Destroy UCR Black Students' Union Office," *Press-Enterprise*, March 16, 1972, B-2.

89. In a May 11, 1982, letter to the chair of the Black Studies Program, Dean David Warren complained about enrollment and faculty size and stability while also writing "I question seriously the legitimacy of . . . the issue of student identification, or 'belongingness'" that program faculty had argued was central to their mission. Similarly, in an October 15, 1982, letter to the chair of Chicano studies, Warren wrote that many of the program's aims were not "legitimately academic." See letters from Warren to Tomás Rivera, S3.B.25.F.14, Rivera Archive, SCA.

90. See E. V. C. Bovell's speech to the Academic Senate, May 10, 1984, S3.B25.F, Rivera Archive, SCA, 2.

91. University of California, Riverside, Committee on Educational Policy, "Ethnic Studies, Chicano Studies, and Black Studies Recommendations," May 10, 1984, S3.B25.4, Rivera Archive, SCA, 6–7, 9.

92. At the time Black Studies Department chair Carolyn Murray, an assistant professor, presented a sharp analysis of the ideological underpinnings of academic austerity as self-fulfilling prophecy when it comes to fields that challenge the status quo: "Rather than providing the resources necessary to attract and maintain the permanent faculty needed for Black Studies at UCR to be strong and successful, the pattern has been to severely restrict the Program's resources and access, blame it for not performing as well as other better endowed programs, then punish it by restricting its resources even more. In effect the program has been victimized by those who think it was ill-conceived in the first place, then blamed for the inevitable results of such victimization." Murray to Academic Senate Chair Woodburne, April 30, 1984, S3.B25.F4, Rivera Archive, SCA. In a speech to the Academic Senate (SCA), Bovell argued that disestablishment would not yield salary savings, since the tiny number of faculty in the two programs would be relocated to relevant departments. The two programs "command only a small fraction of the academic support budget allocated to the college" and "not all of even this small fraction would be realized as savings should the programs be disestablished" since "transferred faculty require transferred budgetary support" (1).

93. Tomás Rivera, remarks to the Academic Senate, ca. 1984, S3.B25.F4, Rivera Archive, SCA.

94. Tomás Rivera, "Planning Statement of the University of California, Riverside," May 10, 1982, S3.B12.F6, Rivera Archive, SCA.

95. Tomás Rivera, Strategic Planning Notes, S3.B21.F6, Rivera Archive, SCA, 53–57.

96. Tomás Rivera, speech to the UCR Academic Senate, ca. 1984, S3.B.20. F8, Rivera Archive, SCA.

CHAPTER 4

1. Deborah R. Vargas, *Dissonant Divas in Chicana Music: The Limits of La Onda* (Minneapolis: University of Minnesota Press, 2012), 54–107. On the importance of radio in Mexican immigrant lives, see Dolores Ines Casillas, *Sounds of Belonging: U.S. Spanish-Language Radio and Public Advocacy* (New York: New York University Press, 2014).

2. Zack Friedman, "Student Loan Debt in 2017: A 1.3 Trillion Crisis," *Forbes,* February 21, 2017, www.forbes.com/sites/zackfriedman/2017/02/21 /student-loan-debt-statistics-2017/#8cc03805daba.

3. Jeffrey J. Williams, "Debt Education: Bad for the Young, Bad for America," *Dissent,* Summer 2006, www.dissentmagazine.org/article/debt-education-bad-for-the-young-bad-for-america. A 2013 study found that at 514 colleges in the United Students, a student is more likely to default on his or her loans than graduate. See Andrew Gillen, "In Debt and in the Dark: It's Time for Better Information on Student Loan Defaults," *Education Sector,* July 2013, www.air.org/edsector-

archives/publications/debt-and-dark-it-s-time-better-information-student-loan-defaults.

4. For a reflection on the American Studies Association 2013 conference theme, see "2013 Reflections," May 21, 2019, www.theasa.net/node/4929. The quotation from Lisa Lowe is from an unpublished draft of the conference theme.

5. Brandon A. Jackson and John R. Reynolds, "The Price of Opportunity: Race, Student Loan Debt, and College Achievement," *Sociological Inquiry* 83, no. 3 (2013): 356. The consequences of student debt for Black students and parents are compounded by the subprime housing crisis, which resulted in a doubling of the gap between Black and white wealth such that, in 2009, Black families possessed only one dollar of wealth for every nineteen dollars owned by white families. Keeping in mind that wealth is calculated by subtracting debt from total assets, we can see how student debt further expands already extreme disparities in wealth and even more tightly ties the life chances of Black people to ongoing histories of U.S. racism. See Jeannette Wicks-Lim, "The Great Recession in Black Wealth," *Dollars and Sense,* January–February 2012, www.dollarsandsense.org/archives/2012/0112wicks-lim.html.

6. Tressie McMilan Cottom, *Lower Ed: The Troubling Rise of For-Profit Colleges in the New Economy* (New York: New Press, 2017).

7. In the words of the lawsuit, "through its concealed relationships with [for profit] colleges having high minority populations and its discriminatory underwriting policies and practices, Sallie Mae steered Plaintiffs into substandard private student loans because of their race." Sasha Rodríguez and Cathelyn Gregoire v. Sallie Mae Corporation, U.S. District Court of Connecticut, *Justica,* December 17, 2007, https://dockets.justia.com/docket/connecticut/ctdce/3:2007cv01866/79960.

8. Stephen Burd, "The Subprime Student Loan Racket," *Washington Monthly,* November–December 2009, https://washingtonmonthly.com/magazine/novemberdecember-2009/the-subprime-student-loan-racket-2/; Mandi Woodruff, "For-Profit Colleges Are Looking Sketchier Than Ever," *Business Insider,* August 20, 2013, www.businessinsider.com/career-education-corp-will-pay-9-million-to-students-after-allegedly-inflating-job-numbers-2013-8; "A.G. Schneiderman Announces Groundbreaking $10.25 Million Dollar Settlement with For-Profit Education Company That Inflated Job Placement Rates to Attract Students," Letitia James, NY Attorney General, January 30, 2014, www.ag.ny.gov/press-release/ag-schneiderman-announces-groundbreaking-1025-million-dollar-settlement-profit.

9. Amanda Armstrong-Price, "Debt and the Student Strike: Antagonism in the Sphere of Social Reproduction," *Reclamations* (blog), June 4, 2012 (site discontinued). See also American Association of University Women, "Graduating to a Pay Gap: The Earnings of Women and Men One Year after Graduation," October 2012, www.aauw.org/files/2013/02/graduating-to-a-pay-gap-the-earnings-of-women-and-men-one-year-after-college-graduation.pdf.

10. American Association of University Women, "Analysis: Women Hold Two-Thirds of Country's $1.4-Trillion Student Debt," press release (about the AAUW report *Deeper in Debt: Women and Student Loans*), May 21, 2018, www.aauw.org/article/women-hold-two-thirds-of-college-student-debt/.

11. Marc Bousquet, *How the University Works: Higher Education and the Low-Wage Nation* (New York: New York University Press, 2008), 27.

12. Bousquet, 6, 86.

13. Gauri Viswanathan, "The Naming of Yale College: British Imperialism and American Higher Education," in *Cultures of United States Imperialism,* ed. Amy Kaplan and Donald E. Pease (Durham: Duke University Press, 1993), 90, 92.

14. In Fenton, Missouri, for example, a two-hour drive east of the University of Missouri in Columbia (which is itself named for Christopher Columbus), Walmart leveled two ancient burial mounds, exposing human remains to looters, to build a new superstore. See "Sacred Lands: Walmart's Relationship with Native Americans," *Walmart Watch,* March 24, 2019, https://grist.files .wordpress.com/2009/09/native_americans_fact_sheet.pdf. See also Sue Sturgis, "Wal-Mart's History of Destroying Sacred Sites," *Facing South,* Institute for Southern Studies, September 3, 2009, www.facingsouth.org/2009/09/wal-marts-history-of-destroying-sacred-sites.html.

15. John Stossel, "Big Cheats on Campus," *ABC News,* November 19, 2004, http://abcnews.go.com/2020/story?id=264646&page=1.

16. Martinez, quoted in Stossel.

17. Dan Glaister, "University Uproar over Heiress Who 'Cheated,'" *Guardian,* November 30, 2004, www.theguardian.com/world/2004/nov/30/usa .internationaleducationnews.

18. Melamed, *Represent and Destroy,* 145.

19. See Bousquet, *How the University Works,* 125–56.

20. Ferguson, *Reorder of Things,* 8. Similarly, Newfield suggests that, while hunger strikes at UC Santa Barbara and UCLA in the early 1990s by students demanding more resources for Chicanx studies briefly focused attention on questions of inequality, in the same years the institutionalization of multiculturalism and norms of abstract formal inclusion coincided with the largely successful culture-war attacks on teaching and research about race that supported student demands for redistribution (*Public University,* 1–2).

21. Ferguson, *Reorder of Things,* 9.

22. Edufactory Collective, "The Double Crisis: Living on the Borders," *Edufactory Web Journal,* zero issue (January 2010): 4–9, www.academia.edu /2472296/The_Double_Crisis.

23. George Caffentzis, "The World Bank and the Double Crisis of African Universities," *Edufactory Web Journal,* zero issue (January 2010): 27–41, www.academia.edu/2472296/The_Double_Crisis.

24. Sunaina Maira and Piya Chatterjee, eds., *The Imperial University: Race, War, and the Nation-State* (Minneapolis: University of Minnesota Press, 2014).

25. Wilder, *Ebony and Ivy.*

26. See Harney and Moten, *Undercommons,* especially the discussion of study and debt, 22–43; Rana Sharif, "The Right to Education: La Frontera to Gaza," *American Quarterly* 62, no. 4 (2010): 856; Laura Pulido and David Lloyd, "From La Frontera to Gaza: Chicano-Palestinian Connections," *American Quarterly* 62, no. 4 (2010): 791.

27. Sharif, "Right to Education," 856.

28. This discussion reflects the headlines on the university's "Right to Education" website when I wrote the 2013 American Studies Association presidential address, on which this chapter is partly based. As of April 2019, the site has new headlines reflecting Israeli attacks on Palestinian access to education. See "Right to Education," Birzeit University, Palestine, May 21, 2019, http://right2edu.birzeit.edu.

29. *Higher Learning* was filmed, however, at UCLA, recalling Arnold Schwarzenegger's film *Junior,* where, in an act of symbolic privatization, UC Berkeley plays Stanford; see chapter 2.

30. John Singleton, dir., director's commentary, *Higher Learning* (Culver City: Columbia Pictures, 1995), DVD.

31. "Reagan and USC: President Reagan's Deep Association with the University of Southern California," Sol Price School of Public Policy, University of Southern California, May 9, 2019, https://priceschool.usc.edu/dp-events/reagan/reagan-and-usc/.

32. The videotape of the speech, which was broadcast on C-Span, includes an introduction by USC president James Zumberge recounting the history of the marching band's salutes to Reagan, as well as Reagan's speech and his and the audience's performance of the USC victory salute. "Reagan and USC."

33. Herbert Winford Hall, ed., *The Semicentennial Celebration of the Founding of the University of Southern California* (Los Angeles: University of Southern California Press, 1930), 117–27.

34. Marez, *Farm Worker Futurism,* 120.

35. Miguel Carmona and Nicolás Slachevsky, "The Double Crisis of the Chilean University," *Edufactory Web Journal,* zero issue (January 2010): 9, www.academia.edu/2472296/The_Double_Crisis. Examples of military and government officials with university posts include Janet Napolitano, the president of the University of California, who previously presided over a record number of deportations while director of Homeland Security; general and former director of the CIA David Petraeus, who has lectured at CUNY and USC; former British prime minister Tony Blair, who has taught courses on faith and globalization at Yale; former U.S. secretary of state Condoleezza Rice, who has served as Business School Faculty and director of its Center for Global Business and the Economy at Stanford; and torture apologist Alberto Gonzales, who has taught a political science course, served as a diversity recruiter at Texas Tech University, and held the Doyle Rogers Distinguished Chair of Law at Belmont University, in Nashville, Tennessee.

36. Bailey, "Bio."

37. Moya Bailey and Whitney Peoples, "Towards a Black Feminist Health Science Studies," *Catalyst: Feminism, Theory, Technoscience* 3, no. 2 (2007): 2–3. Bailey coined the concept in "They Aren't Talking about Me," *Crunk Feminist Collective,* March 14, 2010, www.crunkfeministcollective.com/2010/03/14/they-arent-talking-about-me/. See also Bailey, "New Terms of Resistance: A Response to Zenzele Isoke," *Souls* 15, no. 4 (2013): 341–43. The concept has been further elaborated in a lengthy blog post by Trudy, "Explanation of Misogynoir," *Gradient Lair,* April 28, 2014, www.gradientlair.com/post/84107309247/de ne-misogynoir-anti-black-misogyny-moya-bailey-coined. For a revealing

conversation between the two authors about the concept and its circulation, see Moya Bailey and Trudy, "On Misogynoir: Citation, Erasure, and Plagiarism," *Feminist Media Studies* 18, no. 4 (2018): 762–68.

38. Michelle Wallace, *"Boyz n the Hood* and *Jungle Fever,"* in *Black Popular Culture,* ed. Gina Dent (Seattle: Bay, 1992), 130.

39. Wikipedia, s.v. *"Martin* (TV Series)," last modified April 4, 2019, 04:58, https://en.wikipedia.org/wiki/Martin_(TV_series).

40. While Dawson played Shanaynay without dark makeup, he has also posted a number of blackface videos. See Arielle Dachille, "YouTube Star Shane Dawson Apologizes for Racist Videos and I'm Not Buying It: Video," September 26, 2014, www.bustle.com/articles/41633-youtube-star-shane-dawson-apologizes-for-racist-videos-im-not-buying-it-video.

41. Sara Clark Kaplan, "Sorting through Race Relations at UCSD," excerpt from *These Days,* a program on KPBS radio, February 25, 2010, in *Another University Is Possible,* ed. Alvarez et al. (San Diego: University Readers, 2010), 32–33.

42. "BSU Chairpersons, David Ritcherson and Fnann Keflezighi, BSU Press Conference," in Alvarez et al., *Another University Is Possible,* 68.

43. That spring quarter my colleague Yen Espiritu organized a team-taught, undergraduate course called California's Public Education Crisis, and part of my contribution was to create a digital archive of movies and TV shows filmed on college and university campuses in California, from the silent era to the present, and a companion lecture about the fantasies and desires for education encoded there. The result, which remains available on the *Critical Commons* website, is a project situated at the intersection of American studies, ethnic studies, visual studies, and critical university studies. The course syllabus can be accessed here: "ETHN 189—California's Public Education Crisis: A Team-Taught Course, January 1, 2014, http://ethnicstudies.ucsd.edu/_files/syllabi/SP10-ETHN-189-Y-Espiritu.pdf. See also Curtis Marez, "The University of California in Popular Media," *Critical Commons,* May 9, 2019, www.criticalcommons.org/Members /cmarez/lectures/lecture.2013-01-07.2328475602.

44. Simien, quoted in Jessica M. Goldstein, "'Dear White People' Filmmaker Talks Blackface, Interracial Dating, and Why White People Touch Afros," *Think Progress,* October 15, 2014, https://thinkprogress.org/dear-white-people-filmmaker-talks-blackface-interracial-dating-and-why-white-people-touch-afros-ed82coe52cc8/.

45. Simien, quoted in Goldstein.

46. Juan D. Bruce-Novoa, "When West Was North: Spirits of Frontier Experience, or Can the MacGuffin Speak," *Kriticos* 2 (December 2005), https://inter-theory.org/bruce-novoa.htm.

47. Armstrong-Price, "Student Strike."

48. "Park City '08 Interview: 'Sleep Dealer' Director Alex Rivera," *IndieWire,* January 11, 2008, www.indiewire.com/2008/01/park-city-08-interview-sleep-dealer-director-alex-rivera-73223/.

49. Rivera, quoted in Marez, *Farm Worker Futurism,* 1.

50. DuVernay, quoted in Rachael Kaadi Ghansah, "The Philosopher and Her Camera," *New Republic,* October 2016, 18.

51. DuVernay, quoted in Rebecca Traister, "In Conversation: Ava DuVernay," *New York Magazine*, September 19, 2016, www.thecut.com/2016/09/ava-duvernay-the-13th-queen-sugar-c-v-r.html.

52. DuVernay, quoted in Ghansah, "Philosopher and Her Camera," 20.

53. Ghansah, 20; DuVernay, quoted in Sam Adams, "Surviving Injustice," *Los Angeles Times*, November 10, 2016, S46.

54. DuVernay, quoted in Ghansah, "Philosopher and Her Camera," 18.

55. DuVernay, cited by Traister, "In Conversation."

56. DuVernay, quoted in Alexander C. Kaufman, "In 'Middle of Nowhere,' Cast Found Black Characters beyond the Stereotypes," *Wrap*, November 21, 2012, www.thewrap.com/middle-nowhere-cast-found-black-characters-reflected-not-interpreted-66136/.

57. DuVernay, quoted in Bekah Wright, "Direct Action," *UCLA Magazine*, October 1, 2012. http://magazine.ucla.edu/depts/style/direct-action/.

58. Kimberlé Crenshaw, "Mapping the Margins: Intersectionality, Identity Politics, and Violence against Women of Color," *Stanford Law Review* 43, no. 6 (1991): 1241–99.

59. DuVernay, quoted in Adams, "Surviving Injustice," S46.

60. *13th,* press kit, Herrick Library, AMPAS, 2–3.

61. DuVernay, quoted in Adams, "Surviving Injustice." While powerful and perceptive in many ways, *13th* has been justly criticized for overemphasizing private and federal prisons in ways that obscure the predominance of state and local prisons. See Dan Berger, "Mass Incarceration and Its Mystification: A Review of *13th,*" *Black Perspectives*, African American Intellectual History Society, October 22, 2016, www.aaihs.org/mass-incarceration-and-its-mystification-a-review-of-the-13th/.

62. Adams, "Surviving Injustice," S43.

63. DuVernay, quoted in Adams, S43.

64. Steven Zeitchik, "A Circuitous Route to 'Pariah': With Spike Lee's Help, Dee Rees Has Come a Long Way from Touting Wart Removers," *Los Angeles Times*, January 8, 2012, D8.

65. *Pariah,* press kit, Herrick Library, AMPAS, 2–4.

66. Aurora Guerrero, "Kick It: Aurora Guerrero Finds Strength in Relationships," Sundance Institute (blog), April 28, 2011, www.sundance.org/blogs/creative-distribution-initiative/kick-it-aurora-guerrero-finds-strength-in-relationships.

67. Sophia Mayer, "Pocahontas No More: Indigenous Women Standing Up for Each Other in Twenty-First Century Cinema," *Alphaville: Journal of Film and Screen Media* 10 (Winter 2015): 1–16, www.alphavillejournal.com/Issue10/PDFs/ArticleMayer.pdf.

68. Ana's desire to go to college is resisted by her mother, who instead wants her to stay and help support the family. When Ferrera enrolled at USC in 2003, she asked one of her professors and academic advisers to watch *Real Women Have Curves* so he could better understand her family dynamics and encourage her parents to support her. See Pamela J. Johnson, "Labors of Love for America Ferrera," *USC News*, May 20, 2013, https://news.usc.edu/51159/labors-of-love-for-america-ferrera/.

69. Marez, *Farm Worker Futurism*, 9–11.

70. I am indebted to Oscar Gutierrez for first alerting me to Guerrero's relationship with Communities for a Better Environment.

71. Guerrero, quoted in Ellise Fuchs, "Most of Us Don't Need to Put Labels on It: An Interview with Aurora Guerrero," *Popmatters*, December 5, 2012, www.popmatters.com/164954-interview-with-aurora-guerrero-2495801265 .html.

72. *Mosquita y Mari*, press kit, Herrick Library, AMPAS.

73. See, for example, Charles Hale, ed., *Engaging Contradictions: Theory, Politics, and Methods of Activist Scholarship* (Berkeley: University of California Press, 2008).

AFTERWORD

1. On contemporary horror and precarity, see Camilla Fojas, *Zombies, Migrants, and Queers: Race and Crisis Capitalism in Popular Culture* (Urbana: University of Illinois Press, 2017); Joanna Isaacson, "'It Follows': Contemporary Horror and the Feminization of Labor," *Blind Field: A Journal of Cultural Inquiry*, October 27, 2015, https://blindfieldjournal.com/2015/10/27/it-follows-contemporary-horror-and-the-feminization-of-labor/; and Annie McClanahan, *Dead Pledges: Debt, Crisis, and Twenty-First-Century Culture* (Palo Alto: Stanford University Press, 2017).

2. Doyle, *Campus Sex, Campus Security*.

3. Boggs and Mitchell, "Critical University Studies," 459.

4. "What Latino Film Critics Are Saying about 'Peppermint,'" *Remezcla*, September 10, 2018, http://remezcla.com/lists/film/what-latino-film-critics-are-saying-about-peppermint/; "White Nationalist Flyering on American College Campuses," Southern Poverty Law Center, October 17, 2017, www.splcenter.org/hatewatch /2017/10/17/white-nationalist-flyering-american-college-campuses; Erin B. Logan, "White Supremacist Propaganda Is Inundating College Campuses, Civil Rights Group Says," *Washington Post*, June 29, 2018, www.washingtonpost.com/news /grade-point/wp/2018/06/29/white-supremacist-propaganda-is-inundating-college-campuses-civil-rights-group-says/?utm_term=.65cf25ec29b8; Emma Kerr, "White Supremacists Are Targeting College Campuses Like Never Before," *Chronicle of Higher Education*, February 1, 2018, www.chronicle.com/article/White-Supremacists-Are/242403.

Filmography

13th. Directed by Ava DuVernay. Los Angeles: Kandoo Films, 2016.
The Absent-Minded Professor. Directed by Robert Stevenson. Los Angeles: Disney Productions, 1961.
Ali: Fear Eats the Soul. Directed by Rainer Werner Fassbinder. Munich: Filmverlag der Autoren, 1973.
American Aristocracy. Directed by Lloyd Ingraham. Fine Arts Film: Los Angeles, 1916.
The Americano. Directed by John Emerson. Los Angeles: Fine Arts Film, 1916.
And the Earth Did Not Swallow Him. Directed by Severo Perez. San Diego: KPBS, 1995.
Ashamed of Parents. Directed by Horace G. Plimpton. Los Angeles: Warner Bros. Pictures, 1921.
The Bad Man. Directed by Edwin Carew. Los Angeles: Carewe Productions, 1923.
Basket Ball, Missouri Valley College. New York: American Mutoscope and Biograph, 1904.
Batman and Robin. Directed by Joel Schumacher. Los Angeles: Warner Bros. Pictures, 1997.
Bedtime for Bonzo. Directed by Frederick De Cordova. Los Angeles: Universal-International Pictures, 1951.
Betrayed. Directed by Howard Mitchell. New York: Thanhouser, 1916.
The Birth of a Campus. Los Angeles: KNBC TV, 1965.
The Birth of a Nation. Directed by D. W. Griffith. Los Angeles: Griffith, 1915.
The Blot. Directed by Lois Weber. Los Angeles: Weber, 1921.
Body and Soul. Directed by Oscar Micheaux. Chicago: Micheaux Film, 1925.
Bound in Morocco. Directed by Alan Dawn. Los Angeles: Fairbanks Pictures, 1918.

The Bridge on the River Kwai. Directed by David Lean. Los Angeles: Horizon-American Pictures, 1957.

Brother Rat. Directed by William Keighley. Warner Bros. Pictures, 1938.

Brown of Harvard. Directed by Jack Conway. Los Angeles: Metro-Goldwyn-Mayer, 1926.

The Call of the Wild. Directed by D. W. Griffith. New York: American Mutoscope and Biograph, 1908.

The Cheat. Directed by Cecil B. DeMille. Los Angeles: Lasky Feature Play, 1915.

Chinatown. Directed by Roman Polanski. Los Angeles: Paramount Pictures, 1974.

The City of Dim Faces. Directed by George Melford. Los Angeles: Famous Players-Lasky, 1918.

Clickbait. Directed by Sophia Cacciola. Los Angeles: Launch Over, 2019.

The College Boob. Directed by Harry Garson. Los Angeles: R-C Pictures, 1926.

College Chums. Directed by Edwin S. Porter. Los Angeles: Edison, 1907.

The College Coquette. Directed by George Archainbaud. Los Angeles: Columbia Pictures, 1929.

A College Girl's Affair of Honor. Directed by G. W. Bitzer. New York. American Mutoscope and Biograph, 1906.

College Life at Amherst. Directed by G. W. Bitzer. New York: American Mutoscope and Biograph, 1906.

College Orphan. Directed by William C. Dowdan. Los Angeles: Universal Film, 1915.

The College Widow. Directed by George Archainbaud. Los Angeles: Columbia Pictures, 1915.

Compton in C Minor. Directed by Ava DuVernay. Los Angeles: DuVernay Agency, 2009.

Conquest of the Planet of the Apes. Directed by J. Lee Thompson. Los Angeles: Twentieth Century Fox, 1972.

The Courage of the Common Place. Directed by Ben Turbett. New Jersey: Edison, 1917.

The Cowboy and the Lady. Directed by Edwin Carewe. Los Angeles: Rolfe Photoplays, 1915.

The Curse of the Redman. Directed by Hobart Bosworth. Los Angeles: Selig Polyscope, 1911.

Daddy-Long-Legs. Directed by Alfred Santell. Los Angeles: Fox Film, 1931.

Daddy-Long-Legs. Directed by Jean Negulesco. Los Angeles: Twentieth Century Fox, 1955.

Daddy-Long-Legs. Directed by Marshall Neilan. Los Angeles: Pickford, 1919.

Daughter of the Dragon. Directed by Lloyd Corrigan. Los Angeles: Paramount Publix, 1931.

The Dawn of Love. Directed by Edwin Carewe. Los Angeles: Rolfe Photoplays, 1916.

Dear White People. Directed by Justin Simien. Los Angeles: Code Red, 2014.

The Defiant Ones. Directed by Stanley Kramer. Los Angeles: Lomitas, 1958.

Destiny, or The Soul of a Woman. Directed by Edwin Carewe. Los Angeles: Rolfe Photoplays, 1915.

Dixie. Directed by Webster Campbell. New Haven: Chronicles of America, 1924.

Double Indemnity. Directed by Billy Wilder. Los Angeles: Paramount Pictures, 1944.

Dr. Dolittle. Directed by Richard Fleischer. Los Angles: Twentieth Century Fox, 1967.

The Drop Kick. Directed by Millard Webb. Burbank: First National Pictures, 1927.

Drunktown's Finest. Directed by Sydney Freeland. Santa Fe: Indion Entertainment Group, 2014.

Each to His Kind. Directed by Marshall Neilan. Los Angeles: Lasky Feature Play, 1917.

The Fair Co-Ed. Directed by Sam Wood. Los Angeles: Metro-Goldwyn-Mayer, 1927.

False Evidence. Directed by Edwin Carewe. Los Angeles: Metro Pictures, 1919.

Fencing Class, Missouri Valley College. New York: American Mutoscope and Biography, 1904.

Forbidden Paths. Directed by Robert T. Thomby. Los Angeles: Lasky Feature Play, 1917.

For the Love of Mike. Directed by Frank Capra. Los Angeles: Cane, 1927.

Frank Merriwell in Arizona, or The Mystery Mine. New York: Tip Top Films, 1910.

Free and Equal. Directed by Roy William. Los Angeles: Ince, 1918.

Get Out. Directed by Jordan Peele. Los Angeles: Blum House, 2017.

Getting Straight. Directed by Richard Rush. Los Angeles: Organization, 1970.

The Girl of the Golden West. Directed by Edwin Carewe. Los Angeles: Associated First National Pictures, 1923.

The Girl Who Couldn't Grow Up. Directed by Snub Pollard. Los Angeles: Pollard Picture Plays, 1917.

Goodbye, Columbus. Directed by Larry Peerce. Los Angeles: Paramount Pictures, 1969.

Good News. Directed by Nick Grinde. Los Angeles: Metro-Goldwyn-Mayer, 1930.

The Grandee's Ring. Middletown: Interstate Feature Film, 1915.

Groundhog Day. Directed by Harold Ramis. Los Angeles: Columbia Pictures, 1993.

Happy Death Day. Directed by Christopher Landon. Los Angeles: Universal Pictures, 2017.

A Heart in Pawn. Directed by William Worthington. Los Angeles: Haworth Pictures, 1919.

Her Mad Bargain. Directed by Edwin Carewe. Los Angeles: Stewart, 1921.

Higher Learning. Directed by John Singleton. Columbia Pictures, 1995.

High Noon. Directed by Fred Zinnemann. Kramer Productions, 1952.

Home of the Brave. Directed by Mark Robson. Los Angeles: Kramer Productions, 1949.

Hoverboard. Directed by Sydney Freeland. 2012.

I Am the Law. Directed by Edwin Carewe. Los Angeles: Carewe Productions, 1921.
Inception. Directed by Christopher Nolan. Warner Bros. Pictures, 2010.
In Gay Madrid. Directed by Robert Z. Leonard. Los Angeles: Metro-Goldwyn-Mayer, 1930.
In Mizzoura. Directed by Lawrence McGill. Los Angeles: All Star Feature, 1914.
The Inside of the White Slave Traffic. Directed by Frank Beale. Los Angeles: Moral Feature Film, 1913.
The Invisible Fear. Directed by Edwin Carewe. Los Angeles: Stewart Productions, 1921.
The Jaguar's Claws. Directed by Marshall Neilan. Los Angeles: Lasky Feature Play, 1917.
Jericho. Directed by Thornton Freeland. London: Buckingham Film Productions, 1937.
Jim Thorpe, All American. Directed by Michael Curtiz. Los Angeles: Warner Bros. Pictures, 1951.
Juke Girl. Directed by Curtis Burnhardt. Los Angeles: Warner Bros. Pictures, 1942.
Junior. Directed by Ivan Reitman. Los Angeles: Universal Pictures, 1994.
The Kick-Off. Directed by Wesley Ruggles. Detroit: Excellent Pictures, 1926.
The Kid Is Clever. Directed by Paul Powell. Los Angeles: Fox Film, 1917.
The Knickerbocker Buckaroo. Directed by Albert Parker. Los Angeles: Fairbanks Pictures, 1919.
Knute Rockne All American. Directed by Lloyd Bacon. Los Angeles: Warner Bros. Pictures, 1940.
Langdon's Legacy. Directed by Otis Turner. Los Angeles: Universal Film, 1916.
Li Ting Lang. Directed by Charles Swikard. Los Angeles: Haworth Pictures, 1920.
Live Wires. Directed by Edward Sedgwick. Los Angeles: Fox Film, 1921.
Love Story. Directed by Arthur Hiller. Los Angeles: Paramount Pictures, 1970.
Madame Butterfly. Directed by Sydney Olcott. Los Angeles: Famous Players Film, 1915.
Made in America. Directed by Richard Benjamin. Los Angeles: Warner Bros. Pictures, 1993.
The Male Animal. Directed by Elliot Nugent. Los Angeles: Warner Bros. Pictures, 1942.
Manhattan Madness. Directed by Allan Dwan. Los Angeles: Fine Arts Film, 1916.
The Mark of Zorro. Directed by Fred Niblo. Los Angeles: United Artists, 1920.
Maya, Just an Indian. Saint Louis: Saint Louis Motion Picture, 1913.
Maybe It's Love. Directed by William McGann. First National Production, 1930.
Middle of Nowhere. Directed by Ava DuVernay. Los Angeles: Kandoo Films, 2012.
Mildred Pierce. Directed by Michael Curtiz. Los Angeles: Warner Bros. Pictures, 1941.

Minuet and Dance—College Women's Club. New York: American Mutascope and Biograph, 1904.
Mosquita y Mari. Directed by Aurora Guerrero. Santa Fe: Indion Entertainment Group, 2012.
Mudbound. Directed by Dee Rees. Los Angeles: Armory Films, 2017.
No Más Bebés. Directed by Renee Tajima-Peña. Los Angeles: ITVS, 2015.
North by Northwest. Directed by Alfred Hitchcock. Los Angeles. Metro-Goldwyn-Mayer, 1959.
The Nutty Professor. Directed by Jerry Lewis. Los Angeles: Lewis Enterprises, 1963.
Occupation: Student. Directed by Michael Creedman. Irvine: University of California, Irvine, 1969.
One Minute to Play. Directed by Sam Wood. Los Angeles: R. C. Pictures, 1926.
One Touch of Nature. Directed by Edward H. Chase. Orange: Edison, 1917.
The Pagan. Directed by W. S. Van Dyke. Los Angeles: Metro-Goldwyn-Mayer, 1929.
The Paper Chase. Directed by James Bridges. Los Angeles: Twentieth Century Fox, 1973.
Parched. Directed by Joe Leone. New York: Parched Productions, 2017.
Pariah. Directed by Dee Rees. New York: Chicken and Egg Pictures, 2011.
The Pinch Hitter. Directed by Victor Schertzinger. New York: New York Motion Picture, 1917.
Plain Jane. Directed by James Bridges. Los Angeles: Thompson-Paul Productions, 1916.
The Plastic Age. Directed by Wesley Ruggles. Los Angeles: Schulberg Productions, 1925.
Poltergeist. Directed by Tobe Hooper. Los Angeles: Metro-Goldwyn-Mayer, 1982.
The Poor Little Rich Girl. Directed by Frances Marion. Los Angeles: Artcraft Picture, 1917.
Prank Week. Directed by Manny Velazquez. Chicago: Velazquez Films, 2017.
Pressure Point. Directed by Hubert Cornfield. Los Angeles: Kramer Productions, 1962.
A Pueblo Legend. Directed by D. W. Griffith. New York: American Mutascope and Biograph, 1912.
The Purge. Directed by James DeMonaco. Los Angeles: Blum House, 2013.
The Quarterback. Directed by Fred Newmeyer. Los Angeles: Famous Players-Lasky, 1926.
Raíces de Sangre [Roots of Blood]. Directed by Jesús Salvador Treviño. Mexico City: National Cinematográfica, 1978.
Ramona. Directed by D. W. Griffith. Biograph, 1910.
Ramona. Directed by Edwin Carewe. New York: Inspiration Pictures, 1928.
Readin' Ritin' Rithmetic. Directed by Robert Eddy. Palo Alto: Stanford Ramsdale Productions, 1926.
The Realization of a Negro's Ambition. Directed by Harry A. Grant. Los Angeles: Lincoln Motion Picture, 1916.
The Rejuvenation of Aunt Mary. New York: Klaw and Erlanger, 1914.

Robin Hood. Directed by Alan Dwan. Los Angeles: Fairbanks Picture, 1922.
Rose of the South. Directed by Paul Scardon. Los Angeles: Vitagraph, 1916.
RPM. Directed by Stanley Kramer. Los Angeles: Kramer Productions, 1970.
Salt of the Earth. Directed by Herbert J. Biberman. New York: Independent Productions, 1954.
Santa Fe Trail. Directed by Michael Curtiz. Los Angeles. Warner Bros. Pictures, 1940.
Scream. Directed by Wes Craven. Los Angeles: Dimension Films, 1996.
Seguín. Directed by Jesús Salvador Treviño. Los Angeles: American Playhouse, 1982.
Selma. Directed by Ava DuVernay. Paris: Pathé, 2014.
She's Working Her Way through College. Directed by H. Bruce Humberstone. Los Angeles: Warner Bros. Pictures, 1952.
The Silent Witness. Directed by Captain Harry Lambert. New York: Author's Film, 1917.
Sleep Dealer. Directed by Alex Rivera. Los Angeles: Likely Story, 2008.
The Snowbird. Directed by Edwin Carewe. Los Angeles: Rolfe Photoplays, 1916.
Squaw Man. Directed by Cecil B. DeMille. Los Angeles: Metro-Goldwyn-Mayer, 1914.
The Strawberry Statement. Directed by Stuart Hagmann. Los Angeles: Metro-Goldwyn-Mayer, 1970.
Strongheart. Directed by James Kirkwood. New York: American Mutascope and Biograph, 1914.
Sweet Lavender. Directed by Paul Powell. Los Angeles. Real Art Pictures, 1920.
The Swiss Family Robinson. Directed by Ken Annakin. Los Angeles: Disney Productions, 1960.
Their Compact. Directed by Edwin Carewe. Los Angeles: Metro Pictures, 1917.
This is the Life. Directed by Ava DuVernay. Los Angeles: DuVernay Agency, 2008.
The Thousand Dollar Husband. Directed by James Young. Los Angeles: Lasky Feature Play, 1916.
The Trail of the Shadow. Directed by Edwin Carewe. Los Angeles: Rolfe Photoplays, 1917.
The Trail to Yesterday. Directed by Edwin Carewe. Los Angeles: Metro Pictures, 1918.
The Trooper of Troop K. Directed by Harry A. Grant. Los Angeles: Lincoln Motion Picture, 1917.
Truth or Dare. Directed by Jeff Wadlow. Los Angeles: Blumhouse Productions, 2018.
Two Minutes to Go. Directed by Charles Ray. Los Angeles: Ray Productions, 1921.
Up in Mary's Attic. Directed by William H. Waton. Los Angeles: Ascher Productions, 1920.
The Upstart. Directed by Edwin Carewe. Los Angeles: Rolfe Photoplays, 1916.
Varsity. Directed by Frank Tuttle. Los Angeles: Paramount Famous Lasky, 1928.

When We Were Twenty-One. Directed by Hugh Ford. Los Angeles: Famous Players Film, 1915.

Where Lights Are Low. Directed by Colin Campbell. Los Angeles: Hayakawa Feature Play, 1921.

The Wild Party. Directed by Dorothy Arzner. Los Angeles: Paramount Famous Lasky, 1929.

The Winning Stroke. Directed by Eddie Dillon. Los Angeles: Fox Film, 1919.

Win That Girl. Directed by David Butler. Los Angeles: Fox Film, 1928.

A Wrinkle in Time. Directed by Ava DuVernay. Los Angeles: Disney Productions, 2018.

Young Deer's Return. Directed by Fred J. Balshofer. New York. Bison Motion Pictures, 1910.

Bibliography

"2013 Reflections." American Studies Association. Accessed May 21, 2019. www.theasa.net/node/4929.

"60 Minutes {Ronald Reagan: The Movie; Jimmy Evans; Dead or Alive} (TV)." Paley Center for Media. December 15, 1985. www.paleycenter.org /collection/item/?q=ronald+reagan&p=3&item=T86:1625.

Adams, Sam. "Surviving Injustice." *Los Angeles Times*, November 10, 2016, S46.

"A. G. Schneiderman Announces Groundbreaking $10.25 Million Dollar Settlement with For-Profit Education Company That Inflated Job Placement Rates to Attract Students." Letitia James, NY Attorney General. Accessed January 30, 2014. www.ag.ny.gov/press-release/ag-schneiderman-announces-groundbreaking-1025-million-dollar-settlement-profit.

Ahmed, Sara. *On Being Included: Racism and Diversity in Institutional Life.* Durham: Duke University Press, 2012.

Allen, Lewis, dir. *Mission Impossible.* Episode, "The Pendulum." CBS. Dailymotion Video. February 23, 1973. www.dailymotion.com/video/x6gz95e.

"All Fall Down: The Crisis in Black Studies." In *Tartan*, edited by Bill Elledege, 82–89. Riverside: Associated Students, University of California, Riverside.

Alvarez, Luis, Roberto Alvarez, Cutler Edwards, Stevie Ruiz, Elizabeth Sine, Maki Smith, and Daniel Widener, eds. *Another University Is Possible.* San Diego: University Readers, 2010.

American Association of University Women. "Analysis: Women Hold Two-Thirds of Country's $1.4-Trillion Student Debt." Press release. May 21, 2018. www.aauw.org/article/women-hold-two-thirds-of-college-student-debt/.

———. "Graduating to a Pay Gap: The Earnings of Women and Men One Year after Graduation." October 2012. www.aauw.org/files/2013/02/graduating-

to-a-pay-gap-the-earnings-of-women-and-men-one-year-after-college-gradu-ation.pdf.

American Film Institute. *AFI Catalog of Feature Films*. Accessed May 1, 2019. https://catalog.afi.com/Catalog/Showcase.

Armstrong-Price, Amanda. "Debt and the Student Strike: Antagonism in the Sphere of Social Reproduction." *Reclamations* (blog). June 4, 2012 (site discontinued).

"Arnold Schwarzenegger: Success and Secrets." Transcript. *60 Minutes*. September 30, 2012. www.cbsnews.com/news/arnold-schwarzenegger-success-and-secrets/4/.

Bailey, Moya. "Bio." Personal website. Accessed May 1, 2019. www.moyabailey.com.

———. "They Aren't Talking about Me." *Crunk Feminist Collective*, March 14, 2010. www.crunkfeministcollective.com/2010/03/14/they-arent-talking-about-me/.

Bailey, Moya, and Whitney Peoples. "Towards a Black Feminist Health Science Studies." *Catalyst: Feminism, Theory, Technoscience* 3, no. 2 (2007): 1–27.

Bailey, Moya, and Trudy. "On Misogynoir: Citation, Erasure, and Plagiarism." *Feminist Media Studies* 18, no. 4 (2018): 762–68.

Baldwin, James. *The Devil Finds Work*. New York: Vintage, 2011.

"Behind Schwarzenegger's Brawn, There's Brainpower You Can Bank On." *Rolling Stone*, January 17, 1985.

Benjamin, Walter. *The Arcades Project*. Translated by Kevin McLaughlin. Cambridge: Harvard University Press, 2002.

———. "Theses on the Philosophy of History." In *Illuminations: Essays and Reflections*. Edited by Hannah Arendt. Translated by Harry Zohn. New York: Schocken Books, 1969.

Berger, Dan. "Mass Incarceration and Its Mystification: A Review of *13th*." *Black Perspectives*. African American Intellectual History Society. October 22, 2016. www.aaihs.org/mass-incarceration-and-its-mystification-a-review-of-the-13th/.

Bersani, Leo. "Is the Rectum a Grave?" In *Is the Rectum a Grave? And Other Essays*, 3–30. Chicago: University of Chicago Press, 2010.

Blumer, Herbert. *Movies and Conduct*. New York: Macmillan, 1933.

Blumer, Herbert, and Philip M. Houser. *Movies, Delinquency and Crime*. New York: Macmillan, 1933.

Bogardus, Emory. *The City Boy and His Problems: A Survey of Boy Life in Los Angeles*. Los Angeles: Ralston, 1926.

———. *Essentials of Americanization*. Los Angeles: University of Southern California Press, 1920.

———. "Eugenic Sociology." In *A History of Social Thought*. Los Angeles: University of Southern California Press, 1922.

———. "Hygienic and Eugenic Factors in Social Progress." In *An Introduction to Social Sciences: A Textbook Outline*. Los Angeles: Ralston, 1913.

Boggs, Abigail, and Nick Mitchell. "Critical University Studies and the Crisis Consensus." *Feminist Studies* 44 no. 2 (2018): 432–63.

Bousquet, Marc. *How the University Works: Higher Education and the Low-Wage Nation.* New York: New York University Press, 2008.

Breslin, Catherine. "Not Just Another Interview with Erich Segal." *New York Magazine,* May 31, 1971, 39–42.

Brown, Elspeth H. "Racialising the Viral Body: Eadweard Muybridge's Locomotion Studies, 1883–1887." *Gender and History* 17 no. 3 (2005): 627–56.

Bruce-Novoa, Juan D. *Chicano Authors: Inquiry by Interview.* Austin: University of Texas Press, 1980.

———. "When West Was North: Spirits of Frontier Experience, or Can the MacGuffin Speak?" *Kriticos* 2 (December 2005). https://intertheory.org /bruce-novoa.htm.

"BSU Chairpersons, David Ritcherson and Fnann Keflezighi, BSU Press Conference." In Alvarez et al., *Another University Is Possible,* 67–68.

Buford, Kate. *Native American Son: The Life and Sporting Legend of Jim Thorpe.* New York: Knopf, 2010.

Burd, Stephen. "The Subprime Student Loan Racket." *Washington Monthly,* November– December 2009. https://washingtonmonthly.com/magazine /novemberdecember-2009/the-subprime-student-loan-racket-2/.

Caffentzis, George. "The World Bank and the Double Crisis of African Universities." *Edufactory Web Journal,* zero issue (January 2010): 27–41. www .academia.edu/2472296/The_Double_Crisis.

Carby, Hazel V. *Race Men.* Cambridge: Harvard University Press, 2000.

"CA Republican Gubernatorial Candidate." Getty Images. 1966. Accessed May 24, 2019. www.gettyimages.com/detail/news-photo/republican-gubernatorial-candidate-ronald-reagan-clad-in-news-photo/53379300.

Carmona, Miguel, and Nicolás Slachevsky. "The Double Crisis of the Chilean University." *Edufactory Web Journal,* zero issue (January 2010): 4–9. www .academia.edu/2472296/The_Double_Crisis.

Casillas, Dolores Ines. *Sounds of Belonging: U.S. Spanish-Language Radio and Public Advocacy.* New York: New York University Press, 2014.

Chatterjee, Piya, and Sunaina Maira, eds. *The Imperial University: Academic Repression and Scholarly Dissent.* Minneapolis: University of Minnesota Press, 2014.

Chavez, Cesar. "At Pacific Lutheran University." In *An Organizer's Tale: Speeches,* edited by Ilan Stavans. New York: Penguin Books, 2000.

Clabaugh, Gary K. "The Educational Legacy of Ronald Reagan." *Educational Horizons* 82, no. 4 (2004): 256–59.

Clark, Daniel A. *Creating the College Man: American Mass Magazines and Middle-Class Manhood, 1890–1915.* Madison: University of Wisconsin Press, 2010.

Clark, Perry R. "Barred Progress: Indiana Prison Reform, 1880–1920." Master's thesis, University of Indiana, 2008.

Clarke, Michael Tavel. *These Days of Large Things: The Culture of Size in America, 1865–1930.* Ann Arbor: University of Michigan Press, 2007.

"Classics Scholar on a Fast Track." *Life Magazine,* April 20, 1970.

Cooper, Mark. "Stumbling Schwarzenegger." *Nation,* June 15, 2005. www .thenation.com/article/stumbling-schwarzenegger/.

Cottom, Tressie Mcmilan. *Lower Ed: The Troubling Rise of For-Profit Colleges in the New Economy*. New York: New Press, 2017.

"Craig Reardon on the Film's Makeups." *Poltergeist: The Fan Cite*. Accessed May 1, 2019. www.poltergeist.poltergeistiii.com/reardon.html.

Craven, Bob. "Arson-Set Explosion, Fire Destroy UCR Black Students' Union Office." *Press-Enterprise*, March 16, 1972, B-2.

Crenshaw, Kimberlé. "Mapping the Margins: Intersectionality, Identity Politics, and Violence against Women of Color." *Stanford Law Review* 43, no. 6 (1991): 1241–99.

Critchlow, Donald T. *When Hollywood Was Right: How Movie Stars, Studio Moguls, and Big Business Remade American Politics*. London: Cambridge University Press, 2013.

Critchlow, Donald T., and Emilie Raymond. *Hollywood and Politics: A Sourcebook*. London: Routledge, 2009.

Crowther, Bosley. "'Juke Girl,' a Tumbled Melodrama about Florida Vegetable Growers, Opens at the Strand." *New York Times*, June 20, 1942. www.nytimes.com/movie/review?res=9405E7DE173EE13BBC4851DFB0668389659EDE.

———. "The Screen in Review: 'She's Working Her Way through College,' with Virginia Mayo, New Bill at Paramount. *New York Times*, July 10, 1952, 27.

Dachille, Arielle. "YouTube Star Shane Dawson Apologizes for Racist Videos and I'm Not Buying It: Video." September 26, 2014. www.bustle.com/articles/41633-youtube-star-shane-dawson-apologizes-for-racist-videos-im-not-buying-it-video.

Daniel, Hawthorn. "American History in Moving Pictures." *World's Work: A History of Our Time* 44 (May 1922): 538–47.

———. "Yale's Movie Version of American History." *Literary Digest*, March 4, 1922, 41–43.

Davis, Mike. *City of Quartz: Excavating the Future in Los Angeles*. New York: Verso, 2006.

Deloria, Philip J. *Indians in Unexpected Places*. Lawrence: University of Kansas Press, 2004.

Doyle, Jennifer. *Campus Sex, Campus Security*. South Pasadena: Semiotext(e), 2015.

Drier, Peter. "Labor Pains at UCLA. " *Huffington Post*, August 17, 2009. www.huffingtonpost.com/peter-dreier/labor-pains-at-ucla_b_238723.html.

Duberman, Martin. *Paul Robeson: A Biography*. New York: New Press, 1989.

Du Bois, W. E. B. *The Souls of Black Folk*. In *W. E. B. Du Bois: The Writings*. Edited by Nathan Huggins, 357–548. New York: Library of America, 1987.

Dyer, Richard. *White: Essays on Race and Culture*. New York: Routledge, 1997.

Ebert, Roger "Muscular Tycoon." *Movieline*, July 10, 1987.

Edufactory Collective. "The Double Crisis: Living on the Borders." *Edufactory Web Journal*, zero issue (January 2010): 4–9. www.academia.edu/2472296/The_Double_Crisis.

———. "The Double Crisis of the University and the Global Economy." *Edufactory Web Journal*, no. 1 (March 2010). http://eipcp.net/n/1267628007.

Ellis, Nadia. *Territories of the Soul: Queered Belonging in the Black Diaspora.* Durham: Duke University Press, 2015.

Ephron, Nora. "Mush." *Esquire,* June 1971, 89–93, 152–57.

"Erich Segal." In *Current Biography Yearbook, 1971,* edited by Charles Moritz, 387–89. New York: Wilson, 1971.

"ETHN 189—California's Public Education Crisis: A Team-Taught Course." January 1, 2014. http://ethnicstudies.ucsd.edu/_files/syllabi/SP10-ETHN-189-Y-Espiritu.pdf.

Fanon, Frantz. *Black Skin, White Masks.* Translated by Richard Philcox. New York: Grove, 2008.

Ferguson, Roderick. *The Reorder of Things: The University and Its Pedagogies of Minority Difference.* Minneapolis: University of Minnesota Press, 2012.

———. *We Demand: The University and Student Protest.* Berkeley: University of California Press, 2017.

Field, Allyson Nadia. *Uplift Cinema: The Emergence of African American Film and the Possibility of Black Modernity.* Durham: Duke University Press, 2015.

Fojas, Camilla. *Zombies, Migrants, and Queers: Race and Crisis Capitalism in Popular Culture.* Urbana: University of Illinois Press, 2017.

Foley, Neil. *The White Scourge: Mexicans, Blacks, and Poor Whites in Texas Cotton Culture.* Berkeley: University of California Press, 1999.

Forman, Henry J. *Our Movie-Made Children.* New York: Macmillan, 1934.

Foucault, Michel. *The History of Sexuality.* Vol. 1, *An Introduction.* New York: Vintage Books, 1990.

Fox, Margalit. "Erich Segal, Classicist Who Wrote Populist Blockbuster 'Love Story,' Dies at 72." *New York Times,* January 10, 2010, A15.

Frank Merriwell in Arizona, or The Mystery Mine. 1910. YouTube video, 26:43, posted by Eye. November 17, 2014. www.youtube.com/watch?v=wGO_2pZKTNM.

French, Sean. *The Terminator.* 1996. Reprint, London: British Film Institute, 2004.

Friedman, Zack. "Student Loan Debt in 2017: A 1.3 Trillion Crisis." *Forbes,* February 21, 2017. www.forbes.com/sites/zackfriedman/2017/02/21/student-loan-debt-statistics-2017/#8cc03805daba.

Fuchs, Ellise. "Most of Us Don't Need to Put Labels on It: An Interview with Aurora Guerrero." *Popmatters,* December 5, 2012. www.popmatters.com/164954-interview-with-aurora-guerrero-2495801265.html.

Ghansah, Rachael Kaadi. "The Philosopher and Her Camera." *New Republic,* October 2016, 17–20.

Gillen, Andrew. "In Debt and in the Dark: It's Time for Better Information on Student Loan Defaults." *Education Sector,* July 2013. www.air.org/edsector-archives/publications/debt-and-dark-it-s-time-better-information-student-loan-defaults.

Glaister, Dan. "University Uproar over Heiress Who 'Cheated.'" *Guardian,* November 30, 2004. www.theguardian.com/world/2004/nov/30/usa.internationaleducationnews.

Goessel, Tracy. *First King of Hollywood: The Life of Douglas Fairbanks.* Chicago: Chicago Review Press, 2016.

Goldberger, Paul. "Erich Segal's Identity Crisis." *New York Times Magazine,* June 13, 1971, 16–17, 34–37, 45.

Goldstein, Jessica M. "'Dear White People' Filmmaker Talks Blackface, Interracial Dating, and Why White People Touch Afros." *Think Progress,* October 15, 2014. https://thinkprogress.org/dear-white-people-filmmaker-talks-blackface-interracial-dating-and-why-white-people-touch-afros-ed82c0e52cc8/.

Gordon, Avery. *Ghostly Matters: Haunting and the Sociological Imagination.* Minneapolis: University of Minnesota Press, 2008.

Green, Eric. *Planet of the Apes as American Myth: Race and Politics in the Films and Television Series.* Middletown, CT: Wesleyan University Press, 1998.

Guerrero, Aurora. "Kick It: Aurora Guerrero Finds Strength in Relationships." Sundance Institute (blog). April 28, 2011. www.sundance.org/blogs/creative-distribution-initiative/kick-it-aurora-guerrero-finds-strength-in-relationships.

Gunning, Tom. "Never Seen This Picture Before: Muybridge in Multiplicity." In *Time Stands Still: Muybridge and the Instantaneous Photography Movement,* edited by Phillip Prodger, 222–57. London: Oxford University Press, 2003.

Gutiérrez, David. *Walls and Mirrors: Mexican Americans, Mexican Immigrants, and the Politics of Ethnicity.* Berkeley: University of California Press, 1995.

Gutiérrez y Muhs, Gabriella, Yolanda Flores Niemann, Carmen G. González, and Angela P. Harris. *Presumed Incompetent: The Intersections of Race and Class for Women in Academia.* Logan: Utah State University Press, 2012.

Hacker, Andrew. "He Found It at the Movies: 'Ronald Reagan,' the Movie." *New York Times,* April 19, 1987, BR6.

Hale, Charles, ed. *Engaging Contradictions: Theory, Politics, and Methods of Activist Scholarship.* Berkeley: University of California Press, 2008.

Halper, Evan. "Labor Studies Alone under Gov.'s Budget Ax." *Los Angeles Times,* April 8, 2005. http://articles.latimes.com/2004/apr/08/local/me-labor8.

Hamilton, Clayton. "American History on Screen." *World's Work: A History of Our Time* 48 (August 1924): 525–32.

Harney, Stefano, and Fred Moten. *The Undercommons: Fugitive Planning and Black Study.* New York: Minor Compositions, 2013.

Hartman, Saidiya V. *Scenes of Subjection: Terror, Slavery, and Self-Making in Nineteenth-Century America.* New York: Oxford University Press, 1997.

Harvey, David. *A Brief History of Neoliberalism.* New York: Oxford University Press, 2007.

Hayakawa, Sessue. "Human Motion Pictures." *University of Chicago Magazine* 13 no. 7 (1921): 250–51.

———. *Zen Showed Me the Way to Peace, Happiness and Tranquility.* New York: Bobbs-Merrill, 1960.

Hays, Will H. *The Memoirs of Will H. Hays.* New York: Doubleday, 1955.

Higashi, Sumiko. "Ethnicity, Class, and Gender in Film: DeMille's *The Cheat.*" In *Unspeakable Images: Ethnicity in the American Cinema,* edited by Lester D. Friedman, 112–39. Champaign: University of Illinois Press, 1991.

Hoberman, J. "It's Always High Noon at the White House." *New York Times,* April 25, 2004, AR11.

Hong, Grace Kyungwon. *Death beyond Disavowal: The Impossible Politics of Difference.* Minneapolis: University of Minnesota Press, 2015.

"Honorary Degrees." Cecil B. DeMille Foundation. Accessed May 1, 2019. www.cecilbdemille.com/awards/honorary-degrees/.

Horne, Gerald. *Paul Robeson: The Artist as Revolutionary.* London: Pluto, 2016.

"In Memoriam: Eric T. Pengelley." UC Riverside Academic Senate. 2003. Accessed May 24, 2019. http://senate.universityofcalifornia.edu/_files/inmemoriam/html/erictpengelley.html.

Isaacson, Joanna. "'It Follows': Contemporary Horror and the Feminization of Labor." *Blind Field: A Journal of Cultural Inquiry,* October 27, 2015. https://blindfieldjournal.com/2015/10/27/it-follows-contemporary-horror-and-the-feminization-of-labor/.

Jackson, Brandon A., and John R. Reynolds. "The Price of Opportunity: Race, Student Loan Debt, and College Achievement." *Sociological Inquiry* 83 no. 3 (2013): 335–68.

Jackson, Maurice. "Text of Hinderacker Speech before Emergency Faculty Meeting." Resignation letter. *Highlander,* February 6, 1970, 6.

"Jesús Chavarria." Minority Business Hall of Fame and Museum. Accessed May 24, 2019. http://mbhf.org/inductees/13688/jess-chavarria/.

Jewell, Rick. "John Wayne, an American Icon." *USC News,* August 1, 2008. https://news.usc.edu/15621/john-wayne-an-american-icon/.

Johnson, Pamela J. "Labors of Love for America Ferrera." *USC News,* May 20, 2013. https://news.usc.edu/51159/labprs-of-love-for-america-ferrera/.

Jordan, June. "In the Land of White Supremacy." In Russo, *Life as Activism,* 156–58.

———. "Justice at Risk." In Russo, *Life as Activism,* 173–77.

———. "Nicaragua: Why I Had to Go There." In *Some of Us Did Not Die: New and Selected Essays,* 199–210. New York: Basic Books, 2002.

———. "Toward a Manifest New Destiny." In Russo, *Life as Activism,* 72–84.

———. "Wrong or White." In *Life as Activism: June Jordan's Writings from the Progressive,* edited by Stacy Russo, 26–30. Sacramento: Litwin Books, 2014.

Jowett, Garth S., Ian C. Jarvie, and Kathryn H. Fuller. *Children and the Movies: Media Influence and the Payne Fund Controversy.* Cambridge: Cambridge University Press, 1996.

Kaplan, Sara Clarke. "Sorting through Race Relations at UCSD." In Alvarez et al., *Another University Is Possible,* 31–33.

Karp, Alan. "Arnold Schwarzenegger: Chasing the American Dream." *Boxoffice,* November 1985, 11.

Kaufman, Alexander C. "In 'Middle of Nowhere,' Cast Found Black Characters beyond the Stereotypes." *Wrap,* November 21, 2012. www.thewrap.com/middle-nowhere-cast-found-black-characters-reflected-not-interpreted-66136/.

Kerr, Emma. "White Supremacists Are Targeting College Campuses Like Never Before." *Chronicle of Higher Education,* February 1, 2018. www.chronicle.com/article/White-Supremacists-Are/242403.

Kimmerer, Robin Wall. *Gathering Moss: A Natural and Cultural History of Mosses.* Corvallis: Oregon State University Press, 2003.

Kingsley, Grace. "That Splash of Saffron: Sessue Hayakawa, a Cosmopolitan Actor Who, for Reasons of Nativity, Happens to Peer from Our White Screens with Tilted Eyes." *Photoplay*, March 1916, 139–41.

Klein, Naomi. *The Shock Doctrine: The Rise of Disaster Capitalism.* New York: Picador, 2007.

Knight, Arthur, ed. *Eadweard Muybridge: The Stanford Years, 1872–1982.* Palo Alto: Stanford University Museum of Art, 1972.

Kohn, Howard, and Lowell Bergman. "Ronald Reagan's Millions." *Rolling Stone*, August 26, 1976. www.rollingstone.com/politics/news/reagans-millions-19760826.

Koszarski, Richard. *An Evening's Entertainment: The Age of the Silent Feature Picture, 1915–1928.* Berkeley: University of California Press, 1990.

la paperson. *A Third University Is Possible.* Minneapolis: University of Minnesota, 2017.

Leeds, Jeff, and James Bates. "A Degree of Fame for Each: Schwarzenegger Got a Small Campus Pumped Up in 1979, Leaving in '80 with a Diploma." *Los Angeles Times*, August 22, 2003. http://articles.latimes.com/2003/aug/22/entertainment/et-bates22.

Leibovitz, Annie. "Annie Gets Her Shot." *Vanity Fair*, September 6, 2018. www.vanityfair.com/news/2008/10/annie_excerpt200810.

Lipsitz, George. *Time Passages: Collective Memory and American Popular Culture.* Minneapolis: University of Minnesota Press, 1990.

Logan, Erin B. "White Supremacist Propaganda Is Inundating College Campuses, Civil Rights Group Says." *Washington Post*, June 29, 2018. www.washingtonpost.com/news/grade-point/wp/2018/06/29/white-supremacist-propaganda-is-inundating-college-campuses-civil-rights-group-says/?utm_term=.65cf25ec29b8.

López, Ian Haney. *White by Law: The Legal Construction of Race.* New York: New York University Press, 2006.

Lucas, Christopher J. *American Higher Education: A History.* New York: St. Martin's Press, 1994.

MacGraw, Ali. *Moving Pictures: An Autobiography.* New York: Bantam Books, 1992.

Maira, Sunaina, and Piya Chatterjee, eds. *The Imperial University: Race, War, and the Nation-State.* Minneapolis: University of Minnesota Press, 2014.

Maltby, Richard. "The Production Code and the Hays Office." In *Grand Design: Hollywood as a Modern Business Enterprise, 1930–1939,* edited by Tino Balio, 37–72. Berkeley: University of California Press, 2007.

Marchetti, Gina. *Romance and the "Yellow Peril": Race, Sex, and Discursive Strategies in Hollywood Fiction.* Berkeley: University of California Press, 1993.

Marez, Curtis. *Drug Wars: The Political Economy of Narcotics.* Minneapolis: University of Minnesota Press, 2004.

———. *Farm Worker Futurism: Speculative Technologies of Resistance.* Minneapolis: University of Minnesota Press, 2016.

———. "Pancho Villa Meets Sun Yat-sen." *American Literary History* 17 no. 3 (2005): 486–505.

———. "Public Universities Make Dreams of the Future Concrete: *Conquest of the Planet of the Apes*." *Critical Commons for Fair and Critical Participation in Media Culture*. Accessed May 1, 2019. www.criticalcommons.org /Members/cmarez/clips/uci_planet_of_the_apes.mov/view.

———. "The University of California in Popular Media." *Critical Commons*. Accessed May 24, 2019. www.criticalcommons.org/Members/cmarez/lectures /lecture.2013–01–07.2328475602.

Mariscal, George. *Brown-Eyed Children of the Sun: Lessons from the Chicano Movement, 1965–1975*. Albuquerque: University of New Mexico Press, 2005.

Mattheisen, Donald J. "Filming U.S. History during the 1920s: The Chronicles of America Photoplays." *Historian* 54, no. 4 (1992): 627–40.

May, Lary. *Screening Out the Past: The Birth of Mass Culture and the Motion Picture Industry*. Chicago: University of Chicago Press, 1983.

Mayer, Sophia. "Pocahontas No More: Indigenous Women Standing Up for Each Other in Twenty-First Century Cinema." *Alphaville: Journal of Film and Screen Media* 10 (Winter 2015): 1–16. www.alphavillejournal.com /Issue10/PDFs/ArticleMayer.pdf.

McClanahan, Annie. *Dead Pledges: Debt, Crisis, and Twenty-First-Century Culture*. Palo Alto: Stanford University Press, 2017.

Melamed, Jodi. *Represent and Destroy: Rationalizing Violence in the New Racial Capitalism*. Minneapolis: University of Minnesota Press, 2011.

Meranze, Michael, and Christopher Newfield. *Remaking the University* (blog). Accessed May 22, 2019. http://utotherescue.blogspot.com/search?q= Schwarzenegger.

Minian, Ana Raquel. "'Indiscriminate and Shameless Sex': The Strategic Use of Sexuality by the United Farm Workers." *American Quarterly* 65, no. 1 (2013): 63–90.

Miyao, Daisuke. *Sessue Hayakawa: Silent Cinema and Transnational Stardom*. Durham: University of North Carolina Press, 2007.

Monagan, Amy. "Art and Artifice." *University of Chicago Magazine* 111, no. 1 (2018): 36–37.

Motion Picture Producers and Distributors of America. "Don'ts and Be Carefuls." *MPPDA Digital Archive*. May 24, 1927. https://mppda.flinders.edu .au/records/341.

———. "The Motion Picture Production Code." March 31, 1930. Reprinted in *Hollywood Cinema*, edited by Richard Maltby, 594–95. London: Blackwell, 2003.

"Moving Image: Birth of a Campus, NBC-TV." *Calisphere*. University of California. 1965. Accessed May 24, 2019. https://calisphere.org/item/2f830917– 1ada-45a2-a5b7–198a5d6e85f8/.

Newfield, Christopher. *Unmaking the Public University: The Forty-Year Assault on the Middle Class*. Cambridge: Harvard University Press, 2008.

Nguyen, Terry. "Untold History: How Rufus von KleinSmid Supported the Eugenics Movement at USC." *Daily Trojan*, August 23, 2017. https:// dailytrojan.com/2017/08/23/untold-history-rufus-von-kleinsmid-supported- eugenics-movement-usc/.

Noriega, Chon. *Shot in America: Television, the State, and the Rise of Chicano Cinema*. Minneapolis: University of Minnesota Press, 2000.

"Occupation: Student." 1969. YouTube video, 27:06, posted by University of California, Riverside. October 25, 2013. www.youtube.com/watch?v= uvtYx1FiOJs.

O'Day, Edward F. "Town Talk: Varied Types." *San Francisco Daily Times* 32, no. 1339 (1918): 5.

Omi, Michael, and Howard Winant. *Racial Formations in the United States*. 3rd ed. New York: Routledge, 2014.

Ornelas, Victor F. "Letters." *Pacific Review.* University of the Pacific. Winter 2009. www.pacific.edu/about-pacific/administrationoffices/office-of-marketing-and-communications/publications/pacific-review-/pacific-review-archives/review-letters.html.

Padilla, Yolanda. "Felix beyond the Closet: Sexuality, Masculinity, and Relations of Power in Arturo Islas' *The Rain God.*" *Aztlan* 4, no. 2 (2009): 11–34.

"Park City '08 Interview: 'Sleep Dealer' Director Alex Rivera." *IndieWire,* January 11, 2008. www.indiewire.com/2008/01/park-city-08-interview-sleep-dealer-director-alex-rivera-73223/.

Peterson, Ruth C. and Louis Leon Thurstone. *Motion Pictures and the Social Attitudes of Children*. New York: Macmillan, 1933.

Pfledderer, Sarah. "Inside the Icon: Geisel Library." *San Diego Magazine,* October 13, 2017. www.sandiegomagazine.com/San-Diego-Magazine/October-2017/Inside-the-Icon-Geisel-Library/.

"Presidential Campaign of Ronald Reagan in Illinois, United States on October 18, 1980." 1980. Accessed July 16, 2015. www.gettyimages.com/detail/news-photo/presidential-campaign-of-ronald-reagan-in-illinois-united-news-photo/124131580.

Pulido Laura, and David Lloyd. "From La Frontera to Gaza: Chicano-Palestinian Connections." *American Quarterly* 62, no. 4 (2010): 791–94.

Raheja, Michelle. *Reservation Reelism: Redfacing, Visual Sovereignty, and Representations of Native Americans in Film*. Lincoln: University of Nebraska Press, 2013.

Ransby, Barbara. *Eslanda: The Large and Unconventional Life of Mrs. Paul Robeson*. New Haven: Yale University Press, 2014.

Reagan, Ronald. "Address at Commencement Exercises at Eureka College." Ronald Reagan Presidential Library and Museum. May 9, 1982. www .reaganlibrary.gov/research/speeches/50982a.

———. "Address at Commencement Exercises at the University of Notre Dame." Ronald Reagan Presidential Library and Museum. May 17, 1981. www.reaganlibrary.gov/research/speeches/51781a.

———. "Address by Governor Ronald Reagan: Installation of President Robert Hill, Chico State College." Ronald Reagan Presidential Library and Museum. May 20, 1967. www.reaganlibrary.gov/research/speeches/05201967a.

———. *An American Life*. New York: Simon and Schuster, 1990.

———. "Inaugural Address, Ronald Reagan, 33rd Governor of California." Ronald Reagan Presidential Library and Museum. January 2, 1967. www .reaganlibrary.gov/research/speeches/01021967a.

———. "Remarks to the Students and Faculty at Martin Luther King, Jr. Elementary School." Ronald Reagan Presidential Library and Museum. January 15, 1986. www.reaganlibrary.gov/research/speeches/11586b.

———. "Ronald Reagan on the Unrest on College Campuses, 1967." *History Now*. Gilder Lehrman Institute of American History. August 15, 1967. www.gilderlehrman.org/history-by-era/sixties/resources/ronald-reagan-unrest-college-campuses-1967.

———. "The Unforgettable John Wayne." *Reader's Digest*, October 1979. Reprinted in *Duke, We're Glad We Knew You: John Wayne's Friends and Colleagues Remember His Remarkable Life*, edited by Herb Fagen, xxi–xxvi. New York: Citadel, 1979.

———. "Your America to Be Free." Commencement Address at Eureka College, June 7, 1957. In *Ronald Reagan: The Great Communicator*, edited by David Henry and Kurt Ritter, 127–34. Westport, CT: Greenwood, 1992.

"Reagan and USC: President Reagan's Deep Association with the University of Southern California." Sol Price School of Public Policy, University of Southern California. Accessed May 9, 2019. https://priceschool.usc.edu/dp-events/reagan/reagan-and-usc/.

"Reg Park, 79; Won Mr. Universe 3 Times." *Los Angeles Times*, November 24, 2007. http://articles.latimes.com/2007/nov/24/local/me-park24.

"Right to Education." Birzeit University, Palestine. Accessed May 21, 2019. http://right2edu.birzeit.edu.

Rivera, Tomás. *Tomás Rivera: The Complete Works*. Edited by Julián Oliveras. Houston: Arte Público, 1992.

Robeson, Paul. *Here I Stand*. With Lloyd L. Brown. 1958. Reprint, Boston: Beacon, 1988.

Robinson, Cedric J. *Black Marxism: The Making of the Black Radical Tradition*. Chapel Hill: University of North Carolina Press, 1983.

———. *Forgeries of Memory and Meaning: Blacks and the Regimes of Race in American Theater and Film before World War II*. Chapel Hill: University of North Carolina Press, 2007.

Rogin, Michael. *Ronald Reagan, the Movie and Other Episodes in Political Demonology*. Berkeley: University of California Press, 1988.

Rogin, Michael, and John L. Shover. *Political Change in California: Critical Elections and Social Movements, 1890–1966*. Westport, CT: Greenwood, 1970.

"Ronald Reagan." Getty Images. 1966. Accessed May 24, 2019. www.gettyimages.com/detail/news-photo/1911politiker-usaspielt-mit-einem-kind-football-news-photo/541018555.

"Ronald Reagan on the Unrest on College Campuses, 1967." *History Now*. Gilder Lehrman Institute of American History. August 15, 1967. www.gilderlehrman.org/history-by-era/sixties/resources/ronald-reagan-unrest-college-campuses-1967.

"Ronnie and Co. Do It Again." *Triton Times*, October 4, 1968, 2–3.

Rosenfield, Seth. *Subversives: The FBI's War on Student Radicals and Regan's Rise to Power*. New York: Picador, 2013.

"*RPM* Simulated Campus Riot Almost Became the Real Thing, Says Kramer." *Variety*, December 8, 1970, 3.

Rudolph, Frederick. *The American College and University: A History.* 1962. Reprint, New York: Knopf, 1990.

Russo, Stacy, ed. *Life as Activism: June Jordan's Writings from the Progressive.* Sacramento: Litwin Books, 2014.

"Sacred Lands: Walmart's Relationship with Native Americans." *Walmart Watch.* Accessed March 24, 2019. https://grist.files.wordpress.com/2009/09/native_americans_fact_sheet.pdf.

Sasha Rodríguez and Cathelyn Gregoire v. Sallie Mae Corporation. U.S. District Court of Connecticut. *Justica.* December 17, 2007. https://dockets.justia.com/docket/connecticut/ctdce/3:2007cv01866/79960.

Savage, Howard J., Harold W. Bentley, John T. McGovern, and Dean F. Smiley. *American College Athletics.* New York: Carnegie Foundation for the Advancement of Teaching, 1929.

Sawyer, Donald T. Interview with Jody Swartzbaum. "Sawyer Interview." Chemistry Department. UC Riverside. March 2, 2001. http://chem.ucr.edu/documents/history/interview_sawyer2001.pdf.

Schickel, Richard. *D. W. Griffith: An American Life.* New York: Simon and Schuster, 1984.

Schwarzenegger, Arnold. "2009 Commencement Address." *About USC.* University of Southern California. May 15, 2009. https://about.usc.edu/history/commencement/2009-address/.

———. *Arnold: The Education of a Bodybuilder.* With Douglas Kent Hall. New York: Simon and Shuster, 1977.

———. "Be Hungry to Make Your Mark." Commencement Address, Emory University. *Emory Report,* May 17, 2010, 2.

———. Introduction to "The Power of the Market." *Free to Choose.* 1990. Accessed March 24, 2019. www.freetochoosenetwork.org/programs/free_to_choose/index_90.php?id=the_power_of_the_market.

———. *Total Recall: My Unbelievably True Life Story.* With Peter Petre. New York: Simon and Schuster, 2012.

Scott, Vernon. "Long-Time Rebel Films Story of Campus Revolt." *Los Angeles Herald-Examiner,* February 25, 1970, B-6.

Sedgwick, Eve Kosofsky. *Between Men: English Literature and Male Homosocial Desire.* New York: Columbia University Press, 1985.

———. *Epistemology of the Closet.* Berkeley: University of California Press, 2008.

Seiler, Michael. "Pereira, Architect Whose Works Typify L.A., Dies." *Los Angeles Times,* November 14, 1985. http://articles.latimes.com/1985-11-14/news/mn-2250_1_master-plan.

Seitz, Carl W. "Douglas E. (Electricity) Fairbanks." *Motion Picture Magazine,* December 1916, 66–68.

Sharif, Rana. "The Right to Education: La Frontera to Gaza." *American Quarterly* 62, no. 4 (2010): 855–60.

Shohat, Ella, and Robert Stam. *Unthinking Eurocentrism: Multiculturalism and the Media.* New York: Routledge, 2008.

Silva, Cynthia, Lisa Hinds, and Roberta Young. "Minority and Third World Students." In *How Harvard Rules: Reason in the Service of Empire,* edited by John Trumpbour. Boston: South End, 1989.

Singleton, John, dir. Director's commentary. *Higher Learning.* Culver City: Columbia Pictures, 1995, DVD.

Smith, Shawn Michelle. *Photography on the Color Line: W. E. B. Du Bois, Race, and Visual Culture.* Durham: Duke University Press, 2004.

Somerville, Siobhan B. *Queering the Color Line: Race and the Invention of Homosexuality in American Culture.* Durham: Duke University Press, 2000.

Squier, Emma-Lindsay. "Extra!" *Picture-Play* 9, no. 4 (1918): 177–83.

———. "Was Kipling Right When He Said 'Oh East Is East and West Is West and Never the Twain Shall Meet?'" *Picture-Play* 10, no. 1 (1919): 84.

Stamp, Shelley. *Lois Weber in Early Hollywood.* Berkeley: University of California Press, 2015.

"Statuesque Ron." Getty Images. 1939. Accessed July 16, 2015. www.gettyimages.com/detail/news-photo/american-leading-man-and-future-us-president-ronald-reagan-news-photo/3205546.

Sterritt, David. "Juke Girl." Turner Classic Movies. 1980. Accessed May 24, 2019. www.tcm.com/this-month/article/221743%7C0/Juke-Girl.html.

"Stonewall Jackson and VMI." Virginia Military Institute. Accessed May 11, 2019. www.vmi.edu/media/content-assets/documents/communications-and-marketing/media-relations/VMI_SWJackson_Fact_Sheet_2019.pdf.

Semi-centennial Celebration in Commemoration of the Motion Picture Research Conducted by Leland Stanford with the Assistance of Eadweard J. Muybridge. Program, Stanford University, May 8, 1929.

"Stanford Innovators: Eadweard Muybridge, 1830–1904." *Stanford Stories from the Archive.* Accessed May 1, 2019. https://exhibits.stanford.edu/stanford-stories/feature/stanford-innovators.

Stern, Alexandra Mina. *Eugenics Nation: Faults and Frontiers of Better Breeding in Modern America.* Berkeley: University of California Press, 2016.

———. "'We Cannot Make a Silk Purse Out of a Sow's Ear': Eugenics in the Hossier Heartland." *Indiana Magazine of History* 103, no. 1 (2007): 3–38.

Steward, Tyran Kai. "At the University but Not of the University: The Benching of Willis Ward and the Rise of Northern Racial Liberalism." *American Studies* 55, no. 3 (2016): 35–70.

Stewart, Jacqueline. *Migrating to the Movies: Cinema and Black Urban Modernity.* Berkeley: University of California Press, 2005.

Stossel, John. "Big Cheats on Campus." *ABC News.* November 19, 2004. http://abcnews.go.com/2020/story?id=264646&page=1.

Streeby, Shelley. *Radical Sensations: World Movements, Violence, and Visual Culture Class.* Durham: Duke University Press, 2013.

Sturgis, Sue. "Wal-Mart's History of Destroying Sacred Sites." *Facing South.* Institute for Southern Studies. September 3, 2009. www.facingsouth.org/2009/09/wal-marts-history-of-destroying-sacred-sites.html.

Taylor, Charles K. "The Most Popular Man in the World." *Outlook,* December 24, 1924, 683–85.

Thelin, John R. *A History of American Higher Education.* Baltimore: Johns Hopkins University Press, 2004.

Theweilt, Klaus. *Male Fantasies.* Vol. 1, *Women, Floods, History.* Minneapolis: University of Minnesota Press, 1987.

Tolchin, Martin. "How Reagan Always Gets the Best Lines." *New York Times,* September 9, 1985, B8.

Traister, Rebecca. "In Conversation: Ava DuVernay." *New York Magazine,* September 19, 2016. www.thecut.com/2016/09/ava-duvernay-the-13th-queen-sugar-c-v-r.html.

"Transcription of Oral History Interview with Concepcion G. Rivera." University of California, Riverside. August 13, 1998. www.ucrhistory.ucr.edu/pdf/rivera.pdf.

Treviño, Jesús. *Eyewitness: A Filmmaker's Memoir of the Chicano Movement.* Houston: Arte Público, 2001.

Trudy. "Explanation of Misogynoir." *Gradient Lair.* April 28, 2014. www.gradientlair.com/post/84107309247/de ne-misogynoir-anti-black-misogyny-moya-bailey-coined.

"Turning Iron into Gold." *Hollywood Reporter,* November 23, 1987.

United Farm Workers. "UFW Chronology." Accessed May 9, 2019. https://ufw.org/research/history/ufw-chronology.

Vance, Jeffery. *Douglas Fairbanks.* With Tony Maietta. Berkeley: University of California Press, 2008.

Vargas, Deborah R. *Dissonant Divas in Chicana Music: The Limits of La Onda.* Minneapolis: University of Minnesota Press, 2012.

Viswanathan, Gauri. "The Naming of Yale College: British Imperialism and American Higher Education." In *Cultures of United States Imperialism,* edited by Amy Kaplan and Donald E. Pease, 85–108. Durham: Duke University Press, 1993.

Von KleinSmid, Rufus B. *Eugenics and the State.* Jeffersonville: Indiana Reformatory Printing Trade School, 1913.

———. "Some Efficient Causes of Crime." In *Proceedings of the First National Conference on Race Betterment,* 532–42. Battle Creek, MI: Gage, 1914.

Vora, Kalindi. *Life Support: Biocapital and the New History of Outsourced Labor.* Minneapolis: University of Minnesota Press, 2015.

Wallace, Michelle. *"Boyz n the Hood* and *Jungle Fever."* In *Black Popular Culture,* edited by Gina Dent, 123–31. Seattle: Bay, 1992.

"Walt's Honorary Degrees." *Walt Disney Family Museum,* June 27, 2014. www.wdfmuseum.org/blog/walts-honorary-degrees.

Warga, Wayne. "Arnold Schwarzenegger: Big, Beautiful, Biceptual." *Cosmopolitan,* August 1992, 74.

Wark, Colin. "Emory Bogardus and the Origins of the Social Distance Scale." *American Sociologist,* December 4, 2007, 383–95.

Washington, Booker T. "Atlanta Compromise Speech." 1995. *History Matters.* Accessed May 16, 2019. http://historymatters.gmu.edu/d/39/.

Watterson, Kathryn. *I Hear My People Singing: African American Voices at Princeton.* Princeton: Princeton University Press, 2017.

Wayne, John. *Fifty Years of Playboy Interviews: John Wayne.* Kindle ed. Chicago: Playboy, 2012.

"What Latino Film Critics Are Saying about 'Peppermint.'" *Remezcla,* September 10, 2018. http://remezcla.com/lists/film/what-latino-film-critics-are-saying-about-peppermint/.

"White Nationalist Flyering on American College Campuses." Southern Poverty Law Center. October 17, 2017. www.splcenter.org/hatewatch/2017 /10/17/white-nationalist-flyering-american-college-campuses.

Wicks-Lim, Jeannette. "The Great Recession in Black Wealth." *Dollars and Sense.* January–February 2012. www.dollarsandsense.org/archives/2012 /0112wicks-lim.html.

Wilder, Craig Steven. *Ebony and Ivy: Race, Slavery, and the Troubled History of America's Universities.* New York: Bloomsbury, 2013.

Wilkes, Paul. "Yale Is No 1. with the Promoter and the Idol." *Look,* April 6, 1971, 60–62.

Williams, Jeffrey J. "Debt Education: Bad for the Young, Bad for America." *Dissent,* Summer 2006. www.dissentmagazine.org/article/debt-education-bad-for-the-young-bad-for-america.

Williams, Lena. "After the Roast, Fire and Smoke." *New York Times,* October 14, 1993, C1.

Williams, Patricia J. "Cluelessness and Culture." *Nation,* October 20, 1997, 9.

———. *Open House: Of Family, Friends, Food, Piano Lessons, and the Search for a Room of My Own.* New York: Picador, 2004.

———. "Our Lizard-Brain Politics." *Nation,* October 11, 2012. www .thenation.com/article/our-lizard-brain-politics/.

Winford Hall, Herbert, ed. *The Semicentennial Celebration of the Founding of the University of Southern California.* Los Angeles: University of Southern California Press, 1930.

Wolf, Jessica. "UCLA Professor's Film Documents Forced Sterilization of Mexican Women in the Late '60s and '70s." *UCLA Newsroom.* October 23, 2017. http://newsroom.ucla.edu/stories/ucla-professor-s-film-documents-forced-sterilization-of-mexican-women-in-late-60s-l-a.

Woodruff, Mandi. "For-Profit Colleges Are Looking Sketchier Than Ever." *Business Insider,* August 20, 2013. www.businessinsider.com/career-education-corp-will-pay-9-million-to-students-after-allegedly-inflating-job-numbers-2013–8.

Wright, Bekah. "Direct Action." *UCLA Magazine,* October 1, 2012. http:// magazine.ucla.edu/depts/style/direct-action/.

"You Are the Un-Americans, and You Ought to Be Ashamed of Yourselves': Paul Robeson Appears before HUAC." *History Matters.* June 12, 1956. http://historymatters.gmu.edu/d/6440/.

Zeitchik, Steven. "A Circuitous Route to 'Pariah': With Spike Lee's Help, Dee Rees Has Come a Long Way from Touting Wart Removers." *Los Angeles Times,* January 8, 2012, D8.

Zigler, Rich. "Chairman of Black Studies Tells Why He Resigned." *Press-Enterprise,* February 7, 1970, B-5.

Index

Absent-Minded Professor, The, 105
academic freedom, 88–89. *See also under*
 Ronald Reagan
administration: as cultural performance, 29;
 diversity talk and, 7, 28–29; films
 featuring, 3–4, 27, 106–107, 112–117;
 racial unconscious of, 103; respectability
 and, 138–139; social transformation
 and, 106, 107, 145; student protests
 and, 18, 107. *See also under* Rivera,
 Tomás
Ahmed, Sara, 7, 28–29
Alamo, The, 82
Aldrich, Daniel, 3
Alexander, Michelle, 171
American Aristocracy, The, 34–35, 63
American Association of University
 Professors, 18
American Association of University Women,
 151
American Sociological Association, 15, 17
American Studies Association, ix-x, 148,
 160
Americano, The, 34–35
Angeline, Morning-Star, 174
Anger, Kenneth, vi
Anzaldúa, Gloria, 174
Armstrong-Price, Amanda, 150–151

Bailey, Moya, 24, 161
Baldwin, James, 116

Batman and Robin, 96, 101–102
Bedtime for Bonzo, 85–86
Begay, Magdalena, 174
Bell, Brandon B., 164
Benjamin, Walter, 4, 10, 136
Betrayed, 41–43
Billings, George, 75
Birth of a Campus, 3–4
Birth of a Nation: 13th and, 172–173; Black
 student responses to, 19–20; educational
 films influenced by, 12; USC film school
 and, 16–17; Paul Robeson and, 59;
 Santa Fe Trail derivative of, 77; satirized
 in *Dear White People,* 164. *See also*
 Wilson, Woodrow
Birzeit University, 157
Bitsui, Jerimiah, 174
Black studies, 84. *See also under* University
 of California, Riverside
blackface, 35, 161–162,164–165
Blumer, Herbert, 15–16, 19–20
Blumhouse Productions, 181–182
Bogardus, Emory S., 16–18
Boggs, Abigail, ix, 24, 183
Bousquet, Marc, 151–152
Bovell, Carlton, 143
Bow, Clara, 15, 20
Boyz n the Hood, 162
Brenan, Walter, 80
Bridge on the River Kwai, 66
Brown, Elspeth, 10–11

Brown, John, 77
Brown University, 105
Bruce-Novoa, Juan, 166
Buford, Kate, 38
Burghardt, Franklin, 74, 201n24
Burnett, Charles, 170
Burr, Raymond, 142

Caffentzis, George, 155
California Institute of Technology, 17
Call of the Wild, 40–41
Capra, Frank, 32
Carby, Hazel, 55, 57
Cardoso, Patricia, 176
Carewe, Edwin, 36–37, 195–196n27
Carlisle Indian Industrial School: college
 football teams of, 33–34, 37–38;
 graduates as film actors, 36–37, 75–76;
 graduates as film characters, 40–43
Carlos, John, 90
Carnegie Foundation for the Advancement
 of Teaching, 73
Cattle Queen of Montana, 90
Chapman University, 173
Chatterjee, Piya, 7, 18, 155–157
Chavez, Cesar, 79, 107, 140
Cheney, Dick, 98
Chicago School of Sociology, 14–17
Chicano movement, 106, 123–24, 130
Chicano studies, 174, 177. See also under
 University of California, Riverside
Chico State University, 86
Chronicles of America Film Corporation,
 11–12
Chrystos, 174
City of Dim Faces, The, 46–49
City University of New York, 107, 110. See
 also under Ferguson, Roderick
Cleaver, Eldridge, 90
Clinton, Bill, 116
Cobb, Jelani, 171
Colorado School of Mines, 112
Columbia University, 41, 110, 166, 176
Columbus, Christopher, 11, 158–160,
 213n14
College Chums, 32
College Girl's Affair of Honor, A, 32
Commando, 100
Communities for a Better Environment, 177
Compton, 169–71
Compton Cookout, 161–163
Connors, Chuck, 80
Conquest of the Planet of the Apes, 1–4
Corinealdi , Emayastzy, 179

Cota-Robles, Eugene, 142
Crenshaw, Kimberlé, 171
Crowther, Bosley, 79, 87
Curse of the Red Man, 41
Custer, George Armstrong, 33, 77

Daddy-Long-Legs, 35–36, 195n23
Dartmouth College, 108, 156, 163
Danson, Ted, 102, 204n98
Das, Rhea S., 94
Dash, Julie, 170
Davis, Angela, 69, 82, 89, 171–172, 174
Davis, Mike, 133
Dear White People, 162–167
Death Valley Days, 81
de Havilland, Olivia, 77
DeMille, Cecil B., 36, 41, 186n10
deMille, William C., 11, 41, 48
DePauw University, 16
Devereaux, Minnie, 37
DeVito, Danny, 102
Dixon, Thomas, 9
Doctor Dolittle, 105
double consciousness, 10, 22–24, 42, 44,
 46, 49, 63
Doyle, Jennifer, 19, 181
Drunktown's Finest, 174–176
Duberman, Martin, 59
Du Bois, W. E. B., 22–24, 59
Dumke, Glenn, 84
DuVernay, Ava, 169–173
Dyer, Richard, 76, 95–96, 100

Eakins, Thomas, 10
Ebsen, Buddy, 80
Educational Film Corporation of America,
 12–13
Edufactory Collective, 154
Edwards, Harry, 90
Ehrenreich, Barbara, 100
Eisner, Michael, 122
Ellis, Nadia, 130, 209n55
Epps, Omar, 158
Esparza, Moctesuma, 122–123
Ethno-Communications Program. See under
 University of California, Los Angeles
eugenics, 13, 85. See also under University
 of Southern California
Eureka College, 70–72, 79, 89
Evans, Dale, 80

Fairbanks, Douglas, 16, 34–37, 159,
 194n17, 194n18
Fanon, Frantz, 40, 49, 64, 170

Ferguson, Roderick: American Studies Association conference (2013), 148; City University of New York open enrollment movement, 111–112; "in but not of the university," 24; Lumumba-Zapata College, 89–90; representation vs. redistribution, 7, 107, 154; respectability, 18, 112

Ferrera, America, 167, 216n68

Field, Allyson Nadia, 54–55

film noir, 133–134

Fishburn, Lawrence, 160

Flynn, Errol, 177

Foley, Neil, 132–133

Fonda, Henry, 87

football: college film's featuring, 31, 32–34, 40–41, 52; corporatization of universities and, 73–74; film research and, 15; racial capitalism and, 74; settler colonialism and, 33–34, 72–73. *See also under* Carlisle Indian Industrial School; Hayakawa, Sessue; Robeson, Paul; Reagan, Ronald

For the Love of Mike, 32–33

Ford, John, 80

Ford, Wallace, 63

Foucault, Michel, 37

Francis, Walter, 66

Frank Merriwell in Arizona, 52

Frankfurt School, The, 129

Free and Equal, 52–53

Free to Choose, 95

Freeland, Sydney, 174

Friedman, Milton, 95–97

Friedman, Rose, 95

futurity, 176–177

Garbo, Greta, 15

Gates, Henry Lewis, 171

Gerima, Haile, 170

Get Out, 181

Getting Straight, 106, 110, 114

Gilligan's Island, 105

Gilmore, Ruth Wilson, 102

Goldberg, Whoopi, 102

Goldwater, Barry, 80–81

Gonzales, Peter, 134

Goodbye, Columbus, 110

Gordon, Avery, 4

Graglia, Carolyn, F., 92

Graglia, Lino, 91

Grandee's Ring, The, 52

Griffith, D. W., 16, 40, 172

Guerrero, Aurora, 174–175, 177–178

Gunning, Tom, 10

Gutiérrez, David G., 132

Hadley, Arthur Twining, 31

Hampshire College, 167

Happy Death Day, 181

Harney, Stefano, 7–8, 24, 157

Harrison, Rex, 105

Hartman, Saidiya V. *See under* vicarity

Harvard University: Du Bois, W.E.B. and, 24, 137; films featuring, 190n3, 192n8, 194n17; settler colonialism, slavery and,156

Harvey, David, 92

Hayakawa, Sessue: Asian students played by, 45–50, 197n54; Indigenous student played by, 41; Mexican student played by, 52; University of Chicago football and, 43–45

Hays, Will, 12–14

Heflin, Van, 77

Higher Learning, 158–160

Hinderaker, Ivan, 142

Hitchcock, Alfred, 166

Hobbes, Thomas, 97

Hollywood Babylon, vi

Hong, Grace Kyungwon, 8, 133

Horne, Gerald, 56–57

horror films, 4, 28, 83, 180–182

Horse Feathers, 72

House Un-American Activities Committee, 66

Houseman, John, 105

Human Betterment Foundation, 16

Huntington Park, California, 174, 177–178

Indigenous land and universities, 4, 33, 83. *See also* Morell Act of 1862

Irvine Company, 4, 83

Jackson, Maurice, 142

Jackson, Stonewall, 77, 160

Jaguar's Claws, The, 50–52

James, C. L. R., 61, 130, 208n55

Jericho, 62–66

Jim Thorpe, All American, 66

Johns Hopkins University, 9

Jones, Leroi, 84

Jones, Tommy Lee, 109

Jordan, June, 69, 78–79, 102, 111–112

Judd, Charles, 14

Juke Girl, 79

Junior, 96, 102–104

Kaplan, Sara Clarke, 162
Kimmerer, Robin Wall, 99
King, Martin Luther, 74
Kipling, Rudyard, 42
Knute Rockne All American, 66, 74–76, 91
Koszarski, Richard, 35
Kouka, Princess, 62
Kramer, Stanley, 115–117
Ku Klux Klan, 9, 60, 77, 173

La Roque, Rod, 15
Lancaster, Burt, 66
Laurie, Paige, 152–153
Lawrence, Martin, 162
League of United Latin American Citizens, 132–133
Lee, Spike, 173
Leibovitz, Annie, 100
Lewis, Jerry, 105
Lincoln University, 58
Li Ting Lang, 50
Lockwood, Gary, 113
Long, Nia, 102
López, Josefina, 176
Lord, Daniel, 13
Lorde, Audre, 174
Love Story, 107–110

MacGraw, Ali, 110
MacGuffin, 166–167,181
Madame Butterfly, 35, 41
Made in America, 102–103
Maira, Sunaina, 7, 18, 155–157
Mala, Ray, 37
Male Animal, The, 87
Maltby, Richard, 14
Manhattan Madness, 38
Marcuse, Herbert, 90
Mark of Zorro, The, 34
Marnul, Kurt, 96
Martinez, Elena, 152–153, 160
Massey, Raymond, 77
Maya, Just an Indian, 41–43
Mayer, Louis B., 11
McCrea, Joel, 80
McDowell, Roddy, 1
McMurray, Fred, 105
Melamed, Jodi, 7, 148, 153
Melodians, The, vi
Melville, Margarita, 123
Meranze, Michael, 92
Merriwell, Frank, 34, 38, 52
Mexican Revolution, 34–35, 52, 126, 190n1

Micheaux, Oscar, 57
Middle of Nowhere, 170–171
misogynoir, 24, 161–162, 171, 214n47
Mitchell, Nick, 8, 24, 183
Moore, Carmen, 174
Moraga, Cherríe, 174
Morales, Sylvia, 123
Morell Act of 1862, 21
Mosquita y Mari, 174–178
Moten, Fred, 7–8, 24, 56, 157
Motion Picture Production Code, 12–16, 70
Mount Rushmore, 92
Movies and Conduct, 15–16
Muhammed, Khalil Gibran, 171
multiple consciousness: Chicanx viewers and, 105, 121; college films and, 31, 42–43, 52; definition of, 24; films by women of color and, 173–175
Murphy, George, 81
Muybridge, Eadweard J., 10–11

An-Najah University, 157
Negri, Paolo, 15
Newfield, Christopher, 18, 69, 88–89, 92
New York University, 14, 116, 173
Nixon, Richard, 81, 108
No Más Bebés, 18
Notre Dame University, 73, 75–76, 91
Novarro, Ramón, 20, 198n61
Nutty Professor, The, 105

O'Brien, Pat, 91
O'Neil, Ryan, 107
Oblate College of the Southwest, San Antonio, 122, 123
Occupation: Student, 142
Ohio State University, 14, 74, 110
Omi, Michael, 84
Ontiveros, Lupe, 136
Owens, Jesse, 74
Oxford University, 25, 45
Oyelowo, David, 170

Pacific Lutheran University, 140
Padmore, George, 61
Paper Chase, The, 105
paperson, la, 20–22, 27, 89, 149
Pariah, 173–175
Park, Reg, 100
Parris, Teyonah, 164
Pedroza, Irene, 118
Peña, Luis Fernando, 168
Pengelley, Eric T., 139
Pepper, William, 10

Pereira, William L., 1–2
Perez, Severo, 122
Peterson, Ruth C., 19
Pickford, Mary, 34–36
Pineda, Fenessa, 175
Pinochet, Augusto, 92
police: in *Bedtime for Bonzo,* 89; on
 campus, 81, 111, 123, 137, 156, 158;
 conservative/liberal consensus about,
 106, 116–117; in *Jericho,* 62–64. *See
 also Conquest of the Planet of the Apes;*
 respectability; *RPM; Salt of the Earth*
Poltergeist, 4, 83
Poor Little Rich Girl, 35
Powell, Colin, 98
Predator, 100
Princeton University: film's featuring, 35,
 190n3; football teams, 38, 156; Paul
 Robeson's view of, 58–59. *See also*
 Wilson, Woodrow professors: film
 research by, 10–12, 14–18; men of
 color, 45, 57,112–116, 160; white men,
 12, 33, 52, 105; women of color, 78,
 102, 171–172, 176. *See also under*
 Jordan, June; Reagan, Ronald;
 Schwarzenegger, Arnold
Pueblo Legend, A, 35
Pulido, Laura, 157
Pumping Iron, 100
Purge, The, 181

queerness: blackface and, 165; education
 dependent on burying, 136; student debt
 and, 148; students of color in college
 films and, 165, 174; vicarity and,
 129–130.
Al-Quds University, 157
Quigley, Martin, 13
Quinn, Anthony, 106, 112–115, 117–118

Racho, Susan, 122–123
racial capitalism: Black uplift and, 53–54,
 56; football and 73–74; Hollywood/
 university joint support for, 5, 8;
 Princeton as institution of 58;
 representation in film of, 30–32, 172,
 181; settler colonialism and, 25; student
 protests and, 67, 106
Radcliffe College, 108, 110
Raheja, Michelle, 23, 36–37, 42
Ramona, 36
Ransby, Barbara, 60
Reagan, Ronald: film roles as a student of,
 74–77; film roles as a professor of,

85–88; football and, 72–76; race and
 respectability politics of, 86–92; settler
 colonialism and, 81–83; University of
 California fee increases and, 148–149;
 USC and, 158–159; views on academic
 freedom of, 68–69, 89–92. *See also
 under* Eureka College; Schwarzenegger,
 Arnold
Real Women Have Curves, 176
Realization of a Negro's Ambition, The,
 55–56
Rebecca of Sunnybrook Farm, 35
Red Wing, Princess, 36–37
Rees, Dee, 173
respectability: academic merit and, 5–6,
 70–71, 112, 143–144; Black uplift and,
 55–56; educational films and, 11–12;
 deference to police as defining feature
 of, 69, 84–86, 89, 104, 106; films
 focused on, 12, 85–86; heteropatriarchy
 as defining feature of, 18, 30–31, 32–33,
 72, 92, 99, 106, 112; League of United
 Latin American Citizens and, 132–133;
 opposition to, 6, 107, 129–138,173; size
 and, 98–99; student debt and,160,167;
 student protests and, 81, 84, 115; subor-
 dination of women as defining feature
 of, 33, 92; the United Farm Workers
 and,133; university administrations and,
 18–19, 67; white supremacy as defining
 feature of, 5–6, 12–13, 84, 161. *See also*
 academic freedom; Motion Picture
 Production Code; white nationalism
Rivera, Alex, 167–168
Rivera, Concha, 137
Rivera, Tomás: "Chicano Literature: The
 Establishment of Community," 128,
 129; education of, 118–119, 130–131;
 film studies interests of, 121–124; "El
 Pete Fonseca"/"On the Road to Texas:
 Pete Fonseca," 125–126, 127, 130, 131,
 208n59; "Into the Labyrinth: The
 Chicano in Literature," 126; "Remem-
 bering, Discovery, and Volition in the
 Literary Imaginative Process," 126, 127;
 university administration of, 119–121,
 138, 143–145; wisdom and, 128–130,
 132, 136, 139,143–145; *Y no se lo tragó
 la tierra/And the Earth Did Not Devour
 Him,* 118, 120–121, 132, 124–125,
 134–137. *See also under* University of
 California, Riverside; vicarity
Rivers of Babylon, The, vi
Robeson, Eslanda, 60–61

Robeson, Paul: academic star image of, 57;
 African and South Asian students and,
 60–61, 67; encounters with racism at
 Rutgers, 59; exclusion from Princeton
 of, 9–10, 58; global celebrity of, 57–58.
 See also House Un-American Activities
 Committee; Jericho; Robeson, Eslanda.
Robin Hood, 38
Robinson, Cedric , 8–9, 30, 32, 53, 56, 58,
 172, 189–190n1
Rodríguez and Gregoire v. Sallie Mae, 150
Rodríguez, Jay Stephens, 122
Rogers, Roy, 80
Rogin, Michael, 68, 77–79, 84
Roland, Gilbert, 20
Rose of the South, 32
RPM, 110–118
Rumford Fair Housing Act, 84
Rutgers University, 10, 16, 59, 66, 74

Salaita, Steven, 18
Salt of the Earth, 146–148, 178
Sallie Mae, 150, 212n7
Sam Houston State University, 119
San Francisco State University, 84, 107,
 110–111, 206n11
Santa Fe Trail, 77
Santa Monica Community College, 94, 97
Sawyer, Donald T., 138–139
Saxon, David S., 137
Schultz, George, 95
Schwarzenegger, Arnold: attacks on labor
 studies of, 92–93; attacks on nurses of,
 92; cruelty of, 93, 101–102; education
 of, 93–95; film roles as a professor of,
 101–104; influence of Ronald Reagan
 on, 93, 95, 101–102; settler colonialism
 and, 100–101; sizeism of, 95–99;
 University of California fee increases
 proposed by, 92; USC professorship of,
 102
Scott, Randolph, 80
Sedgwick, Eve Kosofsky. See under vicarity
settler colonialism: settler common sense,
 39; settler gaze, 40. See also football;
 Indigenous lands and universities;
 Reagan, Ronald; respectability
Segal, Erich, 109–11, 115, 118, 123
She's Working Her Way Through College,
 86–88
Sheik, The, 65
Shohat, Ella, 63–63
Shover, John J., 84
Shriver, Maria,102

Silicon Valley, 11
Simien, Justin, 163–165
Singleton, John, 158–159
Sleep Dealer, 167–169
Smith, Shawn Michelle, 22
Smith, Tommie, 90
Smith, William French, 83
South Africa, 57, 67, 78, 100, 155
Southwest Texas Junior College, Uvalde,
 119
Southwest Texas State University, 119
sports: 11, 32, 34; baseball, 43, 77, 191n8;
 basketball, 152, 193n13; crew, 33,
 190n3; hockey, 108–109. See also
 football
Spotted Elk, Molly, 37
Sproul, Robert, 140
Stahl, Leslie, 102
Stam, Robert, 63–64
Stamp, Shelley, 12
Standing Bear, Luther, 37
Stanford, Leland, 10, 102
Stagg, Alonso, 43
Stewart, Jacqueline, 55–56, 198n65
Stern, Alexandra Mina, 17–18
Stevens, Charles, 37
Strawberry Statement, The, 106, 114
Strongheart, 41
Strongheart, Nipo T., 37
students: African, 85, 155, 60–61, 67;
 African American, 9–10, 15–16, 19–20,
 22–23, 52–60, 111–114; 149–150,
 158–160, 164–165; Asian, 60–61, 67;
 Indigenous, 150, 175; Latinx, 50–52,
 111–112, 117–118, 167–169, 205n4;
 protests by, 123, 156–157,158–159,
 161, 163; white, 8–9, 15, 19, 160, 181;
 women of color, 53, 117–118, 150–153,
 170, 173–175, 176–178, 181–182. See
 also under Reagan, Ronald;
 Schwarzenegger, Arnold
Swain, Robert B., 11

Tajima-Peña, Renee, 18
Terminator, The,103
Thalberg, Irving, 13
Thatcher, Margaret, 92
Thelin, John R., 72
Theweilt, Klaus, 99–100
Thief of Baghdad, 34
Third Cinema, 21–22, 183
13th, 171–173, 216n61
Thomas, Marlo, 122
Thompson, Emma, 103

Tommy Trojan, 159
Thompson, Tessa, 164
Thorpe, Jim, 33, 38–39, 66, 75–76
Thurston, Louis Leon, 19
Total Recall, 93
Treviño, Jesús Salvador, 122–123
Troncosco, Venecia, 175
Trump, Donald, 104, 184
Truth or Dare, 181
Tuskegee Institute, 52–56, 59

United Farm Workers, 80, 114
university-cinema–industrial complex:
 defining features of 5–7, 182–183;
 represented in films, 31, 181; respect-
 ability and, 81–82; USC and, 17–19
university deans: as silent film characters
 34, 190n3,192n8; in *Bedtime For
 Bonzo,* 85, 87; in *Junior,* 104; in *Dear
 White People,* 164–165
university presidents: as film characters, 87,
 106, 112–116, 165–166, 193n12,
 206n11; as slave owners, 9, 156. *See
 also* Rivera, Tomás; von KleinSmid,
 Rufus B.; Wilson, Woodrow
University of California, Berkeley: Aurora
 Guerrero's education at, 174, 177; as
 film setting, 41, 102–103; *Pariah* and,
 175; People's Park, 81; Reagan targets,
 69, 80, 84
University of California, Irvine, 1–4, 83
University of California, Los Angeles: as
 film setting, 12, 69, 214n29; Ethno-
 Communications Program, 123; film
 students of color at, 122–123, 170–171;
 Institute for Research on Labor and
 Employment, 92–94
University of California, Riverside: attacks
 on Black studies and Chicano studies at,
 137, 138, 141–143, 205n4, 210n89,
 211n92; Citrus Experiment Station, 17,
 139–141. *See also* Rivera, Tómas
University of California, San Diego, 3,
 89–90, 107, 146, 161
University of California, Santa Barbara, 114
University of Chicago, 14–16, 19, 38,
 43–45, 95
University of Florida, 163
University of Iowa, 14
University of Minnesota, 38
University of Missouri, 36, 152
University of Oklahoma, 152
University of Pennsylvania, 10–11
University of Southern California: college

cheating scandal at, 152–153; Compton
 and,169; eugenics and, 16–18, 34, 81,
 158; film school at, 11, 16–18, 34;
 Reagan and, 86, 158–159; Schwarzeneg-
 ger and, 102, 177, 181. *See also Higher
 Learning;* Wayne, John
University of Southern Mississippi, 163
University of Texas at Austin, 36, 91, 119
University of the Pacific, 118
University of Wisconsin, Superior, 94

Vanzetti, Bartolomeo, 87
Varela, Leonor, 168
Vargas, Deborah R., 146
Vargas, Jacob, 168
Veblen, Thorstein, 74
vicarity: critical, 126–129, 137, 183;
 Hartman, Saidiya V. and, 24, 124;
 incorporation into hegemonic projects
 and, 56, 125; Nadia, Elis and, 130,
 208n54; Rivera, Tómas and, 24 25,
 124–130; Sedgewick, Eve Kosofsky and,
 129–130; top-down, 24, 80, 124
Virginia Military Institute, 71, 160
Viswanathan, Gauri, 152
von KleinSmid, Rufus B., 16, 34, 188n3

Walker, Alice, 174
Walker, Scott, 92
Wallace, Michelle, 162
Walmart, 97, 152, 213n14
Walter-McCarran Act, 66
Walthall, Henry B., 41
Warner, Jack L., 159
Warren, David, 142
Washington, Booker T., 14, 110
Watts uprisings, 3, 84
Wayans, Kim, 174
Wayne, John, 80–82
Weber, Lois, 12
Weider, Joe, 97
Wellesley College, 110
West African Students' Union, 80
West Point, 20, 33
Whiley University, 56
white nationalism: college films and, 32–36,
 81, 182–184; Hollywood and university
 support for, 4–6, 16, 18; Ronald
 Reagan and, 68, 77–79. *See also Higher
 Learning,* Production Code; respectability
Whitman, Walt, 129
Wilder, Craig Steven, 8, 156, 167
Williams, Jeffrey J., 147–148
Williams, Patricia J., 68–69, 91–92

Williams, Tyler James, 164
Winant, Howard, 84
Winfield, Paul, 113–114
Wilson, Woodrow. *Birth of a Nation* and,
9–10; racism while Princeton president
of, 9–10,
Woodburne, Michael O., 138, 143

Xiaoping, Deng, 92

Yale University: colonialist history of, 152,
156; film research at, 11–12,14; football
teams of, 36, 38, 52; silent films and,
31–33 190n3, 191n8. *See also* Segal,
Erich
Young Deer, James, 36–37, 40, 43
Young Deer's Return, 43

Zukor, Adolph, 11